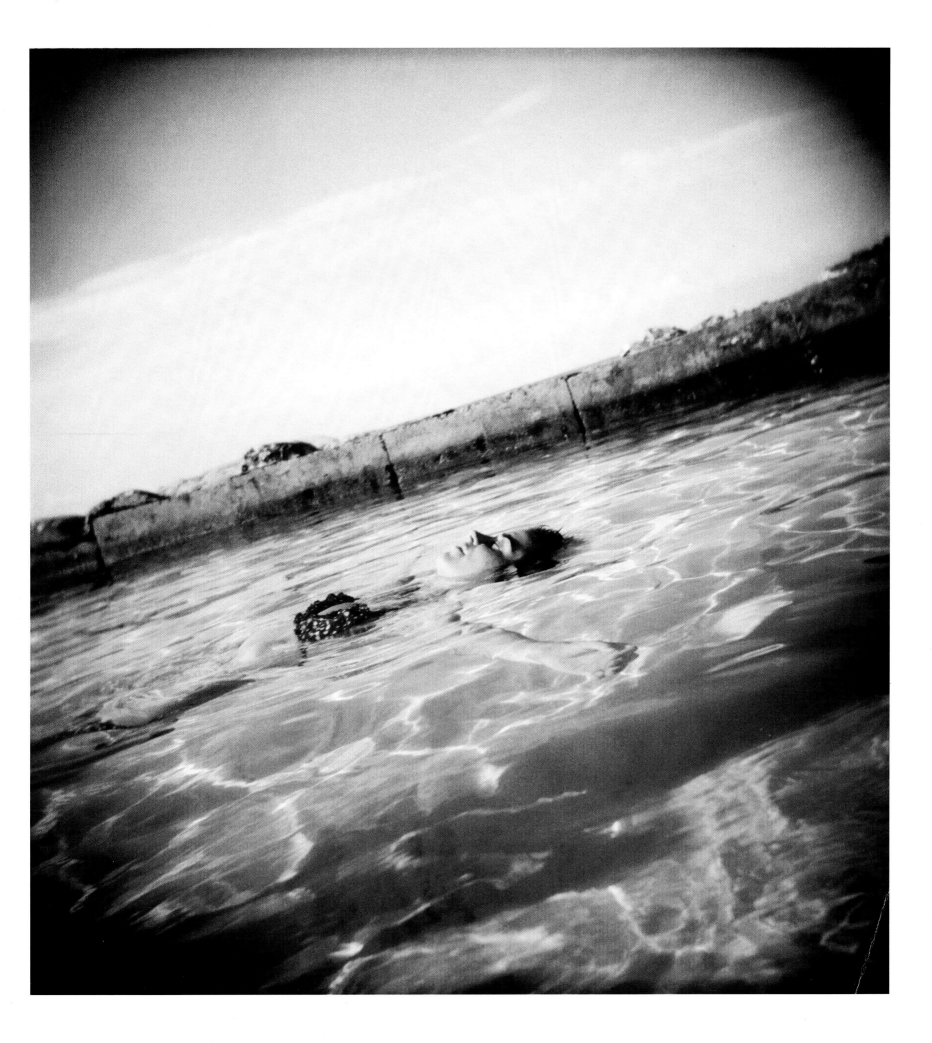

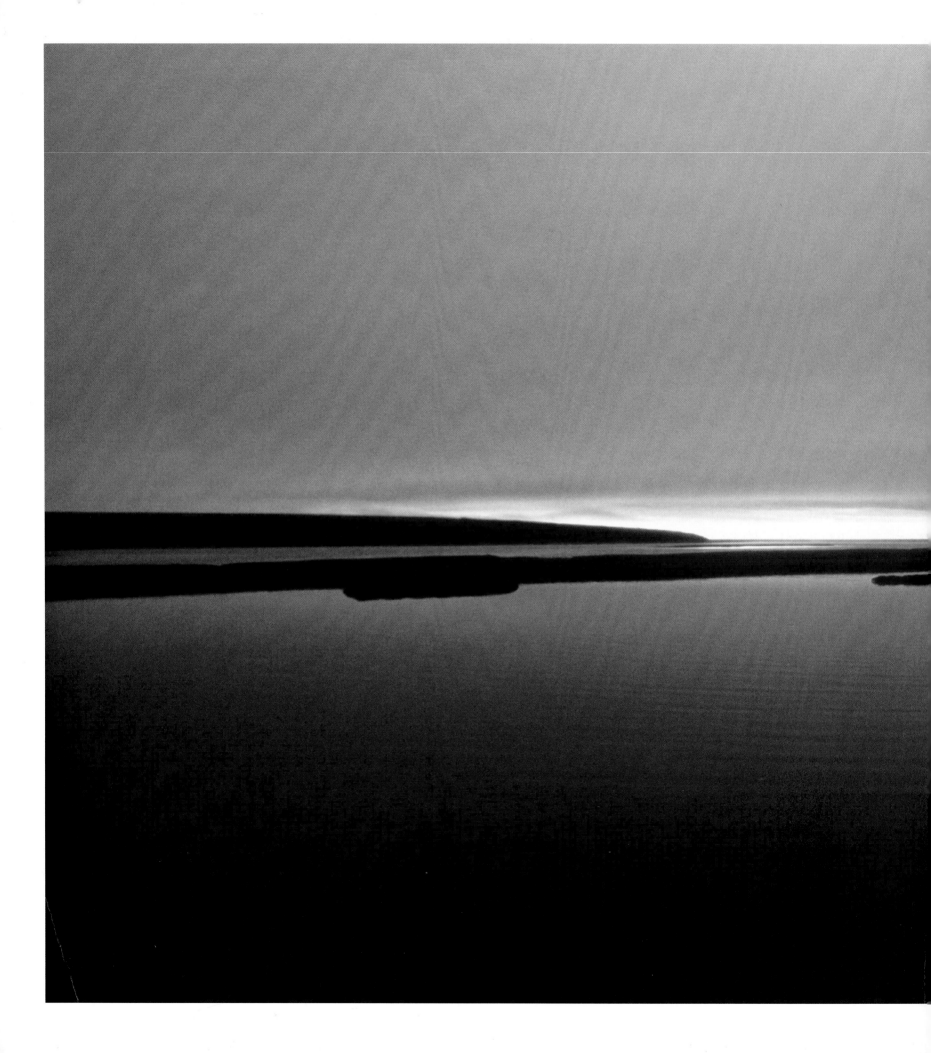

VISIONS *of*
PARADISE

NATIONAL GEOGRAPHIC

WASHINGTON, D.C.

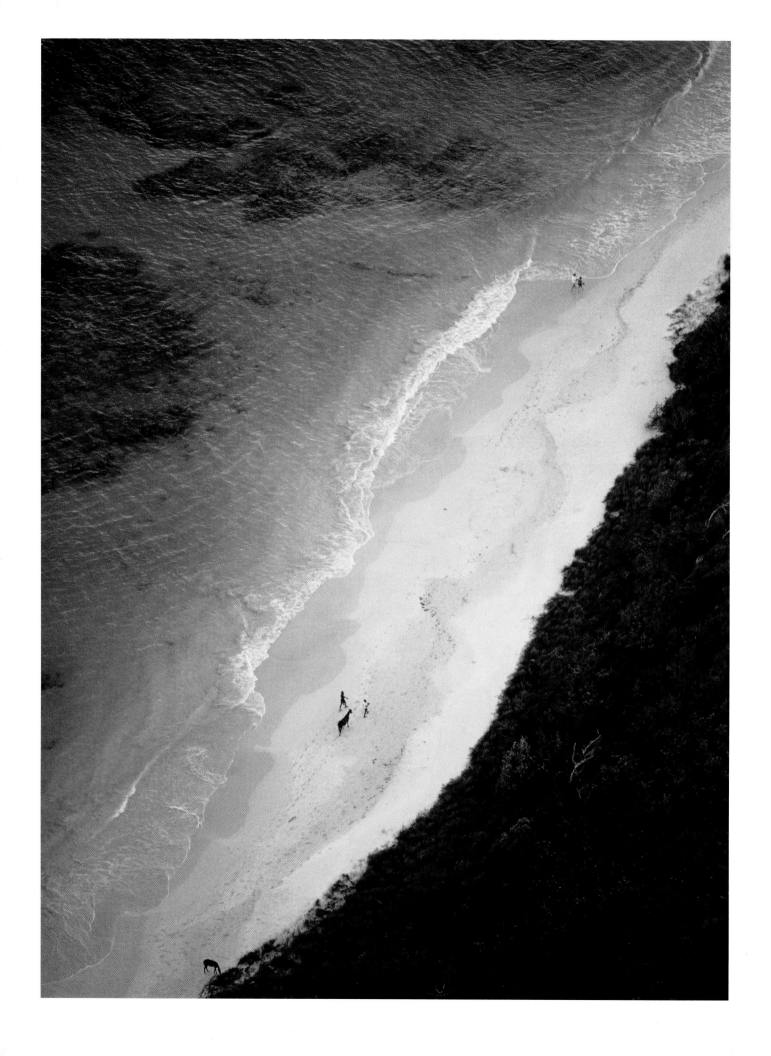

PAGE 1: CHRISTOPHER ANDERSON | *Cuba* | 2003 | A woman lolls in the water during a hazy, hot day. | *PAGE 2-3:* JOHN DUNNE | *Alaska* | 2000 | The Arctic sun stalls on the horizon over Turner River at Demarcation Bay in the Arctic National Wildlife Refuge. | *PAGE 4:* JODI COBB | *Antigua* | 2000 | Two people walk along the beach in Half Moon Bay. | *PAGE 6-7:* MICHAEL NICHOLS | *California* | 1995 | A baby white tiger in the Marine World Africa USA (now Six Flags Discovery Kingdom) shakes off water after a swim in the pool. | *PAGE 8-9:* GORDON WILTSIE | *People's Republic of China* | 2000 | A climber walks nearby Shipton's Arch in the Taklimakan Desert. | *PAGE 10-11:* FLIP NICKLIN | *Canada* | 2002 | A gray whale cruises the waters of Grice Bay in British Columbia. | *PAGE 12-13:* JODI COBB | *England* | 1999 | A glimpse of the street in London from inside a taxicab during a rainstorm. | *PAGE 14-15:* DAVID DOUBILET | *Cayman Islands* | 2000 | Three stingrays search for dinner after the waves swept the sand smooth during the afternoon. | *PAGE 16-17:* GORDON WILTSIE | *Russia* | 1995 | A helicopter begins the journey to Cape Arkticheskiy, a popular place to begin treks to the North Pole.

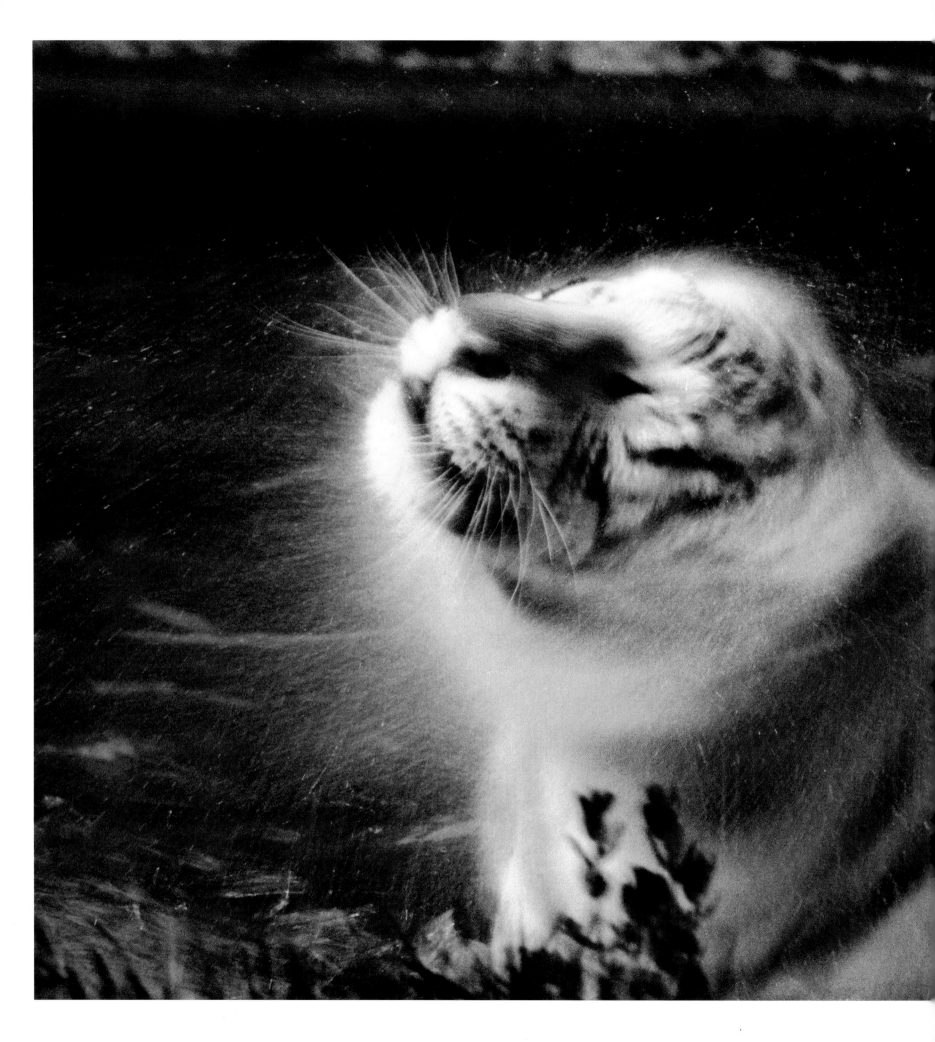

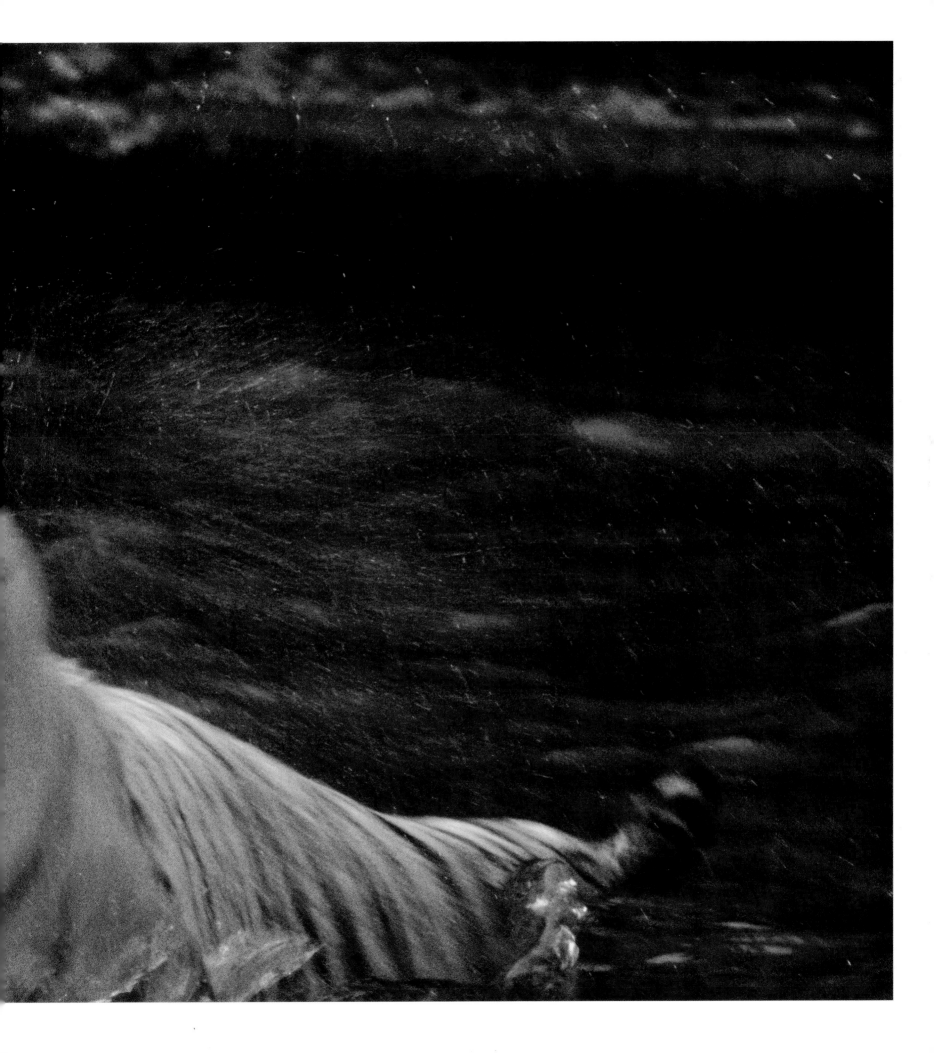

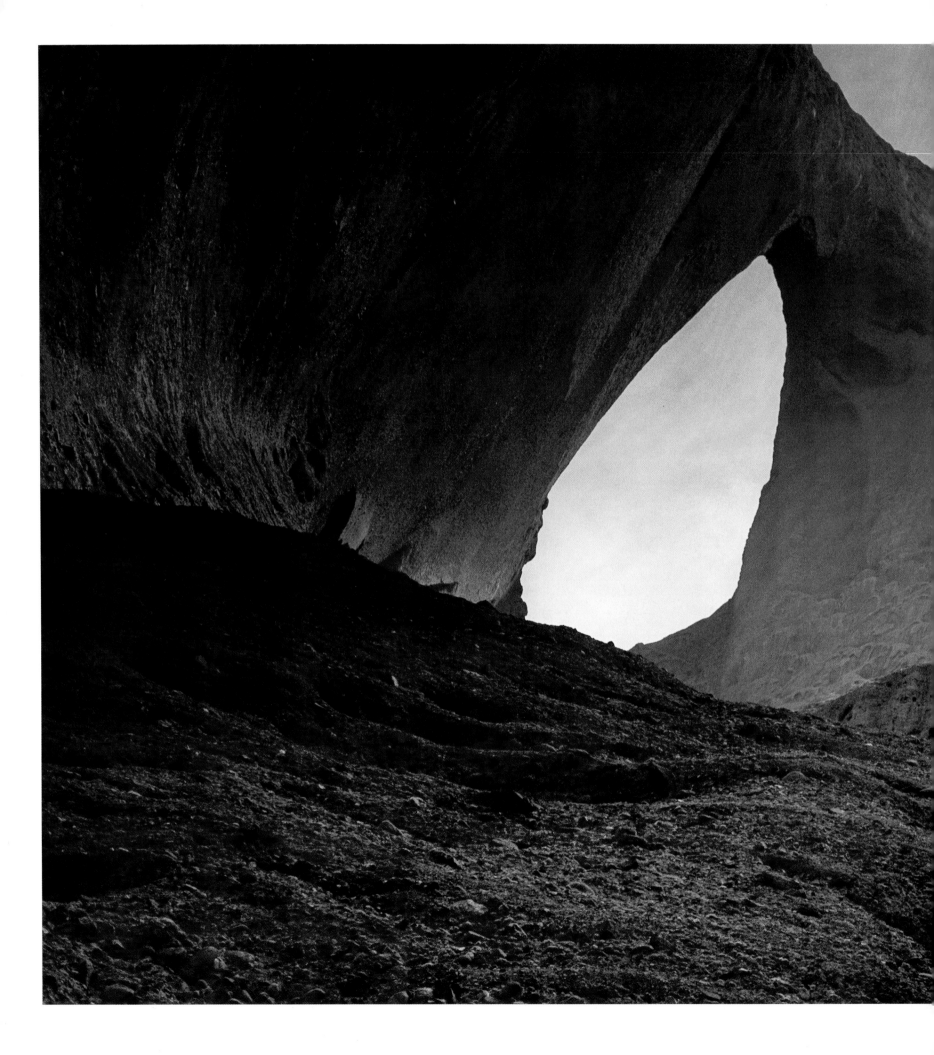

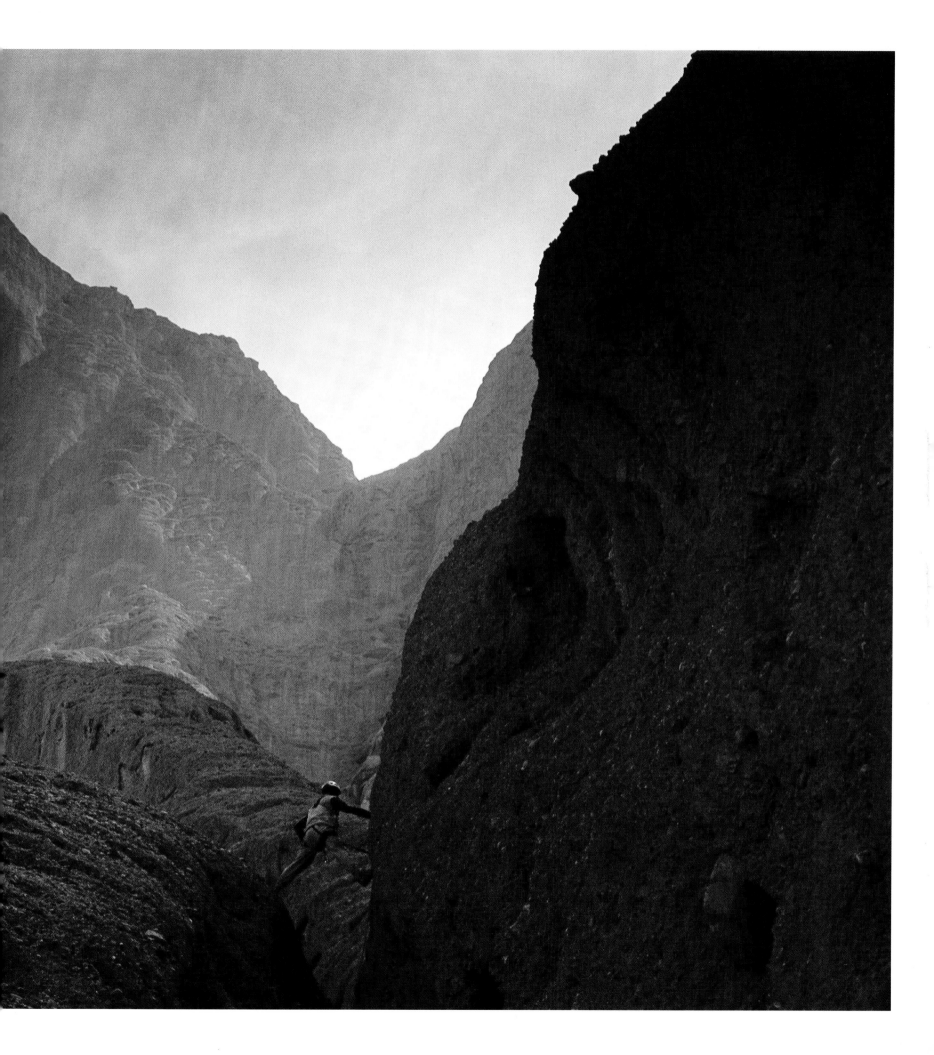

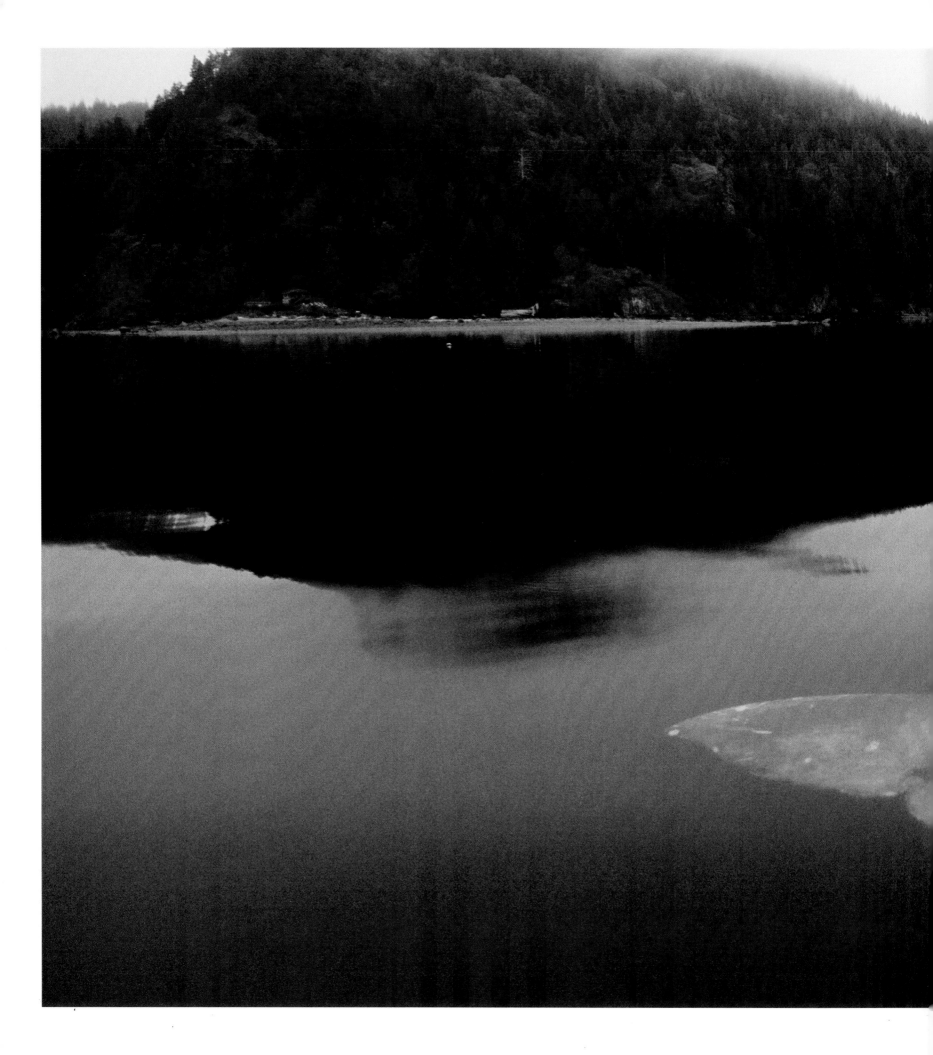

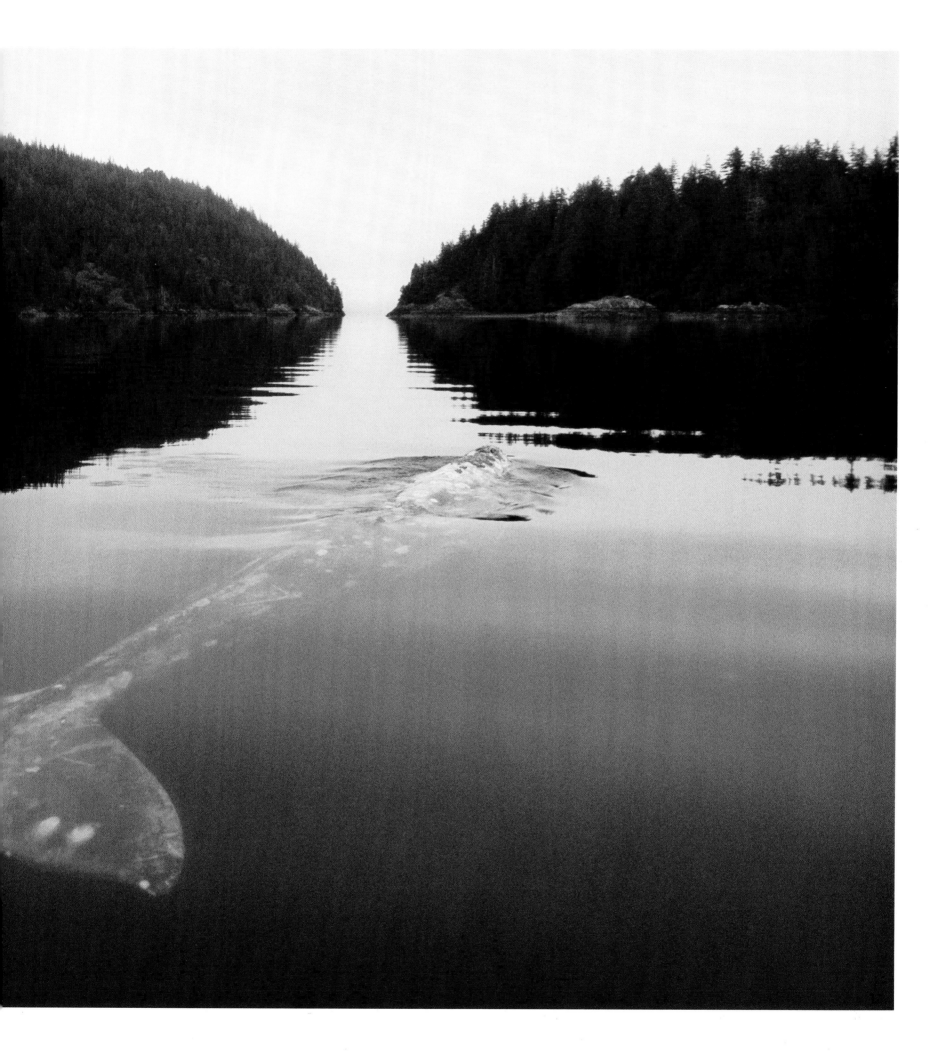

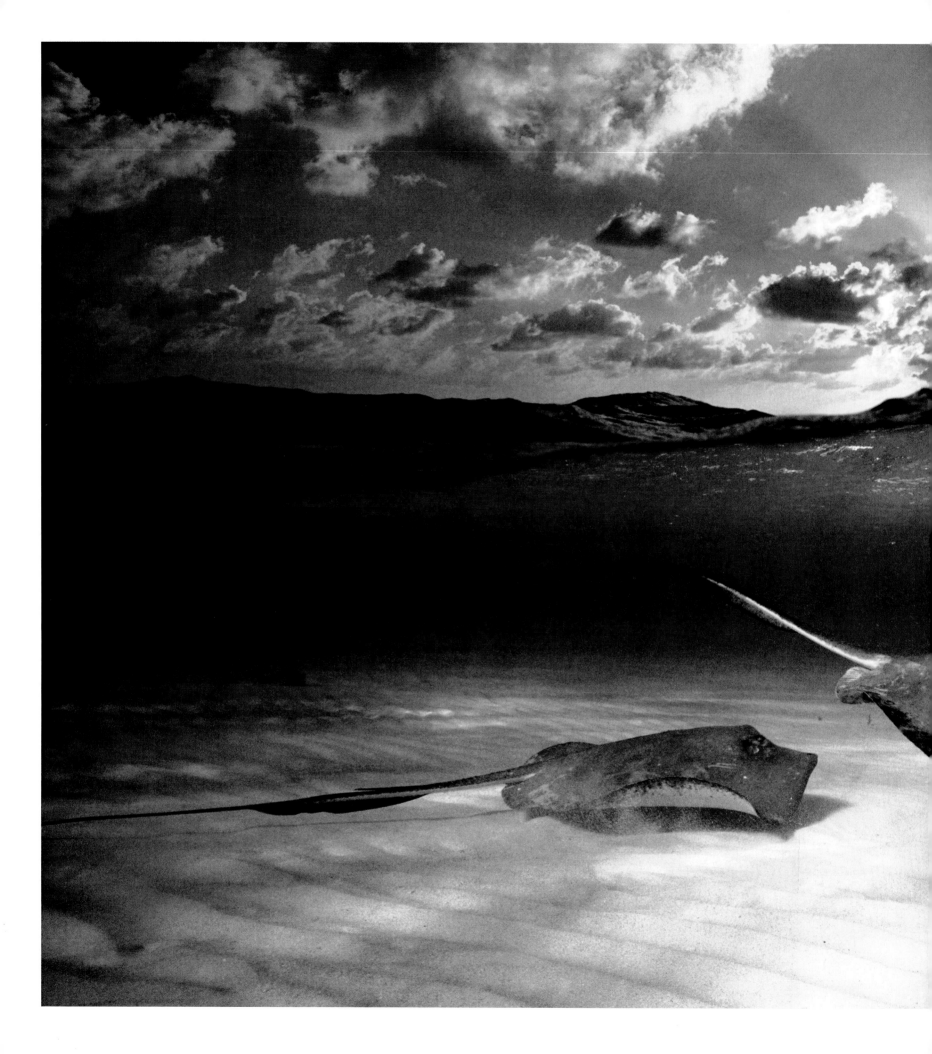

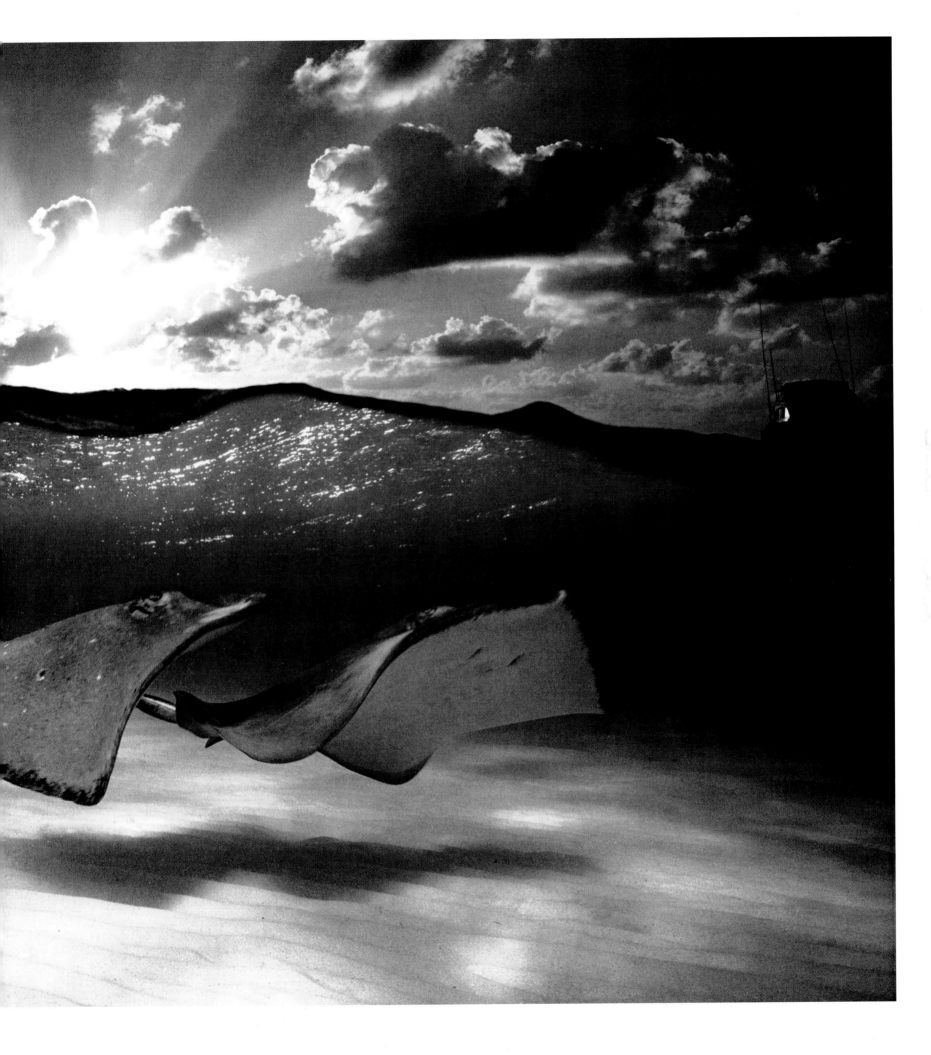

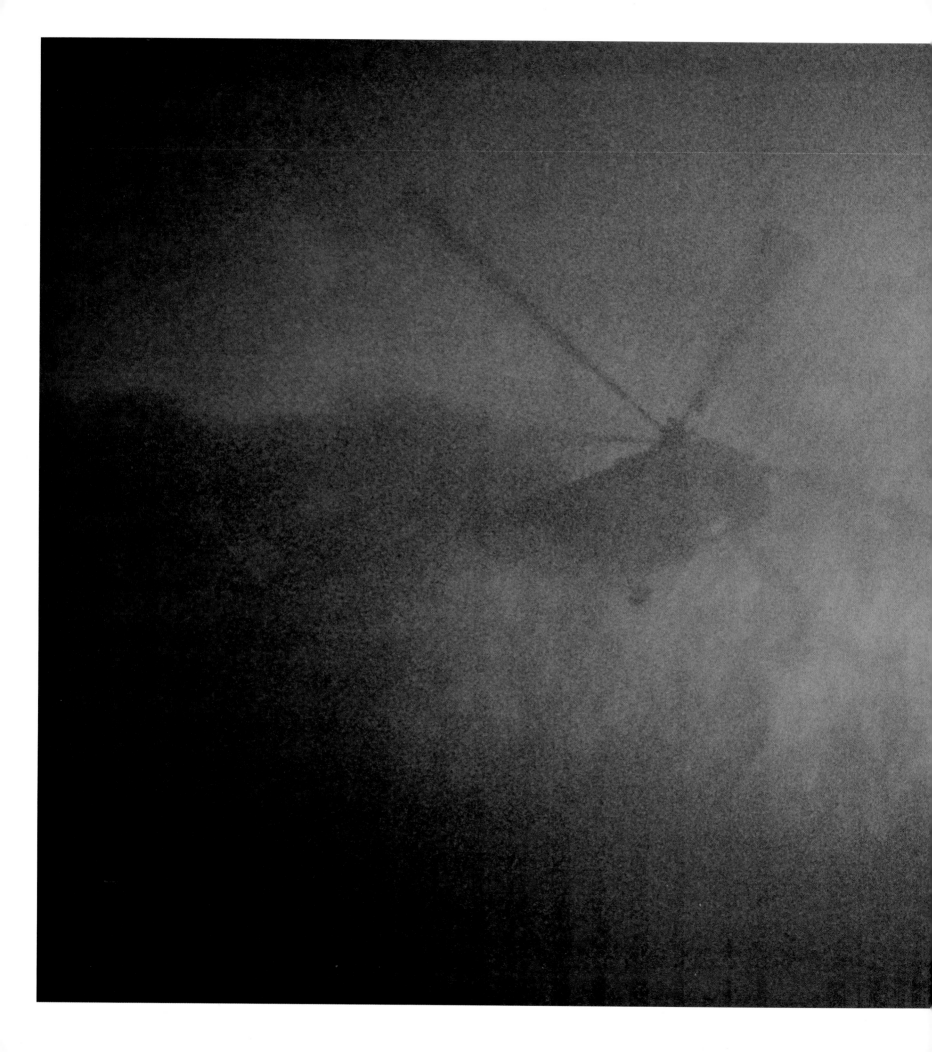

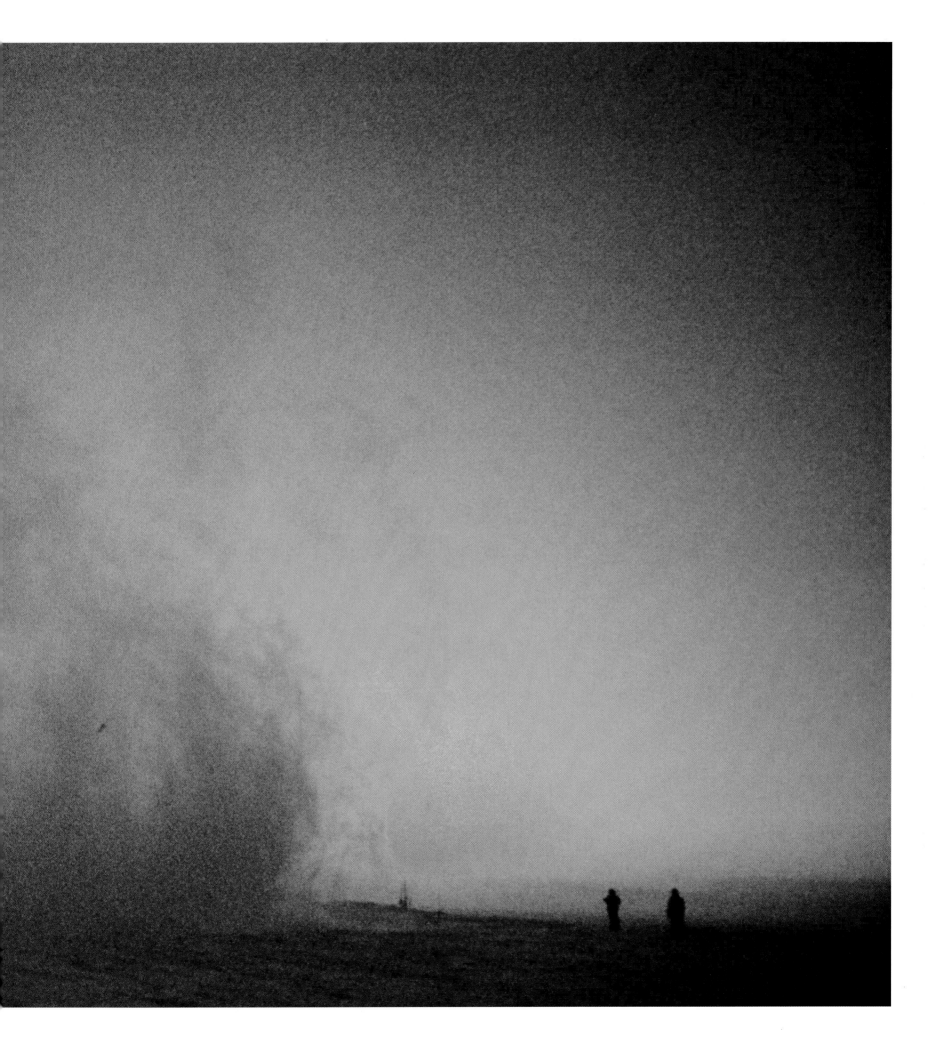

Bronwen Latimer

INTRODUCTION

The idea for this book arrived one summer afternoon. I was escaping the thick, clammy heat of a Washington, D.C., lunchtime by browsing the photography books in my local (air-conditioned) bookstore. I found personal retrospectives, beautiful architectural tomes, and bold, glamorous well-designed photography albums nestled in heavy boxes. Thumbing through the books, I dove into one world after another, smitten. As I left the store, the image I carried in my head from that visit into books was full of leaves—green, glossy leaves—and a tiny girl standing among them. She looked like she was standing in paradise.

As I walked through the steel and glass and concrete canyons of downtown back to my office, I wondered if there was a simple idea of paradise or if there could be many ideas. I called a few photographers—the most peripatetic group of people I know—to ask them. Where was heaven on Earth? Most people told me their ideas in less than a minute. Some fretted over the question and promised to call back but never did. Some people gave the question some serious thought and then sent me a written paragraph or two of their own. In short order, *Visions of Paradise* started to become a book.

I was unable to cover the globe in a fair and equal edit. For instance, not many photographers chose cities to represent paradise. I love cities; particular moments come to mind, as in Paris when the streetlights turned on, or in Prague when the remnants of revolution were still hanging in the air on Wenceslas Square. But journeys and the idea of paradise are personal. Many, many

deserving places are not pictured as a result. I hope that the citizens of countries such as Italy, Spain, Saudi Arabia, Uzbekistan, Vietnam, and others will understand these limits and know of their own paradisiacal corners, but love this book anyway.

These are the large lessons I learned along the way. Paradise seems to be most likely in places that are remote, untouched, original, defined, organic, and just plain simple. Antarctica appears many times in this book for these reasons. But paradise can also be a moment in time that is lost forever, and that is why you will find majestic and fleeting formations in the natural world of the landscape photography. I am thinking of Sam Abell's picture of a lone shark cornering a school of salmon off the coast of western Australia, or David Doubilet's Grey grunts, or Chris Johns's elephants, when I write these words.

Many of the photographers did set out to do one story and found another one to capture their mind. Vincent Laforet made a picture about solitude in New York while he was out photographing a real estate story. Kenneth Garrett was in Egypt to photograph the lost gospel of Judas when he was awakened by pilgrims from Korea trekking past his camp on the way to Mount Sinai. Christian Ziegler found bliss in Brunei only after he tried to escape the depression he felt in Borneo when he saw nothing but plantations where forests used to be.

Many of the photographers have a deep passion for the stories they photograph because the subject matter is somehow a part of

them. Gerd Ludwig spent much of his childhood in the woods near his hometown in Germany, and those memories fuel his desire to document the incredible losses we have seen in Chernobyl and now the beginning of what we are losing in the Great Smoky Mountains. Tim Laman, who has amazing photographs from the waters of Fiji and the treetops of Indonesia, earned a Ph.D. in rainforest biology, and his camera was a tool in his research before the artistry of his photography overtook the scientist in him. And once you have met Joel Sartore, you can never not love Nebraska, even if you have never set foot in the state. He lives there, and he loves the place.

Many photographers made me laugh during our conversations. It was hard to stop speaking with Sarah Leen who is still besotted with Siberia ten years after working there. Michael Kenna spoke eloquently about standing in Hokkaido without a sound around him except for the small puffs of his breath and the falling snow, only to end with, "And the karaoke there is amazing!" David McLain was right back in Greenland as he spoke, remembering how exhausted he was after five weeks of walrus hunting on the ice only to find solace in an abandoned hut with a broken propane heater and a cold beer.

Some people changed me forever. Reza took the longest time to consider my question. He, who has dedicated his photographic career to giving a voice to those who may not have one, sat in silence in my office, and when he began to speak, he spoke of hell, for a reason you will soon read. Stephen Ferry taught me about the

lessons he learned from several tribes in the Sierra Nevada mountains, lessons in both political dialogue and environmental survival that are powerful to learn no matter where you live. And then there is Maggie Steber. Before we even spoke about the Indian chief she photographed, we discussed the lizard that had wandered into her home that morning in Miami. Should she send it back out? But the heat might kill it outside, and yet its food was outside. What was the right thing to do? (Maggie, to this day I can't kill the stinkbugs and spiders in my house. I take them into the garden, thank you.)

As much as I needed to rely on the visions of the photographers, this book benefited from the talent and expertise of six other people as well—four very talented writers, one patient text editor, and one amazing designer. Linda Kulman writes about the important issues concerning our land, and how we need to change our ways to keep it healthy. Joel K. Bourne, Jr., a regular contributor to *National Geographic* magazine, paints a bleak yet hopeful picture about the state of the world's water. Brian Doyle, who I thought might want to write about water because of his treatise on anchovies one year, chose to write about air, and did he ever! His essay might leave you breathless. Katy Kelly gives us a brief biography of each of our contributors so that you may get to know them just a little bit better. Karin Kinney, who was the first person to read the book, had the last say on our words. And finally, Melissa Farris, our designer, wove our research, our ideas, and our photographs into a beautiful story that you can hold in your hand. The intricacies of type and materials are manifold, and this book is imbued with her style and grace.

LAND

Linda Kulman

MY LAND, OUR LAND

Who has never picked up a stone and shoved it into his or her pocket? It's a simple act, but it points to our fundamental attitude toward the land. We take it to be ours. And we have shaped it, literally, to suit our purposes—planting prefab houses on what was once farmland; lopping off mountaintops to extract coal; adding unnatural amounts of fertilizer to the soil to produce cornstalks as tall as traffic signs and red apples the size of stoplights.

We kid ourselves that human beings haven't always been so self-indulgent—that generations lived in concert with the land, caretakers, who tracked their quarry for dinner yet tread so lightly that they left no broken twig in their barefooted wake. In truth, there never was such a golden age. That post-Enlightenment fantasy was conjured up in the 19th century, just as industrialization hit full throttle.

Man first targeted nature's bounty some 50,000 years ago when he figured out how to make and use a weapon. The arrival of the first people in Australia about four thousand years later wiped out not just 10-feet-tall kangaroos but most of the continent's oversized animals, easy marks thanks to evolution, which left them lacking the guile necessary to defend themselves. Without exception, everywhere human beings went, from North America to the Mediterranean Sea and the Pacific Islands, the largest and slowest native creatures died off. Other species that weren't killed for food or hides still vanished due to the disruption of their habitat or man-made disease. It's proof, Jared Diamond writes in his book *Collapse*, that ancient peoples were no different than we are. "Managing environmental resources sustainably has *always* been difficult."

And survival is a powerful motivator. Hunter-gatherers had to keep moving just to put mastodon chops on the tree stump; overstaying their welcome in any one spot meant certain starvation. Some 40,000 years passed before we *Homo sapiens* understood that long-term staying power depended on learning to farm. Along with crops like flax, barley, and chickpeas came stability. Man's "rise was meteoric," says Daniel Quinn in his controversial 1992 novel *Ishmael* about the history of civilization and its survival. "Settlement gave rise to division of labor. Division of labor gave rise to technology. With the rise of technology came trade and commerce. With trade and commerce came mathematics and literacy and science, and all the rest"—including, of course, the drive toward ever-increasing consumerism, from a taste for mahogany furniture as a sign of gentility in the 19th century to today's yearning for a rustic mango wood dining table from Crate and Barrel. Things we once prized as luxuries have, over time, come to be considered standard, especially in America, where families have gone from owning one car to often buying three and expanding their garages to match.

But the land didn't fare as well as its tenants. The Stone Age's early adapters figured out how to fashion flint axes and soon after arrived at how to clear the land. Going from one tree to the next they cut a two-inch incision around each trunk to stop the sap from rising. By this primitive method, it took only a couple of years

PREVIOUS PAGES: **CARSTEN PETER** | *Sicily* | 2004
Hot lava from Mount Etna pours through a channel between two
beds of hardened lava.

for towering hardwoods to become skeletons, which farmers then torched. They used the ash as fertilizer (though whether intentionally or not is hard to tell), planting crops among the charred stumps. Forging fields out of primeval forests had altered the landscape of much of Eurasia long before the Bronze Age dawned or the New World was discovered. A survey, ordered just after William the Conqueror became the king of England in A.D. 1066, showed that 85 percent of Britain was already deforested. "Even though there weren't that many people around, almost every one of them was a farmer," says climate scientist William Ruddiman. Few civilizations, if any, realized what harm they were doing to the land. Indeed, their actions weren't born of malevolence so much as of shortsightedness in a world with seemingly infinite resources. But today there's ample evidence that such widespread deforestation and the massive erosion of the soil that followed set the stage for the fall of entire cultures, including the Maya and the Roman Empire.

Still, the Earth's abundance was so great and the population so small—about 300 million in A.D. 1—that nothing we did was so bad. But today the planet is the home of almost 7 billion people, with a million new mouths to feed every four days. At this rate, we're expected to reach 9 billion in just four decades. Meanwhile our finite resources are buckling under the pressure. If, as Napoleon said, an army moves on its stomach, so does every man, woman, and child: These days to assuage our hunger, we're changing the global land-use pattern significantly, shifting tens of millions of acres into food production. In the United States, to satisfy our

lust for bigger, better houses, two farms are being plowed under every minute. Nonetheless, about a third of the Earth's land is used either for cultivation or grazing, thus responsible directly or indirectly for what we eat. Go into the heart of South America, says Alan Weisman, the author of *The World Without Us*—a book that envisions nature's response after human beings have vacated the planet—and it's planted in this huge monoculture of soybeans, an enormous percentage of which is used only to feed cattle.

While much attention is paid to rising gas prices, our dependence on coal is growing, the same energy source that stoked the fires of the industrial age. In China alone, coal generates half of the country's electricity. There and here, such heavy need is carving up a new landscape via strip mining with bucket-wheel excavators, some of the world's largest machines. Another method—mountaintop mining, used increasingly in the Appalachian coalfields of West Virginia, Kentucky, Virginia, and Tennessee, which reaches coal seams deep below the surface—is shaving off some of the world's oldest peaks, with the rubble funneled to fill in the once-verdant valleys and streams below, choking off whatever wildlife may have lived in its path. The areas' natural topography excised, the flattened-out countryside might as well be Kansas. But Kansas and Nebraska have their own thing going on, as hundreds of thousands of acres of prairie are being turned into fields to grow corn for making fuel.

Land preservation does not come naturally to man. Like the beautiful youth Narcissus in Greek mythology, we have looked into a

lake and seen only our reflection. At nearly every instance where human interests conflicted with the natural world, it was nature that suffered calamity. After all, when given a choice, as Jared Diamond posits in *Collapse,* "Do you really care less for humans than some lousy useless little fish or weed, like the snail darter or the Furbish lousewort?" But that turns out to be a false choice. Wildlife does things for us we either can't afford to do ourselves or can't do at all. "Elimination of lots of lousy little species regularly causes big harmful consequences for humans," Diamond says, "just as does randomly knocking out many of the lousy little rivets holding together an airplane."

And it's not just the "lousy" species being singled out. *National Geographic* photographer Joel Sartore, who has traveled the world for 20 years documenting endangered species, says that among those most at risk are "specialists, animals that require a specific type of food or habitat, or they will fail." This includes beloved species like polar bears and seals; both need ice to survive in a world where the thermometer is rising. It includes the ivory-billed woodpecker that can only get its grubs from trees that have been dead for two years or so. It includes amphibians in the Amazon. "We're quickly becoming a planet of weeds," Sartore says, meaning "species that can adapt quickly to any conditions." Human beings are that way. Other adaptive species—starlings and rats, for instance—will scurry to fill whatever vacuums our disregard for biodiversity leaves behind.

Yet when we close our eyes and imagine the Earth, what we picture is the Blue Planet as the astronauts viewed it from space,

not a scarred, flattened world, crawling with highly resourceful cockroaches, and overgrown with kudzu, brought from Japan in the 19th century amid great promise and now known to strangle all vegetation (and everything else) in its path. While we tend to look no farther than the cities in which we live, we still expect that if we can just book the right excursion far enough away, there are Edens left to enjoy—uninhabited islands ringed by unspoiled beaches with virgin vistas just over the next hill. As Simon Schama points out in his book *Landscape and Memory,* we still believe in the promise put forth by the original environmentalists Henry David Thoreau and John Muir that "in wildness is the preservation of the world." Indeed, we crave such wilderness. And pristine exceptions do exist—deep in the lush forest of the Amazon and perhaps the Congo; in the snow-capped, forested mountain regions of the eastern Andes; in the high desert—places that have been preserved largely because we can't get to them.

Mostly what we can count on these days are compromises. "And even that," says Michael Novacek, provost of science at the American Museum of Natural History in New York and author of the book *Terra,* "is something to be grateful for," adding, "Securing land is in the eye of the beholder. One person's wilderness is another person's farm." Although the biodiversity we've lost is irretrievable, it's possible to recapture some of the Earth's original glory. There are countless examples of shade-thick forests that have either naturally regenerated themselves with new growth or been converted to plantations. Sustainable farms are blossoming on the landscape. In the majestic Adirondack Mountains of New York, conservationists

have capped the number of people who can hike there at any one time, reducing the human impact on trails. Even the great polluter McDonald's agreed to a two-year moratorium on the purchase of soybeans from newly deforested areas in Brazil.

Along with these small, often haphazard, efforts are large-scale examples of our improved stewardship. Wildlife corridors such as those that thrive in Costa Rica and the Rocky Mountains allow animals to migrate over long distances as a sort of superhighway for natural species, exacting payment in the form of land easements and acceptance on the part of the people who share these biodiverse habitats with panthers, wolves, and grizzlies, planning roads and houses around the animals' need for space. Brazil has recognized that, while it is too late for the rainforest to be declared a development-free zone, this precious resource must be carefully managed so that loggers will no longer cut in a road just to reach a single, valuable tree.

We have a long way to go. We have transformed parts of the world into a toxic stew of chemicals. Fertilizers have stuffed the ground beneath our feet with nitrogen and phosphorus. Industrial products and derivatives have filled our soil with cadmium, lead, mercury, trichloroethylene, formaldehyde, acetone, and benzene. In Europe and Asia, we have spawned Chernobyl and Bhopal. South American and African soil have been contaminated by "hand-me-down" pesticides like DDT. Too toxic for America, they're sent abroad sometimes in the name of international "aid." Even at home, too many people live within miles of an Environmental Protection Agency–designated Superfund site. Though most of us aren't guilty of reckless disregard, we are careless. Our offices are overheated in winter and supercooled in summer, while the windows are permanently sealed shut. Our automatic sprinklers shower gardens and golf courses whether it's raining or not. Without thinking, we daily squander one of Earth's most precious resources—the lack of which has led people in other parts of the world to kill each other. And though most of us live in a place where the water from the kitchen sink is within easy reach of a drinking glass, we guzzle bottled water from plastic bottles, some 51 billion of which wind up in U.S. landfills each year. While conscientious citizens now recycle, we still live in an overpackaged society. Where tea was once sold loose in a reusable canister, it now comes in a tea bag that comes in a foil packet that comes inside a cardboard box that's wrapped in cellophane.

While we can't redress old grievances, we can respect the land, like the old Blackfoot tribal saying that one must ask a rock's permission before picking it up and pocketing it. It's a small step. But it serves to remind people that the Earth doesn't belong to us; we belong to it.

Linda Kulman *is a veteran journalist living in Washington, D.C. She is a contributor to* U.S. News & World Report, *where she worked as a senior writer for a decade. More recently, she was the founding editor of NPR's weekly online feature and podcast "Book Tour." In addition to writing for* National Geographic *magazine, the* Washington Post, *and other publications, she has collaborated on four nonfiction books.*

VINCENT LAFORET
New York City | 1999

Having grown up in Manhattan, Vincent Laforet thought he knew the city quite well before he began to photograph the terrain from a helicopter. Then he realized how three-dimensional it is. "There is always something going on above you or beneath you," Laforet says.

One afternoon he flew along the East Side of Manhattan for a real estate story. As the helicopter buzzed back and forth near Sutton Place, he watched a man standing peacefully by himself in the park for several minutes. "It's so rare to find a single person alone in New York," says Laforet. "You can never really be alone." With one click of a shutter, Laforet made this man's moment last forever.

next pages, Vincent Laforet
Bryant Park, New York City, 2007

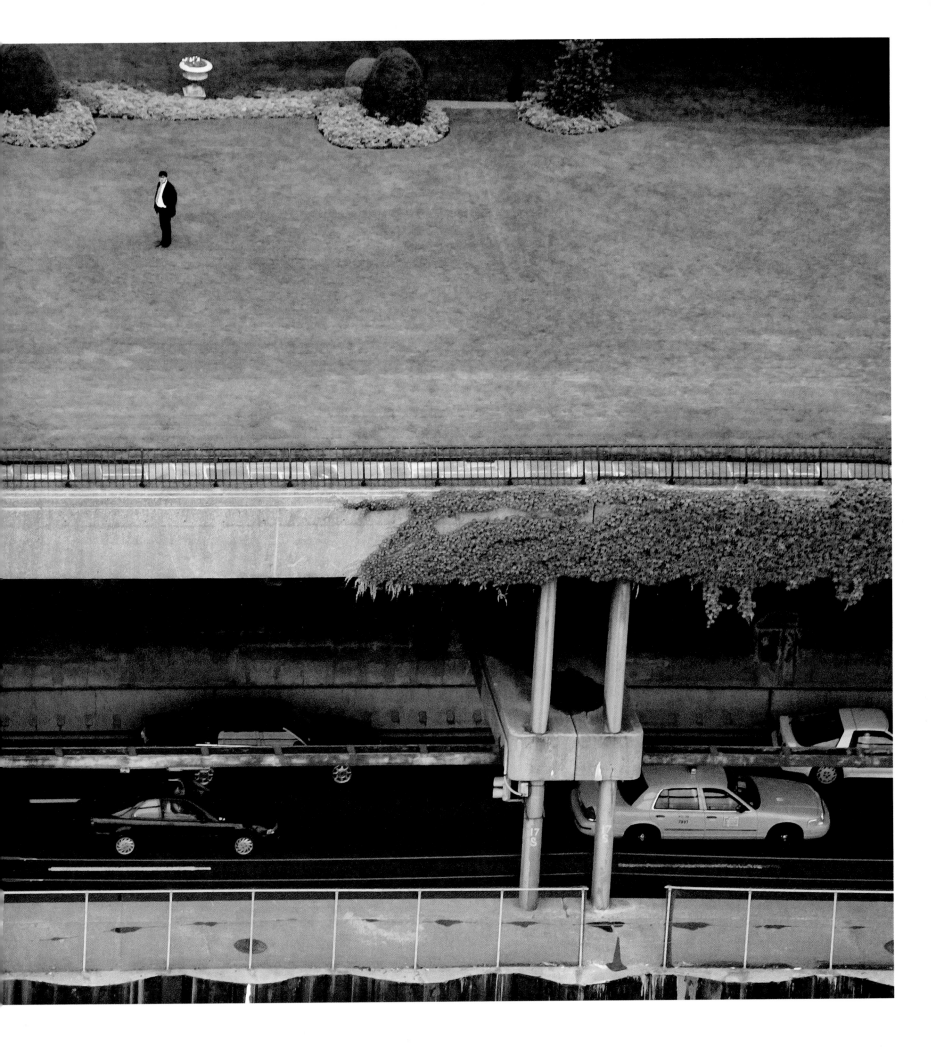

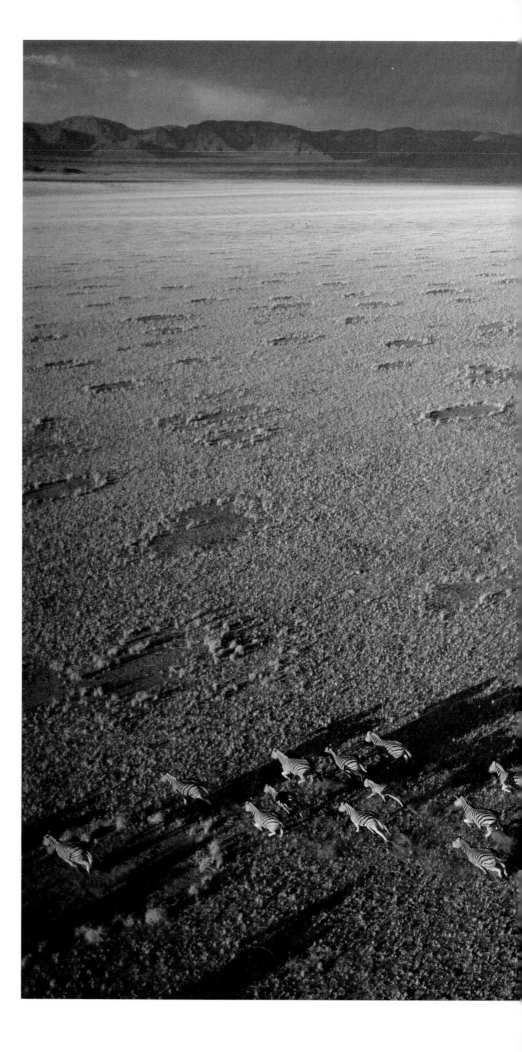

GEORGE STEINMETZ
Namibia | 2004

While riding in his self-styled paraglider, Stein-
metz startled a herd of zebra late one after-
noon in the Namib Rand section of Namibia.
They ran through the immense savanna dotted
with fairy circles, mysterious round patches
of sandy soil. "No one seems to know how
the circles are made," says Steinmetz. Some
scientists deemed them to be termite mounds
or eucalyptus roots but definitive conclusions
have never been reached. Whatever the rea-
son, the effect is magical.

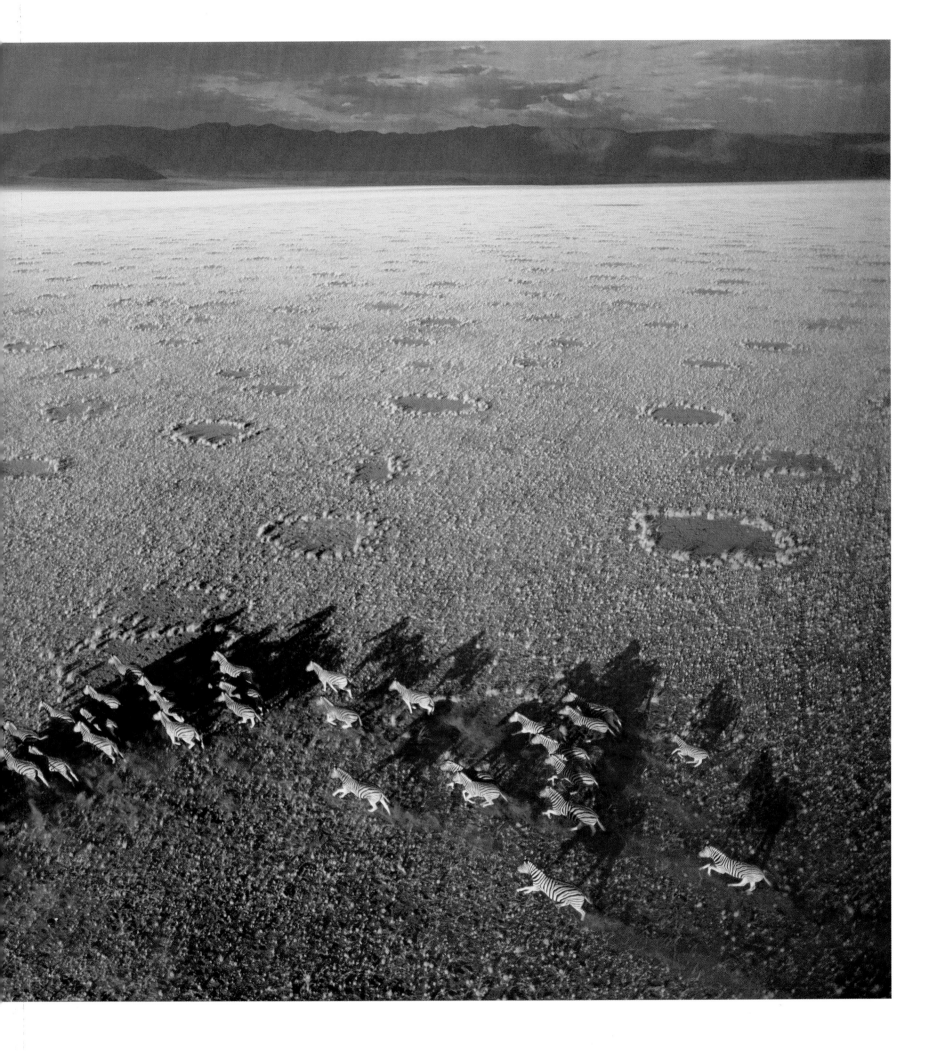

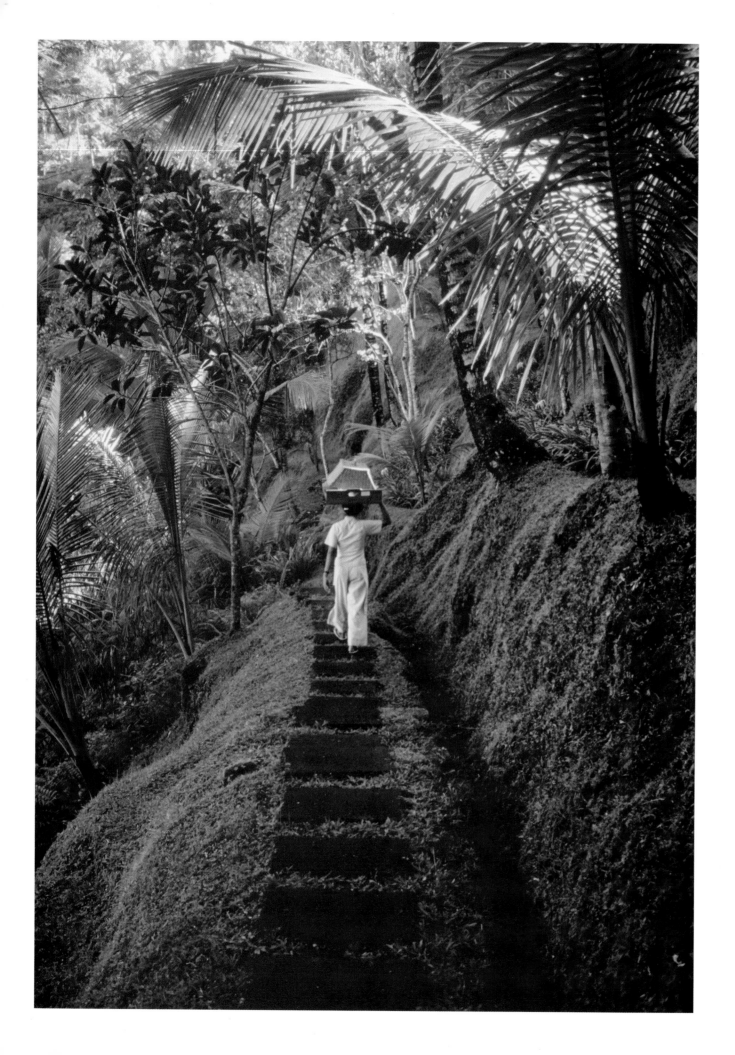

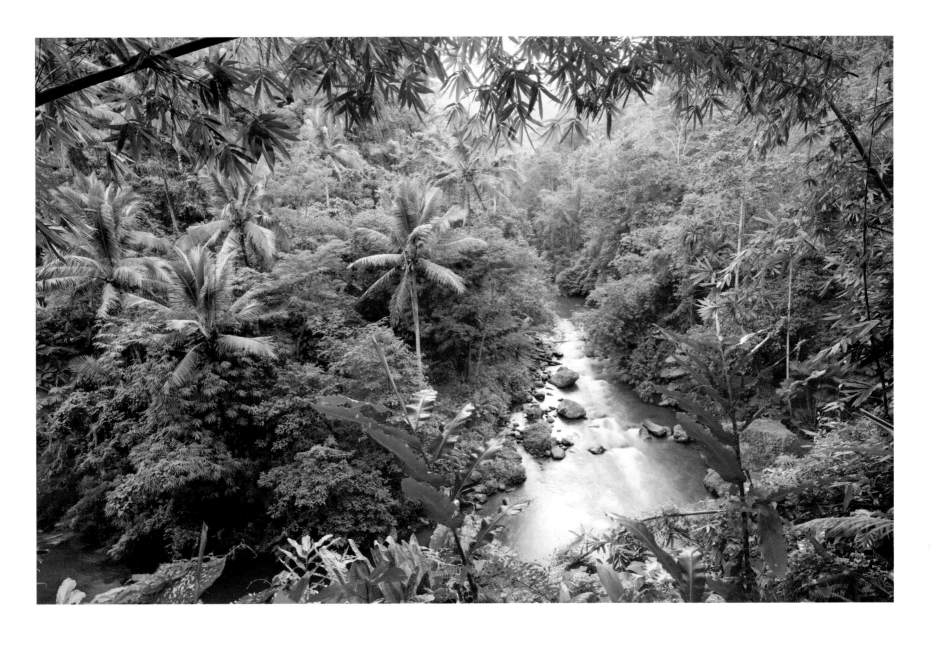

JUSTIN GUARIGLIA
Bali | 2002

Near the small village of Ubud on the Indonesian island of Bali, an estate near the Ayung River is a sanctuary for Justin Guariglia. "The first time I went there for the *National Geographic Traveler* magazine, I was supposed to stay for one night, and I stayed for five," remembers Guariglia. "This place was just submerged in nature. Lush steps led down to the river through a tropical rainforest. The place has incredibly good feng shui. It has been landscaped by humans, but it feels so dense and lush and right."

MEDFORD TAYLOR

Iceland | 1993

"I didn't understand how the midnight sun worked, I guess," admits photographer Medford Taylor, who traveled to Iceland during the summer to do a story on the 830-mile Ring Road that encircles that country. After Taylor checked into his hotel, he went out for a drive in the late afternoon. "I just kept driving and driving—the light was so magical. Before I knew it, I had driven 125 miles, and I didn't get back to the hotel until 9:30 the next morning."

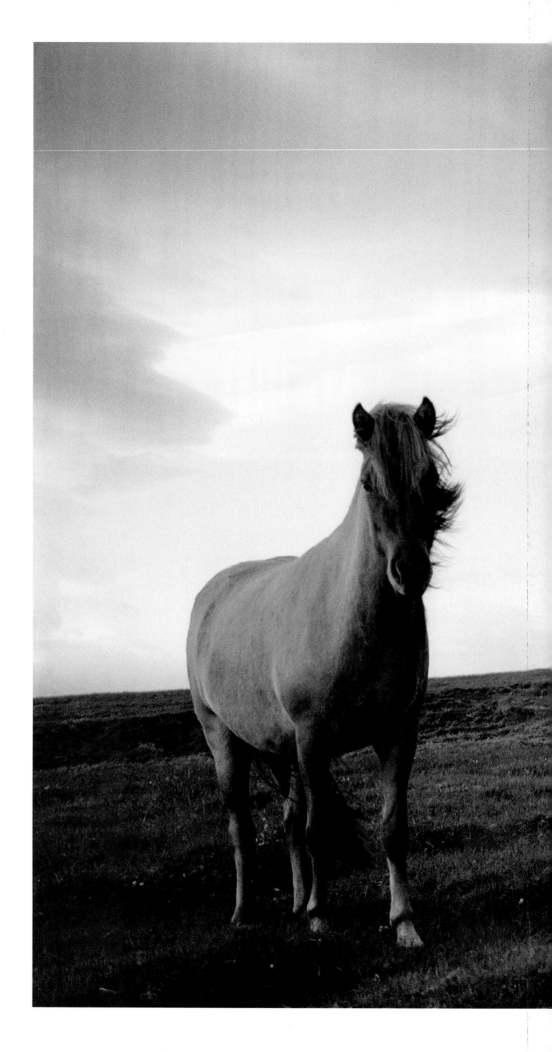

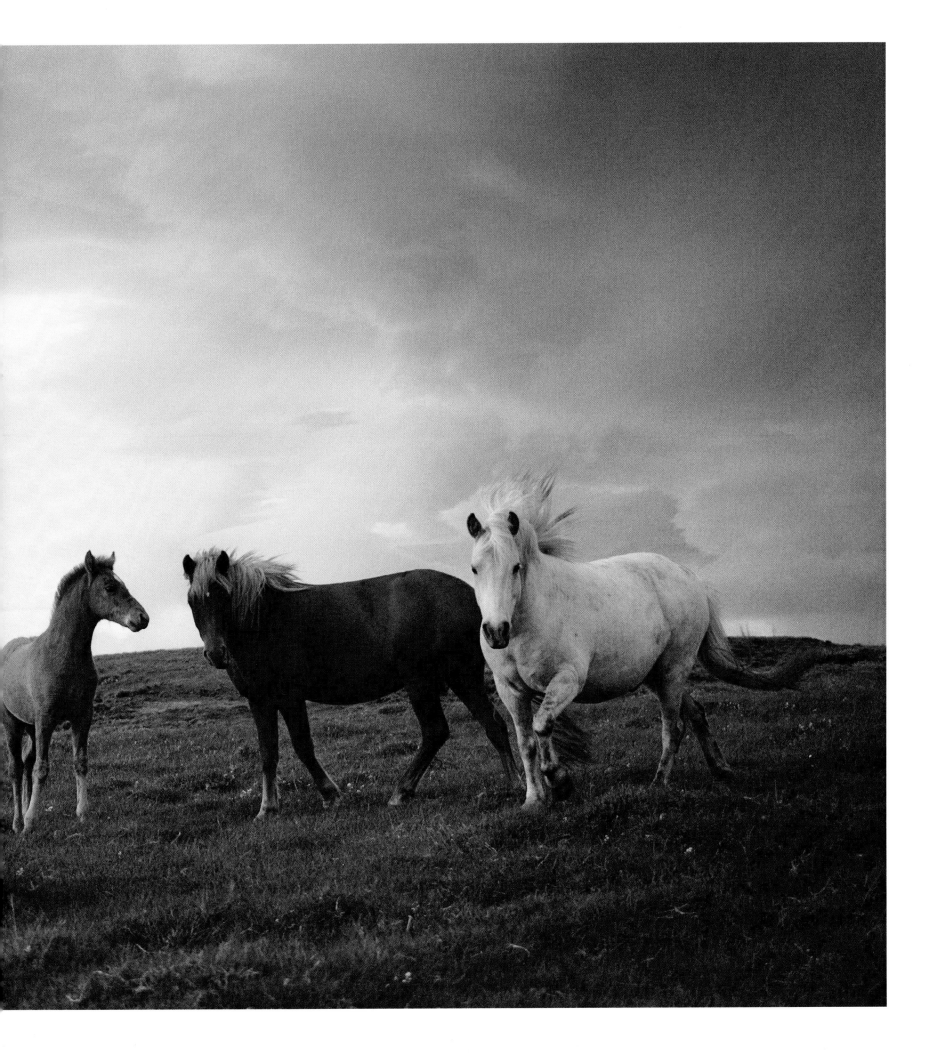

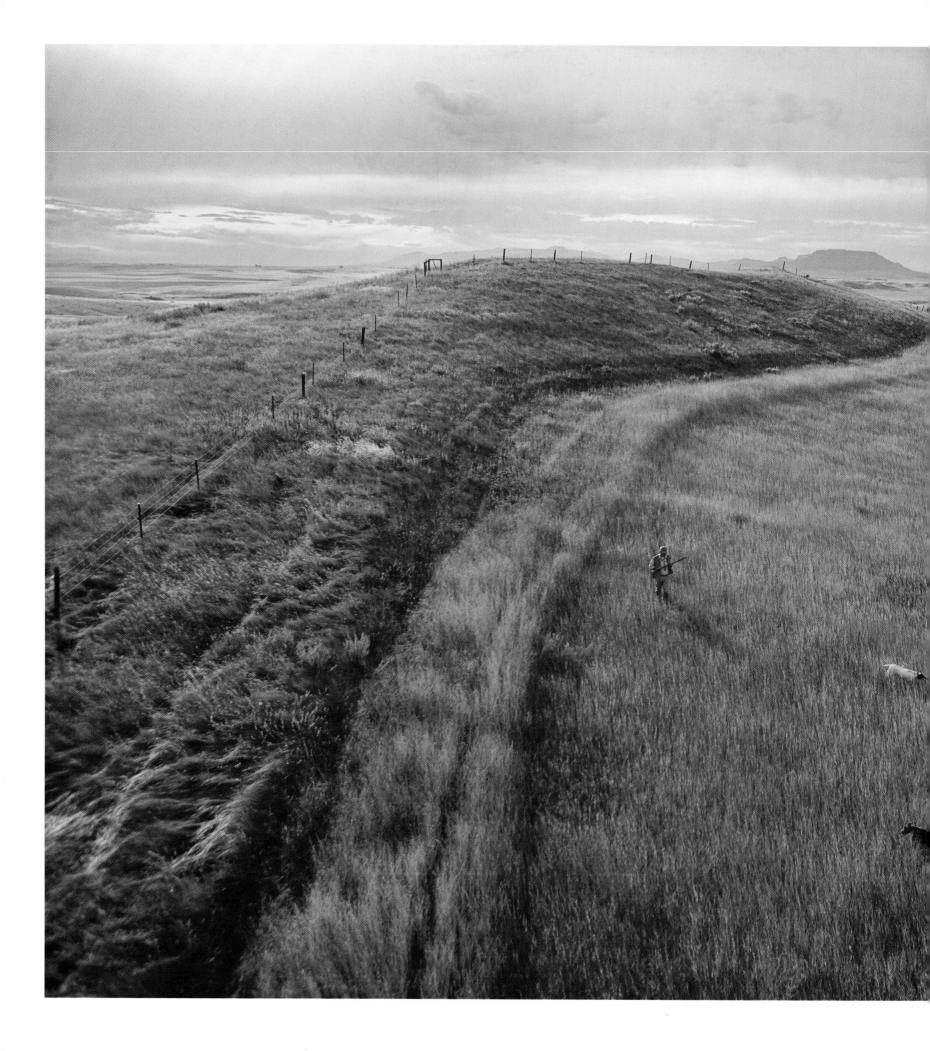

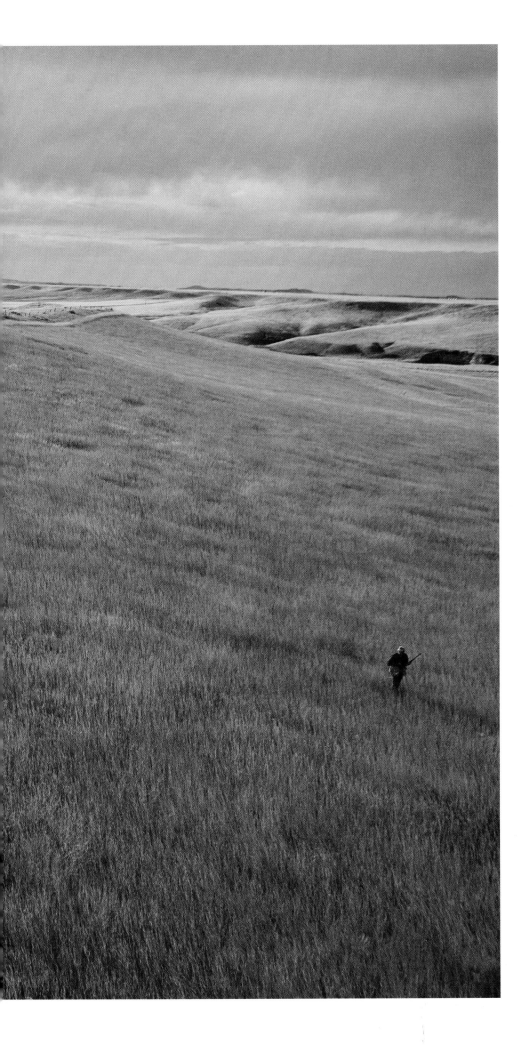

WILLIAM ALBERT ALLARD
Montana | 2007

Once upon a time—a good century-and-a-half before the fence in this picture was built—immense herds of buffalo still swept across central Montana in endless hump-backed waves of brown. Crow and Cheyenne and Blackfeet, their bodies and horses gaudily painted for hunting or fighting, rode through grasses sometimes belly-deep to their mounts. How spectacular that must have been to see—a vision of a Western paradise inhabited by very few. From what we know in retrospect, those first Americans didn't think of this land in the way we've traditionally been taught to think of ownership. It was both simply and profoundly country they lived in or went to for different reasons at different times; perhaps to ride against their enemies and earn honors by stealing their horses, or to hunt buffalo. As the curtain descended on the 19th century, with the coming of the first settlers and cattle, the telegraph and the railroads, and a conscious effort by the government to rid the land of the Indians' commissary, the buffalo were eliminated. The land probably seemed a lot less like paradise then to those who had known it at its best. That was very long ago. To me there are parts of Montana such as this landscape with Square Butte anchoring the horizon that are still capable of instilling a feeling of wonder at the beauty of the land, the sharp edge of pristine air and—when one's vision isn't grayed by the ashes of a forest burning because of human carelessness or an act of nature—the possibility of seeing seemingly forever. It isn't the same as it once was, of course, but it's good enough still to make one almost tremble at the thought of just how wonderful it must have been.

CHRISTOPHER ANDERSON

Paris, France | 2004

Paris is like a second home for me. I spent five years living there, and I am still connected to the place. My agency has an office there, and my wife is French. I took this picture on my way to meet my wife at a café where we would often meet after she had finished working. The picture contains two of the things that I love most about Paris: the extraordinary afternoon light and café culture. In Paris, life takes place in the café. When I am in New York or any other city, I always miss Paris afternoons in a café.

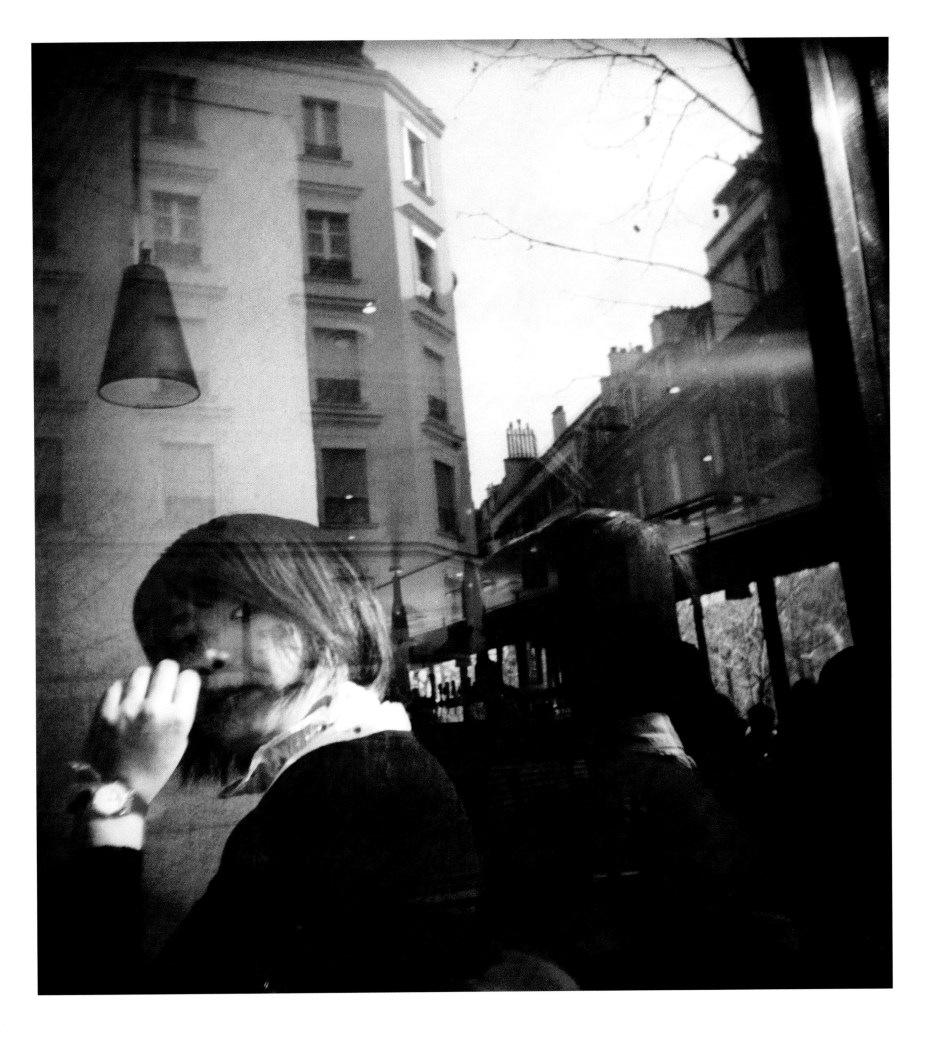

STEPHEN ALVAREZ

Belize | 2003

In a Mayan ceremonial cave complex, a rare hand-print graces the wall of one of the chambers.

next pages:
KEVIN HORAN

Russia | 1992

On a long, wintry journey during the time of perestroika, Kevin Horan's car broke down. While his friends fixed the car, Horan stared at two dense groves of birch trees in front of them and behind them. Then he assembled his tripod and started working. The trees outlived the car.

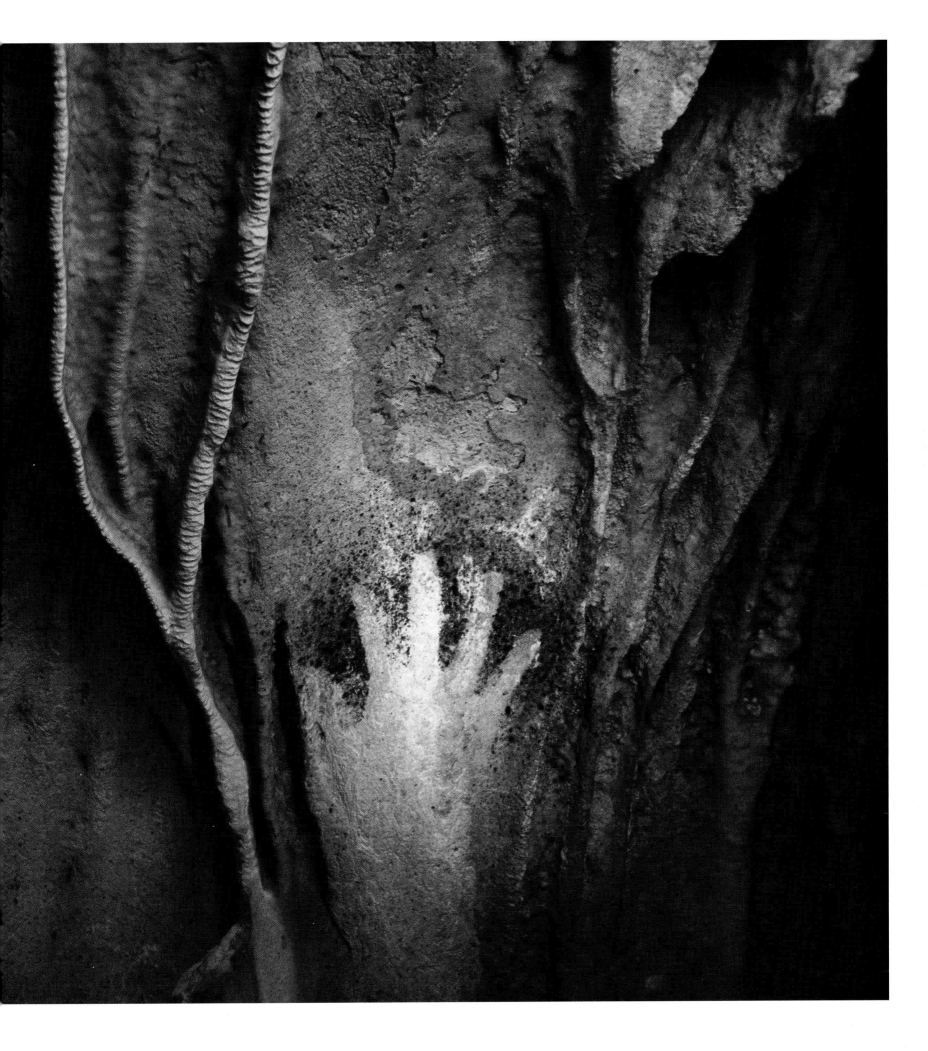

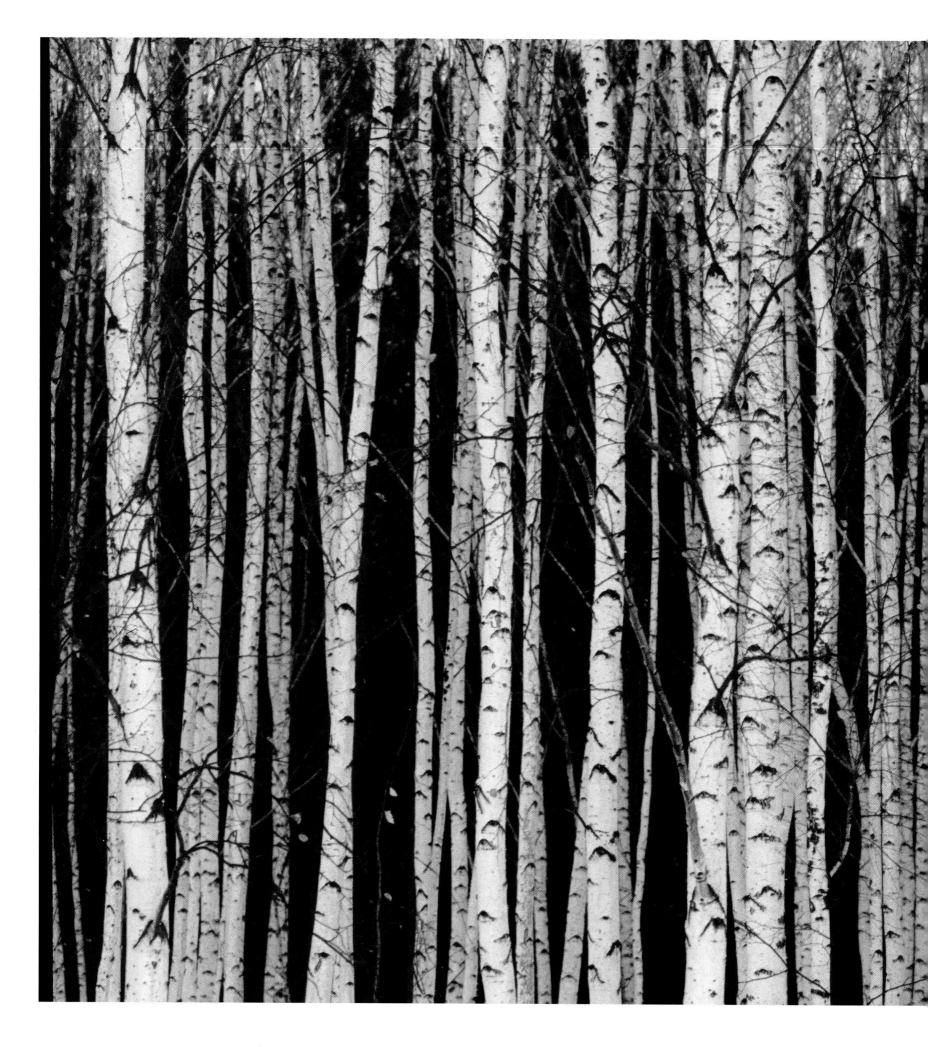

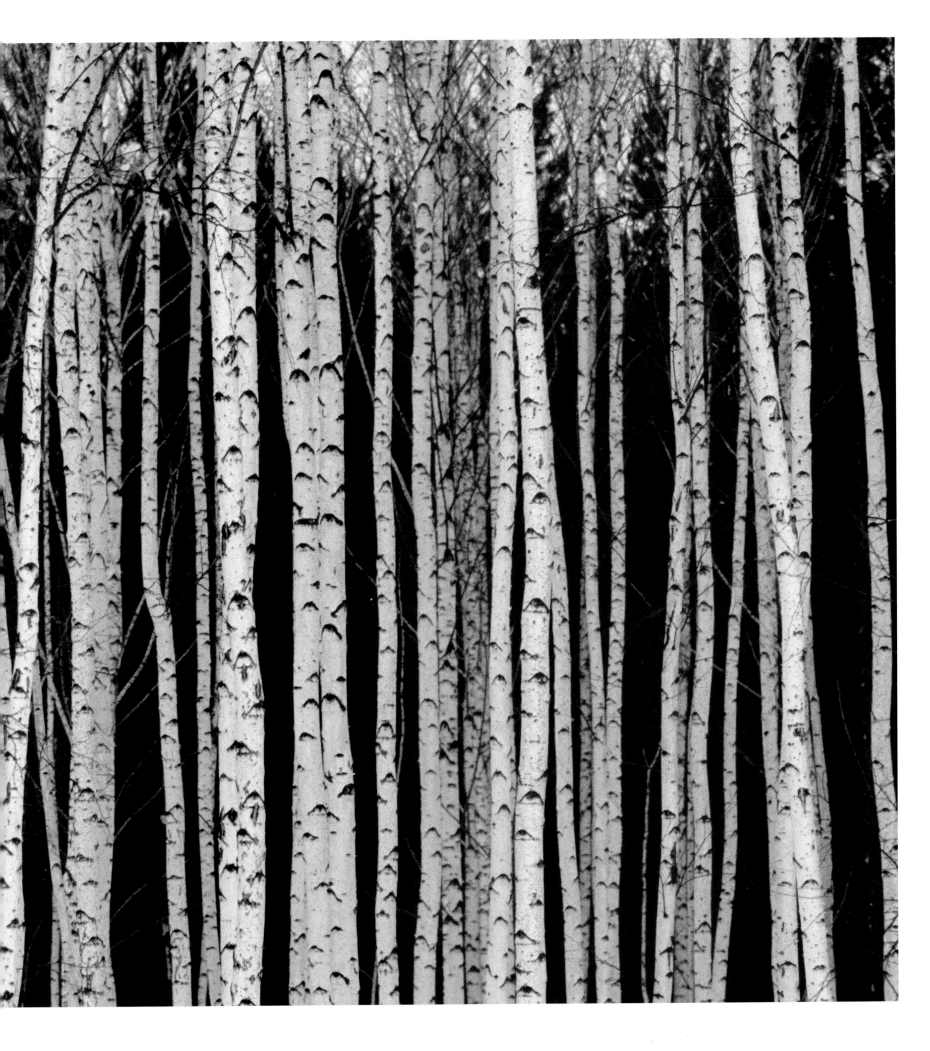

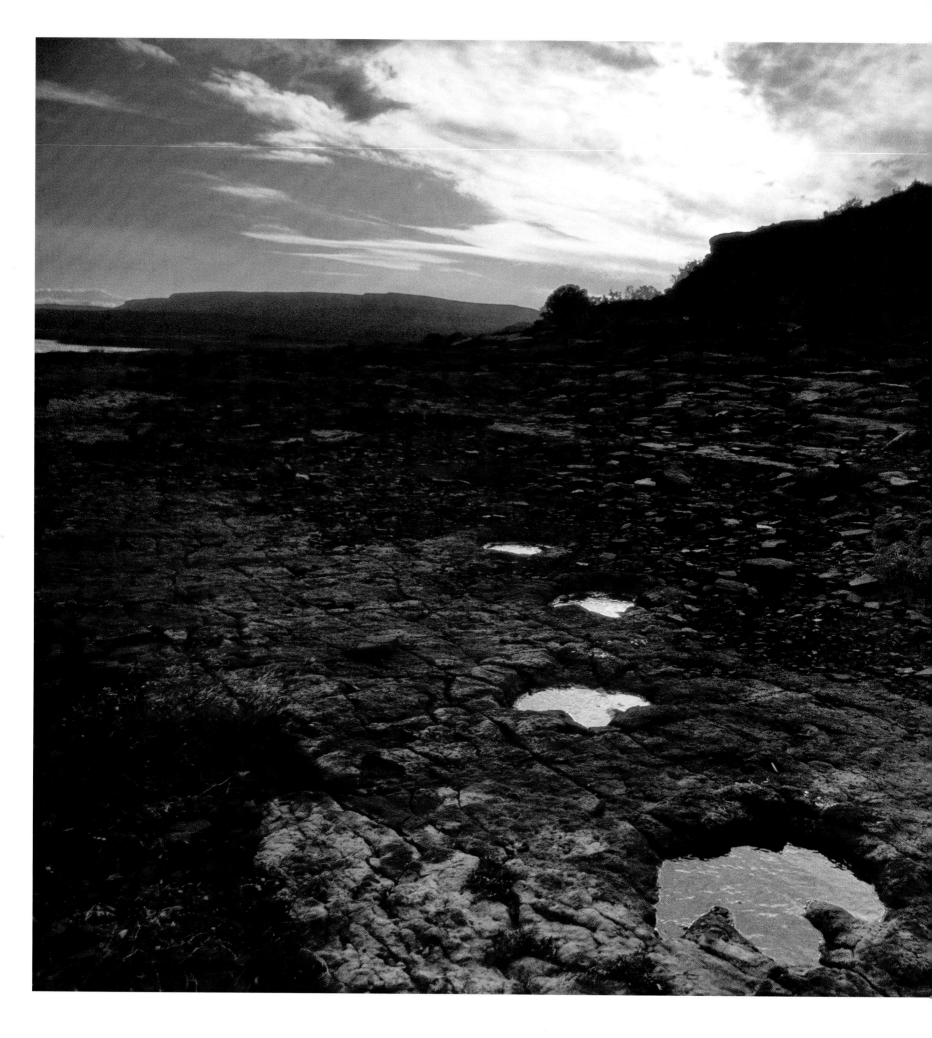

ROBERT CLARK

Patagonia | 1996

When I think of Patagonia, I think of a blank canvas. Nothing interrupts the horizon in this area, and you feel as if you could see forever. It's as if you were living in another time. I went back to this place four times, waiting for the rain, so I could make an interesting picture of these dinosaur footprints. It was like touching another time period because these creatures had walked there 65 million years ago.

STEPHEN ALVAREZ

Mexico | 2003

In San Luis Potosi, most mornings, a few people sit quietly at the edge of the *Sotano de los Golondrinas*, or "Pit of the Swallows," a giant underground cave. They wait for the *golondrinas*—the swallows—to rise in a great tornado of bright green feathers as the nearly three million birds leave the safety of their nests inside to seek food and water. They swirl en masse to escape the hawks that lurk nearby. The vision of the green swirl is what the tourists seek.

Photographer Stephen Alvarez, a veteran caver and National Geographic photographer, however, wanted to see the bottom of the cave. To get there, he needed rope and lots of it. With a grant from the Banff Mountain Center, he ordered one hundred pounds of rope to be made in Canada that would hold him and his gear as he rappelled for more than 20 minutes to reach the cave floor almost 1,400 feet below. "It's a surreal experience," explains Alvarez. "The roof doesn't get any smaller and the bottom doesn't get any closer for a long time. You look down, and you see what you think are ants, only to realize they are the people you are following into the cave."

On the ground, however, the area—the size of several football fields—is magical and eerie and breathtaking all at once. Some experts think that caves like this are formed by hydrothermal waters that are slightly acidic and slowly eat through the limestone foundations of the mountains. Others believe that the underground waters, when in contact with petroleum, dissolve limestone over time. Whichever theory may be right, cavers from around the world are willing to defy the fear of a long, lonely drop, and the grueling hour-long climb to get out, just to experience its otherworldly atmosphere, as the millions of birds swirling around them clearly do.

next pages: Stephen Alvarez

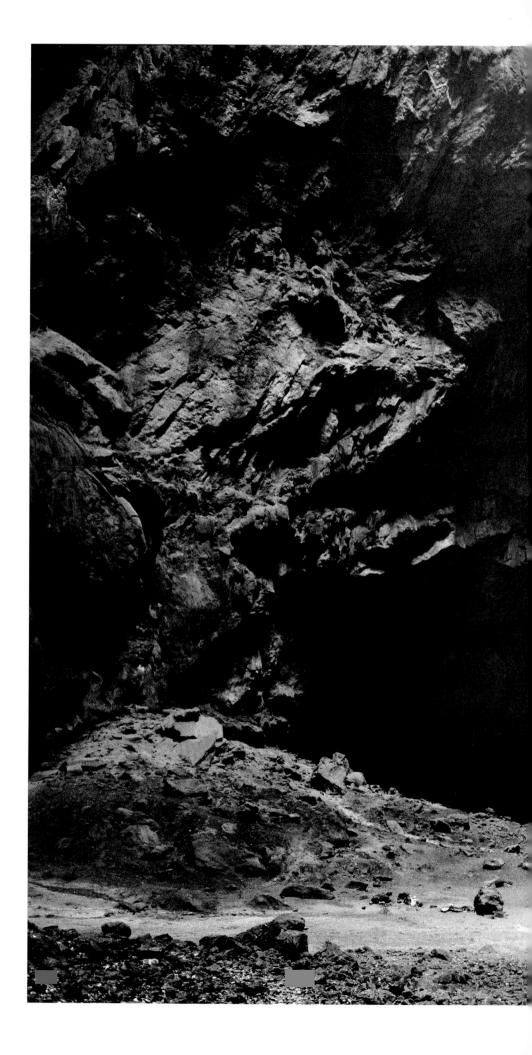

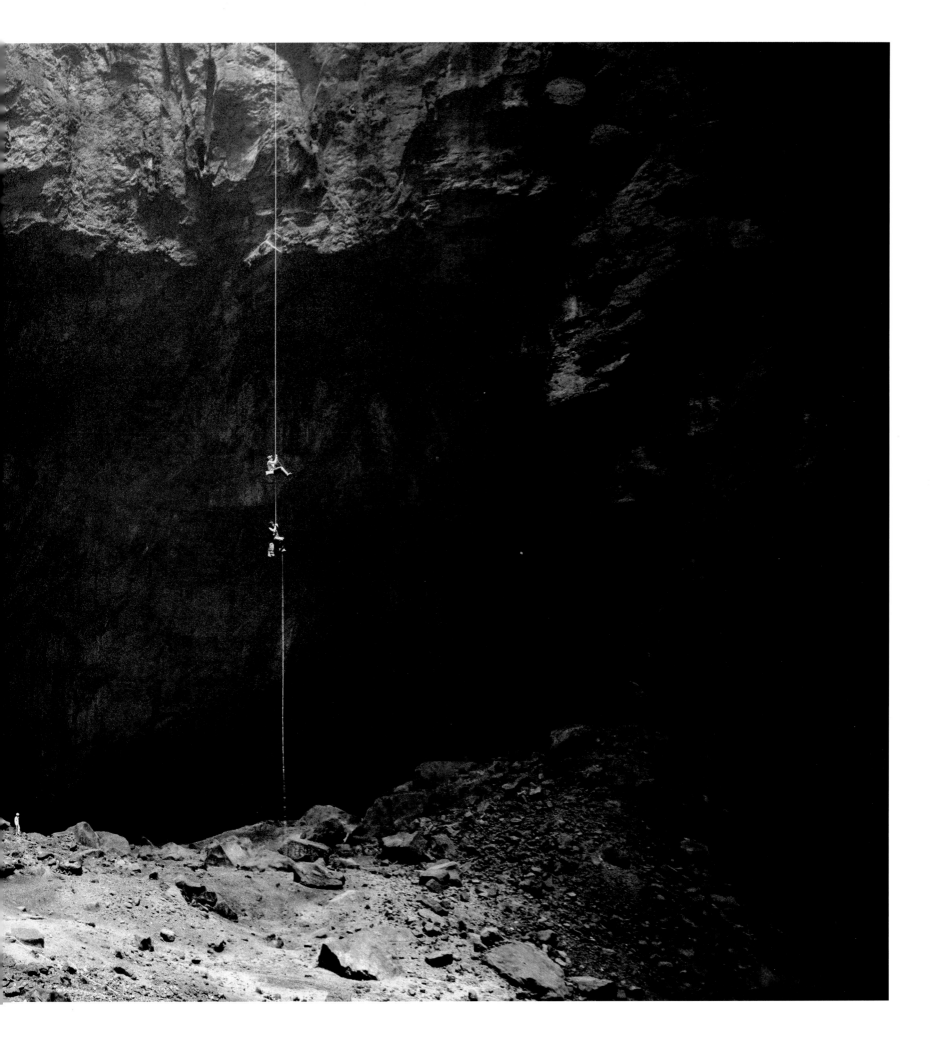

MARIA STENZEL
Antarctica | 1997

Hikers stand on the peaks overlooking the Wright Valley, a dry valley among the glaciers.

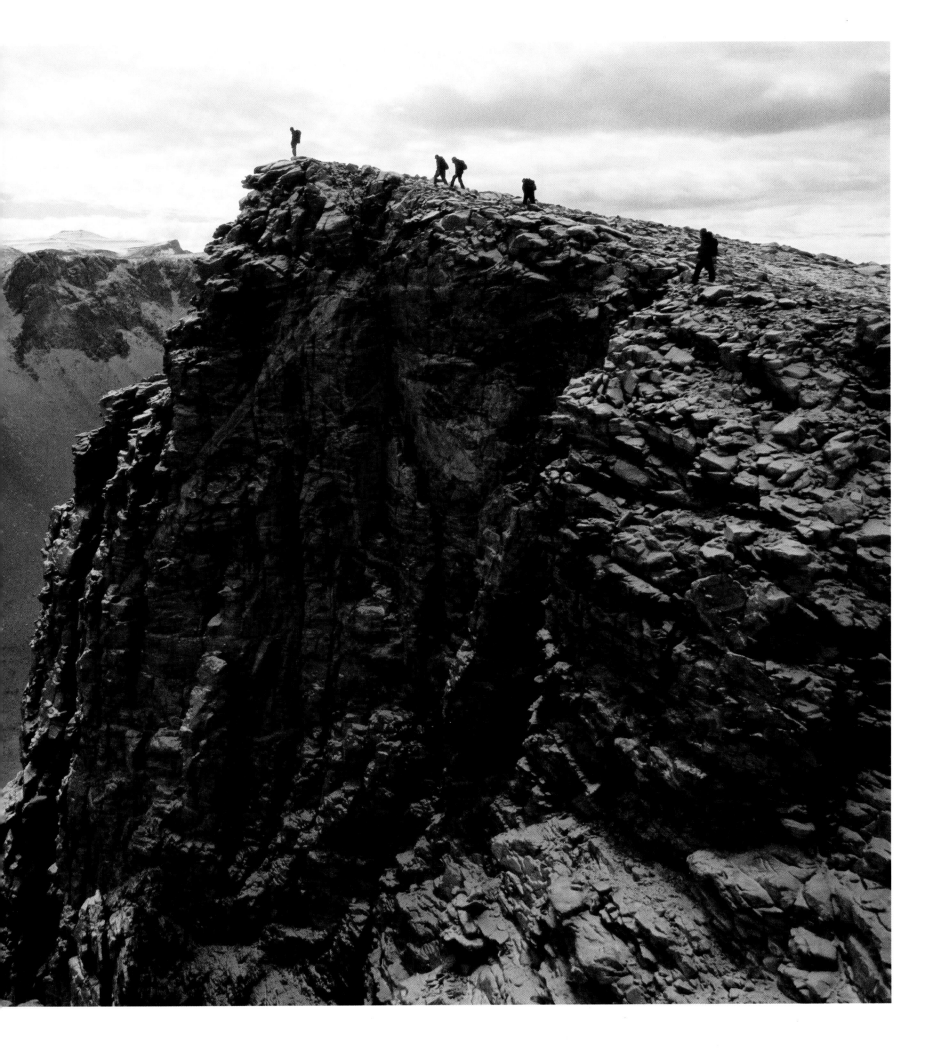

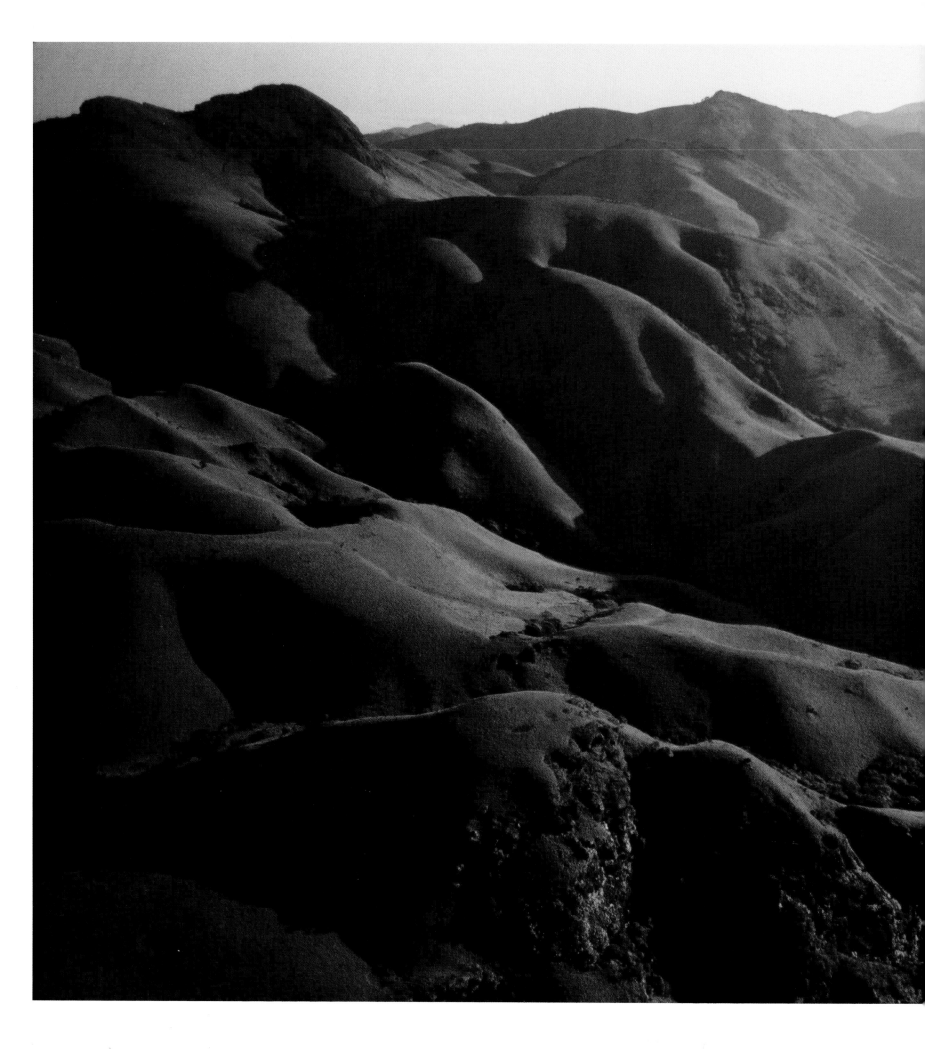

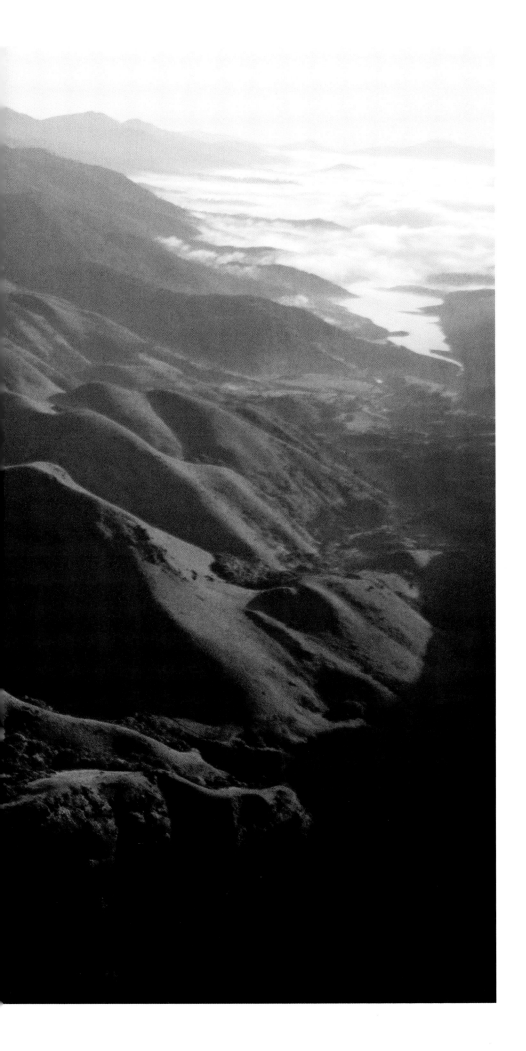

FRANS LANTING
India | 2001

The Western Ghats, 5,000 square miles of forests and grasslands on the southwestern coast, is rich with animal and plant life that can't be found anywhere else on Earth.

next pages:
ROBERT B. HAAS
Paraguay | 2006

While photographing the entire South American continent from the air, Bobby Haas captured a beautiful, methodical herd of cattle winding its way through marshy swampland in Lago Ypoa National Park.

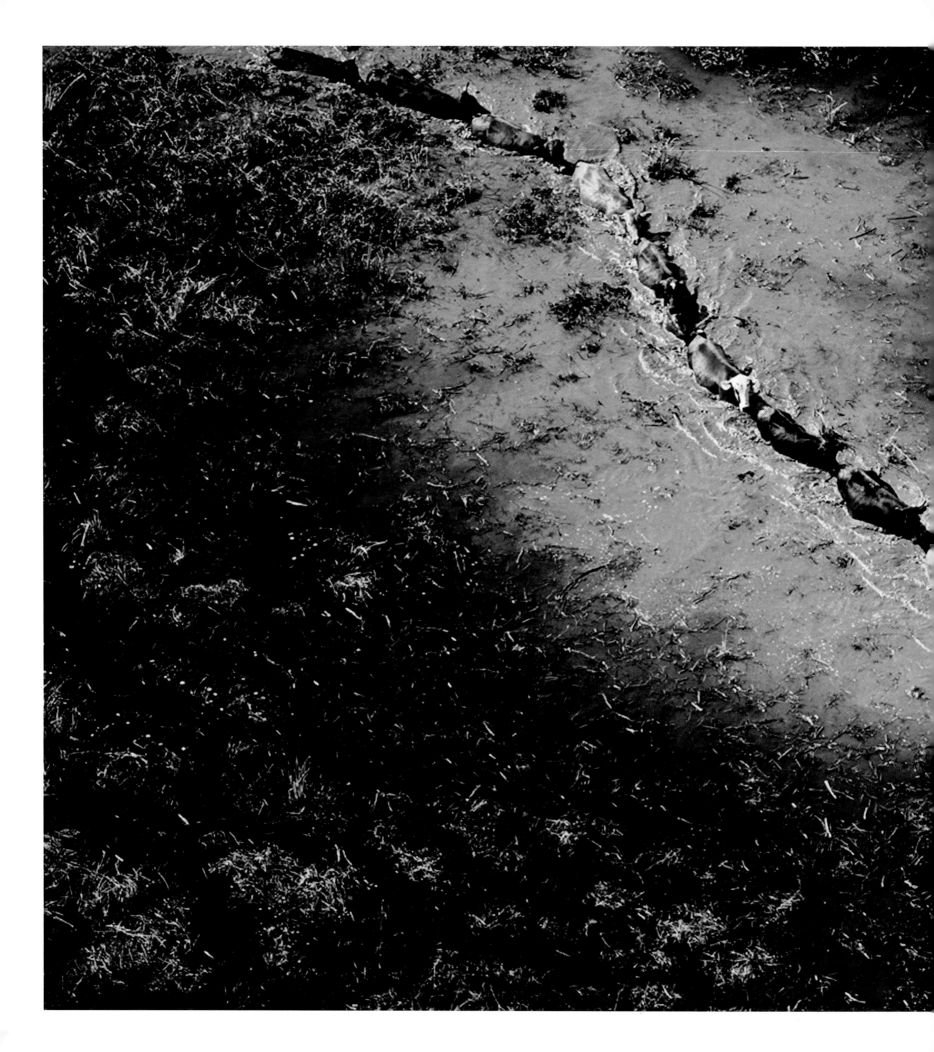

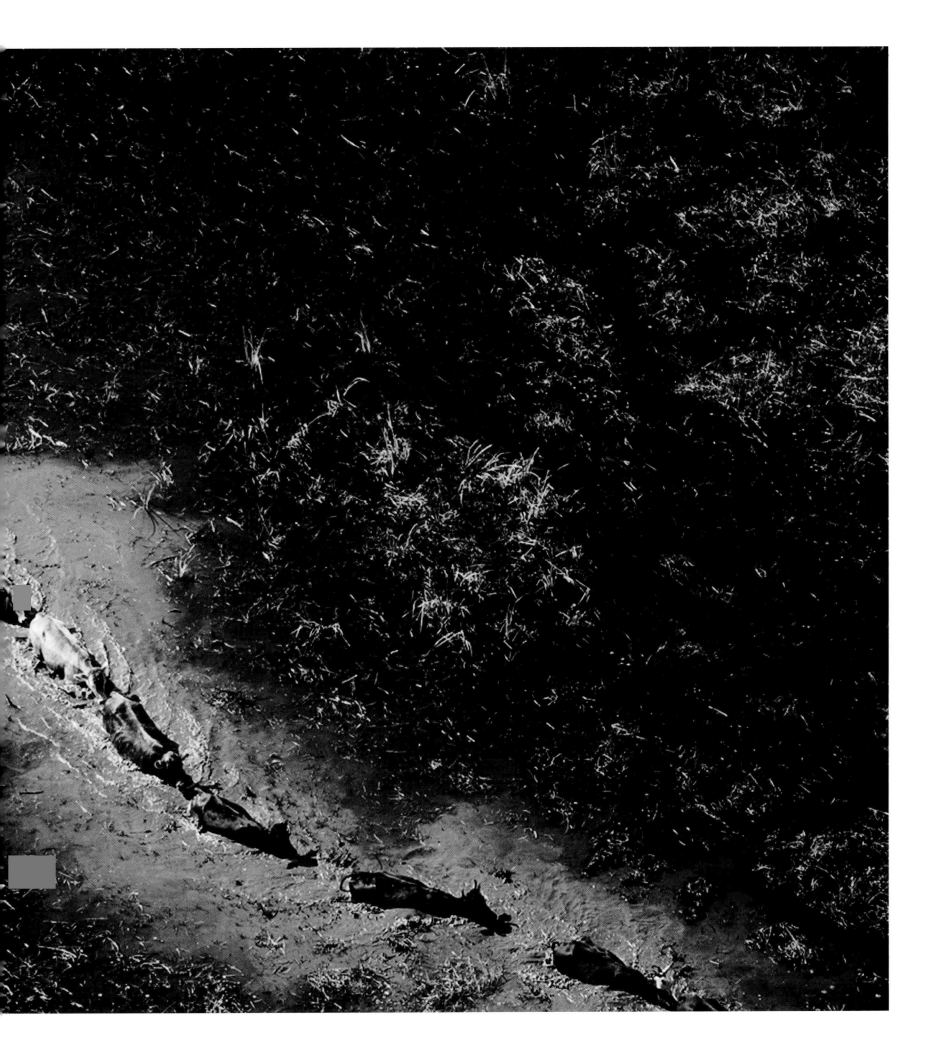

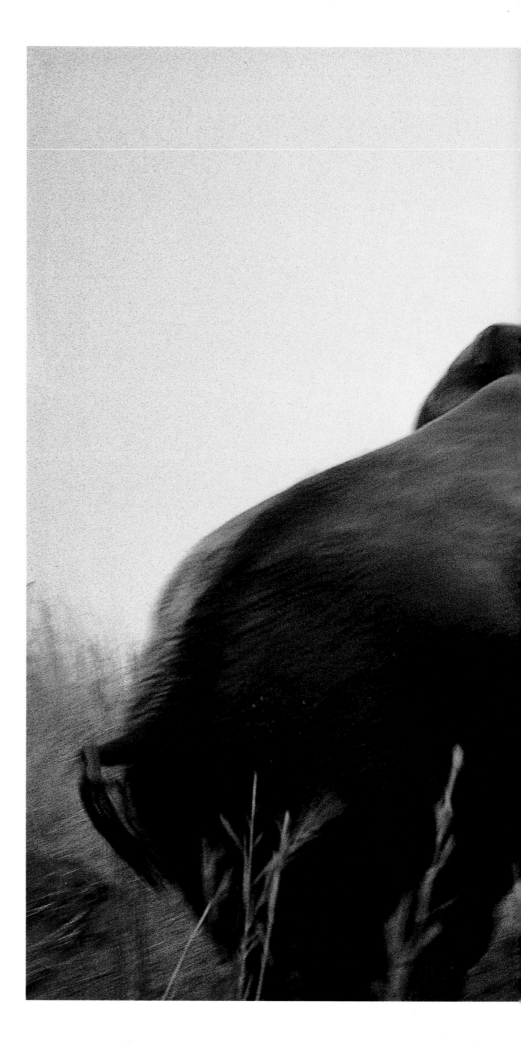

CHRIS JOHNS

Botswana | 1996

An elephant matriarch clashes with an intruder near the Chobe River in Chobe National Park.

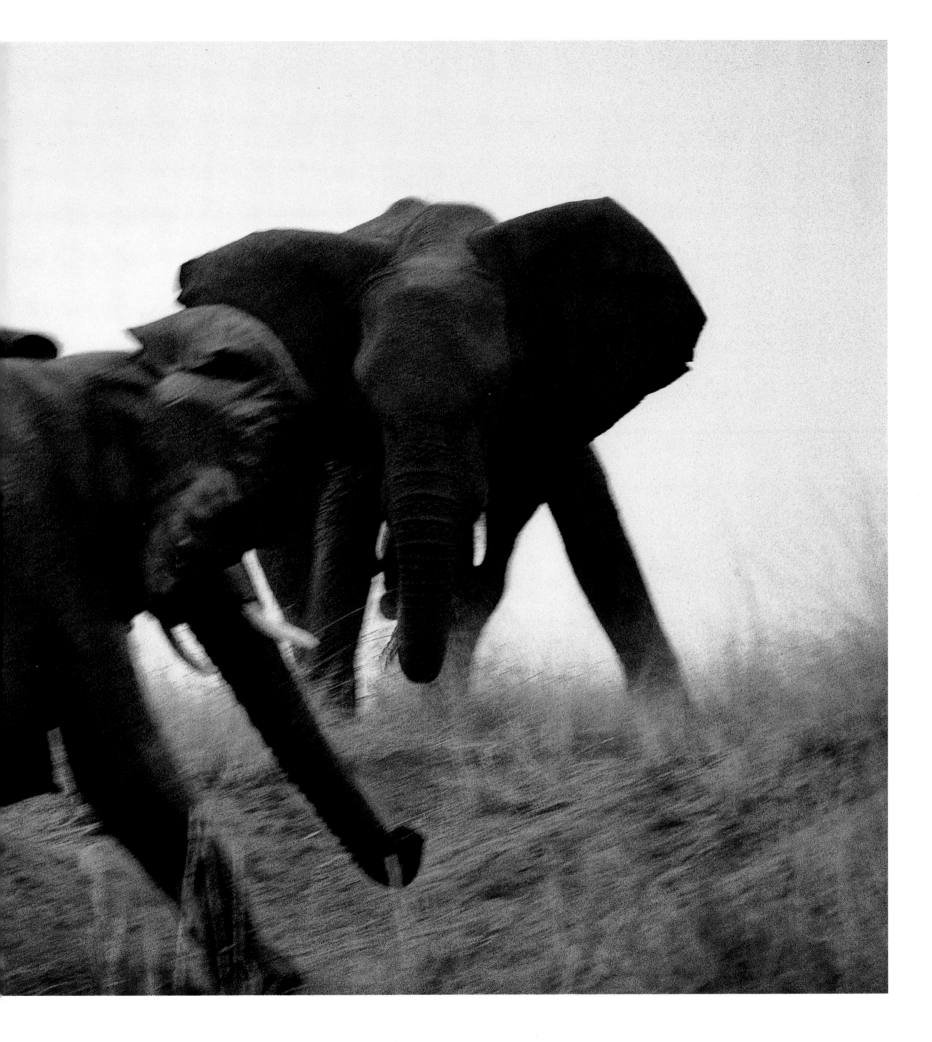

COLBY CALDWELL
St. Mary's City, Maryland | 2003

For artist Colby Caldwell, heaven is in the process of making photography. All of his landscape work is close to home, its content near and dear to his heart and his chosen life. "To me the destination is the process—the time, the light, just being there—and taking the picture. I do find that any heavenly moment is interior."

After 15 years living in an emerging, urban area in Washington, D.C., Caldwell moved to southern Maryland where he found an old farmhouse a hundred yards from the waters of the Chesapeake Bay. This road figures both in his collection of Super 8 film stills entitled *Still Time,* to which fig. (4) belongs, and in his more recent work, *After Nature.*

fig. (4)
inkjet print mounted and hand waxed on wood panel

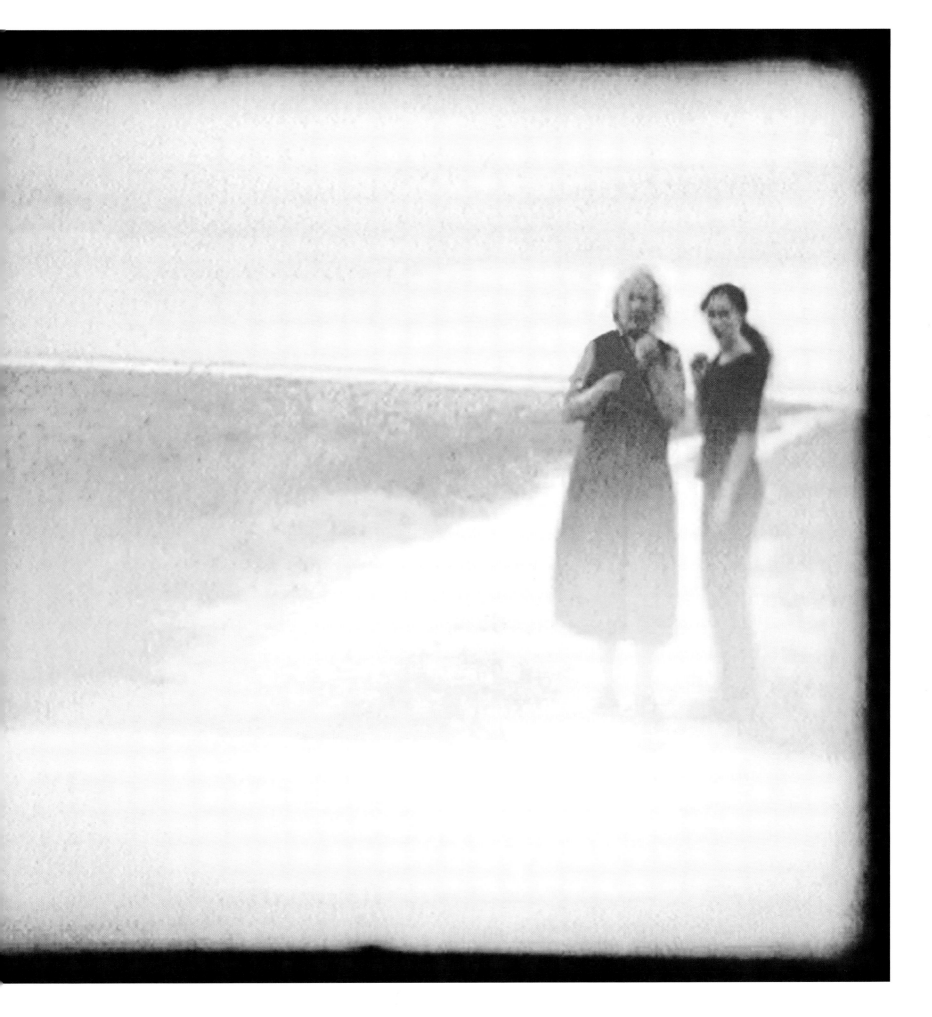

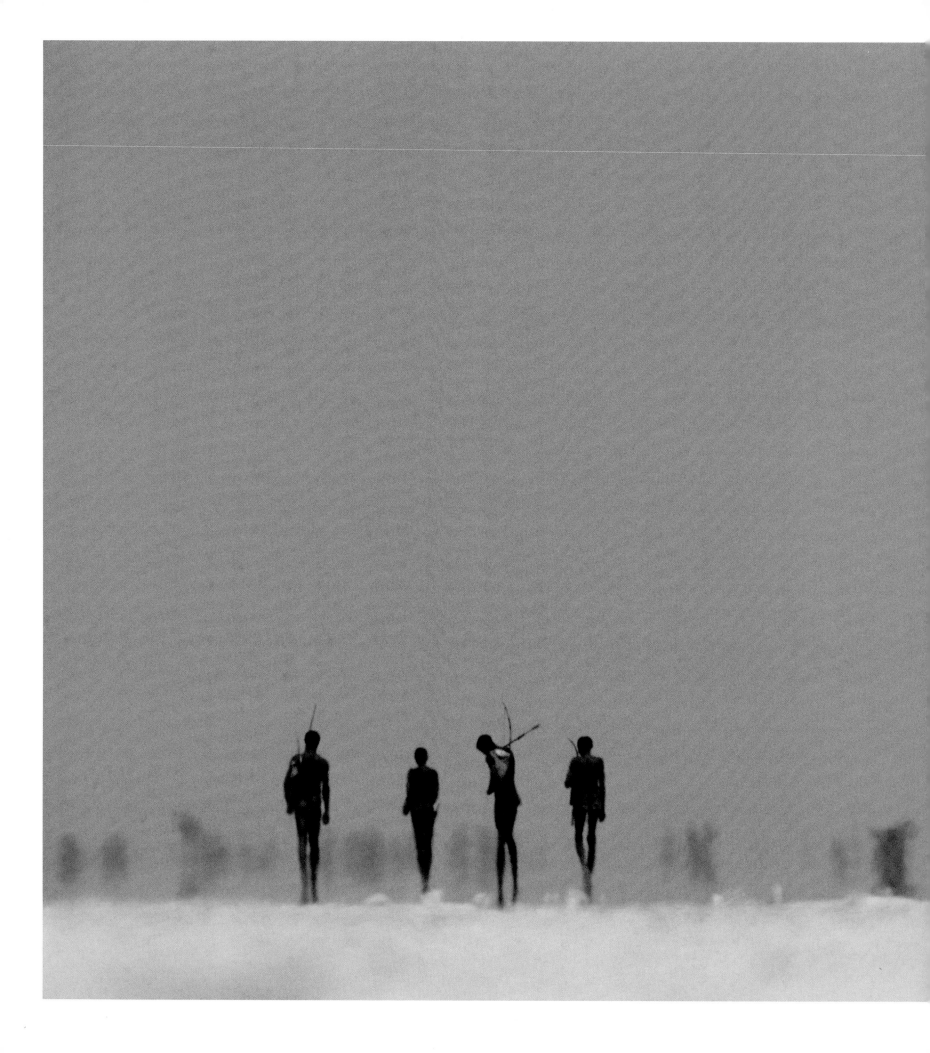

CHRIS JOHNS
Namibia | 1999

Bushmen walk through the Nyae Nyae Conservancy, home to the Ju/'hoan San people.

next pages:
AMI VITALE
Mali | 2004

Every day a small village called Boujbeja, north of Timbuktu, is buried by layers of sand, yet the people refuse to leave. The sand makes it hard for them to live: They cannot grow food. They must dig wells almost 250 feet into the ground to find water. "Even though they struggle with their daily existence," says Vitale, "they don't ever want to leave because they believe they have at least peace and harmony here."

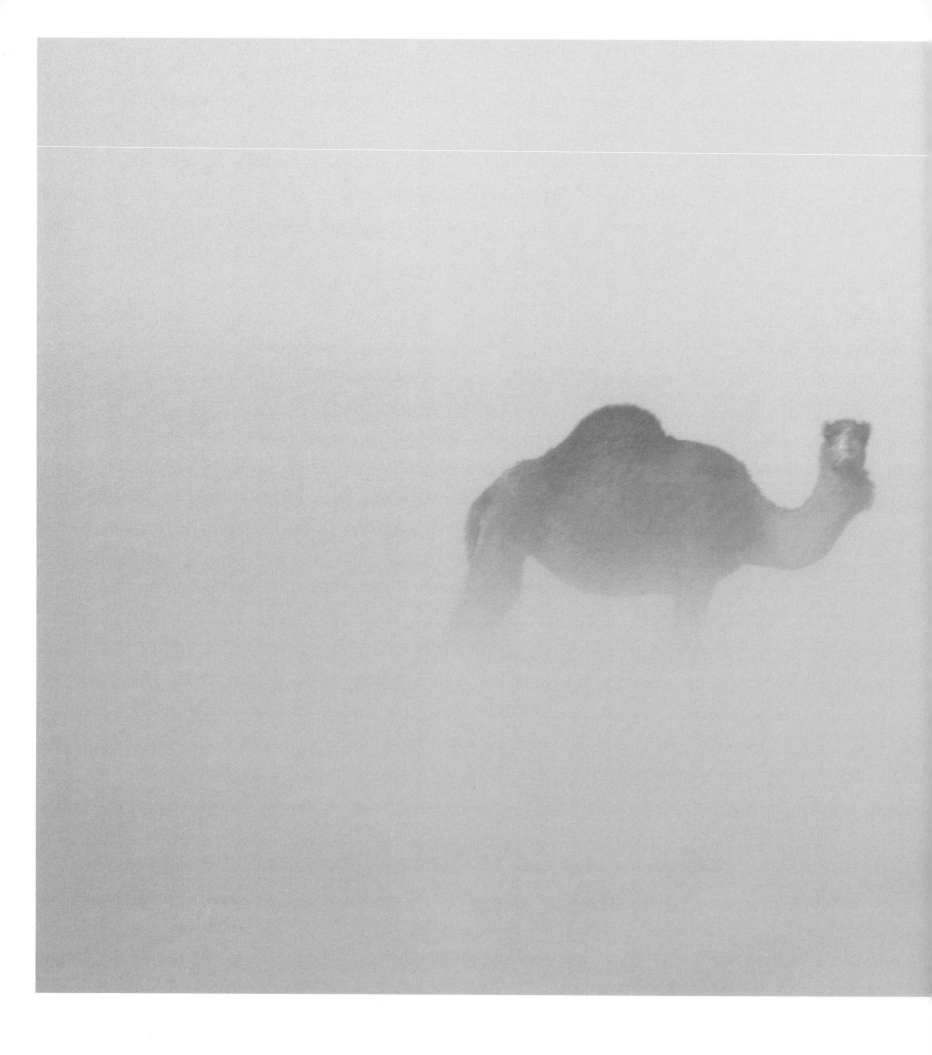

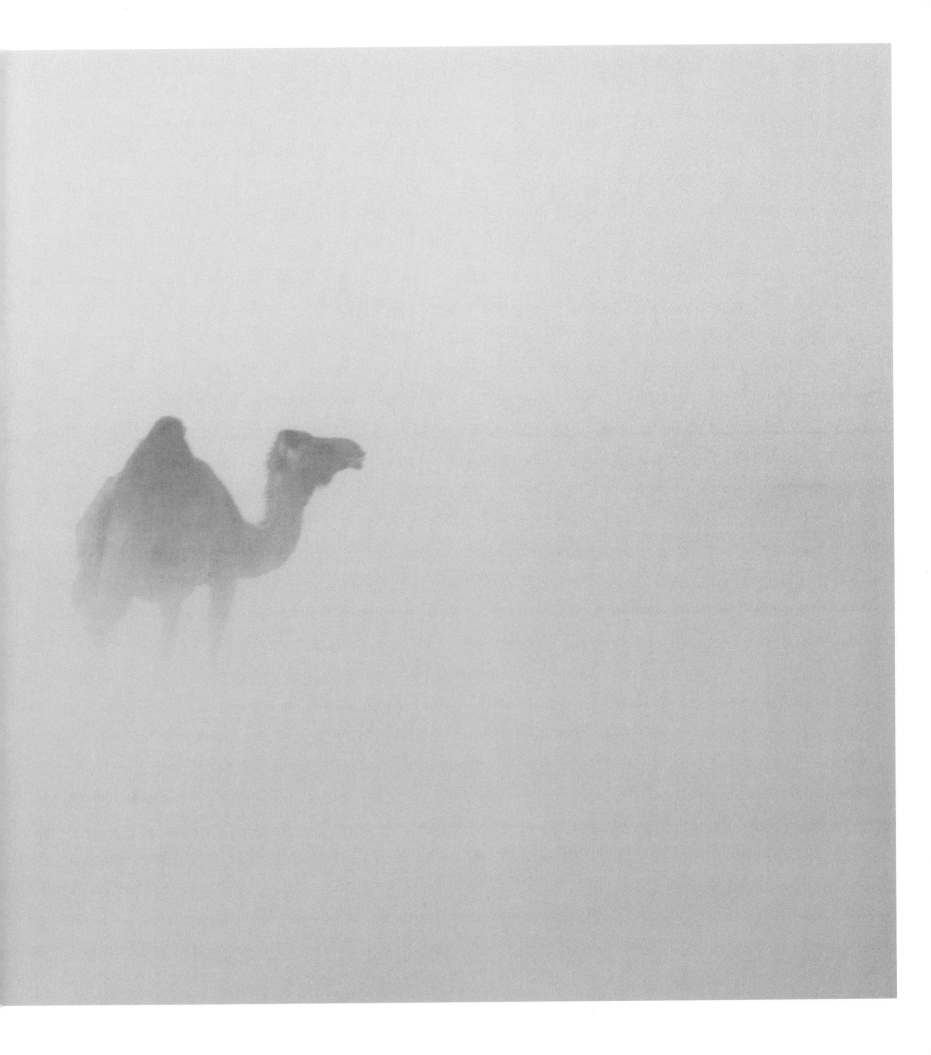

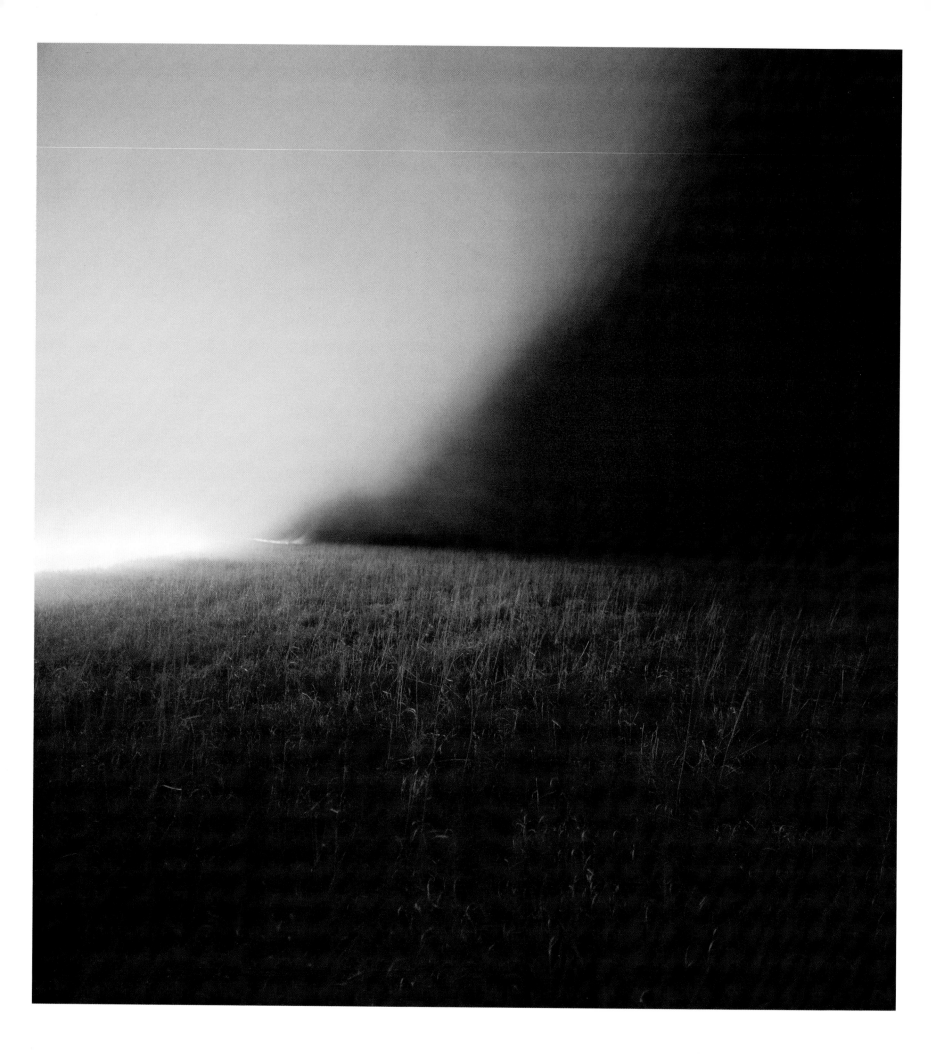

LARRY SCHWARM

Near Cassoday, Kansas | 1990

Seventeen years ago when Larry Schwarm moved to Kansas, he photographed the burning of the tallgrass prairies in the spring—an annual event—for the first time. It was early evening, the time of day when the winds die down on the prairies. It is also a favorite time for landscape photographers.

Burning is a way for conservationists to nourish the earth and keep the tallgrass prairies alive. The whole town sometimes comes out to watch. But Schwarm didn't just see the necessity of the fires. He saw the basic complementary colors—the deep, dark blue of the sky and the molten reds and yellows of the fire, and he saw potential. "I was mesmerized by it," says Schwarm.

MICHAEL "NICK" NICHOLS

Virunga National Forest | 1982 to present

Without hesitation, Nick Nichols names the chain of active volcanoes known as Virunga National Park in Africa his personal paradise. "Every time I leave that place I'm in tears," he says. "That place made me into the environmental photojournalist I am today."

The park, now a World Heritage Site, lies in the Democratic Republic of Congo and borders on Rwanda and Uganda. Besides volcanoes and lava plains, the area is rich in lowland forests and swamps, savannas and snow-capped mountains. Dian Fossey studied the mountain gorillas here. Hippopotamuses, elephants, and any number of endemic species live here.

But the park has been affected by politics as well, and the results of war and strife often seep deep into the forest. During the civil war in the Congo and the 1994 Rwandan genocide, refugees sought food and shelter in the jungle, cutting down trees to build shelter and killing endangered species for food. Others chopped down trees to sell the wood and create pastures for cattle. In 2007, unknown assailants shot several of the rare mountain gorillas, unprotected creatures that draw tourism dollars to the region.

Nothing has stopped Nichols from returning, or from creating memorable, gripping, emotional photographs.

next pages: Nick Nichols

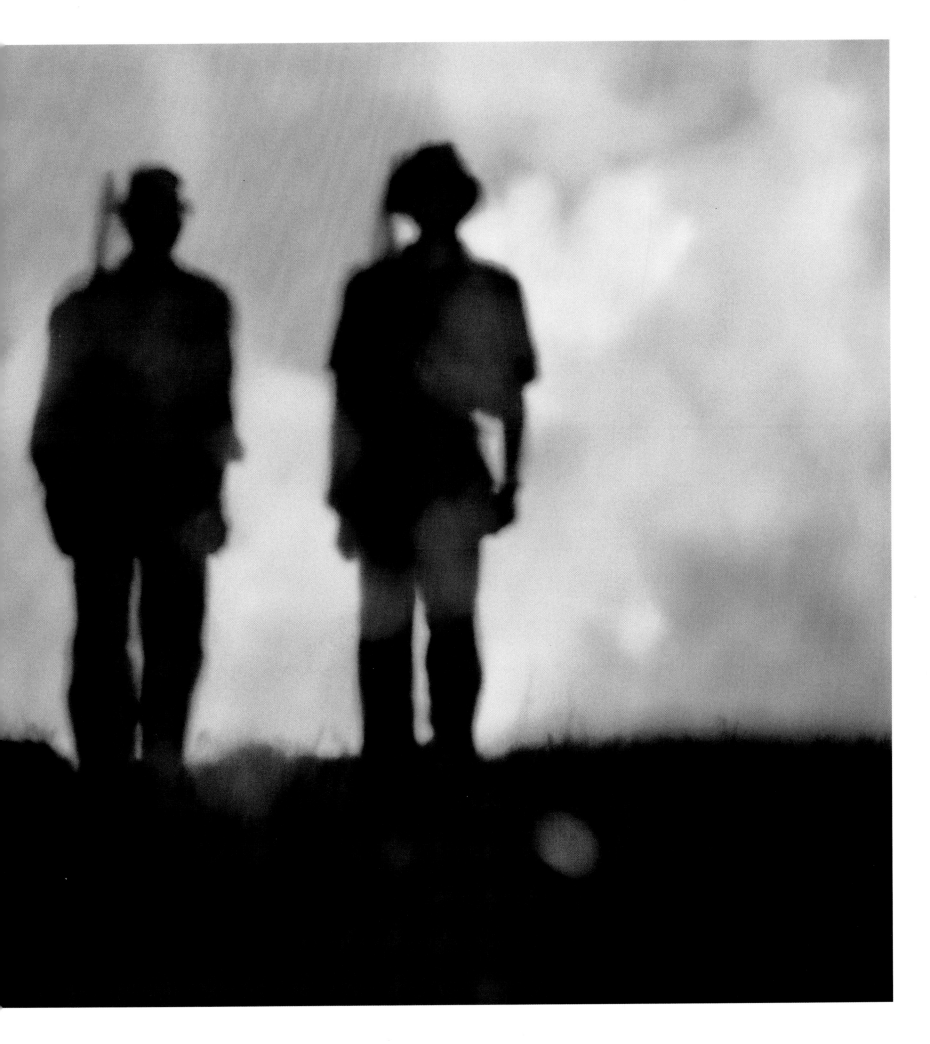

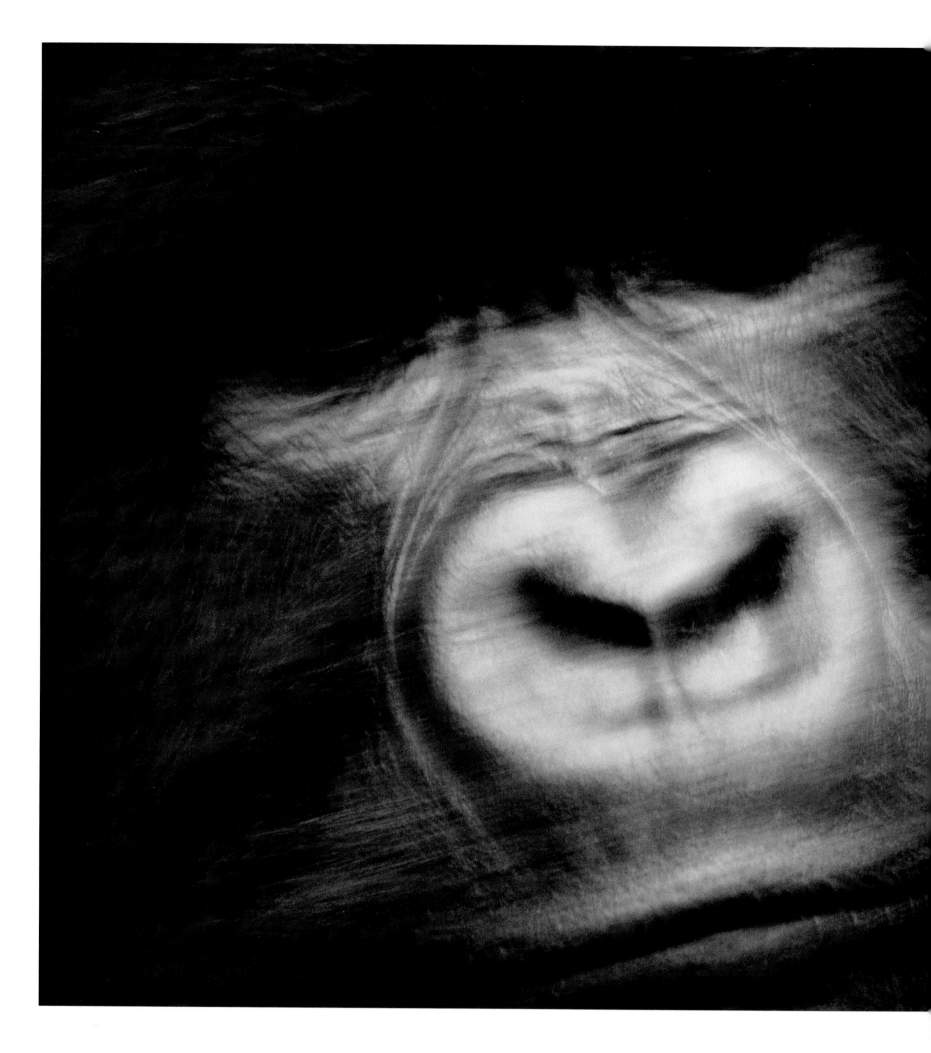

DAVID BUTOW

China | 1998

Along the Old Silk Road in the Chinese province of Xinjiang, an ancient ethnic group called the Uighurs maintain a basic and self-sufficient lifestyle in the city of Kashgar. The Uighurs, descendants of the Turks, have their own language and follow Muslim traditions, unlike the more modern, mainstream Chinese. "This photograph has a timeless quality," says Butow. "The way the people are dressed and what they are doing is similar to the way they lived in the 19th century."

next pages: David Butow

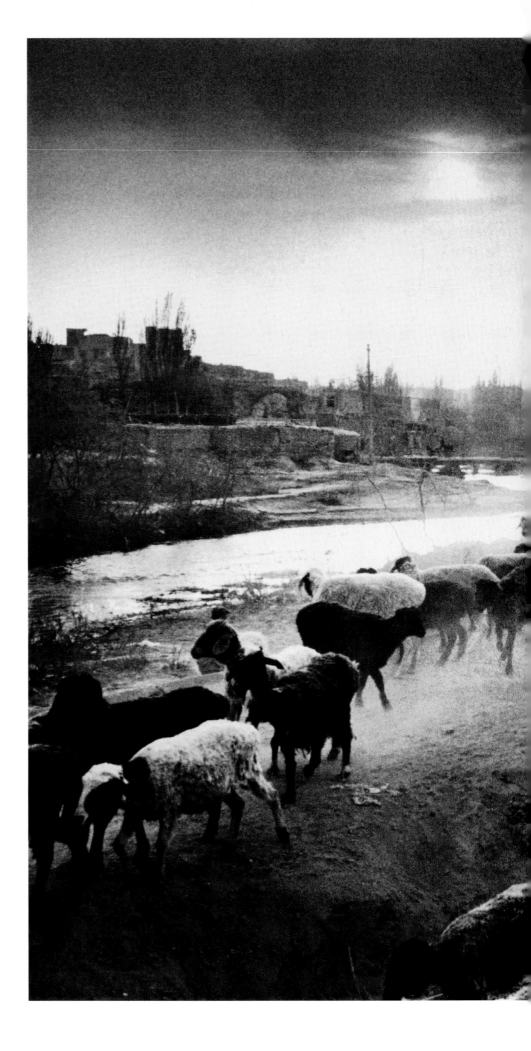

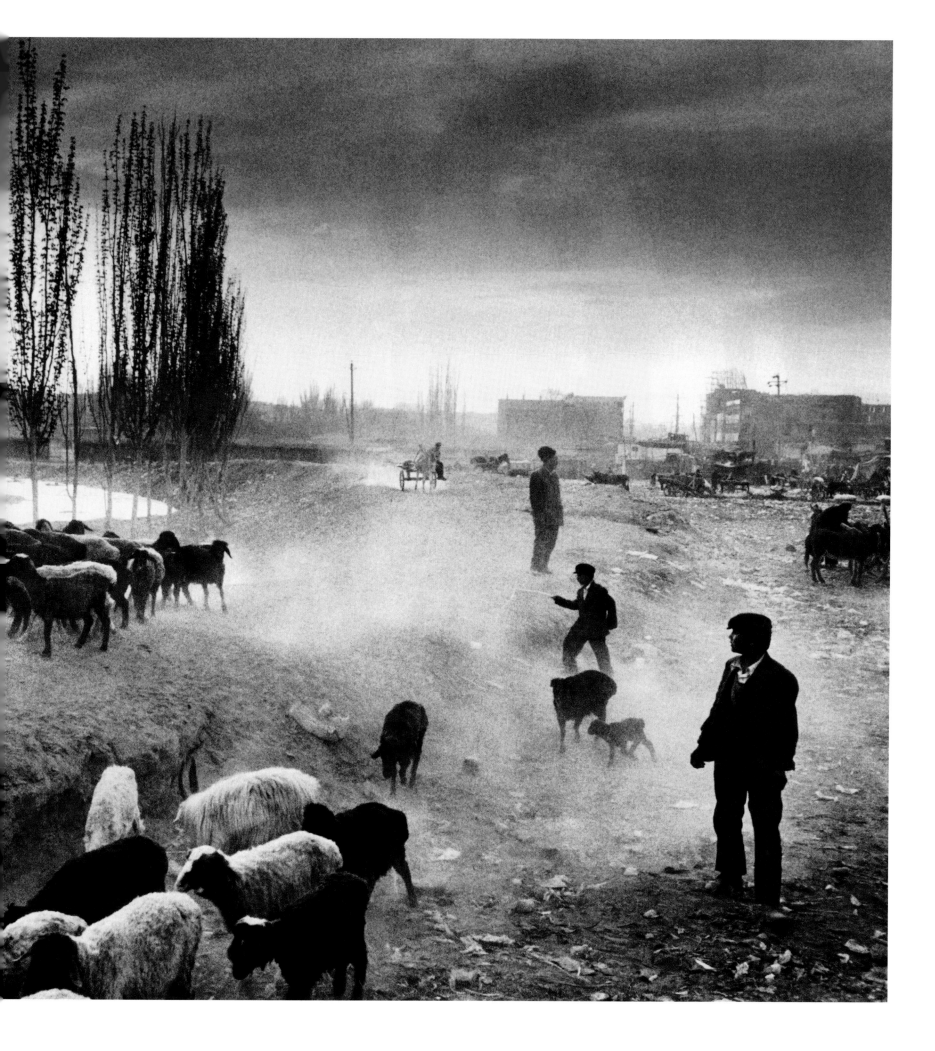

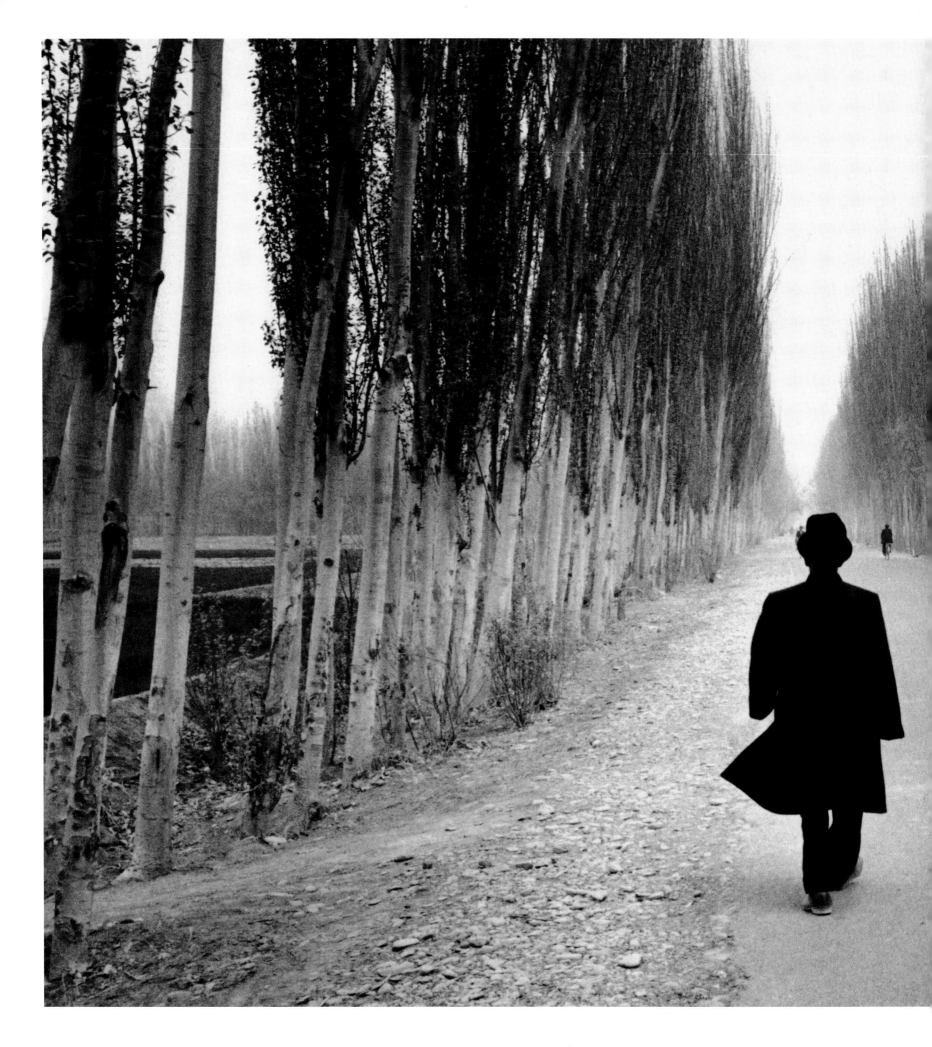

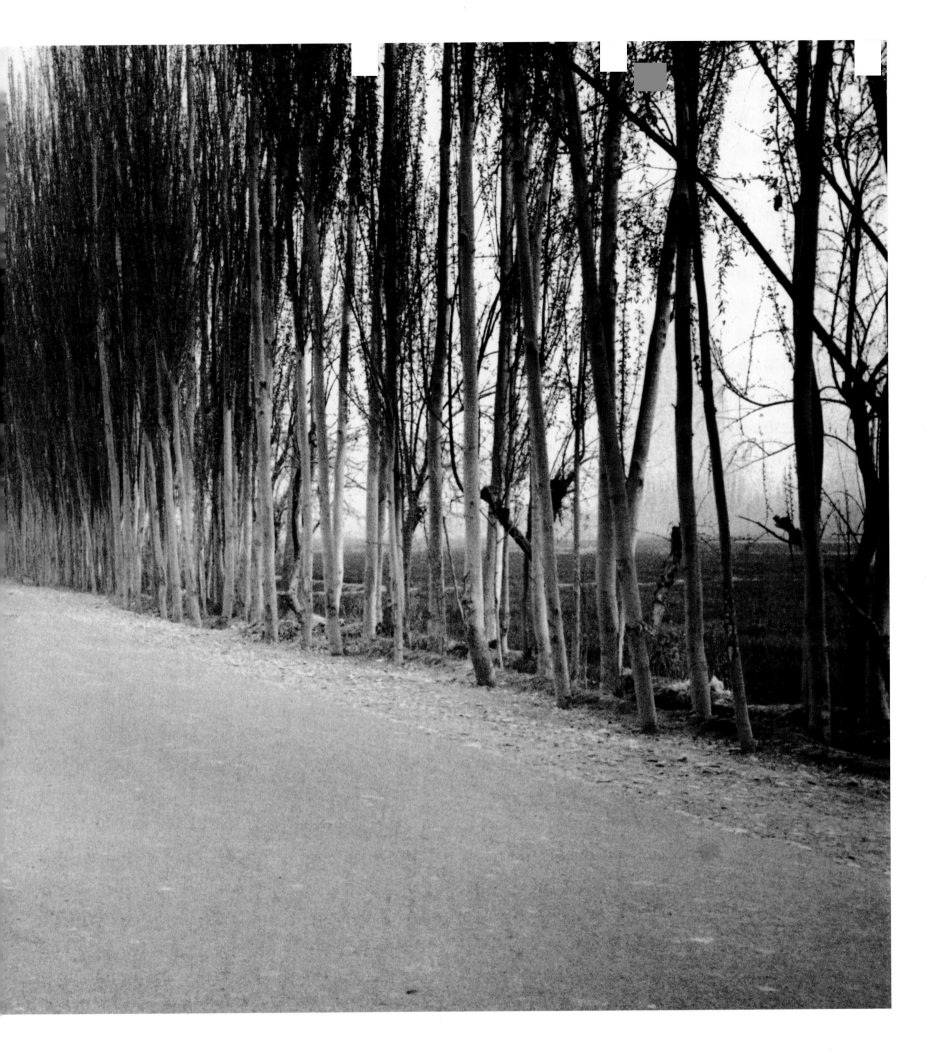

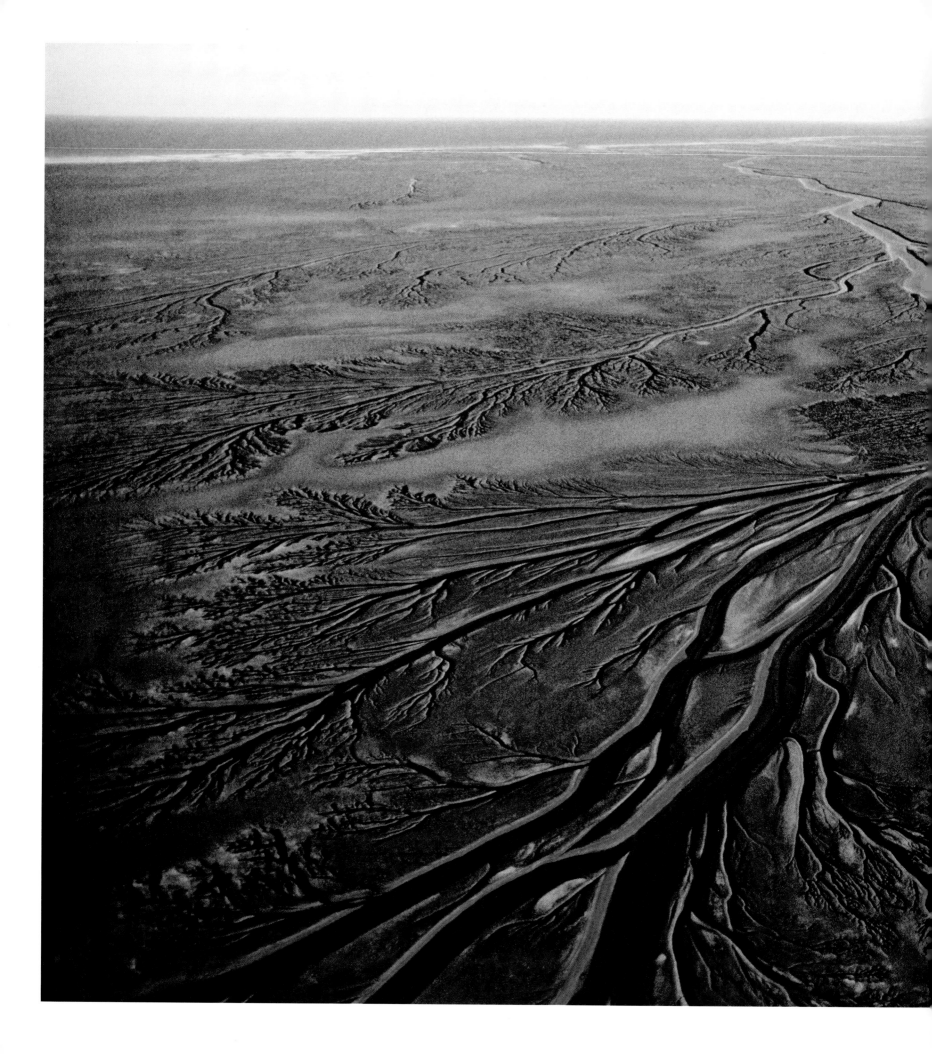

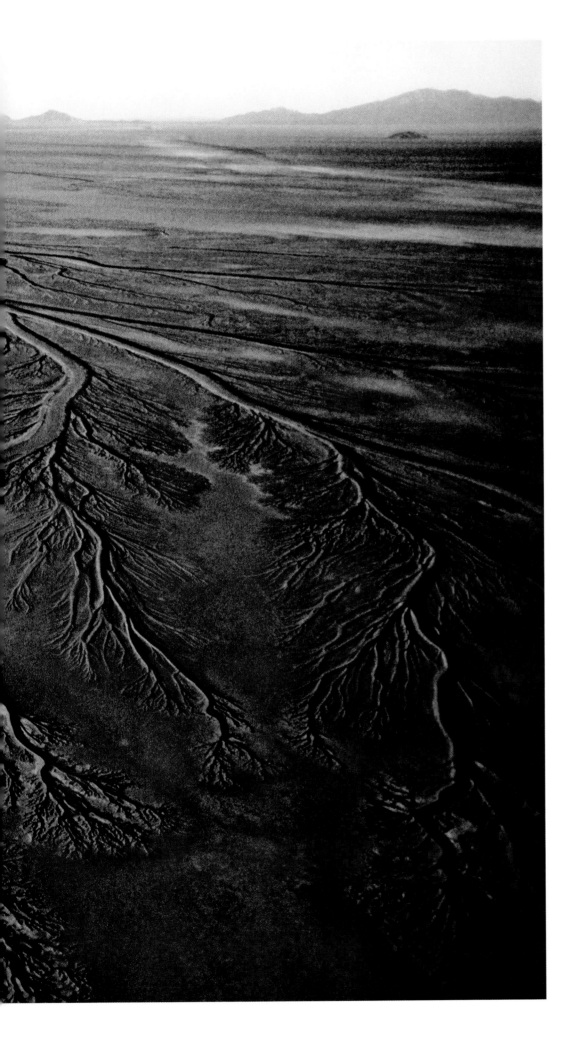

ANNIE GRIFFITHS BELT

Mexico | 1997

Mudflat remains of the Colorado River Delta near the Sea of Cortez.

ROBERT CLARK
Ohio | 1991

For some people, the wooden rollercoaster in Paramount's King's Island in Cincinnati is sheer joy itself. For Robert Clark, however, it was the silence of an early morning near the river that fascinated him. "The humidity from the river valley blankets the rollercoaster, and all you can hear is the occasional clap, clap, clap of a hammer as the men, who walk the length of the rollercoaster every morning, search for loose nails."

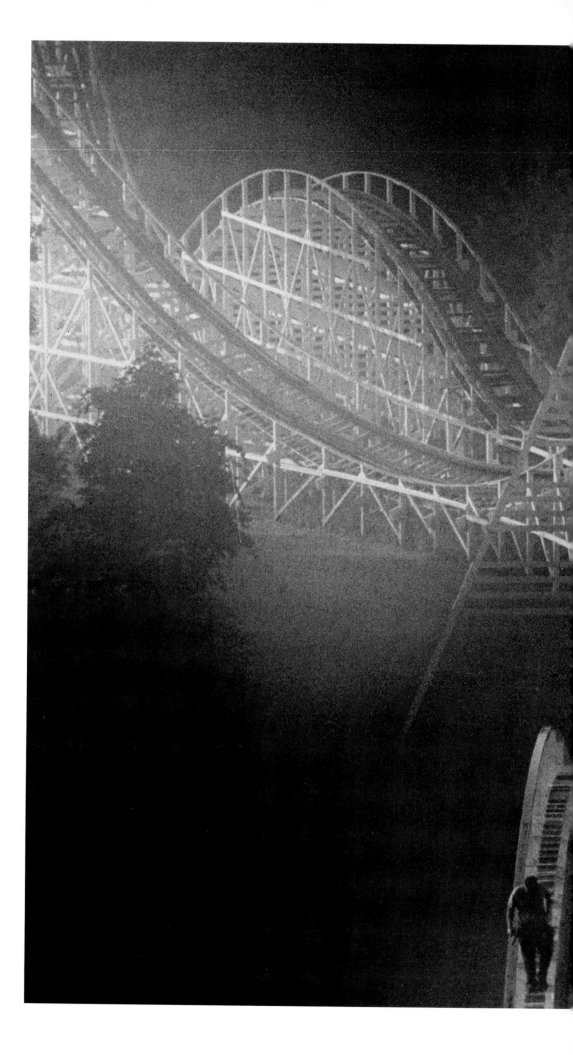

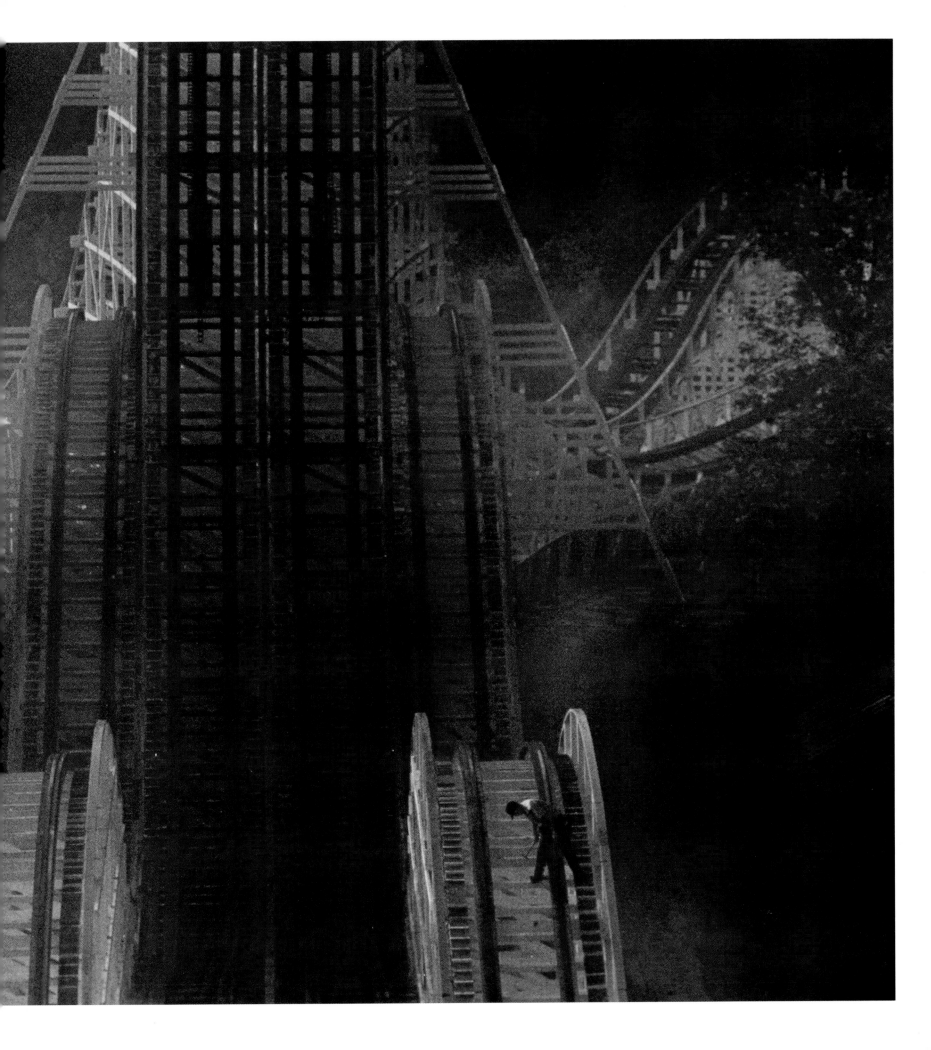

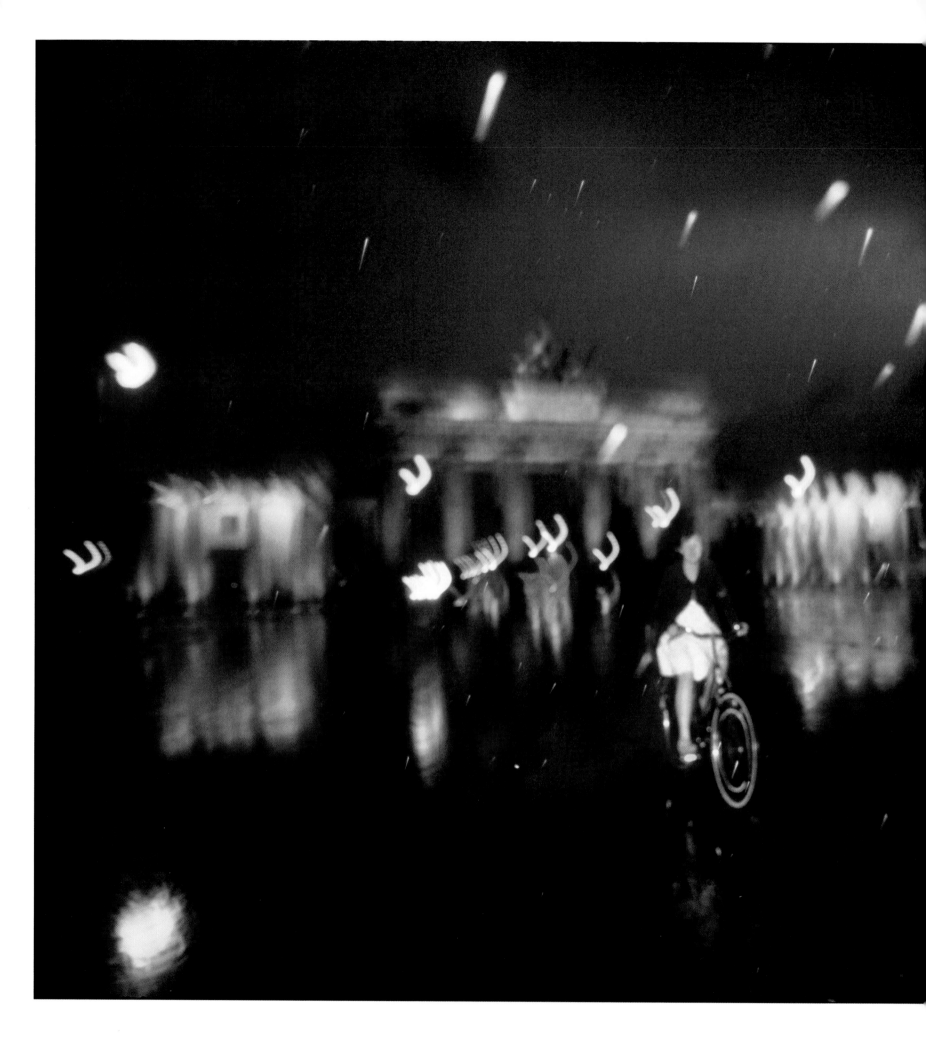

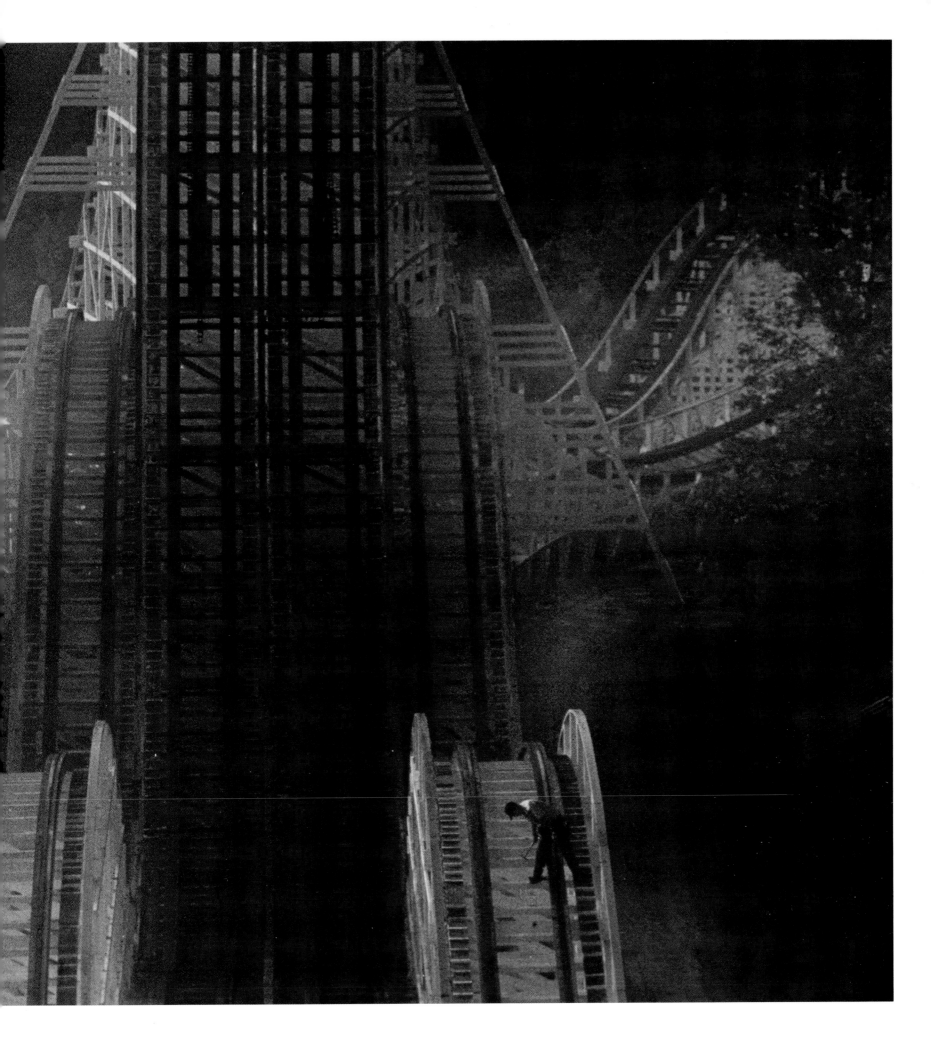

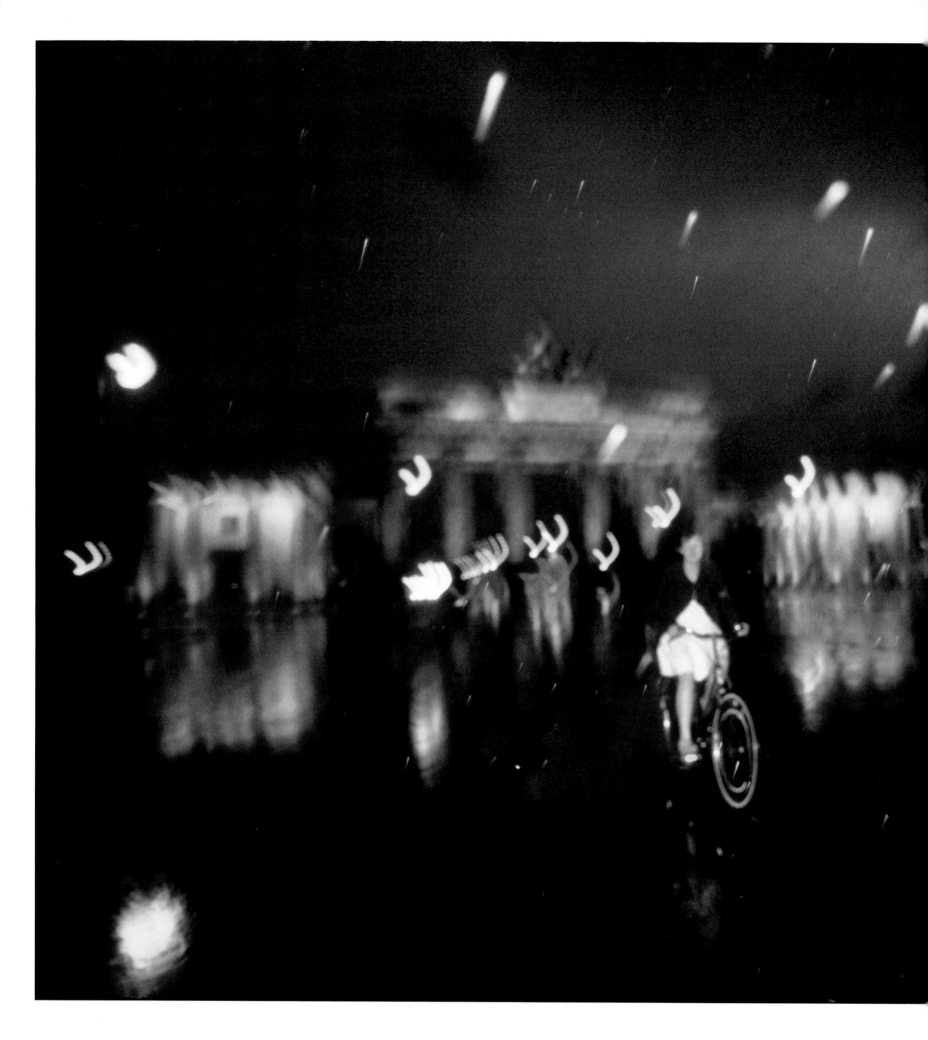

GERD LUDWIG

Berlin | 1996

"Seven years after the Berlin Wall fell, the area surrounding the Brandenburg Gate was deserted and felt a bit eerie on this cold and rainy night," remembers German-born Gerd Ludwig. "Seeing that woman ride by alone on her bicycle was a ghostlike vision from the past, yet there was something romantic as well." She personified that time and place in history—and Ludwig caught the moment, and the feeling, forever.

REZA

Cape Town, South Africa | 1985

"Unfortunately if you had asked me where hell was I would have had many more immediate answers. Paradise has a more religious undertone to it than hell. Even if they have the same aspect, there are more people living in hell than looking for paradise. It's internal peace one needs. If you have that, then you have paradise everywhere you go."

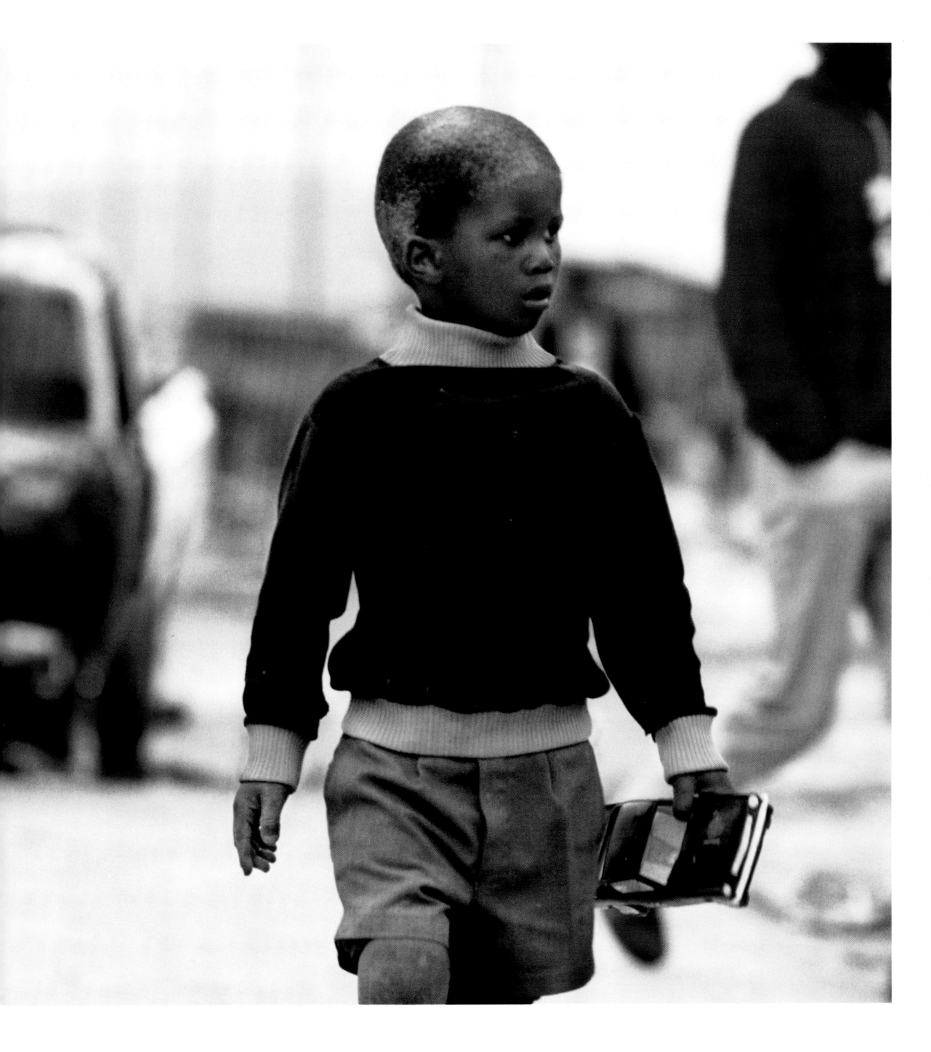

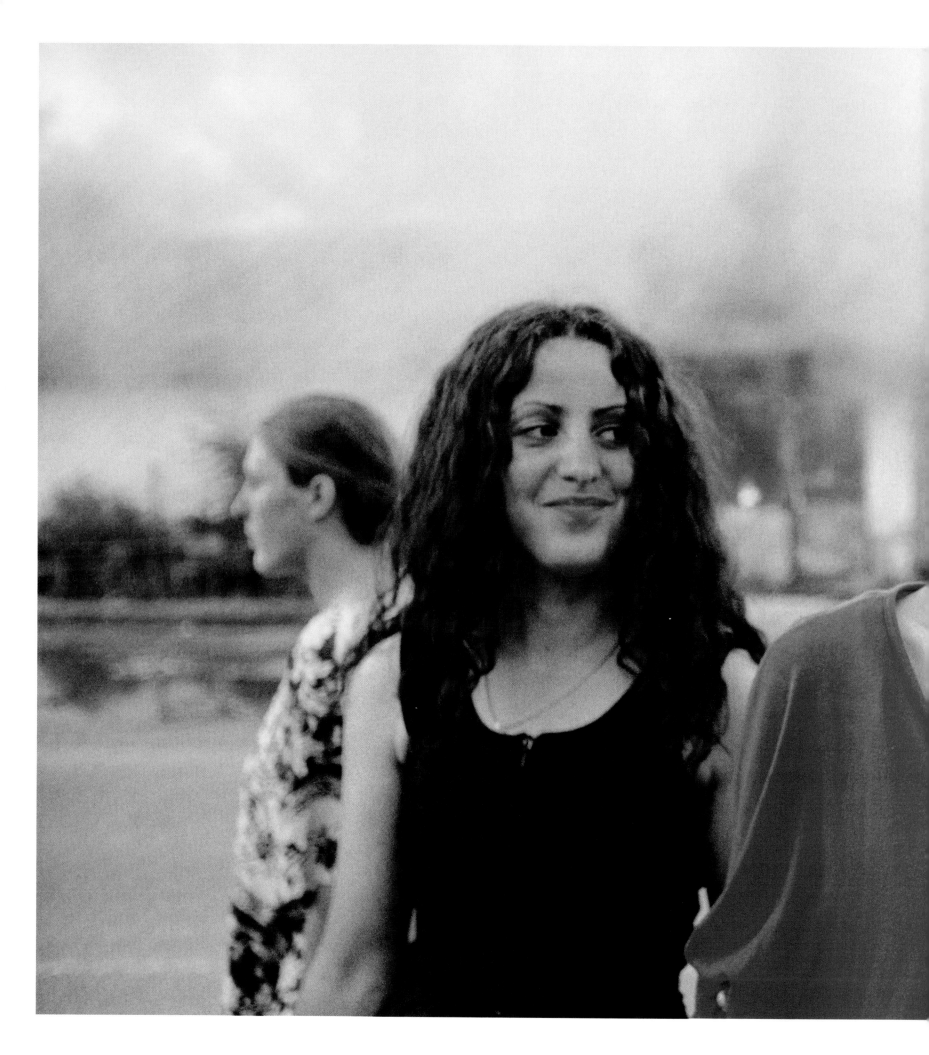

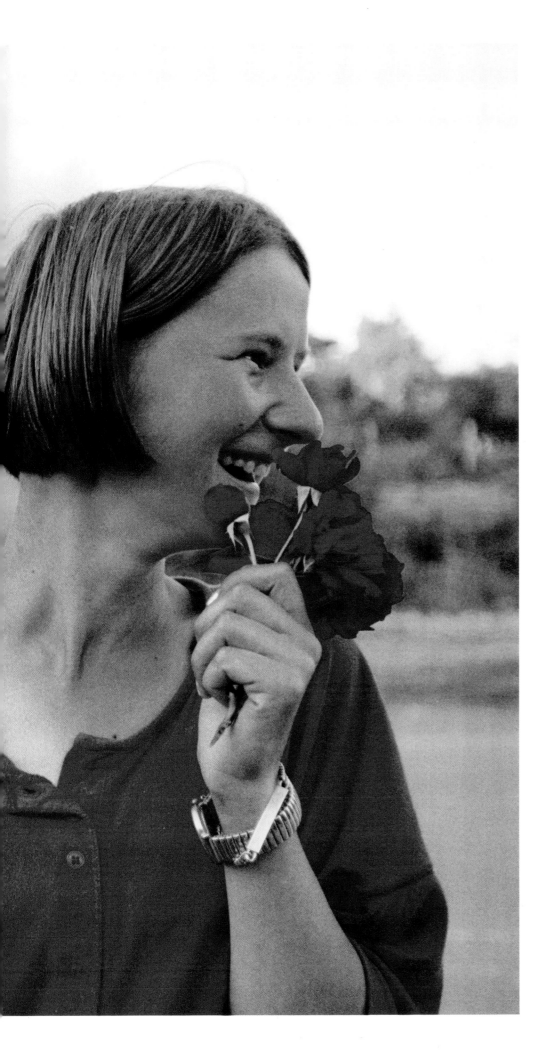

ALEXANDRA BOULAT
Kosovo | 1999

In politics, the law governing individuals can sometimes involve the land they live on, and so it was in 1999 when the world and NATO turned their attention to the suffering of ethnic Albanians under the governance of the Serbs in Kosovo, a part of the Federal Republic of Yugoslavia. Photographer Alexandra Boulat, who dedicated her career to illuminating the hardship and the suffering of wrongly oppressed people all over the world, was there to capture the steady flow of refugees and the suffering this displacement brought. On the day in June that NATO troops declared the Kosovars liberated, Boulat journeyed back to Pristina on the road from Mitrovica. There she found joy among a few young Kosovars who celebrated that day, while a torched home belonging to a local Serb family burned in the background.

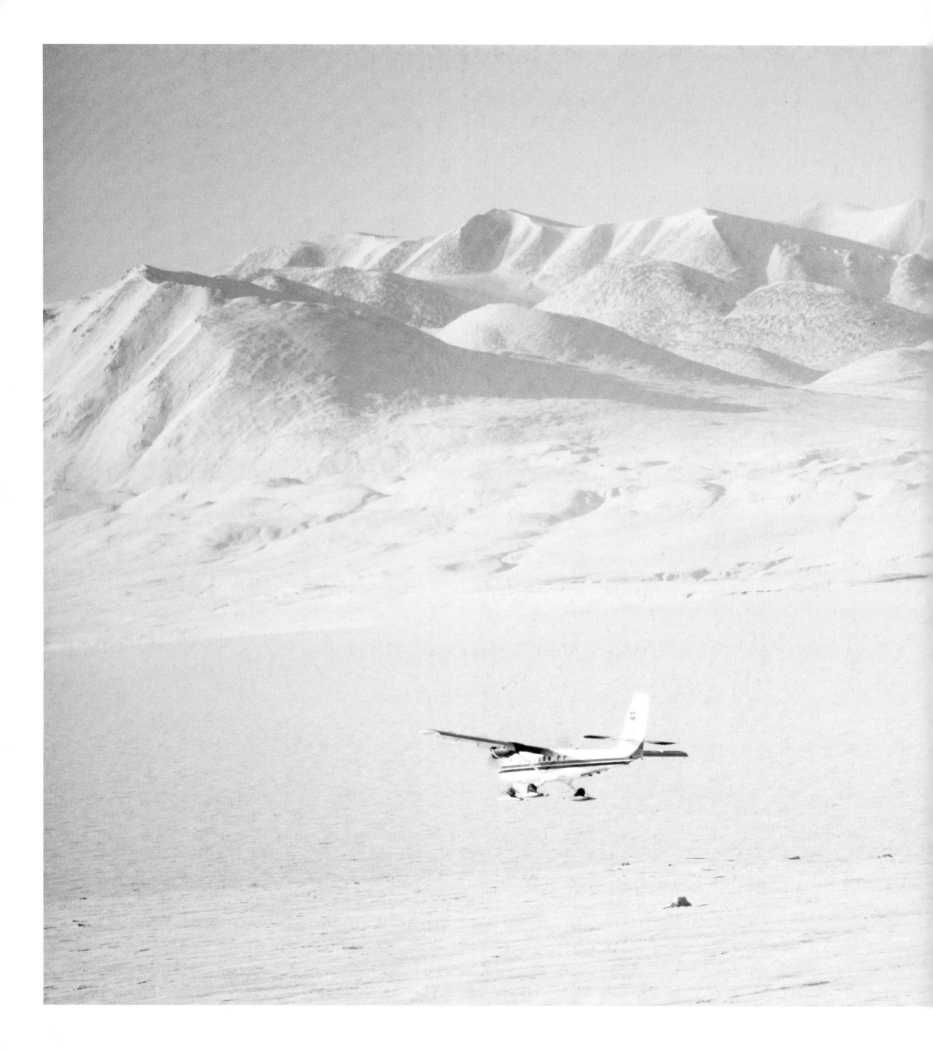

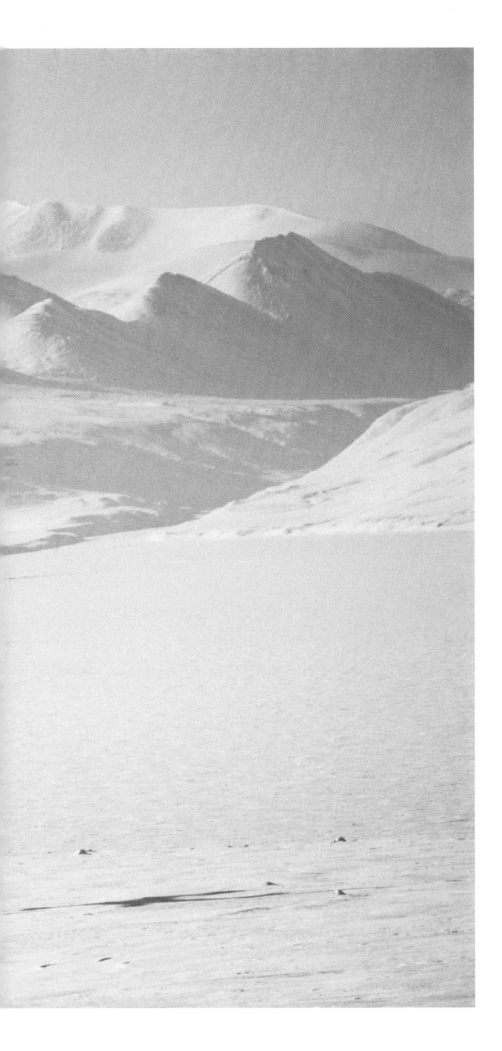

O. LOUIS MAZZATENTA

Ellsmere Island, Canada | 1973

I was traveling with a team, and we were retracing the footsteps, rather the wake, of Sir John Franklin, who vanished with his ship's crew in 1847 while searching for the Northwest Passage. The daily temperature was around minus 30°F. We visited many sites but the most spectacular was Lake Hazen, nicknamed the "Garden Spot of the Arctic," on Ellsmere Island. It is an incredible landscape with an iced-over, sparkling, flat surface and a backdrop of splendid snow-covered mountains. For dinner, we bored a hole through the ice with an auger and fished for Arctic Char, as the midnight sun never set. A lone, white wolf sauntered by against a majestic background and looked at us curiously.

next pages: O. Louis Mazzatenta

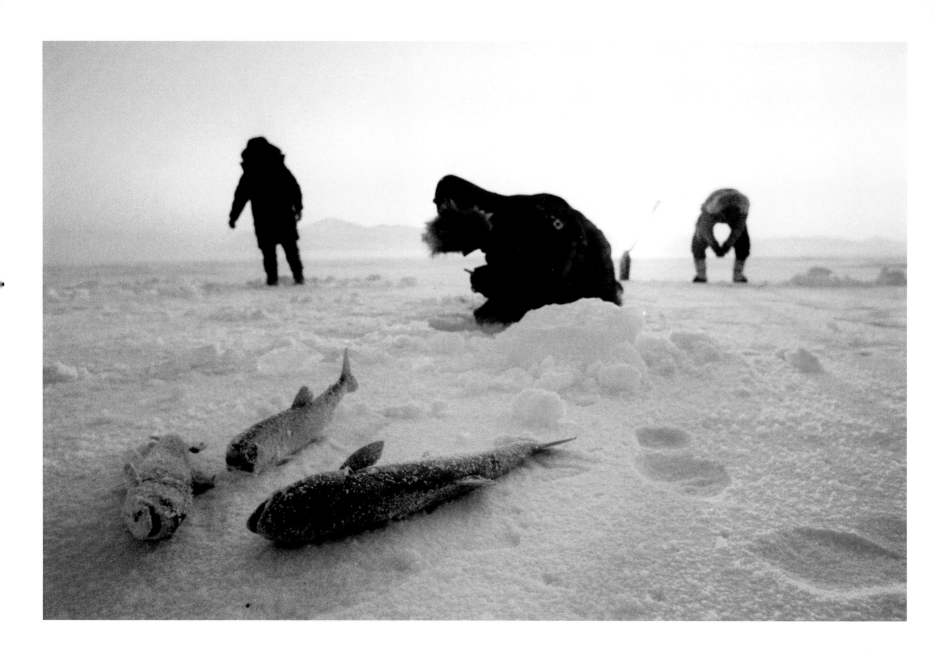

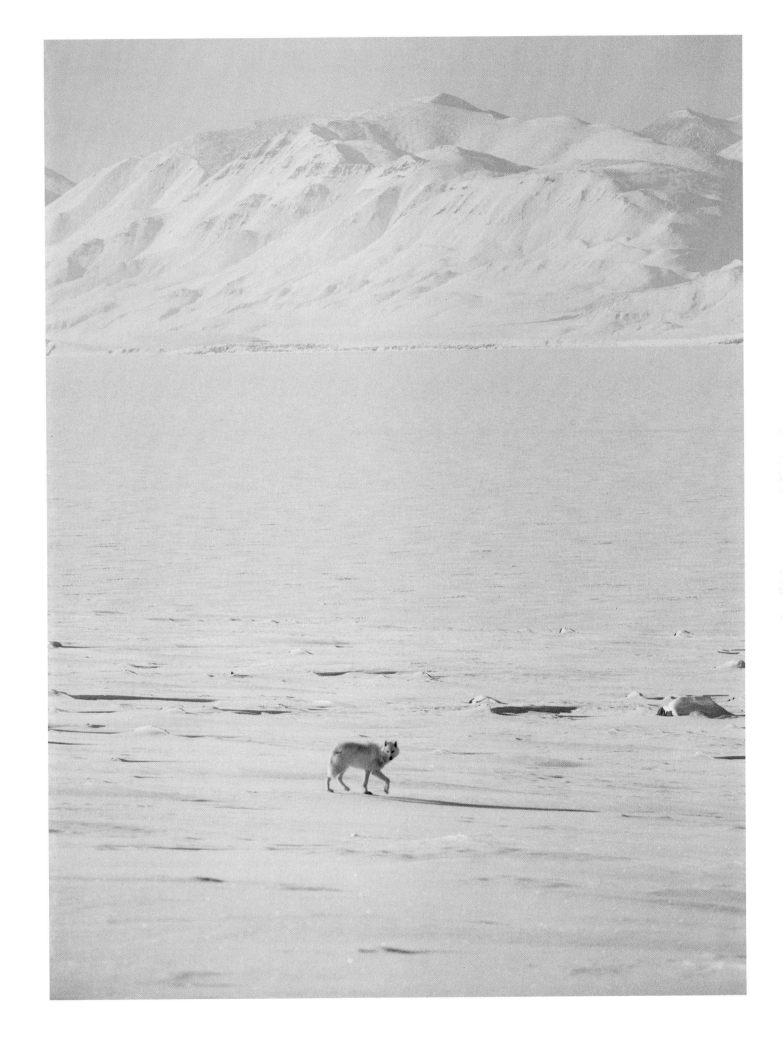

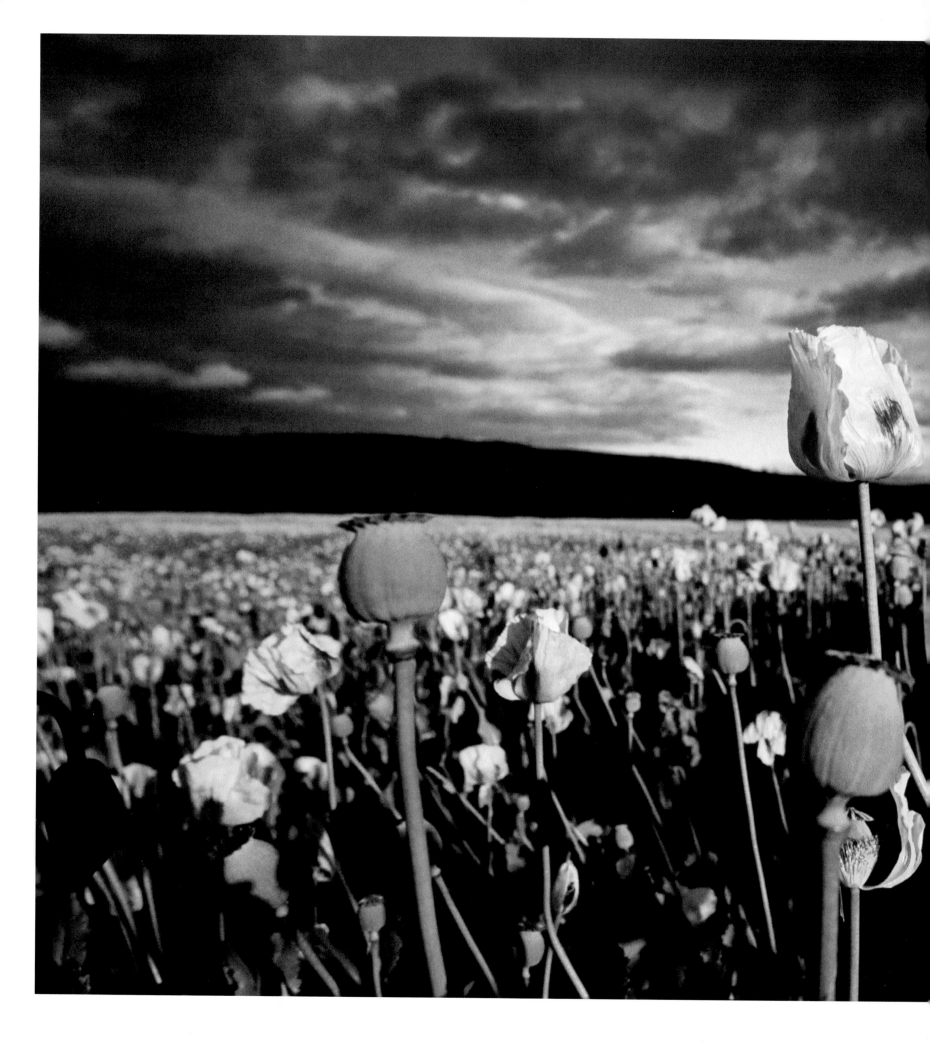

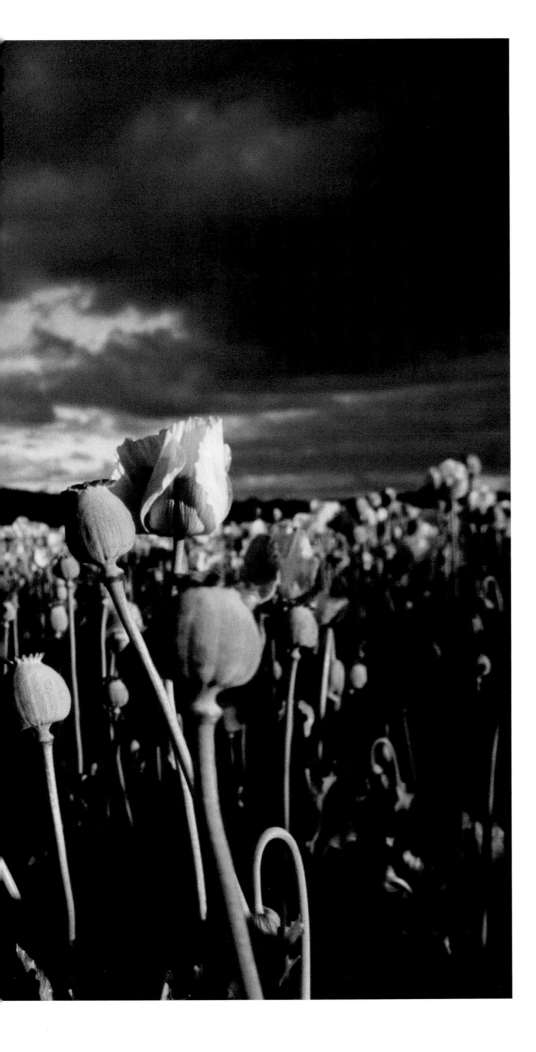

GERD LUDWIG

Tasmania | 2000

The beautiful poppy fields of Richmond, Tasmania, are a reminder of opium's many important medicinal uses; opium farming is one of the Australian island's most lucrative industries.

STEPHEN FERRY

Chivilongui, Colombia | 2004

An ancient tribal village belonging to the Kogi, who live high above the Caribbean Sea on the edges of the Sierra Nevada de Santa Marta, is a sacred site. It is the place where all the members of the Kogi tribe congregate a few days of the month for spiritual work or communal labor. The rest of the time they work small plots of land, a day's walk away, to harvest manioc and corn, sugarcane and pineapples, potatoes and onions.

next pages

Photographer Stephen Ferry found this village when he discovered the incredible story of resilience displayed by the Kogi, Wiwa, and Arhuaca tribes, ancient tribes caught between two modern forces capable of robbing them of their way of life. At the base of their mountain, leftist guerrillas and right-wing paramilitary decimated the forests to create oil palm plantations and coca fields. Above them, the effects of global warming had begun to melt the glaciers on top of the mountain, an important water source for them and their subsistence farming. Despite these forces, the members of the tribes employed their spiritual teachings to help find innovative answers. "The next photograph is a true expression of how I felt that morning. It was clear to me what they say is how they are living, and at the same time that's why they live so peacefully."

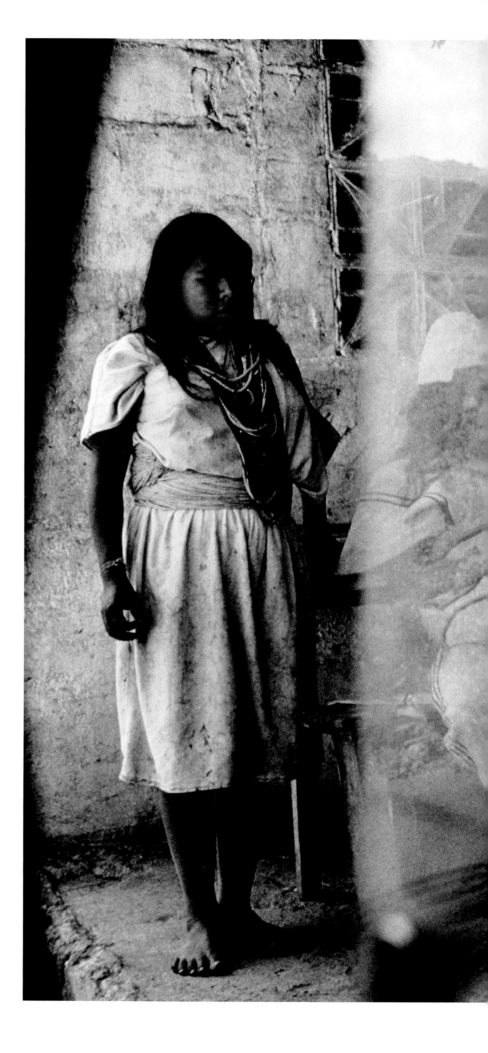

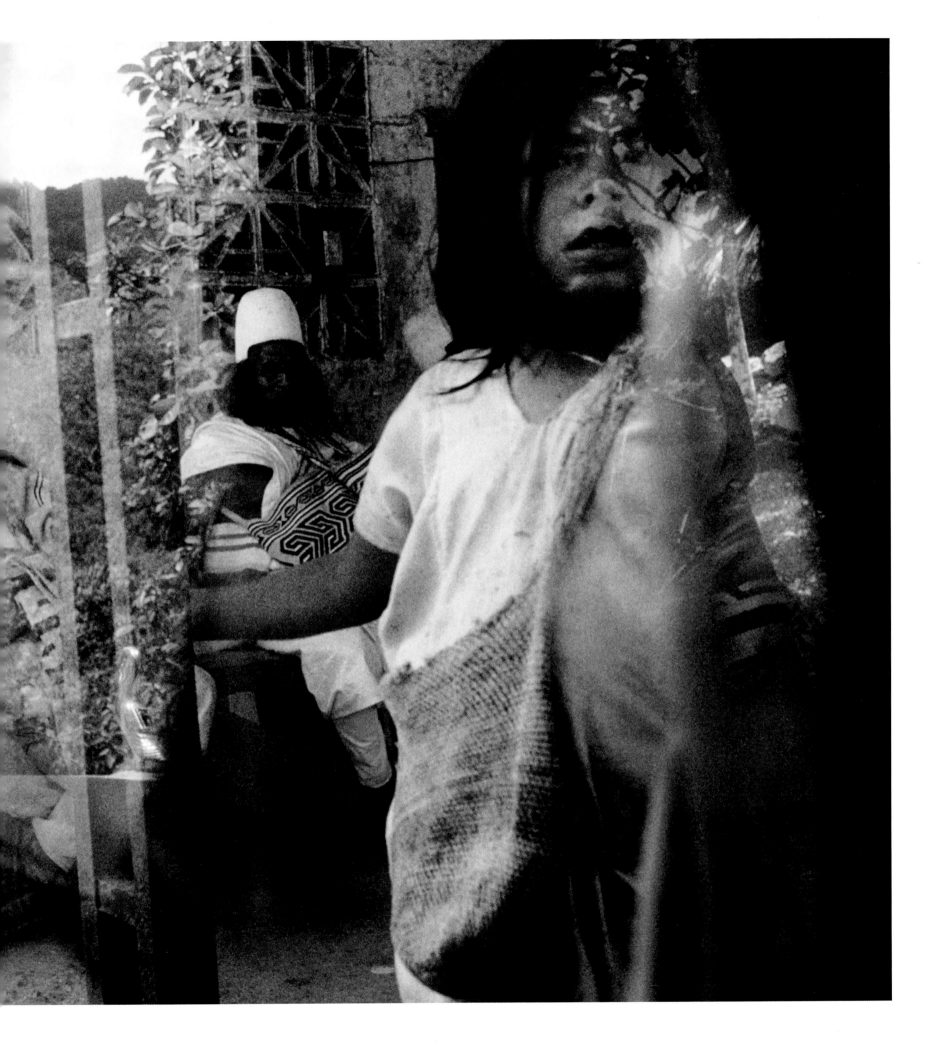

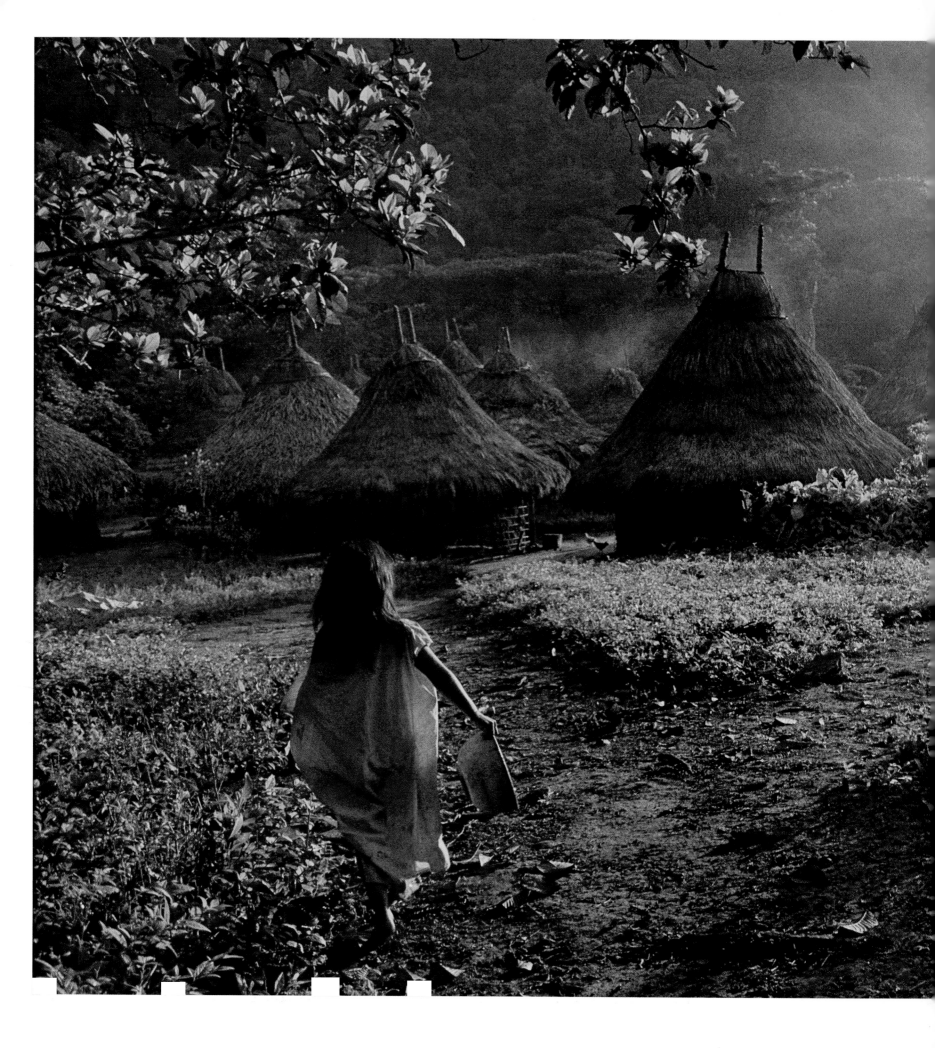

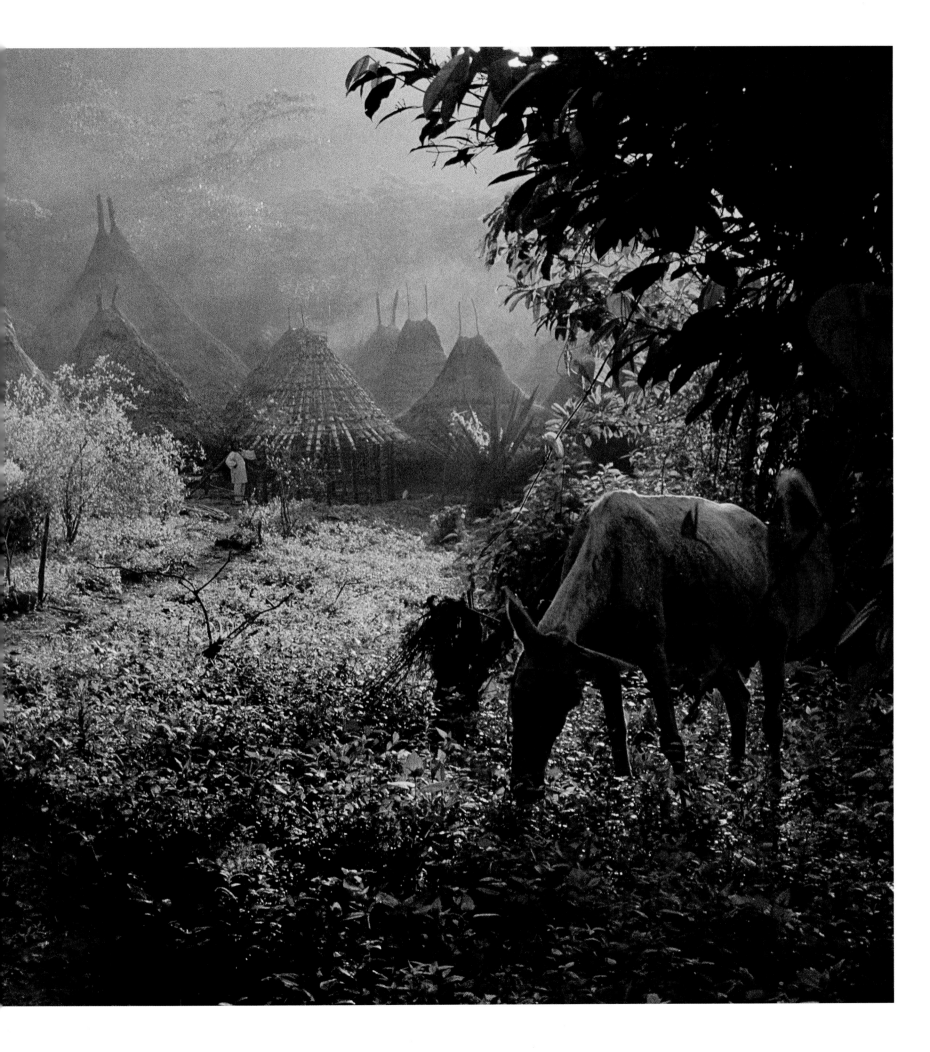

SISSE BRIMBERG

France | 1988

Sometimes paradise is not what it is claimed to be. Sometimes the secluded place where you can find solitude—where you can get rejuvenated—that is paradise. For Sisse Brimberg that place was inside the Paleolithic cave in Lascaux, France.

The French Ministry of Culture closed the cave in 1962, protecting its winding hallways and rooms from harmful bacteria and light. After months and months of negotiations, Brimberg received permission to photograph the space, but she was limited to one hour each visit, an amount of time that allowed her only to work as fast as she could before she would be led back out into the sunshine. Finally one day, one of the four men who had discovered the cave left her alone in the Hall of the Bulls, his trust in her evident. For half an hour she sat staring at the paintings. "These animals looked as if they were dancing on the ceiling and on the walls," she remembers. "The space was incredible, and I realized that many people would never experience this wonderful place. It was a dark and moist and damp place, but it was very, very special."

Brimberg learned later that Picasso often visited the caves after they were discovered in 1940. It is rumored that when he came out, he said, "We have invented nothing. They knew it all, even then."

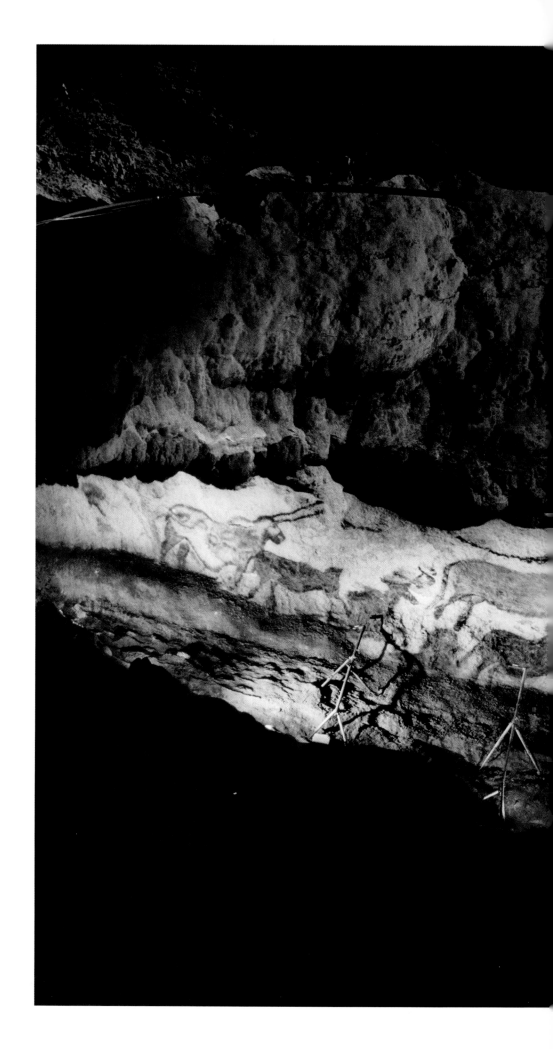

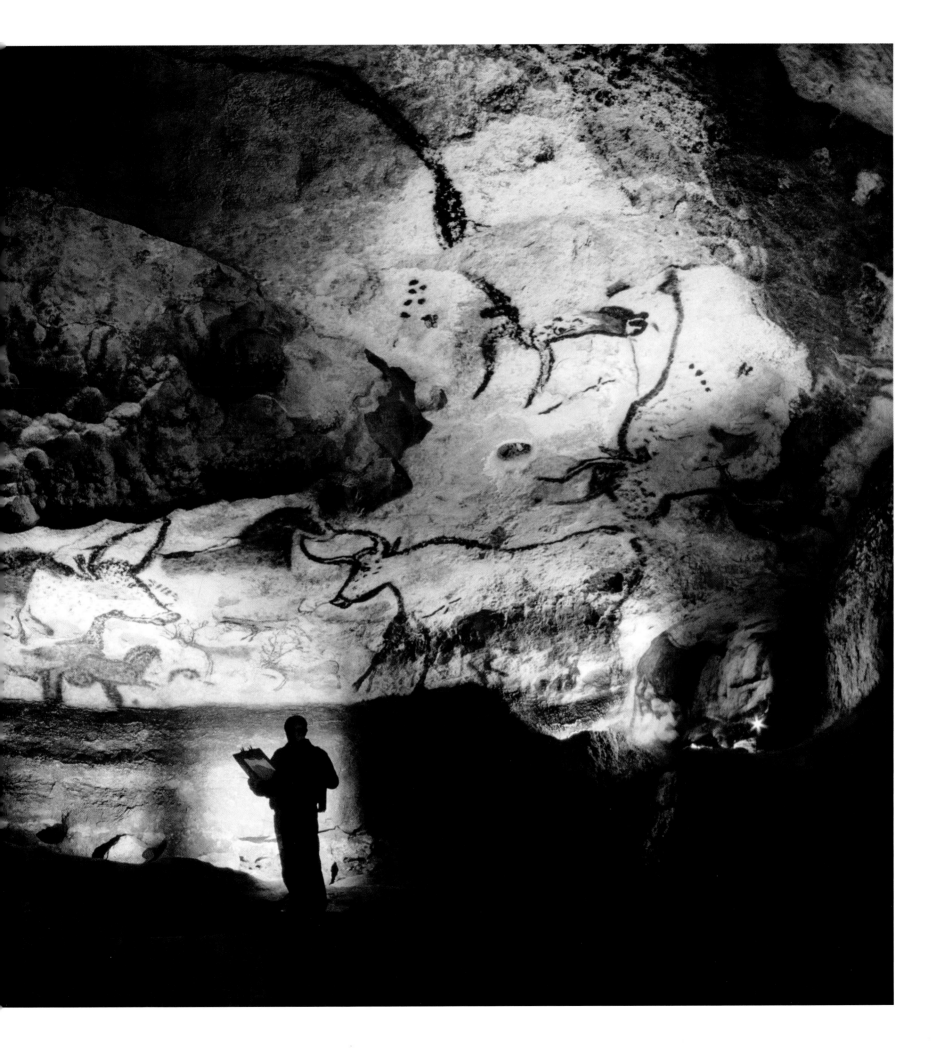

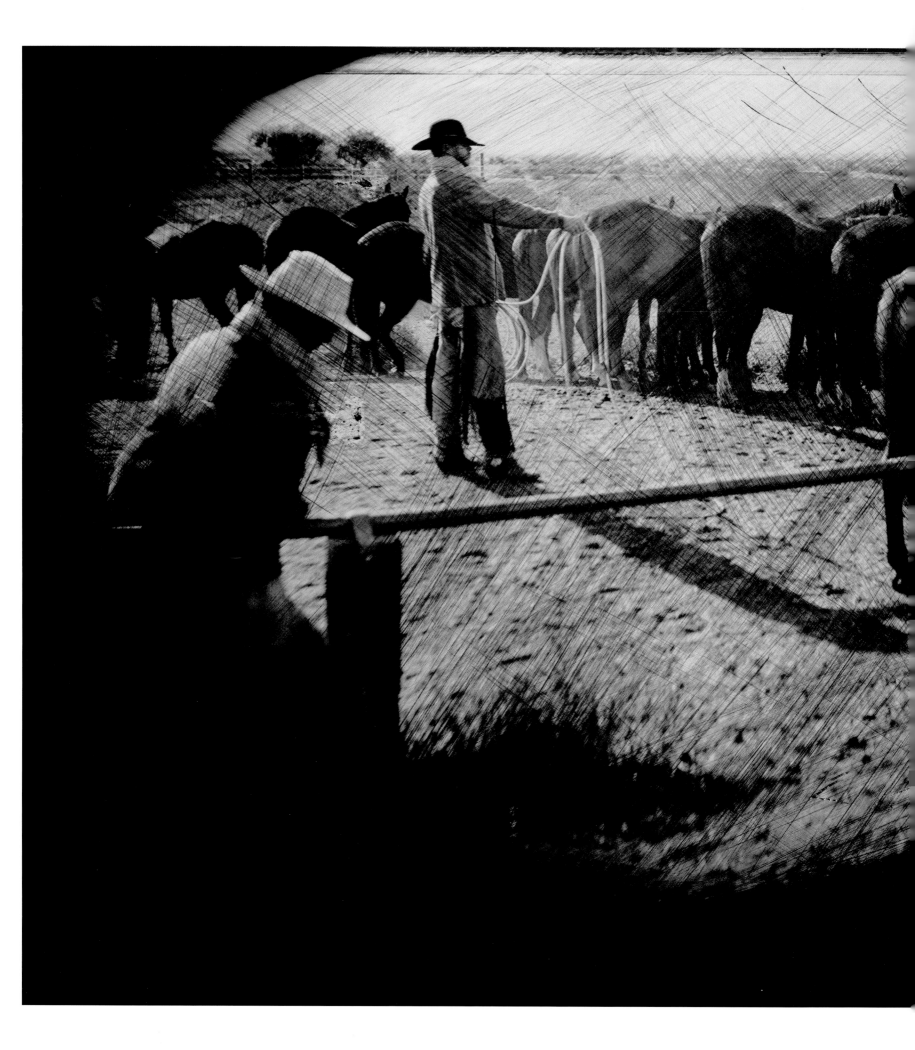

ROBB KENDRICK

Oregon | 2006

Where Robb Kendrick lives—San Miguel de Allende, Mexico—the weather is pleasantly predictable; 50 degrees in the morning, 75 degrees in the afternoon, sunshine almost all the time. It is a wonderful life for a photographer, but sometimes the draw of the true West overtakes him. "The open space, the independent spirit, and the extreme terrain—the place can be a true physical and mental test," says Kendrick of a town called Paisley, where he made this tintype photograph of two cowboys. "The winters are harsh there, and the summers can be very hot. During the spring and fall, you have a real appreciation for the special times."

MATTIAS KLUM

Himalaya | 2000
"This was a very spiritual journey for me."

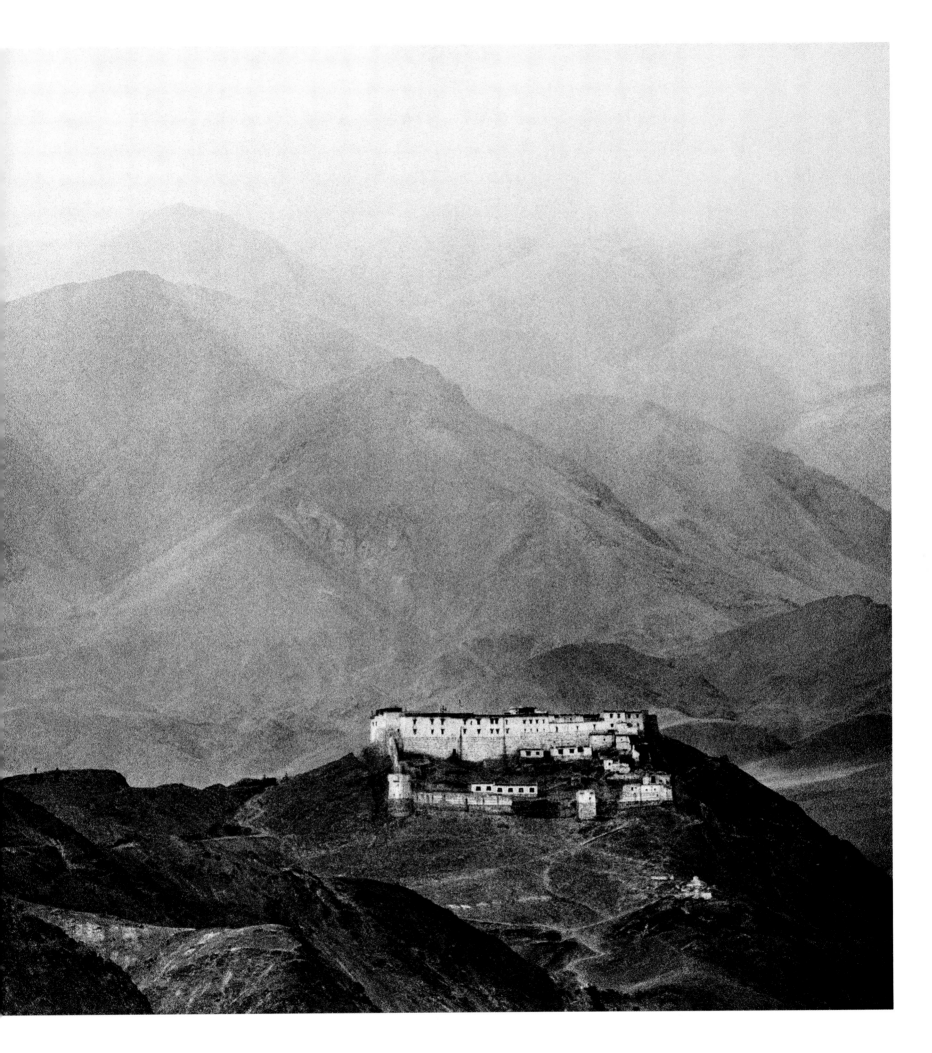

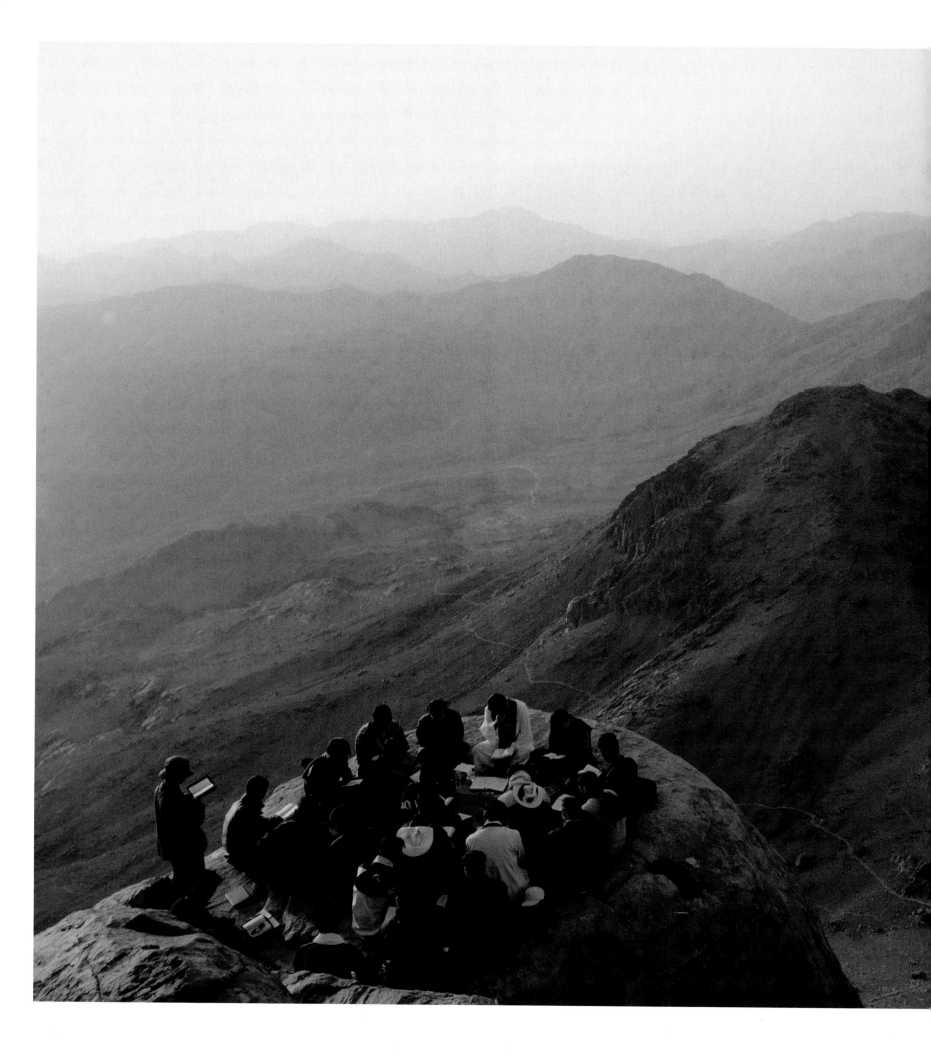

KENNETH GARRETT
Egypt | 2005

Kenneth Garrett lived in the desert for weeks, while he was working on a story about the lost gospel of Judas. "It was so quiet, and then all of a sudden there would be hundreds of people walking in the dark with flashlights at 2 a.m.," he remembers. The people were pilgrims, and their mission was to reach the summit of Mount Sinai, the place where the Bible describes the conversation between God and Moses having taken place, before sunrise. The prayer session on this particular morning lasted only a few minutes. "I was working, and then I looked up and everyone was gone. All I could hear was singing coming from somewhere down the mountain trail."

JAMES P. BLAIR
India | 1986

For personal reasons, India is a place Jim Blair loves to visit again and again. "My late wife and I loved India," says Jim Blair. "The character of the people intrigued me. I find it simply to be a warm and inviting place."

With a book proposal in his back pocket to photograph the World Heritage Sites of the world, places of cultural and natural importance selected by the United Nations Educational, Scientific, and Cultural Organization (UNESCO), Blair got his wish in 1986. Each morning and each evening he wandered through some of the most pristine landscapes India has to offer. During one of those walks he discovered the beauty of openbill storks, a bird indigenous to the region. On this particular morning he captured them nesting in the trees by the marshes of the Keoladeo National Park in the Rajasthan state of India.

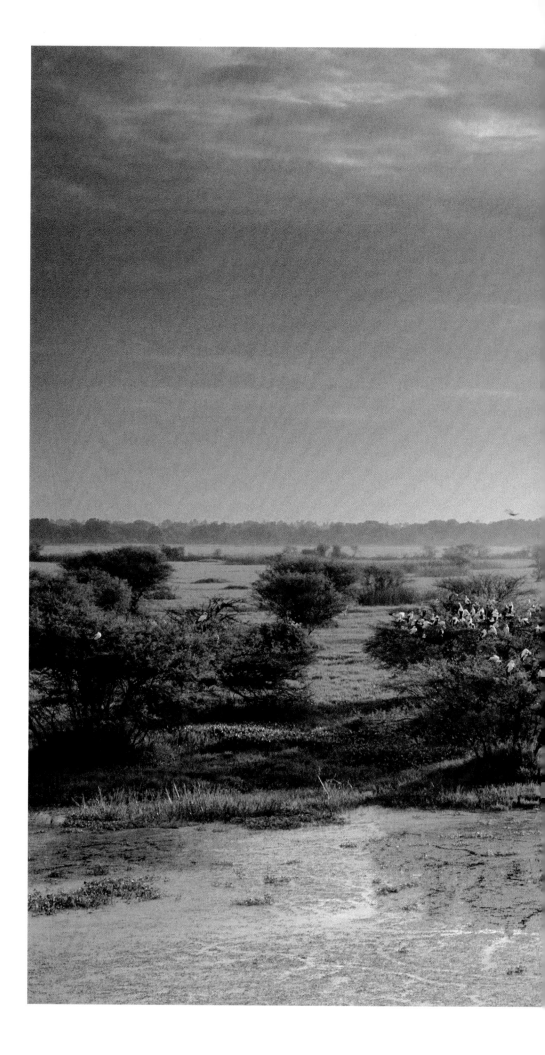

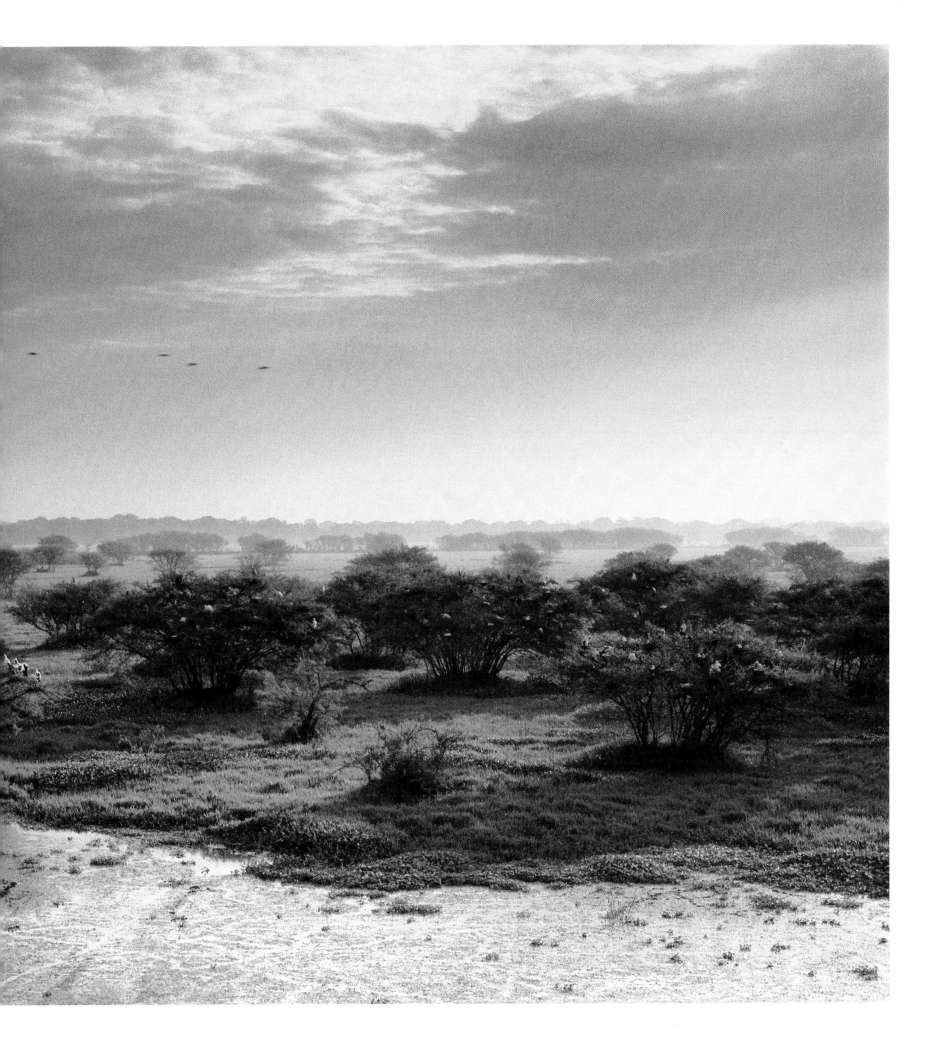

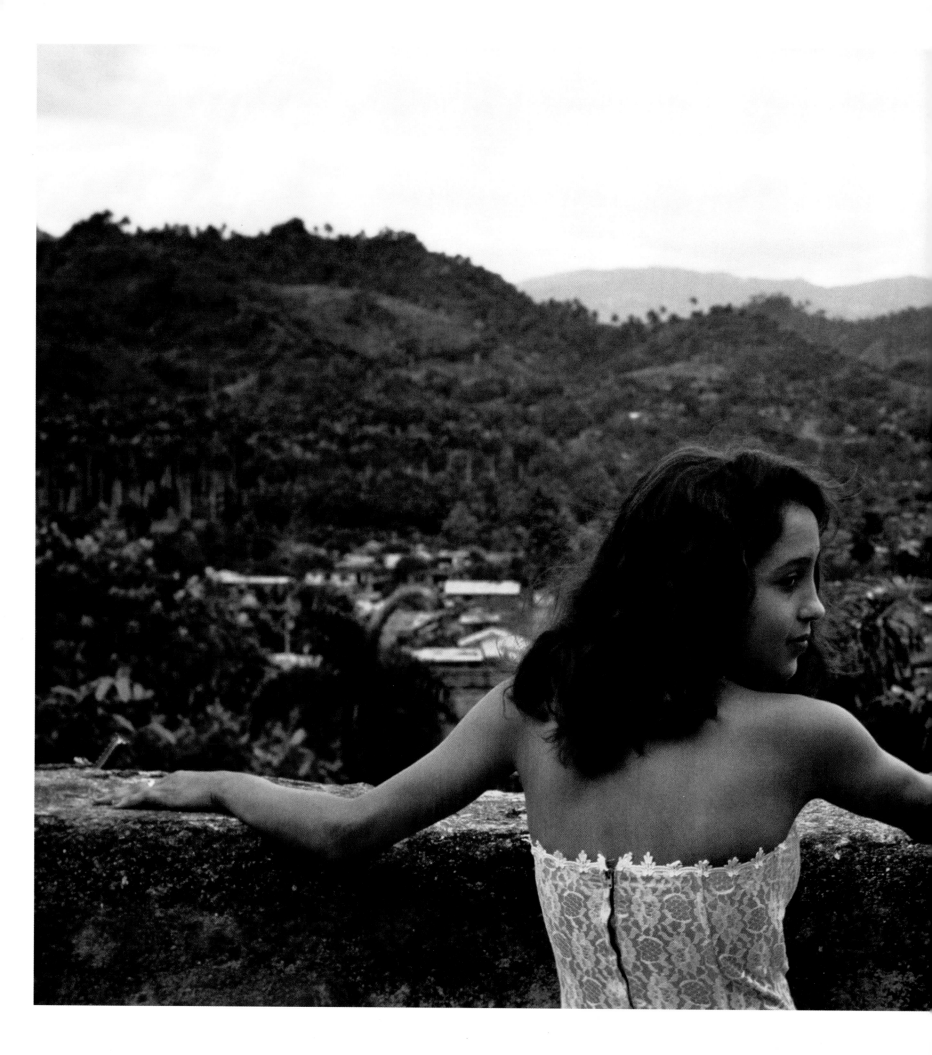

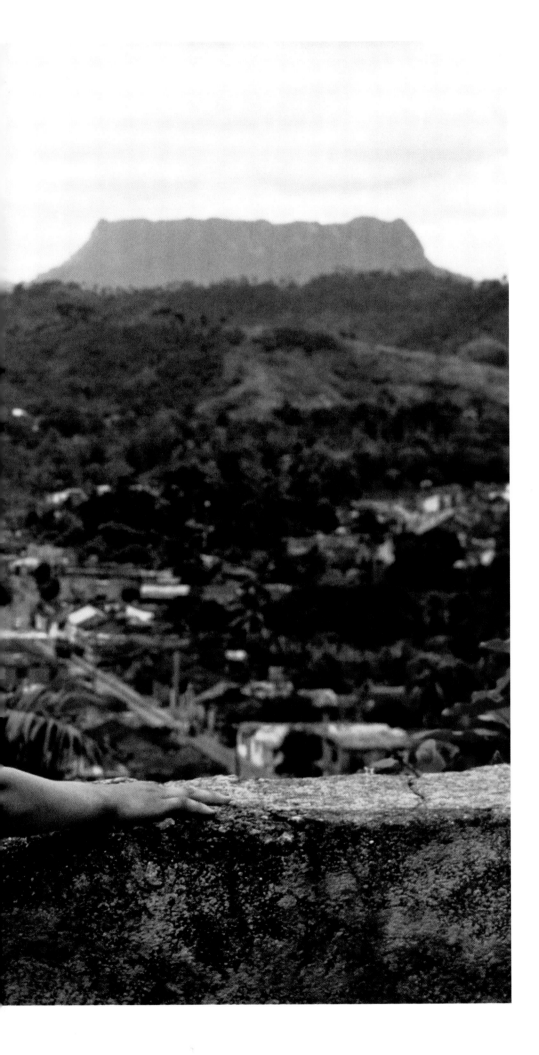

DAVID ALAN HARVEY
Cuba | 1998

A girl poses in front of El Yunque, a flat-topped mountain, in Baracoa.

LYNSEY ADDARIO

Bhutan | 2007

Every morning while Lynsey Addario worked in Bhutan, she rose at 5 a.m. to look for scenes of daily life. She passed by this forest and decided to return a few mornings in a row to wait for people to walk through the forest, an informal pathway. "This woman was on her way to visit a relative on the other side," remembers Addario. "Bhutan is a place where you are constantly driving through the clouds because you are always 6 or 7 or 8,000 feet high. You see lush valleys and people wearing traditional clothes. In this day and age it's hard to find a place as unspoiled. It's magical."

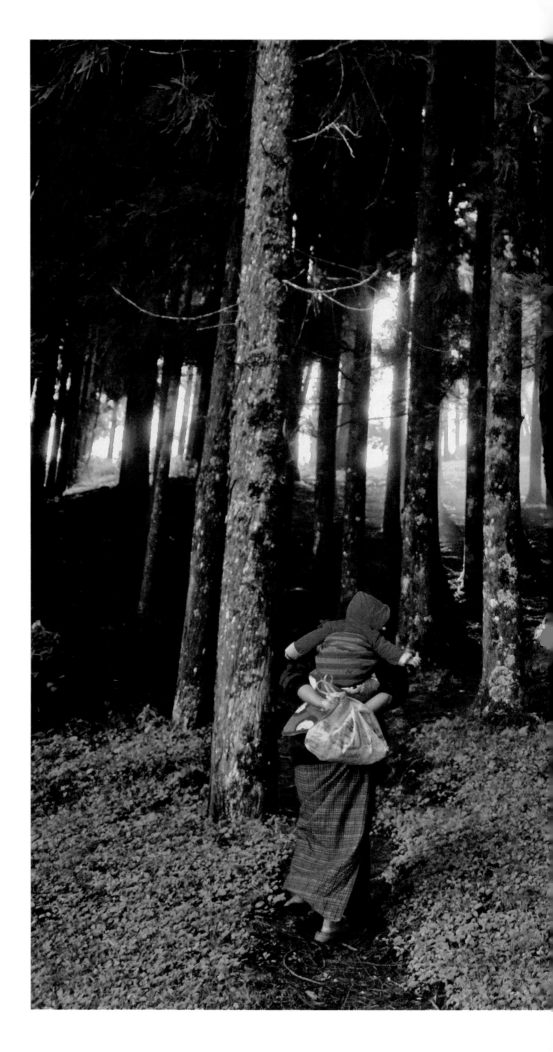

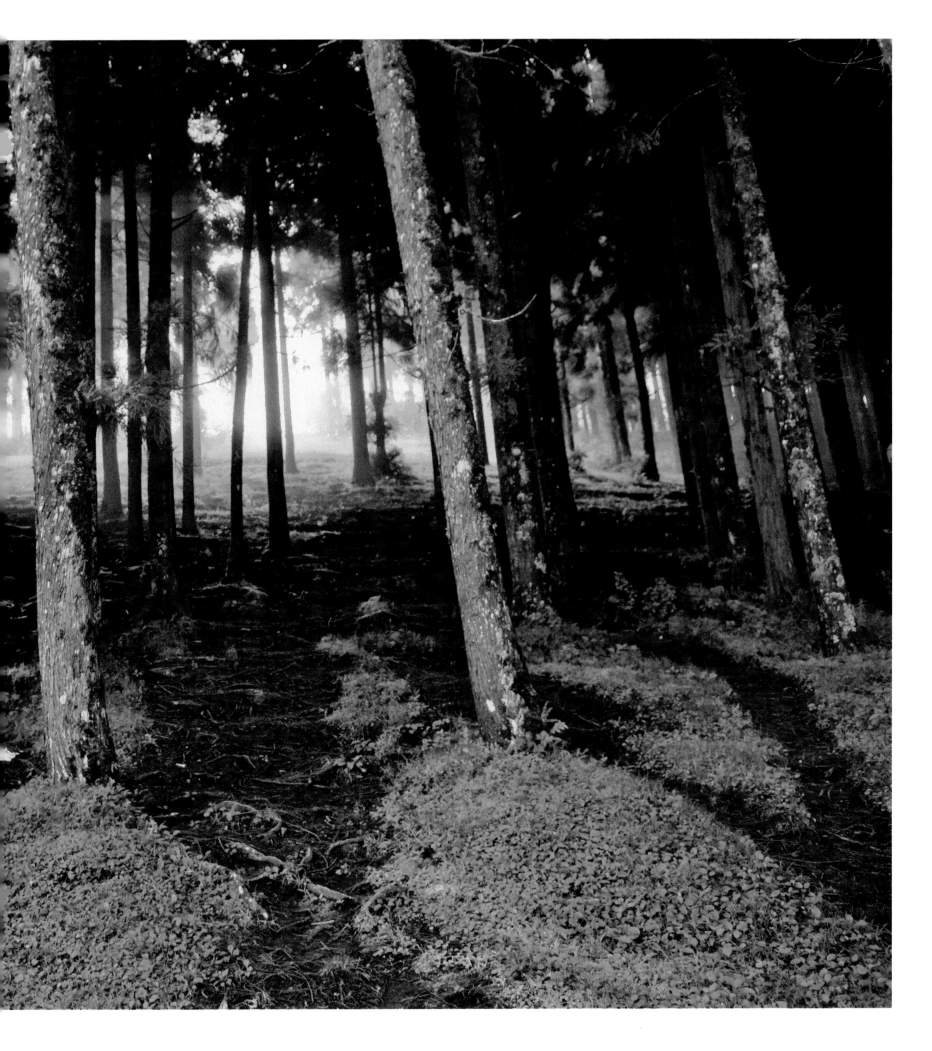

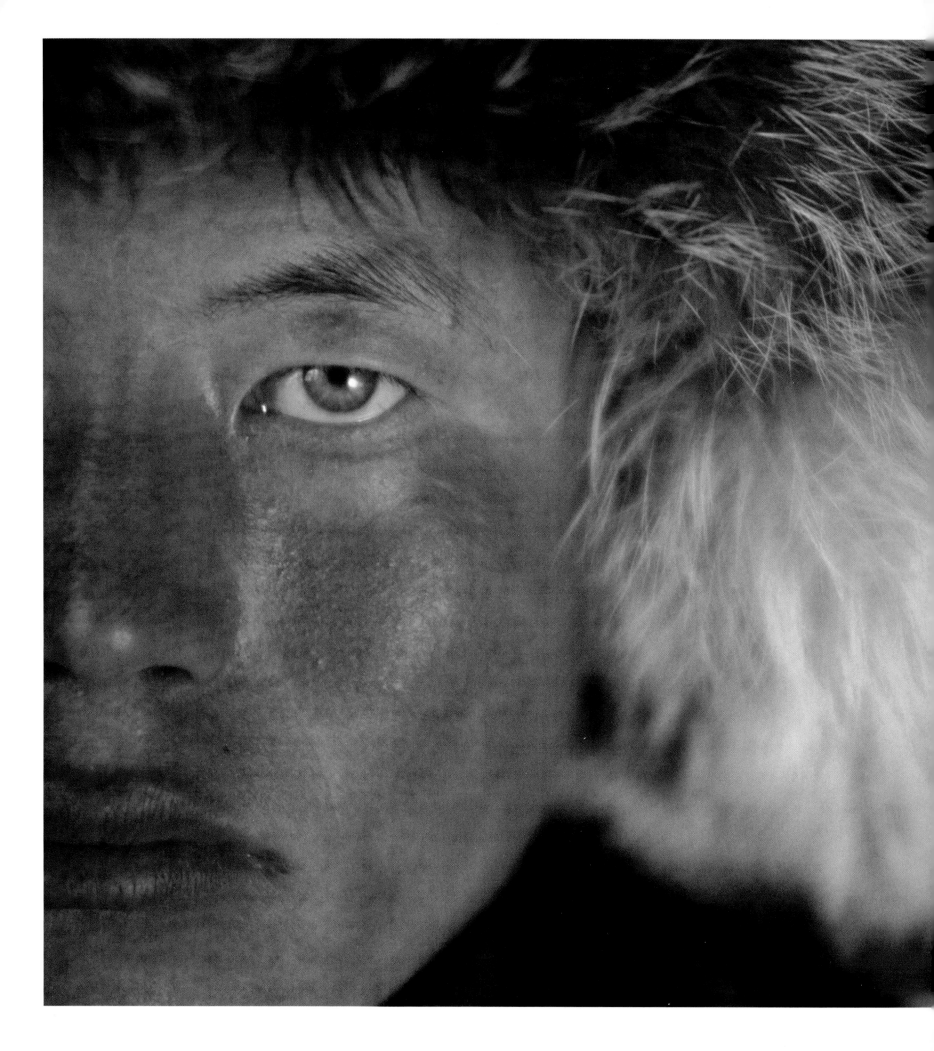

DAVID EDWARDS
Western Mongolia | 1998

While photographing a rough rugby-like game on horseback called Buskashi in Peshawar during the Afghan-Russian War in Afghanistan, David Edwards decided he wanted to photograph the remaining horse cultures in the world. He chose Kazakhstan as his first destination, until someone convinced him that finding the Kazakh people who lived in Western Mongolia would be better. There he discovered the eagle hunters, people who trained eagles with 7-foot wingspans and claws able to crush the spine of a wolf in one squeeze. The hunt always begins on horseback, the eagle riding blindfolded on the leather-covered arm of its owner. Fathers and sons, like 17-year-old Sangsai (left), set out in the bitter cold of winter before sunrise to reach promontories where the eagle, blindfold undone, can quickly scan the wide open land-scape for prey as the sun rises.

Edwards may have found the horse culture he sought, but in the journey, Mongolia also found him. He has been back there 14 times, and he plans to go there a 15th time to bring a group of adventurers on horseback up the ancient trails that border China. On such journeys he brings along axes and saws, along with his cameras, to clear the trails that nature has attempted to erase. "Mongolia is like a big yam that stretches the distance between Washington, D.C., and Colorado," says Edwards. "You could ride from one end to the other and never get off your horse to open or close a gate, it's that open and that immense."

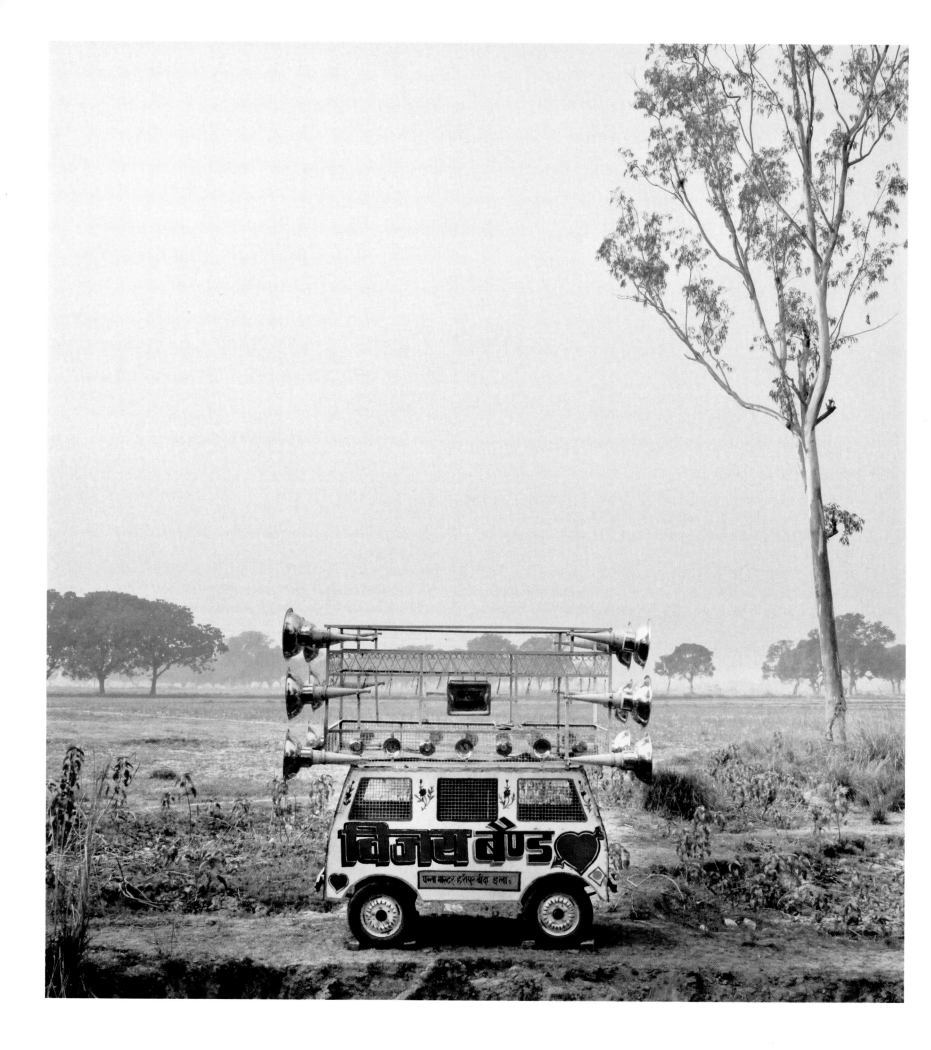

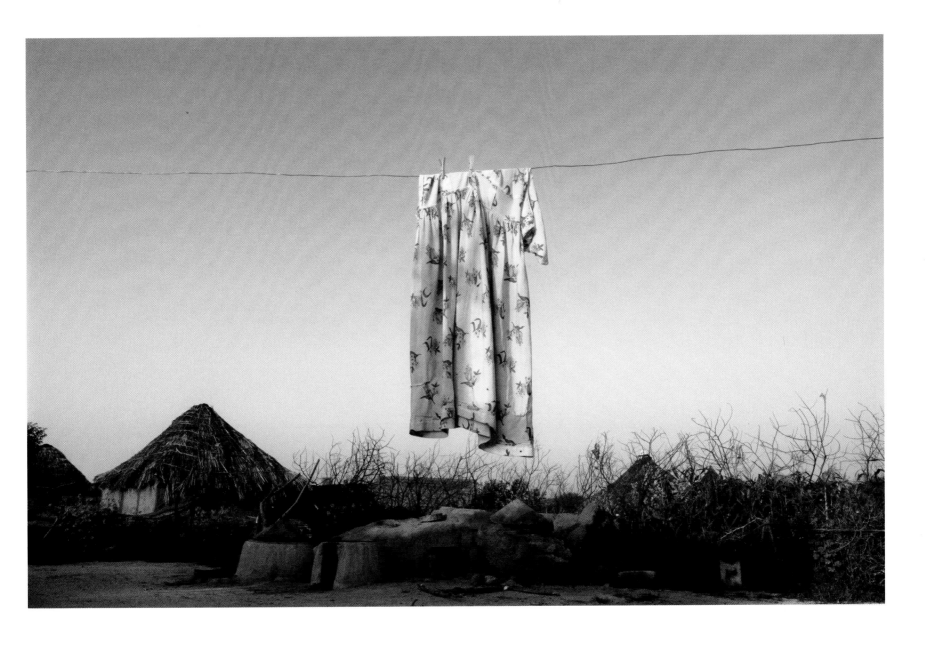

AMI VITALE
India & Eritrea | 1996

Forever traveling, Ami Vitale finds beauty in the people she meets wherever she goes, especially the women. The truck (at left) in India, blares slogans and music during political rallies. Sometimes the truck may even accompany a bride to her new village during a marriage ceremony.

In the village of Shilabo, Eritrea (above), Vitale spent time with women who had just been given a donkey to help them carry water from the well several miles away, a task that often took them half a day.

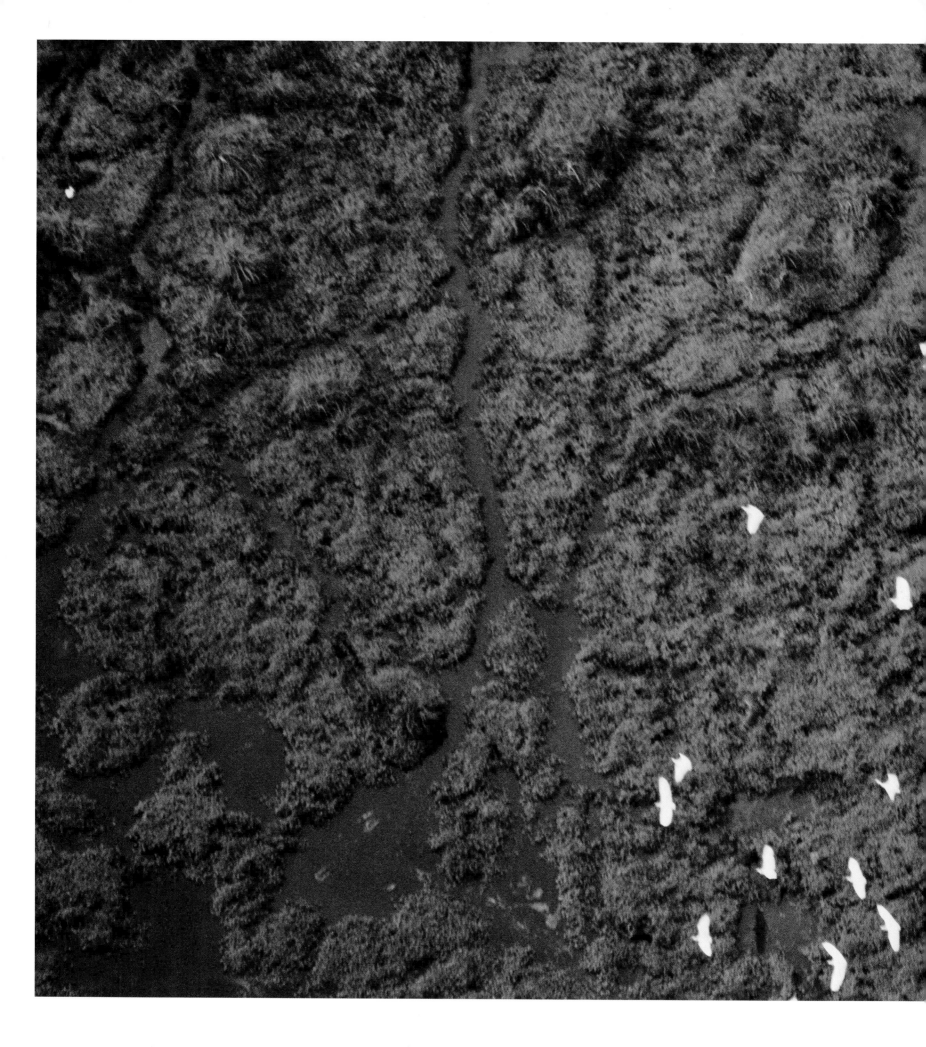

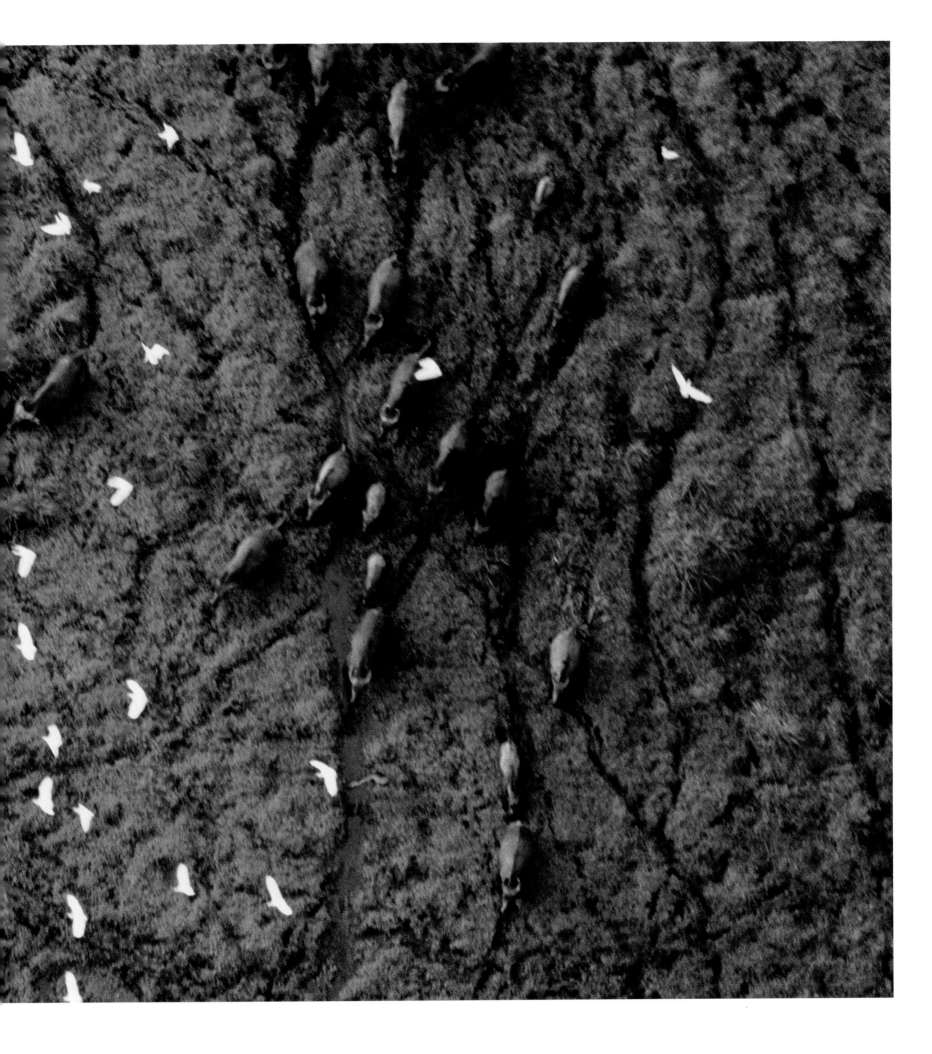

ED KASHI
Syria | 1995

Published photographs have the chance to form a collective memory of events or places. In the case of this photograph, Ed Kashi remembers mostly the personal circumstances around it. "I had a minder, and I really wanted to see the beehive architecture of these small ancient villages in the Halab province," he said. Kashi was eager to see the homes, he learned held the coolness inside during the heat of the summer and the warmth during winter, but he was also keen to be free of his minder for a while.

"As a photographer, you find these moments," he said. "Sometimes it's a split second. Sometimes you pre-visualize it, and you wait for it to happen. Another time it happens unexpectedly, and you have to react without thinking."

The children had been playing in between the houses when Kashi first saw them in the late afternoon as he wandered through the narrow streets. It was a moment, when he managed to walk alone for a bit, when he saw the girl walking on the rooftops. "It was just a moment when it was tranquil, full of peace and beauty," says Kashi, "before the minder returned."

previous pages:
MICHAEL NICHOLS
Republic of Congo | 2004

An aerial view of forest buffalos and egrets in the Ozdala National Park.

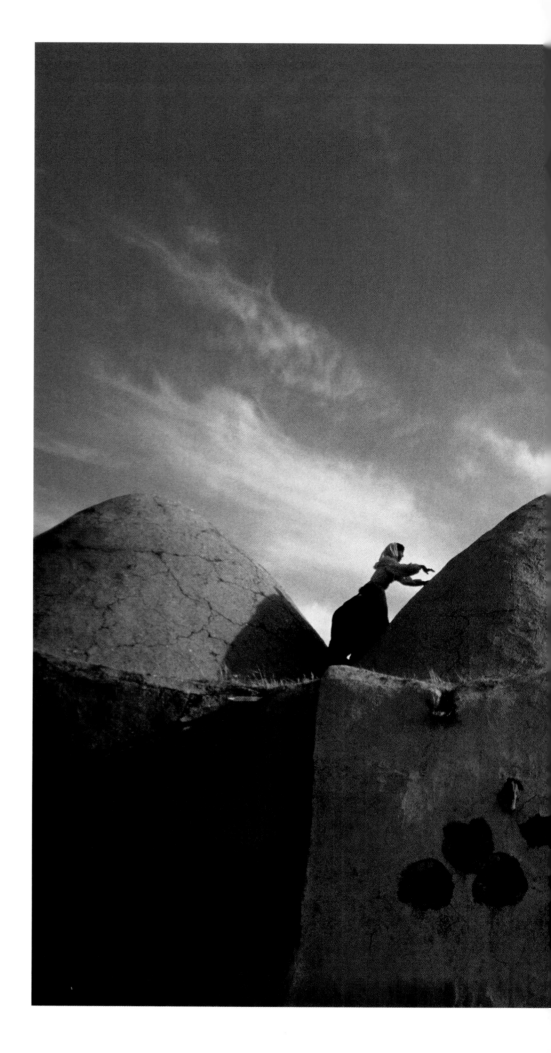

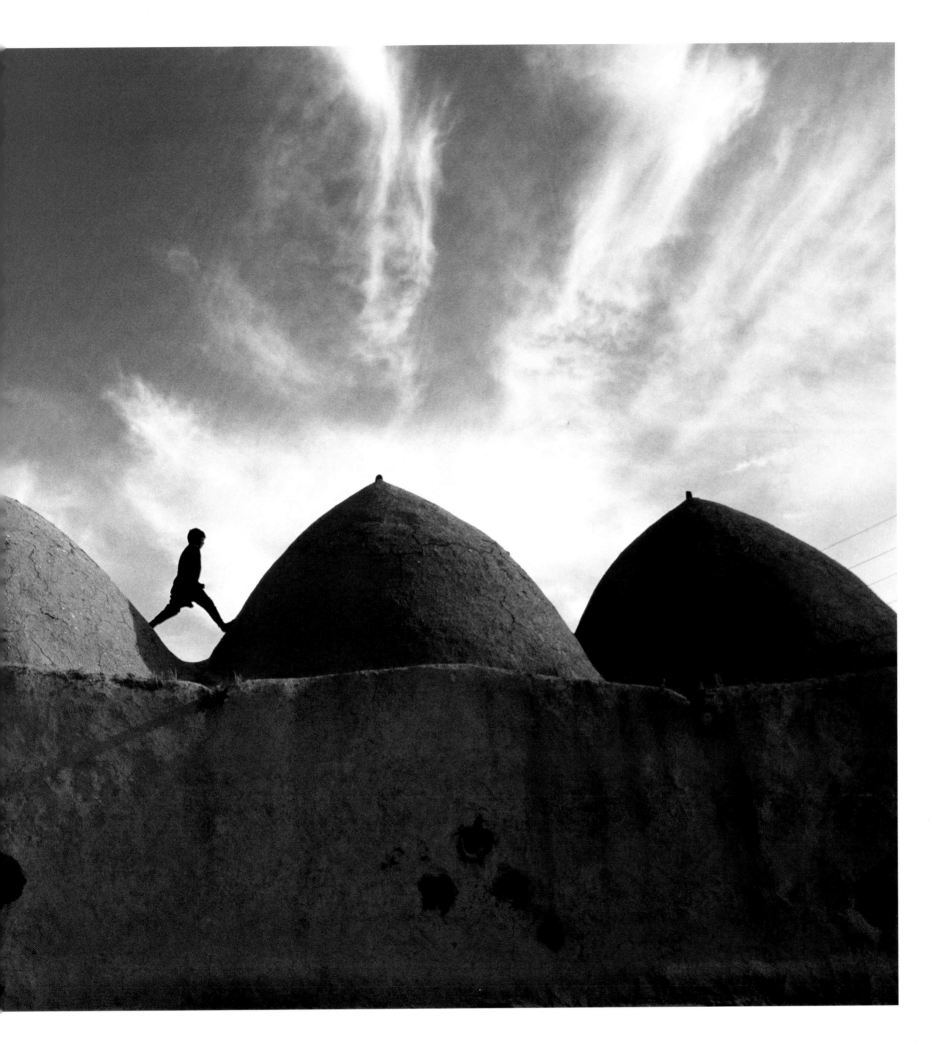

SARAH LEEN
Siberia | 1992

Just north of the Japanese islands is a tear-drop-shaped peninsula that dangles from the tip of Siberia. This is Kamchatka, a rural and rugged wild terrain once off-limits to the citizens of the former Soviet Union because of the nuclear submarines stored there during the Cold War years. When the Soviet Union broke into 16 republics and Boris Yeltsin uttered the words "free market," those limits lifted. Photographer Sarah Leen was one of the first journalists to go there, living there for months at a time to document the people, the reindeer herds, the bears, and the landscape full of volcanoes and rivers and plains. "It was time travel," says Leen. "No cell phones. No Internet. No e-mail. I was sending telexes every few weeks to my husband that said, "Still alive!"

"You really had the chance to live with the people and on the land. There were no hotels," continues Leen. "We'd go eight days without a bath, and then when we had the banja with everyone else, it was an all-day event. Someone would chop the wood for the fire we used to heat the water. We would wash our clothes then too. It was the cleanest I had ever been because I had never been so dirty!"

"Kamchatka and Lake Baikal," Leen says, "they're both very special."

next pages: Sarah Leen

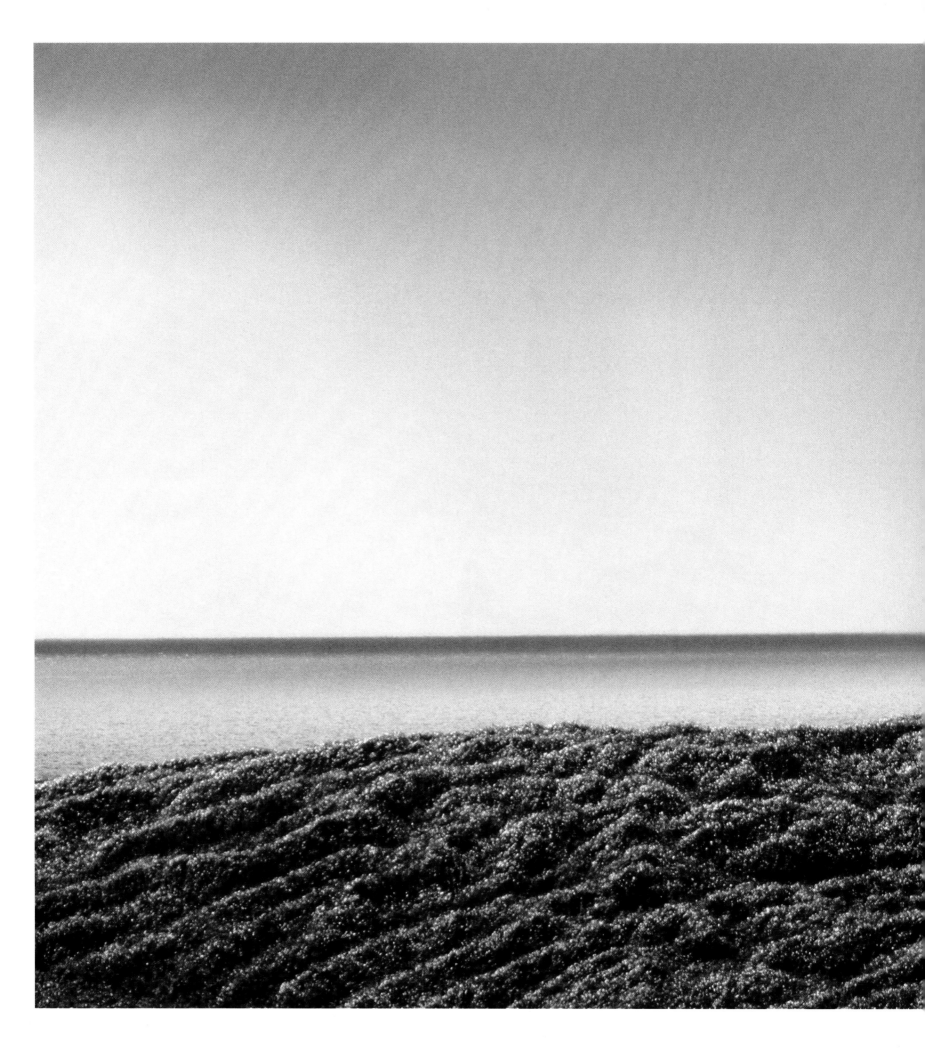

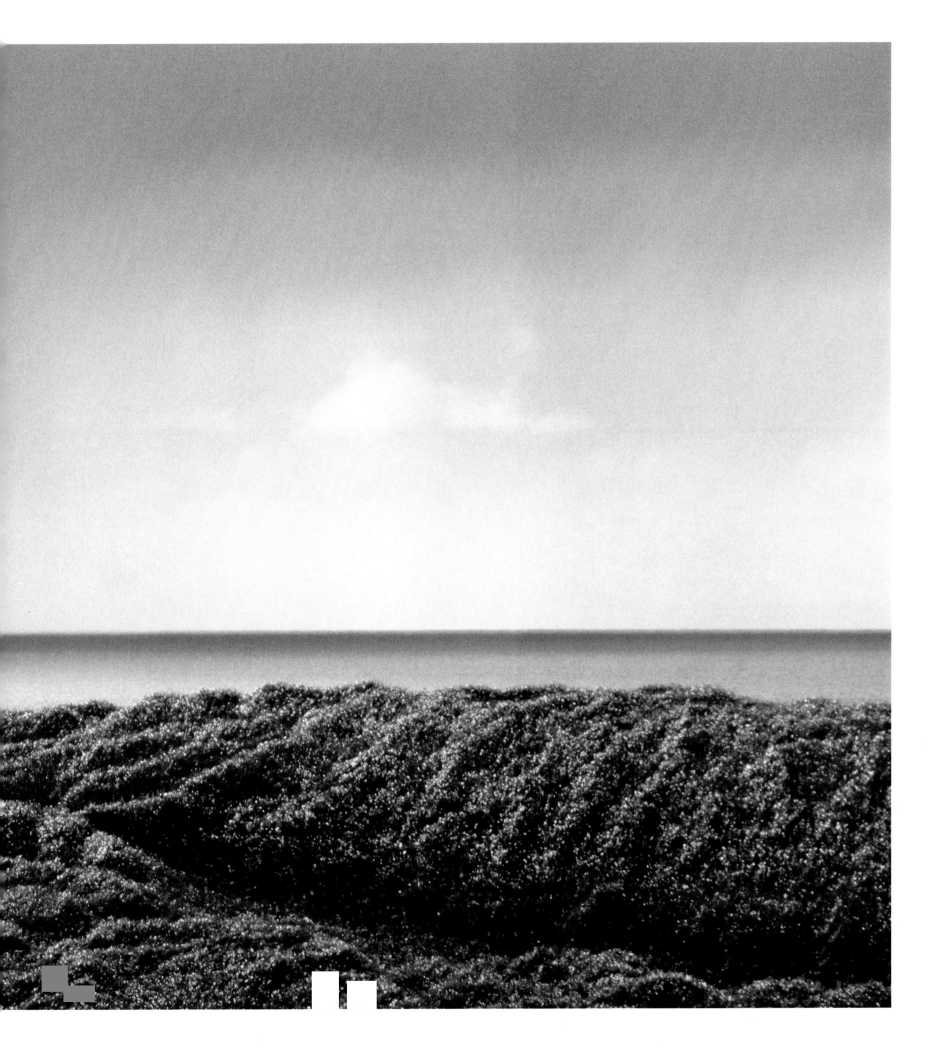

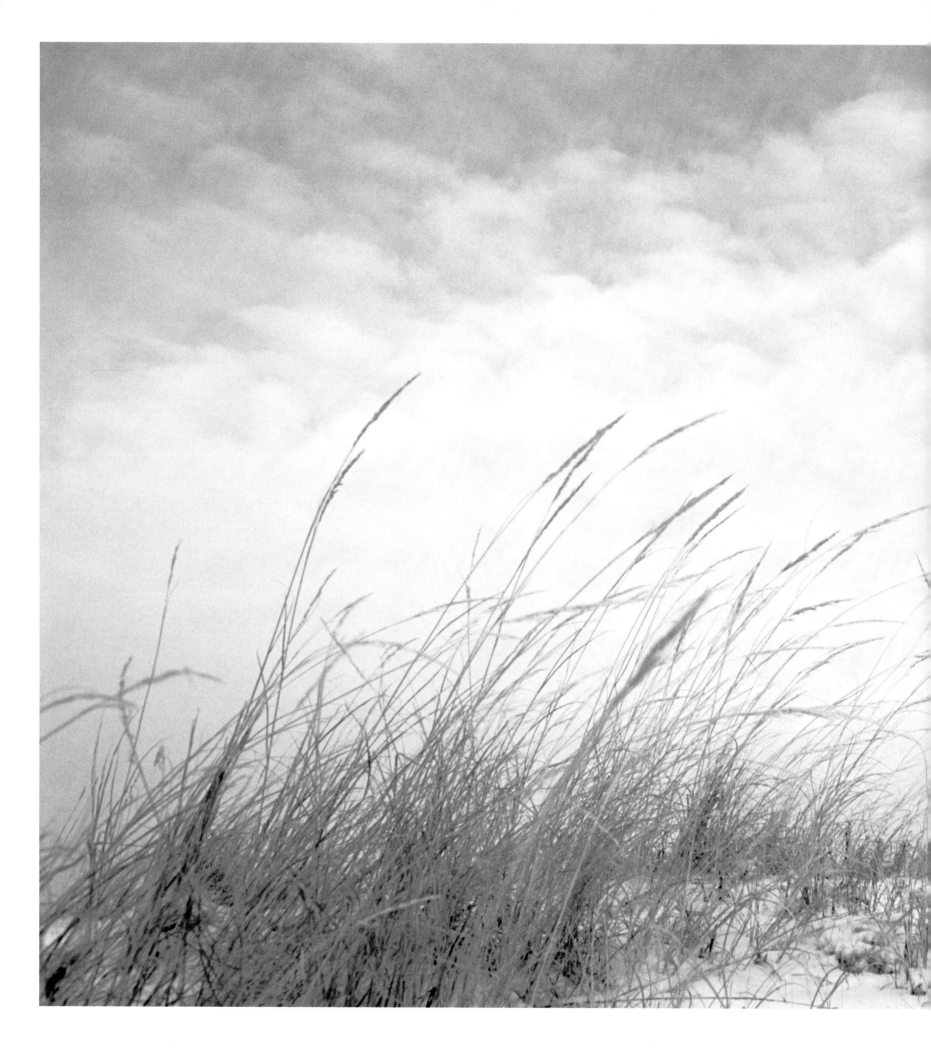

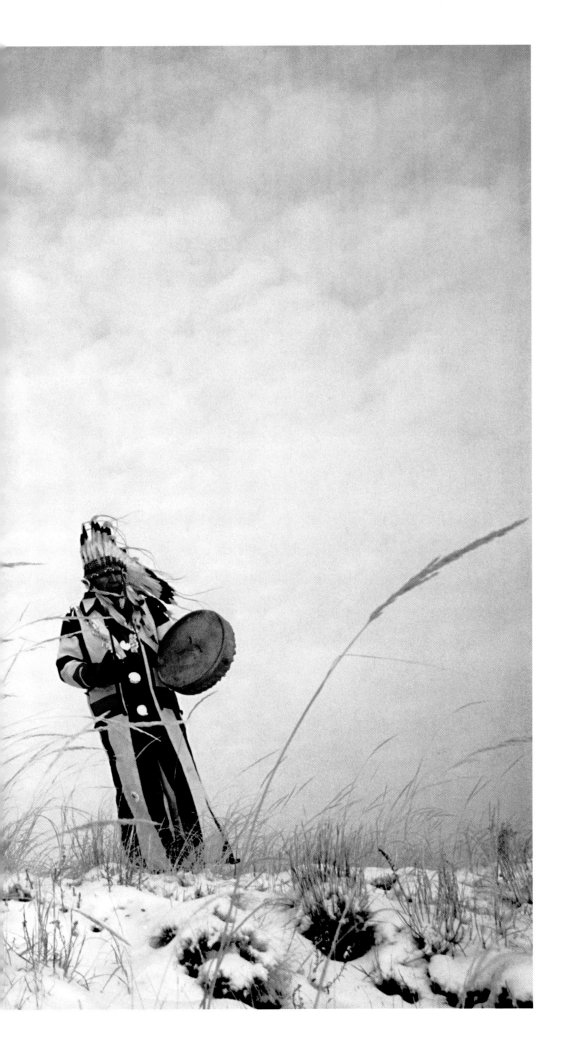

MAGGIE STEBER

South Dakota | 2004

"I have always had this wrangling in my mind whether Earth is heaven or hell or both," says Maggie Steber, who photographed this Indian chief on the Cheyenne River Reservation. He takes his children each day into the landscape, where they pray and pay their respect to the beauty of the land they live in. Steber, at times, felt the same inexplicable connection to the land he did, what she describes as a silent thunder roaring inside of you. "To look at what we have done to heaven is startling. We have choices to make every day, good choices and bad choices. Those are the choices between heaven and hell."

MICHAEL KENNA
Hokkaido, Japan | 2002

For years Michael Kenna has photographed Japan. "Hokkaido was always stark to me," says Kenna, who started to spend more time there when the landscapes began to look like two-dimensional pen-and-ink drawings to him. "There are towns and cities and traffic lights in places, yes," he says, "but the simplicity is what appeals to me. To be alone in the silence with only the sound of your heartbeat and the snow falling … it's wonderful."

next page left,
Huangshan Mountains, Study 1, Anhui, China, 2008

next page right,
Sunflowers, Sanai, Hokkaido, Japan, 2004

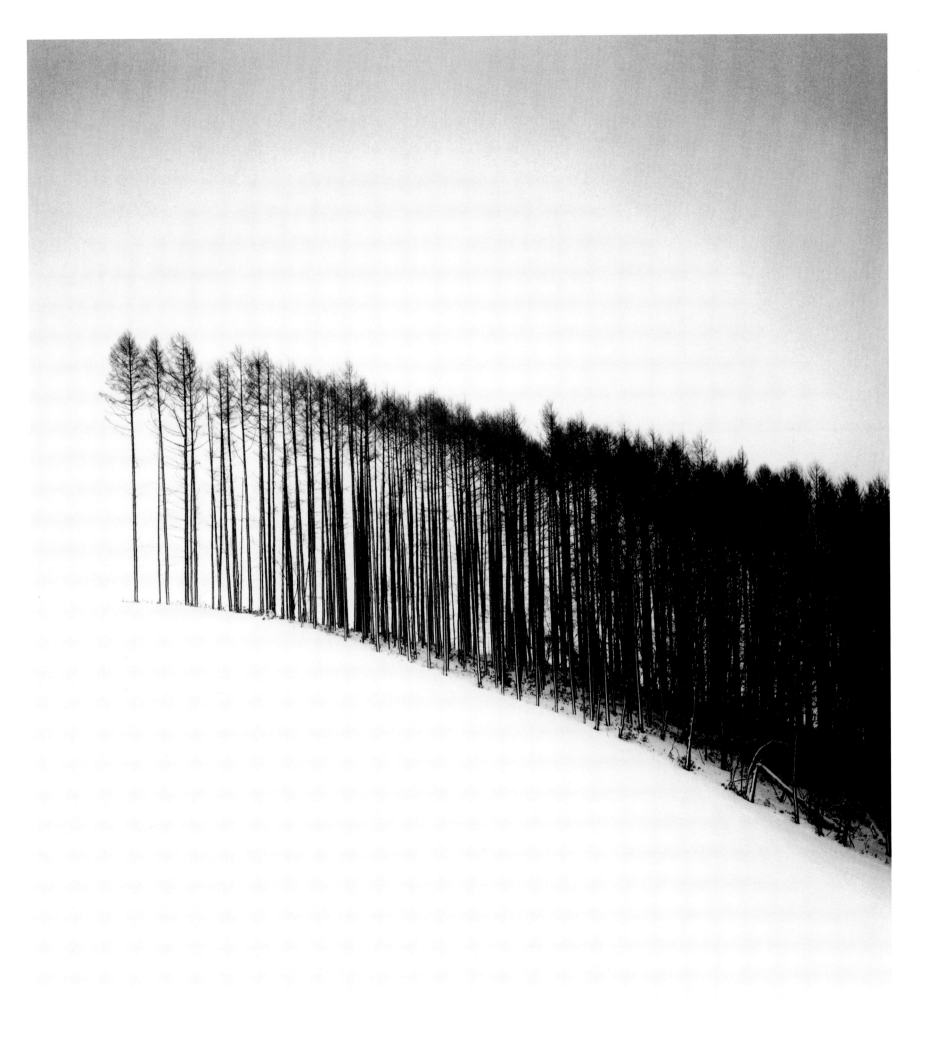

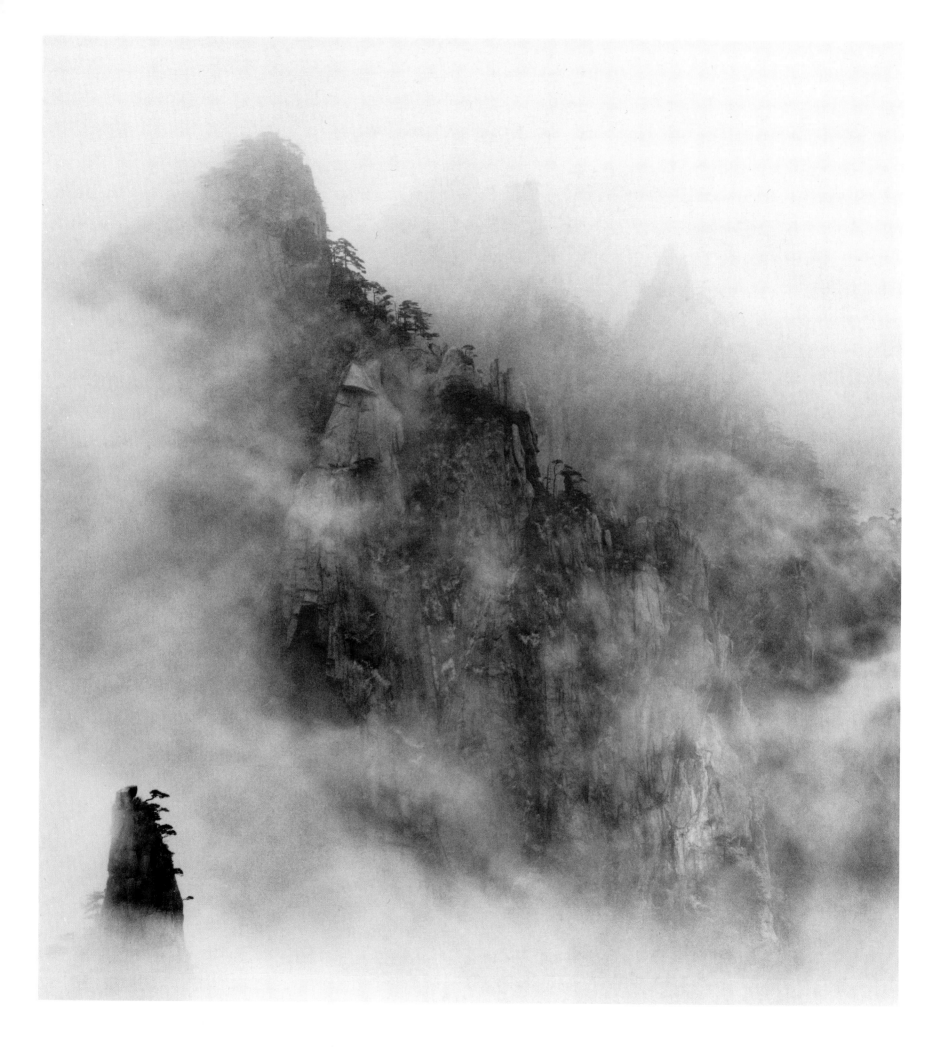

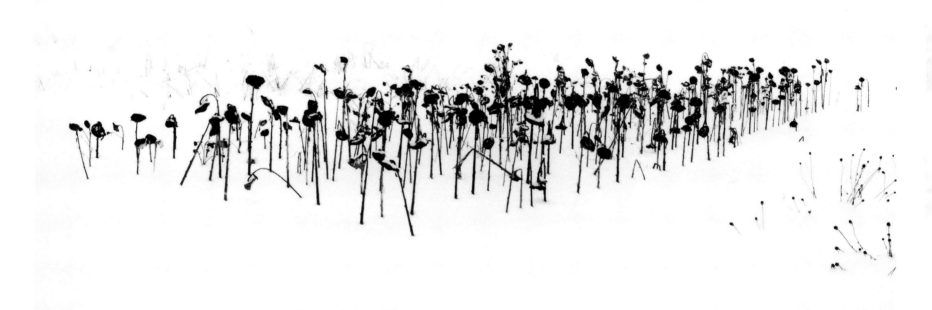

STEVE WINTER

Kashmir | 2007

While tracking the elusive and beautiful snow leopard among the mountains of Tibet, Kashmir, and India for four months, Steve Winter grew to love the enormity of the places he trekked. "To find areas totally untouched by man is hard to do these days," says Winter. "The higher you go up the mountains, the more you understand that nature has the foothold, not man."

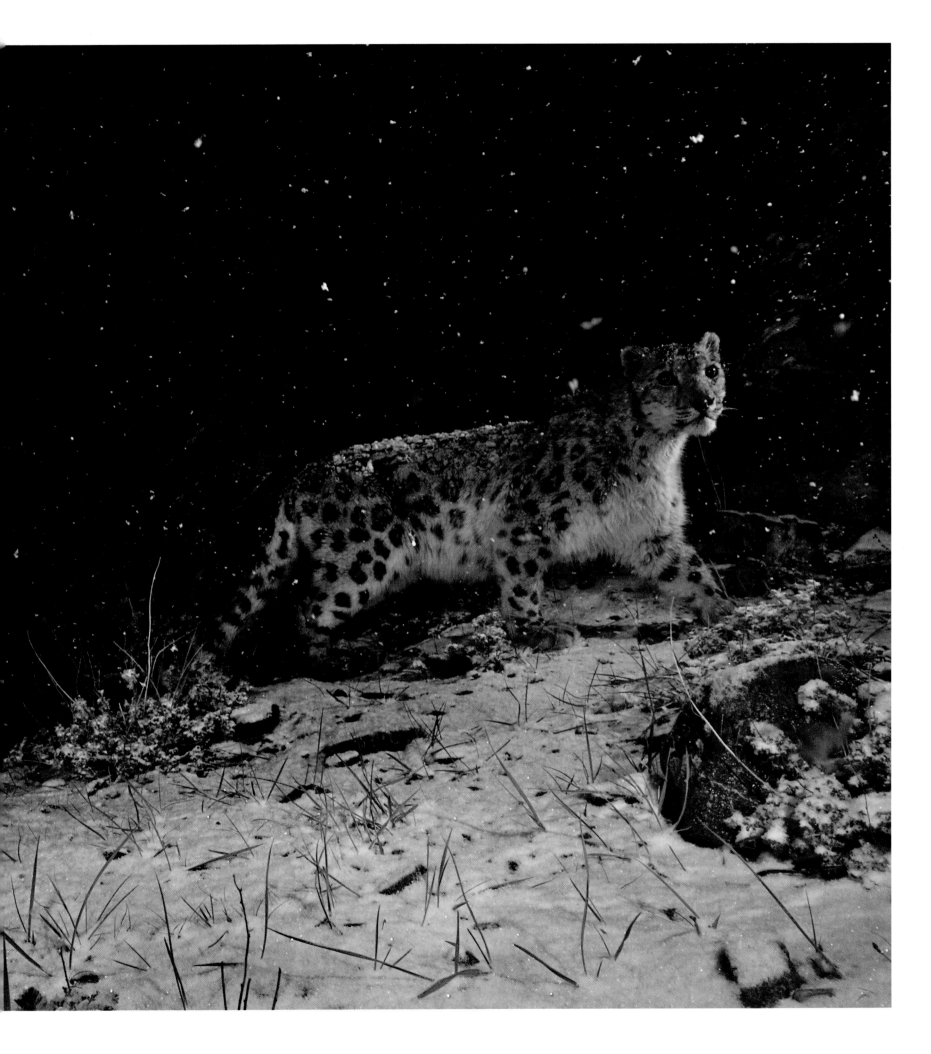

NINA BERMAN
North Dakota | 2008

It was February, and the temperature was minus double digits on the Fahrenheit scale. "That it's Fargo doesn't matter, and to me that's why it's paradise. I love it when I encounter a space that transports me beyond the physical place, especially if it's a seemingly ordinary landscape, and carries me to a psychological space, a literary space, so that standing in the middle of the road I felt for a moment elevated into a fictional universe, where I was a traveler at the end of a journey, or a character in a Beckett play, or some crazy sci-fi dream, with nothing before me and nothing behind me, only the abstracted, unmapped beyond, beckoning me in color and sunshine. I took two frames, and the paradise was lost. The winds whipped up as they had all morning, and everything disappeared into an impenetrable white cloud of fog and snow."

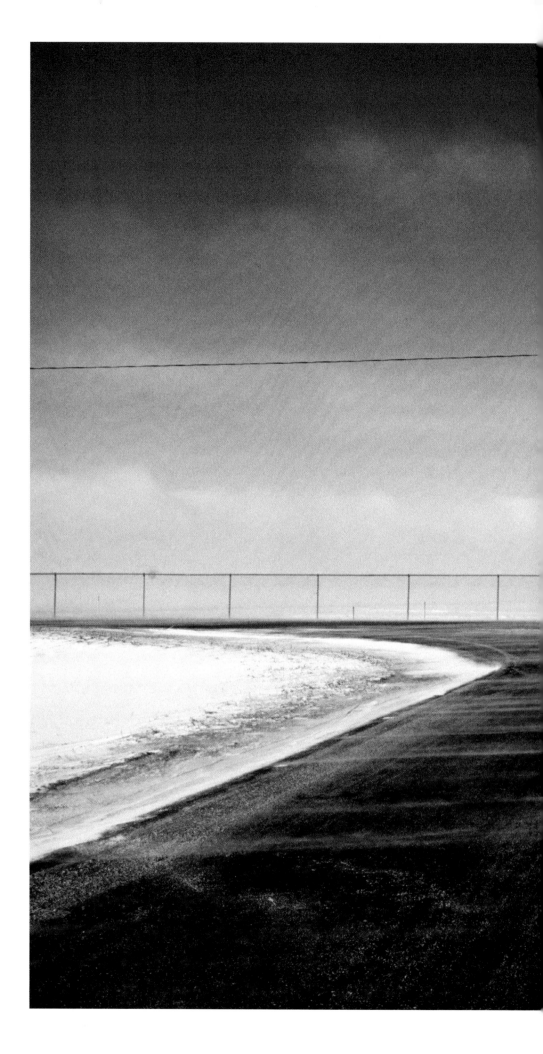

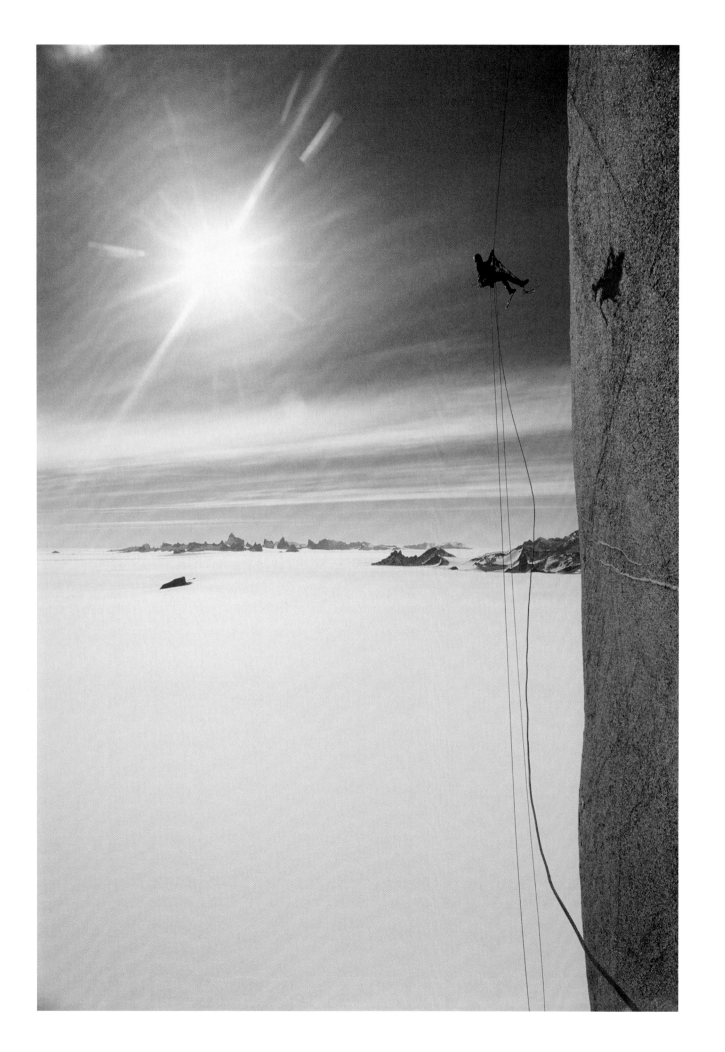

GORDON WILTSIE

Queen Maud Land | 1996

To get to Queen Maud Land in Antarctica, Wiltsie first needed to dream and plan. "I have never been to a place that pristine," says Wiltsie. By "pristine" Wiltsie means no airports, no trains, no roads. For ten years he and an expedition team had to plan their approach, their descent, and their ascent up Rakekniven, fondly known as "the Razor" among climbers. The ascent was 2,000 feet up on the sheer face of unmapped territory and a dream come true.

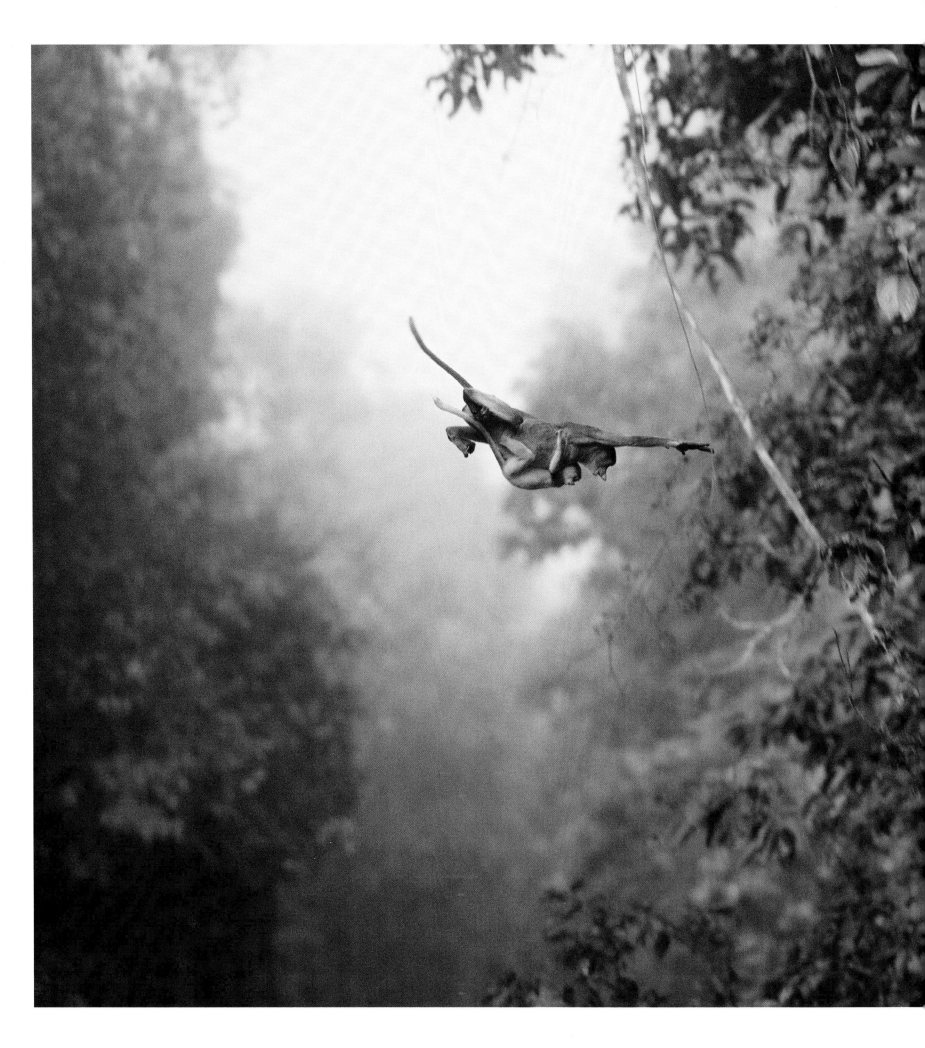

TIM LAMAN

Borneo, Indonesia | 1997

During 1987, photographer Tim Laman lived in the Gunung Palung National Park. Trained as a field biologist, Laman decided to use his photographic skills to tell stories about endangered wildlife and habitats. He first saw the rhinoceros hornbills (next page) soaring above the treetops of the rainforest then, but he never caught them on film.

Ten years later, Laman returned, this time to do a story on the deforestation of Borneo. The tropical timber was disappearing at an alarming rate, fueling the world's desire for wooden furniture, paper pulp, and other manmade goods. The national park, once surrounded by forest, was now surrounded by oil palm plantations and cleared land. The orangutans did not know they were living in one of the last four protected places for them on Earth.

This time Laman photographed the hornbills looking over the rainforest as he had seen them during the two years he lived there. "This place is so special to me," he says.

next pages: Tim Laman

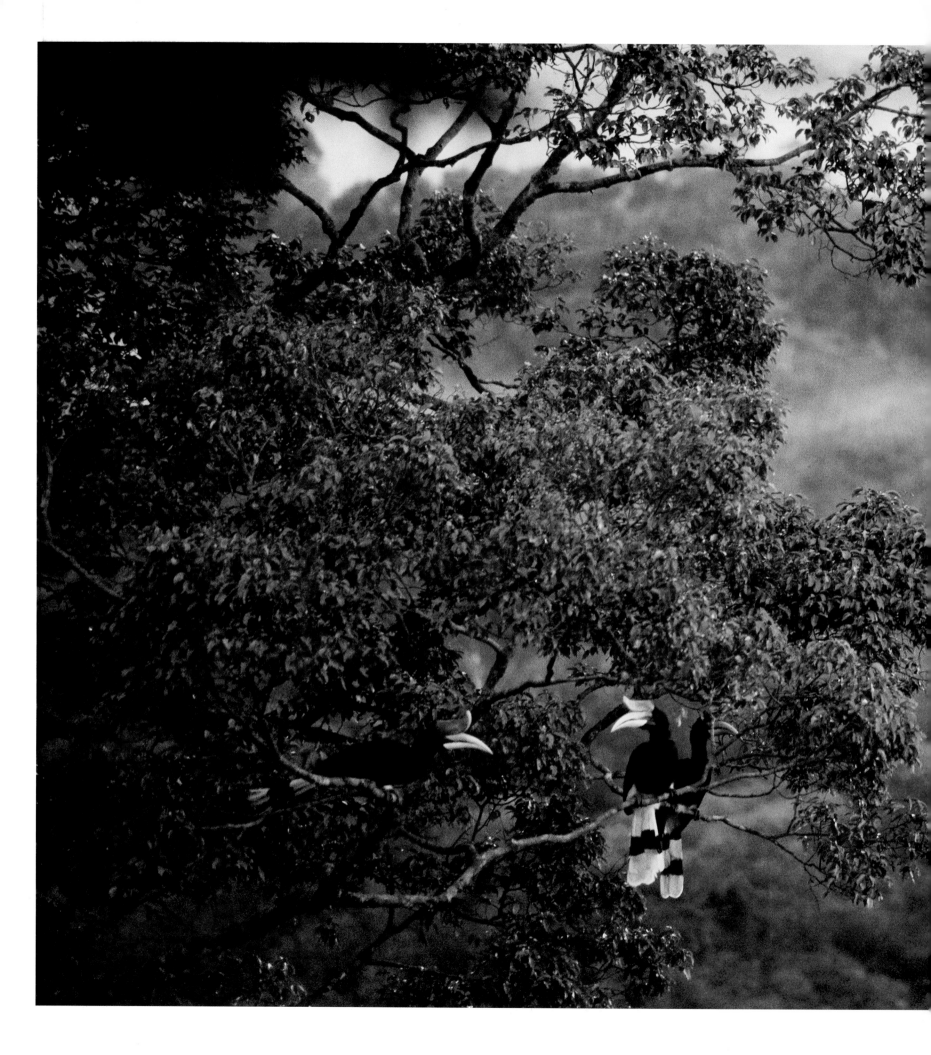

JIM RICHARDSON
Wales | 2005

As a descendant of Celtic ancestors, Jim Richardson feels a strong personal connection to the people and the distant terrains of Ireland, Scotland, and Wales. "Because they lived in these isolated areas, they had to come to grips with these wild places and because of that, they came up with an interesting world view. Ireland, for instance, is not the most wealthy place in the world, but the people live life with relish, and that is magnetic."

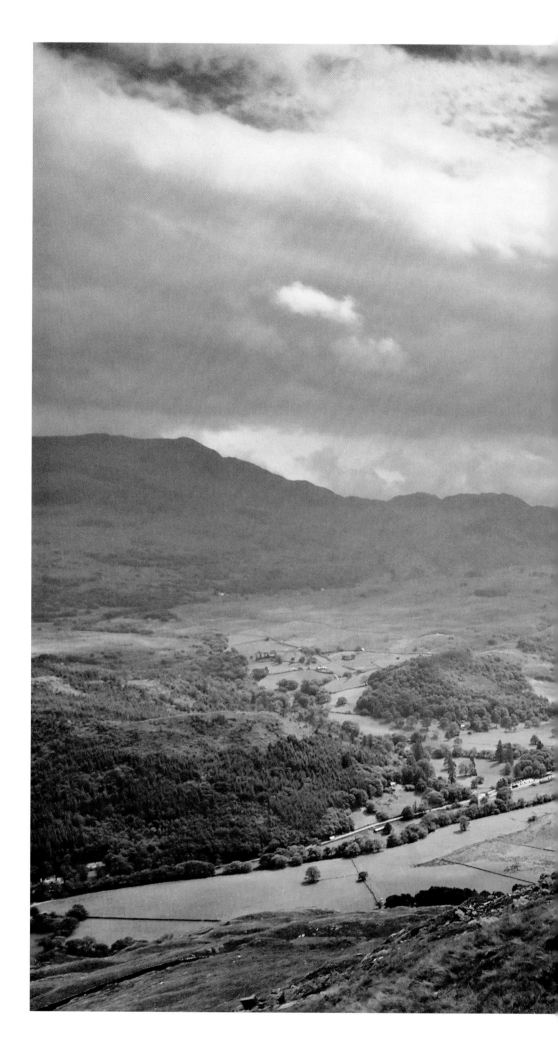

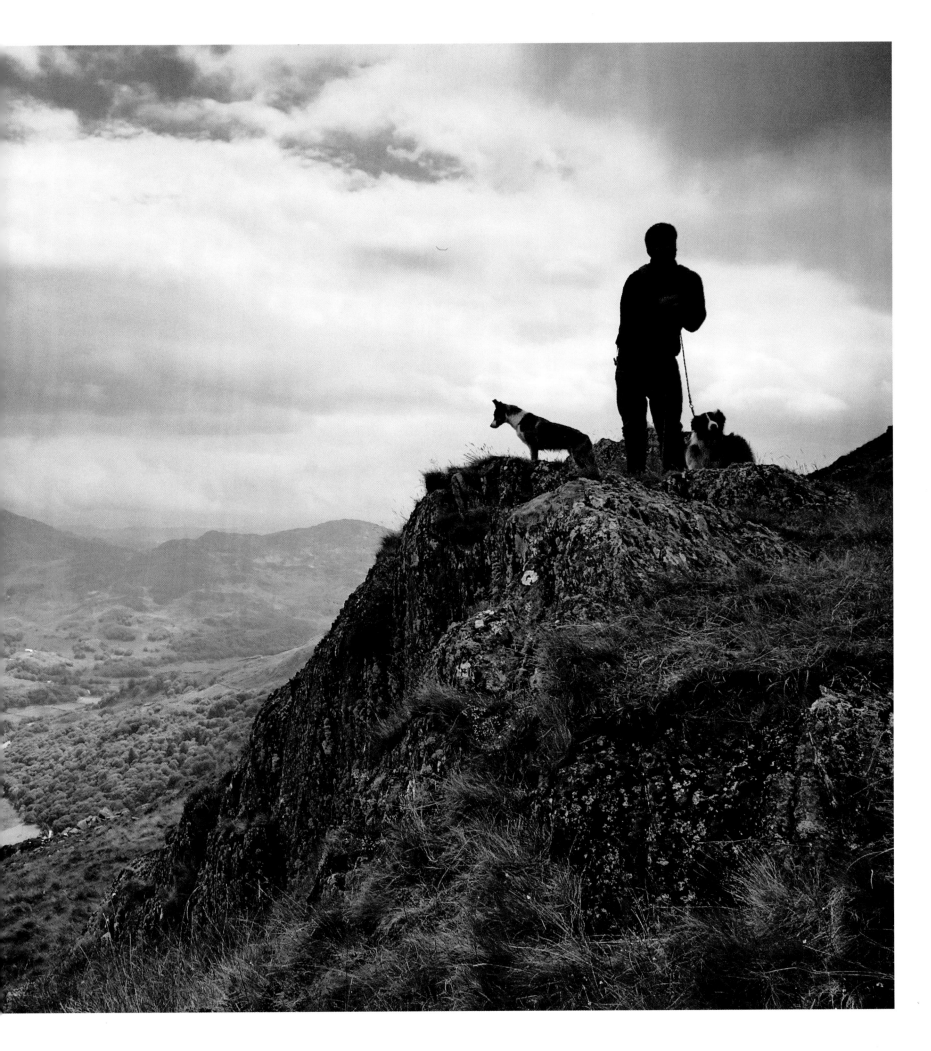

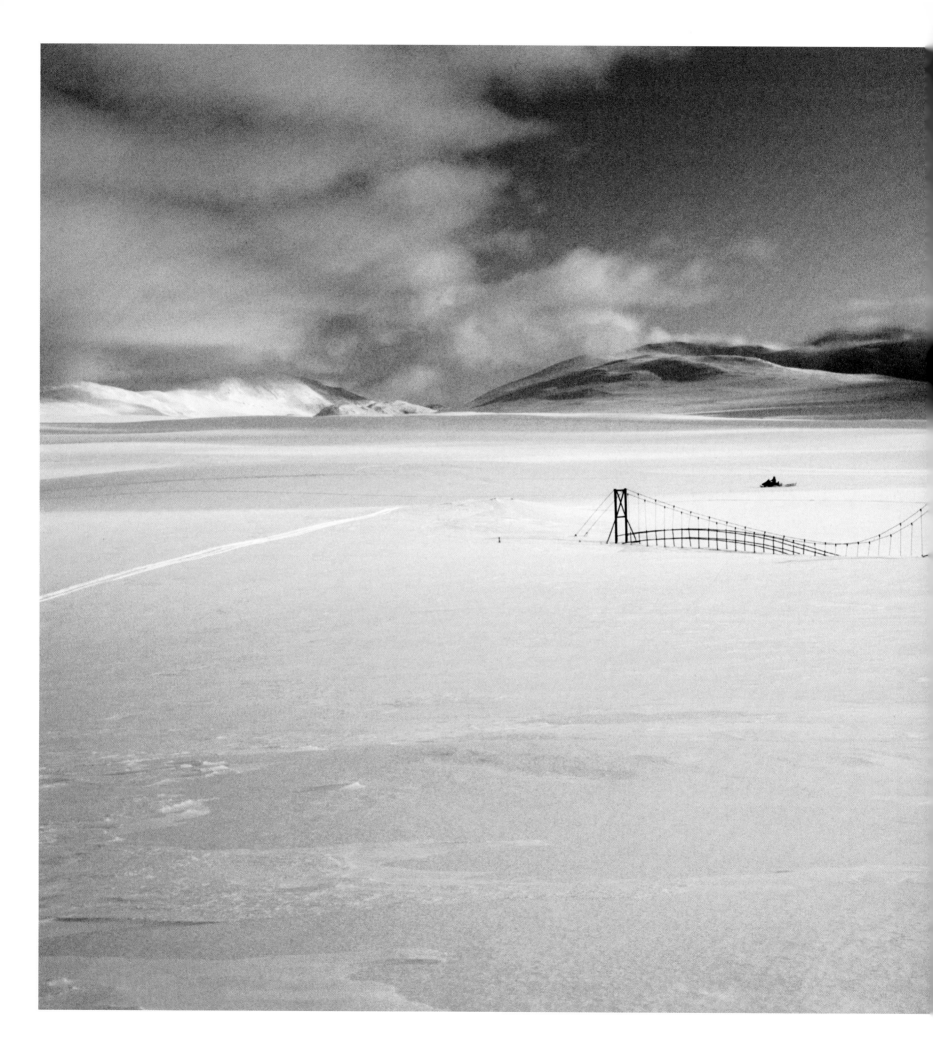

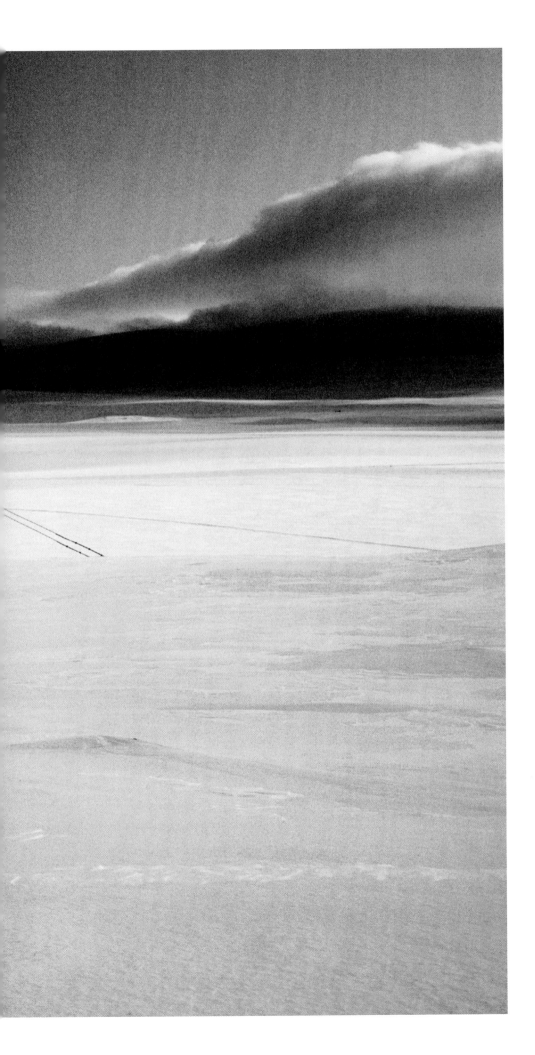

TOMASZ TOMASZEWSKI
Sweden | 1992

A snow-covered footbridge lies north of the
Arctic Circle.

SAM ABELL

Newfoundland | 1970

My favorite place is the first place I saw as a National Geographic photographer. Cape St. Mary's is a bird sanctuary on the southern tip of Newfoundland's Avalon Peninsula. The year was 1970, and the area at that time was undeveloped and deserted. You parked your car in a foggy field and walked to the edge of a cliff. And there below and all around was the entire pageant of life on Earth, or so it seemed. A massive column of the coast was standing in the surf. It was covered with nesting gannets. Still more thousands of gannets were mulling in the sky above the crashing surf. It was the most life-filled scene of my life and, I thought, a promise of many more scenes like it to come. But in the years and decades that followed I never saw such a sight again.

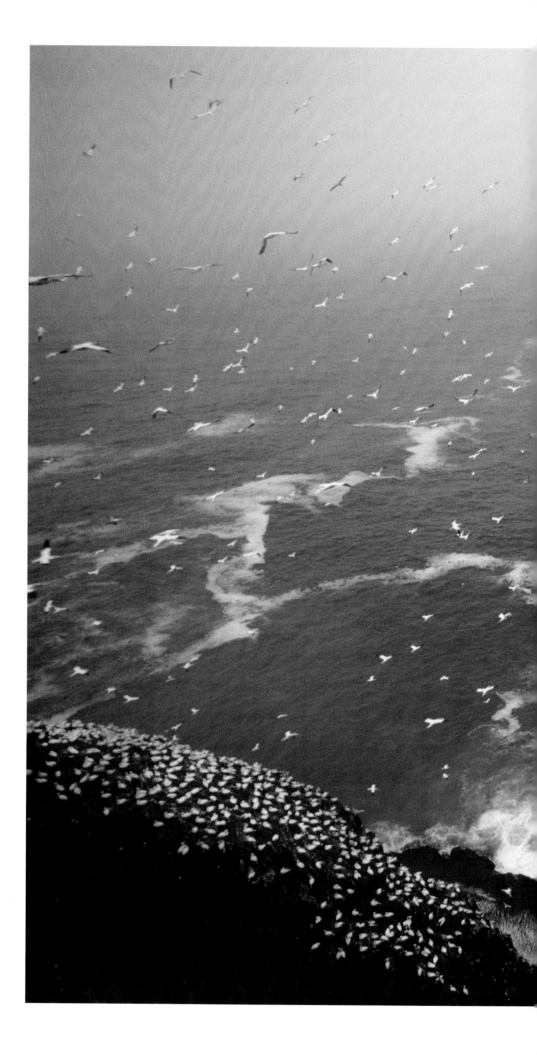

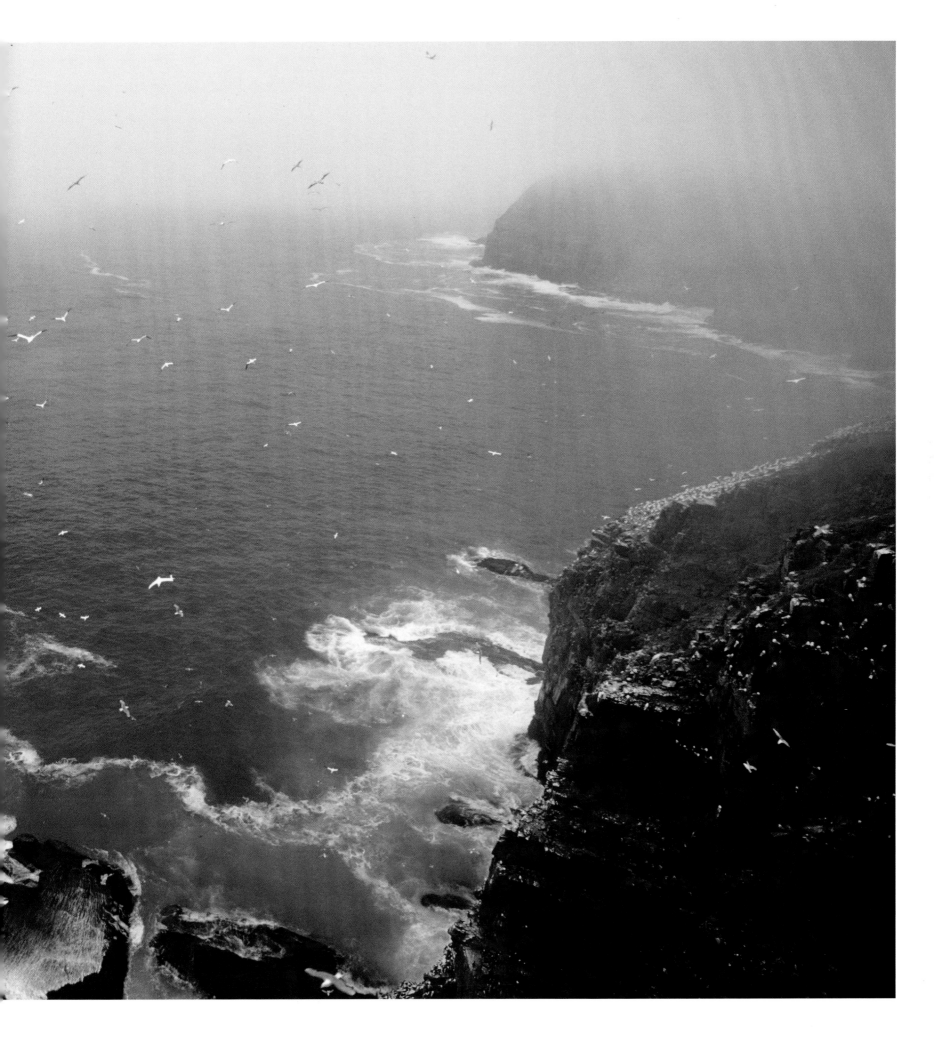

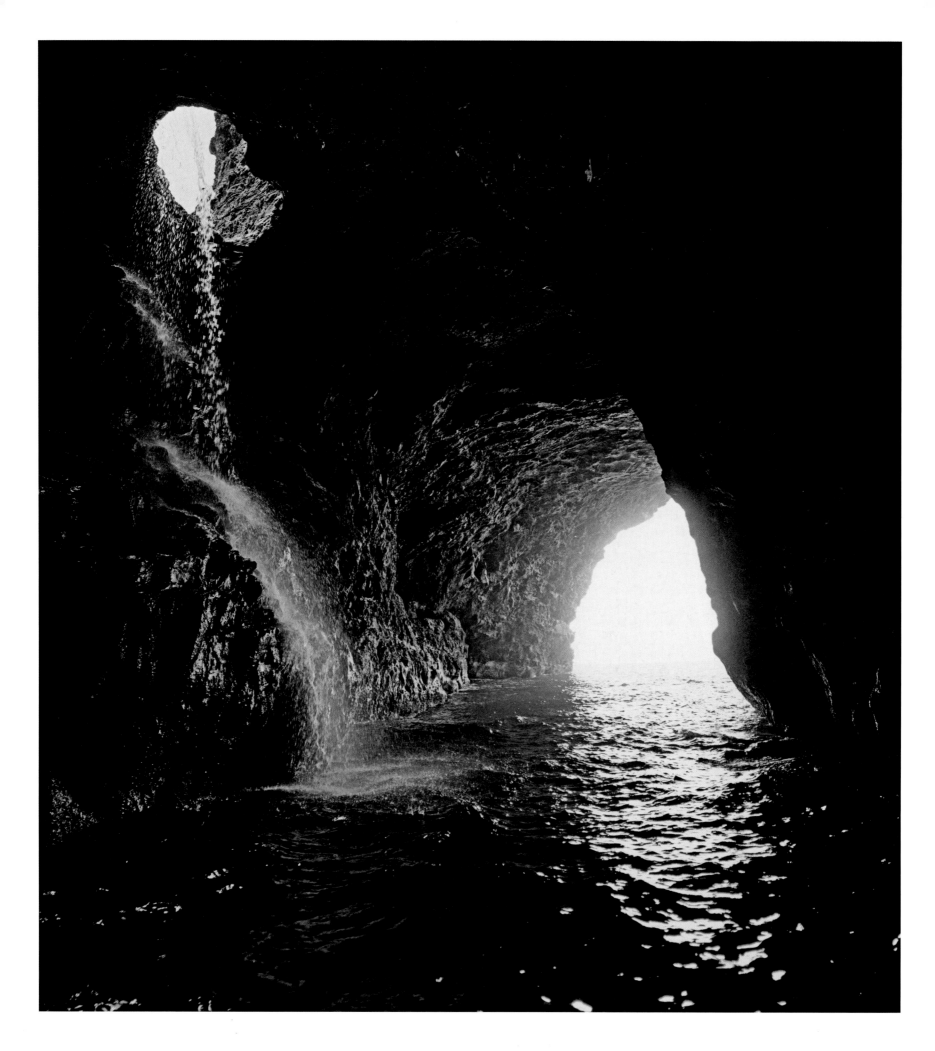

DIANE COOK / LEN JENSHEL
Hawaii | 2007

The Na Pali Coast is a 15-mile stretch of pristine land, beaches, cliffs, and caves once dubbed "Shangri-la" by *National Geographic* magazine in 1960. For Diane Cook and Len Jenshel, who first visited in 1990, nature still triumphs here. "It's a living piece of sculpture," says Cook, who marvels at the way the winds and waves have shaped the hillsides. "Humankind can't break in there. They can't build a road through there. They have tried!"

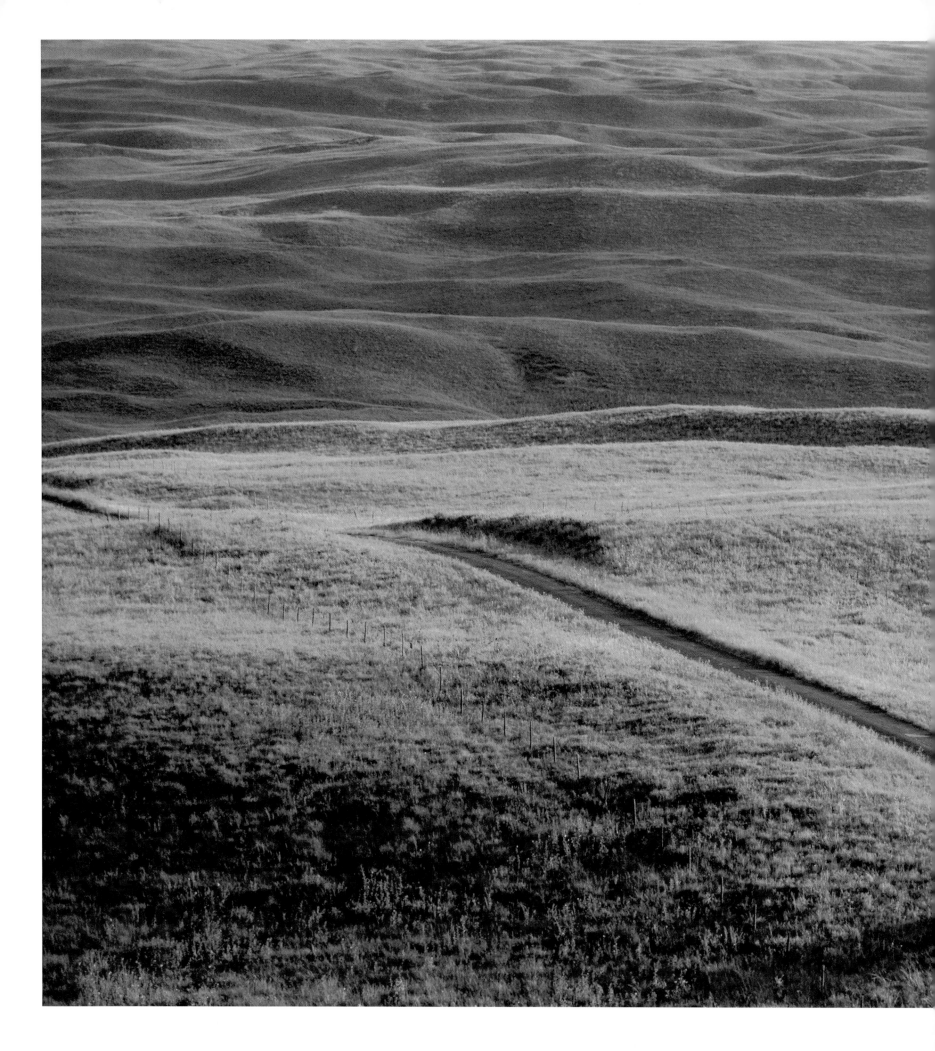

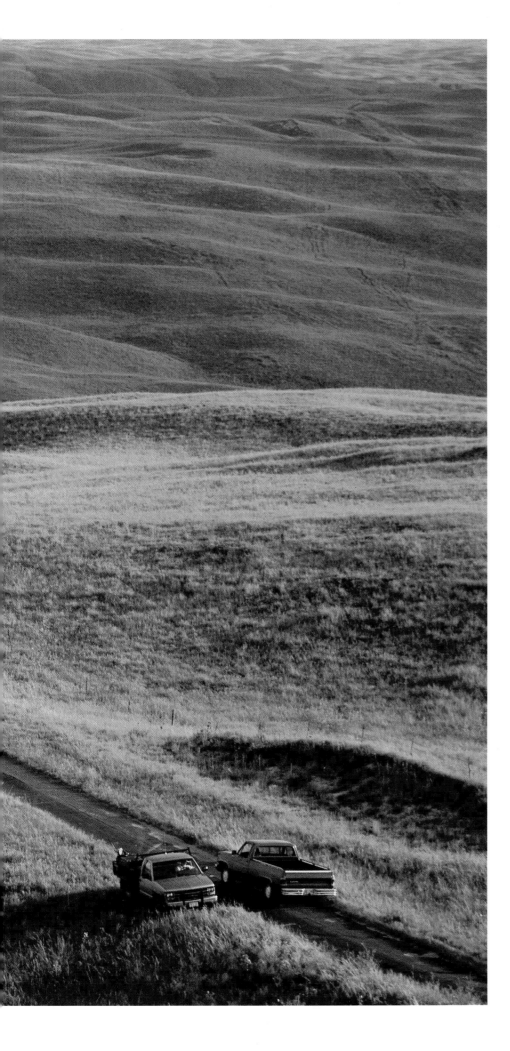

JOEL SARTORE
Nebraska | 1996

People often ask me what's my favorite place to shoot, and every time I tell them the Nebraska Sandhills. Geographically it's simply the world's largest grass-covered dune field, but it's much more than that. The people are friendly, helping out neighbors and strangers alike. Wildlife abounds, from grassland birds to swift fox. Approaching storms both threaten and excite. The whole place is the real thing.

In a world where every square inch seems to be filling up with people and their accompanying messes, the Sandhills haven't changed much. Sparsely populated and clean, this area is one of the last intact prairie ecosystems on Earth. And because there's very little topsoil, this area is extremely fragile. Any wounds to the land are evident for years. The people out there know that and live accordingly. They have been good stewards. "Pristine and well-cared for" are the words that first come to mind.

The result: an enormous amount of space that's bright, fresh, and wide open. In a weary and tattered world, this is where I go to clean up.

CHRISTIAN ZIEGLER

Brunei | 2007

"I had gone to do a story about a national park in Borneo," explains Christian Ziegler. "I thought I would find the vista I had always thought of as paradise there, but a lot of it is gone now. You see land without timber and oil palm plantations, parks that are little islands within the devastation. I was so depressed by that."

So Ziegler made a side trip to the island of Brunei. There, 150 feet up the mountain, he found the vista he thought he would find in Borneo. "This was my fantasy. Emotionally, it was my Borneo," Ziegler recalls. "I saw hornbills flying from ridge to ridge. I heard gibbons singing. It's a funky little country."

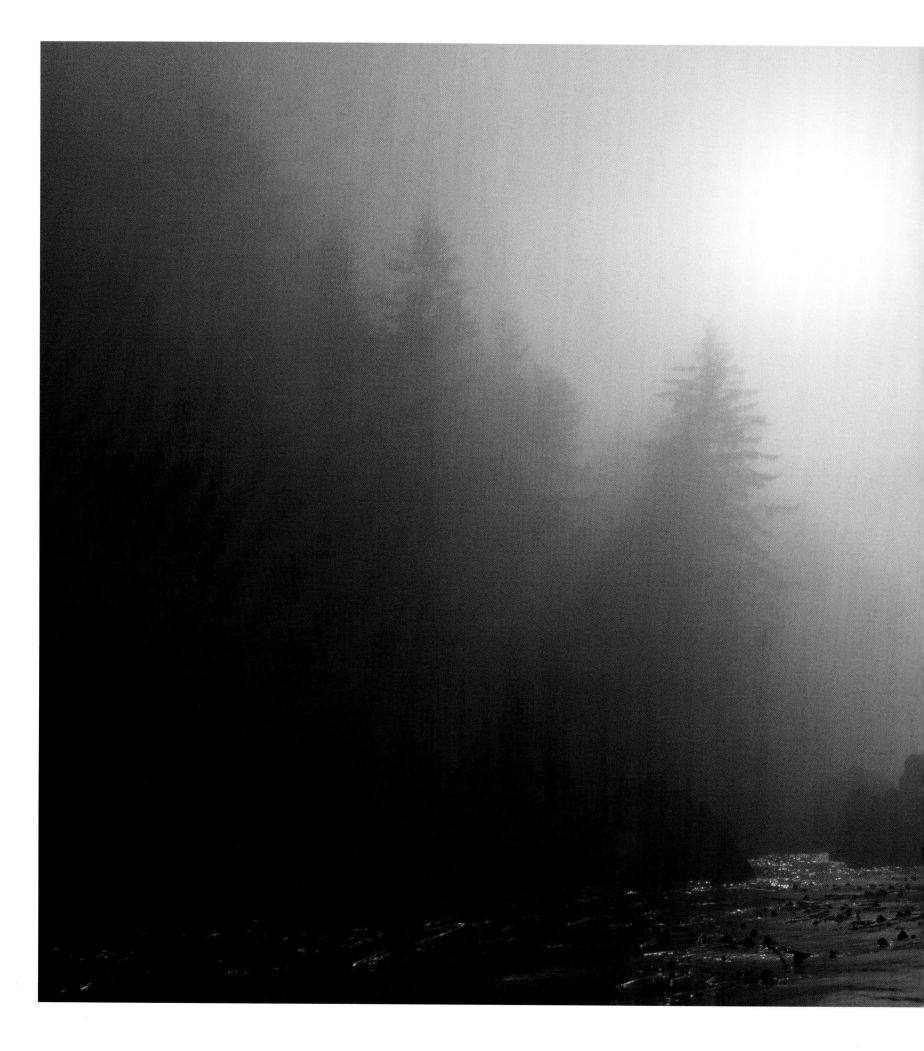

RAYMOND GEHMAN

Queen Charlotte Islands | 1994

A naturalist at heart, Raymond Gehman thinks of Canada when he thinks of paradise. For four weeks he traveled through the Queen Charlotte Islands while photographing Canada's national parks. "Everywhere I looked I saw images. The place was so rich in everything—the life, the water, the forest, the light, the people. It was so teeming with life, you could almost see things grow."

SAM ABELL

Japan | 1999

Manicured hedges define the peaceful Imperial Gardens in Tokyo.

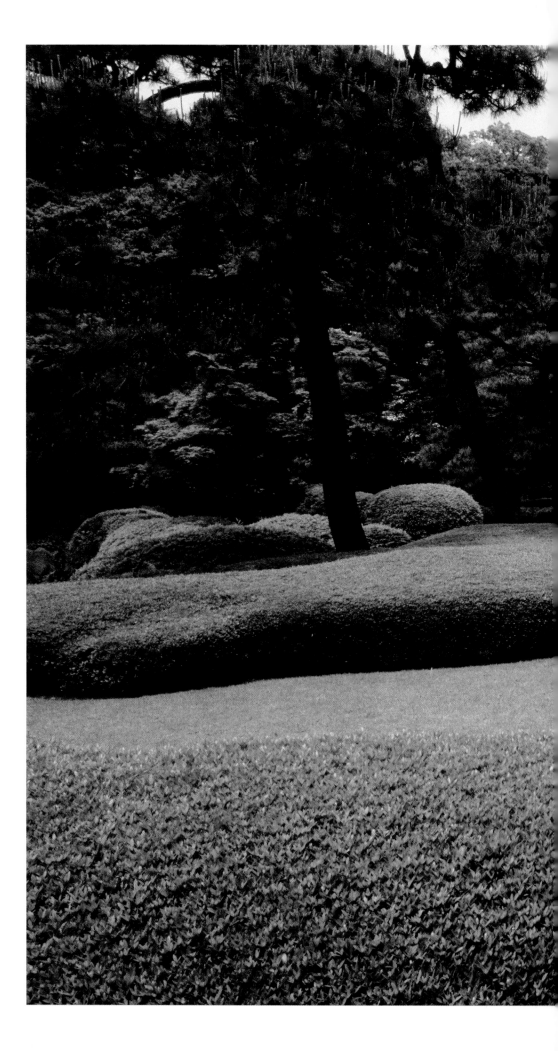

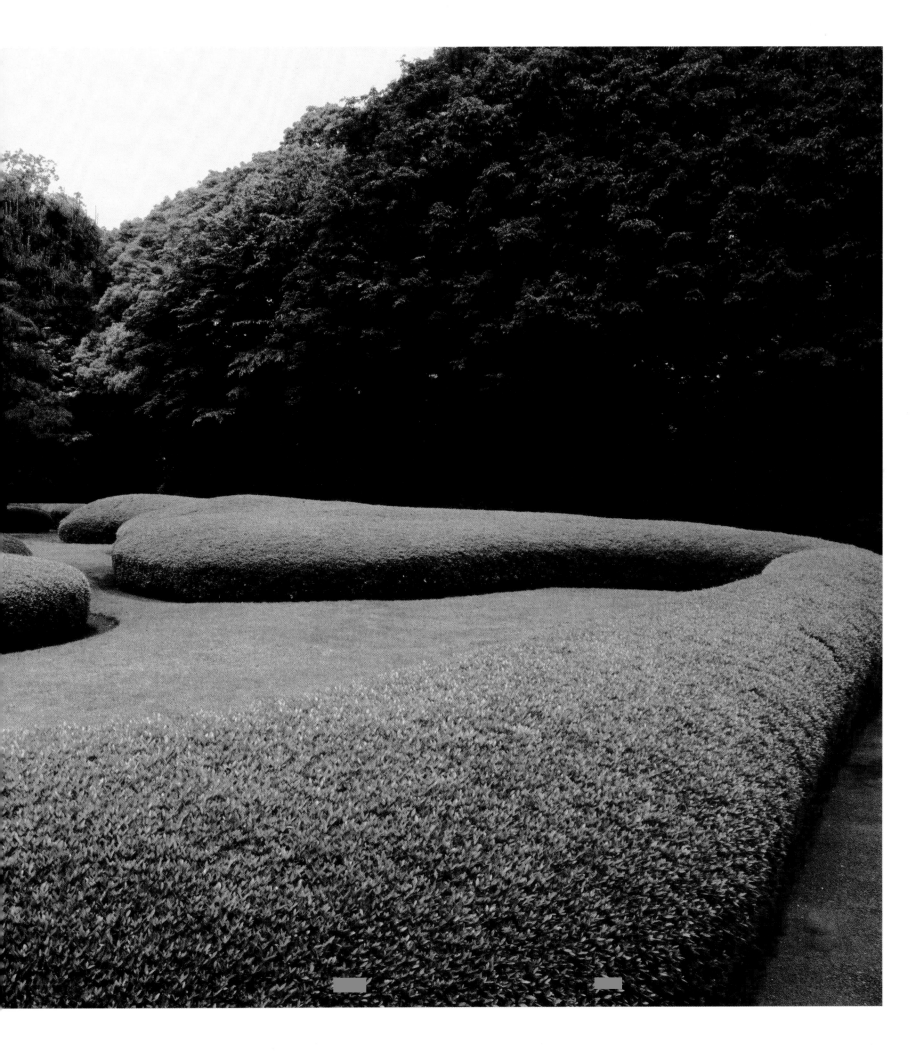

BOBBY MODEL

Libya | 2004

A Tuareg tribesman prays at twilight.

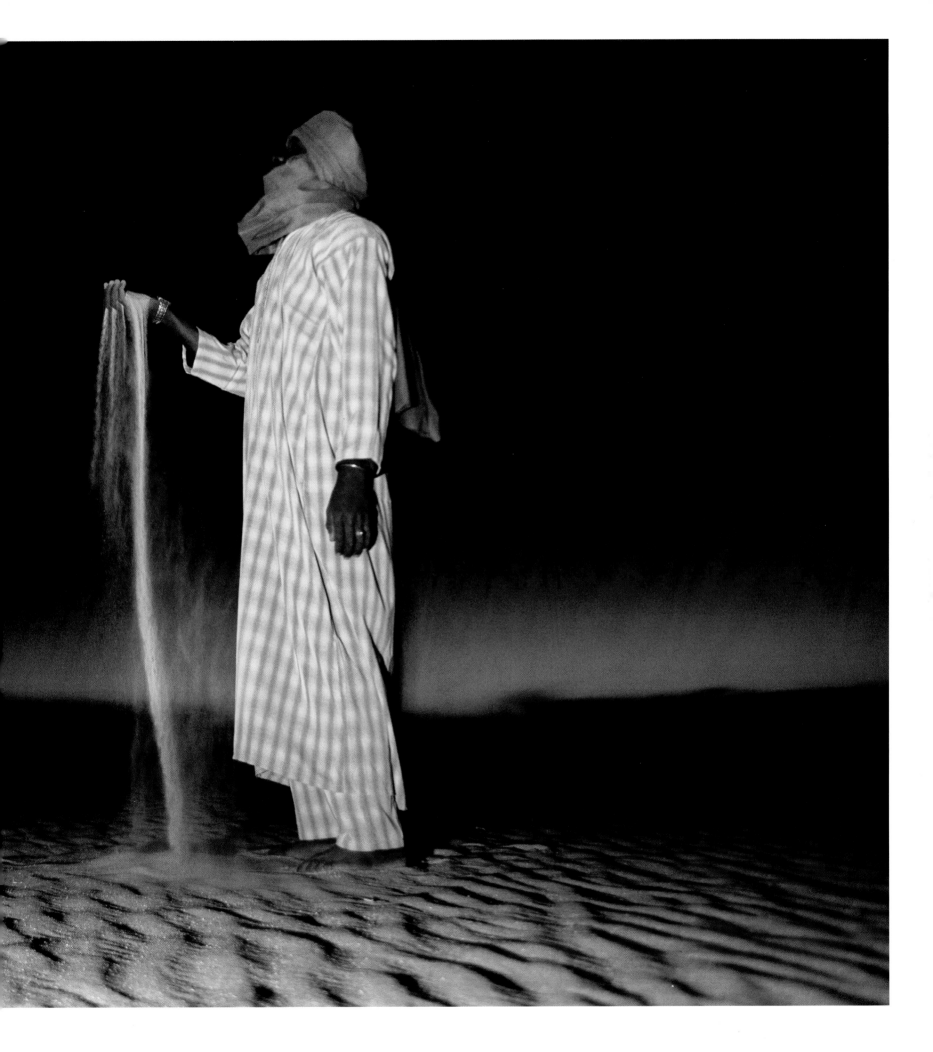

WATER

Joel K. Bourne, Jr.

OUR WATERY WORLD

It was a goat trail, really—a narrow reddish-yellow path that climbed along the crumbling cliff face. On my left, the shoulder of the five-million-year-old volcano that became Kauai reached toward a cloudless sky; on my right 800 feet below, the Pacific Ocean stretched out its sparkly blue-green endlessness for as far as the eye could see. I welcomed a passing afternoon shower on my hike, gulping down some drops, totally oblivious to the great water cycle revolving all around me. I could not see the torrent of water vapor lifting from ocean to sky, nor did I think much about the cloudburst that returned it as fresh water to the thirsty island, where it fed streams and underground aquifers before completing the round-trip to the sea. No. I was too mesmerized by the vision of paradise before me, bedazzled by that infinite blue realm.

And that's the problem. We are water. Sixty percent of our bodies, 70 percent of our planet, are simply H_2O. Water fuels our fields, our industries, and the intricate transfer of information between our cells. It is such an elemental requirement for even the simplest of life's forms that we've spent billions of dollars looking for it in the dusty corners of our solar system, in hopes, of discovering that we are not alone out here. Our planet is so awash in the stuff it's more aquasphere than earth. So we take it for granted.

Now, however, with human population pushing seven billion and the demand for H_2O never greater, we are tweaking the great water cycle that sustains us in ways we once couldn't have imagined. Increasingly water is becoming problematic at every arc of its cycle. It's now such a source of tension that a billboard posted outside the Fourth World Water Forum in Mexico in 2006 declared: "The Next World War Will Be Fought Over Water."

Dr. Peter Gleick, who has been studying water issues for more than two decades at the Pacific Institute in Oakland, California, thinks that's stretching it a bit. Besides, we've been fighting over water, he notes, since Hammurapi's time of 1790 B.C. But he admits there is a growing risk of violence over water allocations on a regional scale. "The biggest single water problem we have is our failure to meet basic human needs for human consumption and sanitation," Gleick says, an amount he estimates at 13 gallons per person per day. "More than a billion people don't have access to safe and affordable water, and that leads to water-related diseases such as cholera, dysentery, and guinea worm that kill two million people a year, mostly children under the age of five. It's completely preventable, but we've completely failed to prevent it."

It's not that we're running out of water. Of all the water on Earth, only three percent is fresh water and only a tenth of that is available in lakes, rivers, and underground aquifers. The rest is frozen in the world's ice caps and glaciers. Rainfall exceeds evaporation on the continents by around 1,553,845,329 cubic feet a year—or about 4,000 gallons per person per day, more than enough to slake the thirst of the world. The problem is distribution. Some parts of the world get buckets, others get virtually none, and many get all their rain during a narrow wet season, while the rest of the year is dry. Others get water through melting snow pack or glaciers that feed rivers during the dry season. "There is a water crisis

today, but the crisis is not about having too little water to satisfy our needs," according to the World Water Council, an international organization of water experts. "It's a crisis of managing water so badly that billions of people and the environment suffer."

Managing the world's water supplies is getting trickier. Since 1958, researchers at the Mauna Loa Observatory have measured rising carbon dioxide levels in the atmosphere, largely due to the burning of fossil fuels. The rise in carbon dioxide, a potent greenhouse gas, is mirrored by steadily rising global average temperatures. As the atmosphere warms, it absorbs more moisture, changing rainfall patterns around the globe. As seas warm, they expand, raising sea levels and affecting the great ocean currents that drive weather phenomena like El Niño and La Niña. "You can't change climate without changing water," says Gleick, "and we've been managing water without realizing that climate is the key."

The effects of climate change on the world's freshwater resources have already begun. A warmer atmosphere holds more moisture and more heat energy, increasing the potential for storms and heavier rains, but also increasing evaporation. As a result wet areas are getting wetter, while arid regions are getting drier. Areas that once received much of their precipitation as snow are getting rained on instead, and often the rain seems biblical in proportion. Last year in Bihar, India, it rained for 20 days straight, dumping nearly three feet of water. Floods throughout South Asia displaced some 40 million people. Moreover, the melting of mountain glaciers and reduction in snow pack worldwide is causing major

water stress in regions that depend on meltwater during their dry season, as in many parts of Latin America and Asia.

The reduction of snow pack is even threatening the affluent cities of the U.S. Southwest, which remain locked in the grip of a decade-long drought. Researchers at the Scripps Institute of Oceanography have conservatively estimated that Lake Mead—the giant reservoir that forms the safety net for cities dependent on the snow-fed Colorado River—could run dry by 2021 if current trends in consumption and climate change-reduced runoff continue, potentially cutting off the taps of some 36 million people in San Diego, Los Angeles, Phoenix, and Las Vegas, among others.

Oddly enough, ice is even melting at the Arctic and the Antarctic, parts of which have warmed at more than double the rate of the rest of globe. The loss of summer sea ice in the Arctic, which shrank by nearly half a million square miles last summer from its previous minimum in 2005, is playing havoc with polar bears that depend on it to hunt, rest, and travel. Scientists say the bear may be extinct by the end of the century. Despite that gloomy prediction—and possible protection of the bears under the Endangered Species Act—the loss of Arctic ice has spurred the U.S., Canada, Norway, and Russia to explore newly ice-free areas of the bear's Arctic Ocean home for future oil exploration, even though the burning of oil is a major cause of climate change.

At the Antarctic Peninsula, which has experienced the highest rate of warming in the world, 2° to 4°F above average, ice shelves

continue to crack off. In March 2008, scientists at the National Snow and Ice Data Center at the University of Colorado reported that more than 5,000 square miles of the Wilkins Ice Shelf have begun to disintegrate, an area nearly twice the size of Rhode Island.

Sea level rise—like rising carbon dioxide levels in the atmosphere—is one of the clearest signs of climate change. Seas rose about 400 feet after the last ice age ended some 21,000 years ago, stabilizing around 2,000 to 3,000 years ago just as human civilization was cranking up and allowing cities to grow along the coasts. But as the seas began to warm and glaciers began to melt through the greenhouse effect, the oceans began a slow, inexorable expansion, rising about .039 inch per year since the early 20th century.

It doesn't sound like much … a little more than a foot by 2100 according to the latest estimate by the Intergovernmental Panel on Climate Change, the Nobel-prize winning group of the world's top Earth scientists. But there was a caveat to that estimate because no one knows how to quantify the dynamics of melting ice in Greenland and Antarctica, the world's two great frozen reservoirs that hold enough water to raise sea level by some 230 feet. The researchers who study Greenland's glaciers—now thought to be losing 150 to 200 billion tons of ice each year—put the figure at closer to three feet by the end of the century, enough to displace millions of people around the globe who live in low-lying places like Bangladesh, or island nations. The atoll nation of Tuvalu has already negotiated an evacuation pact with New Zealand should their islands submerge. Nor will prosperous countries be spared. Three feet of sea level rise will make life extremely difficult if not impossible in New Orleans, Houston, Miami, even London, Washington, D.C., and New York.

But climate change is changing the oceans in subtler ways as well. Atmospheric carbon dioxide mixes readily with the ocean water to produce carbonic acid. The acid depletes carbonate ions in seawater that are the building blocks of shellfish, crustaceans, and most importantly, coral reefs. "At some point calcium carbonate can't be sustained," says Bob Steneck, a professor at the University of Maine. "Given the trajectory we're on, reefs can't persist."

If acidification weren't worrisome enough, bleaching events, in which the sea gets so hot the corals expel the symbiotic algae they need to survive, are becoming commonplace. In 1997-1998 global bleaching events killed 16 percent of the world's corals. Such reefs have been dubbed the rainforests of the ocean, because they are the foundation of an entire aquatic ecosystem. Coral reef fisheries feed more than a billion people. Yet a recent report by the United Nations Environment Program estimated that more than 80 percent of the world's coral reefs could die within decades.

Reef fisheries aren't the only ones at risk. Most of the oceans' great fish stocks are in total collapse due to overfishing. Only ten percent of large predatory species like sharks, swordfish, and great bluefin tuna remain. And we are "fishing down the food web," catching smaller and less complex sea creatures as entire pelagic food webs collapse. As big table fish wane, jellyfish and algae are taking their place, spurred by an increasing number of low-oxygen "dead

zones" around the world fueled by nutrient-laden runoff from agriculture and coastal development. The annual dead zone in the Gulf of Mexico is now the size of New Jersey.

Dr. Daniel Pauly, director of the Fisheries Centre at the University of British Columbia, found that the world's total fish catch has been declining since the late 1980s. Think what you will about the concept of "Peak Oil," but with every commercial fishery exploited to the hilt, we are decidedly past the point of "Peak Fish." The real problem, says Pauly, isn't our appalling inability to manage our fisheries, but our perception of normality. "We can't conceive of an ocean in which top predators aren't missing or rare. We can't imagine what it was like to have oyster banks so large you couldn't navigate in the Chesapeake Bay that also kept the water clean. I call it "shifting baselines." We can't even conceive of that change because we can't imagine what it was like before. That is a big problem."

Despite these depressing trends, there are a few glimmers of light, and one of them lies 140 miles from my trail on Kauai. The recently established Papahānaumokuākea Marine National Monument is the largest protected area in the United States, covering nearly 140,000 square miles of Pacific Ocean, atolls, seamounts, and coral reefs in the Northwest Hawaiian Islands. Here lie the healthiest corals in U.S. waters. A recent study comparing fish biomass there to the heavily fished waters around the main Hawaiian Islands blew marine scientists away. "Around the main islands, two percent of the biomass was top predators, sharks, tuna, and other large fish," says Jane Lubchenco, a marine ecologist at Oregon State University.

"We think of that as normal. But if you look at the Northwest Hawaiian Islands, half of the biomass is top predators ... half. That's what it used to look like, and what it could look like again."

Such marine refuges, and their effects on surrounding waters, makes Lubchenco cautiously optimistic about the future. Australia recently declared a third of the Great Barrier Reef as a "no-take" zone, following New Zealand, and South Africa. The tiny Pacific island nation of Kiribati recently protected a swath of ocean, reefs, and atolls the size of California, the largest marine protected area in the world. Though less than .01 percent of the oceans are currently protected, Lubchenco believes such havens, along with efforts to reduce overfishing, wasted bycatch, and marine pollution, could turn the tide. "It sounds daunting," Lubchenco says, "but we have to do it sooner rather than later, before they are completely demolished."

From my trail in Kauai I watched a rainbow arcing from land to sea. I could not help thinking about the Hawaiian proverb, *Malama 'Aina,* which translates to "care for the land that sustains us." The early Hawaiians built irrigated taro fields and fish ponds and had strict fishing seasons governed by kapu—with violators put to death. I suspect there was no clear boundary in their minds between land and water. Each element was precious to them, necessary for life. It's time we did the same.

Joel K. Bourne, Jr., *a former senior editor of* National Geographic *magazine, has reported on water issues for the past two decades. He and his family live on the coast of North Carolina.*

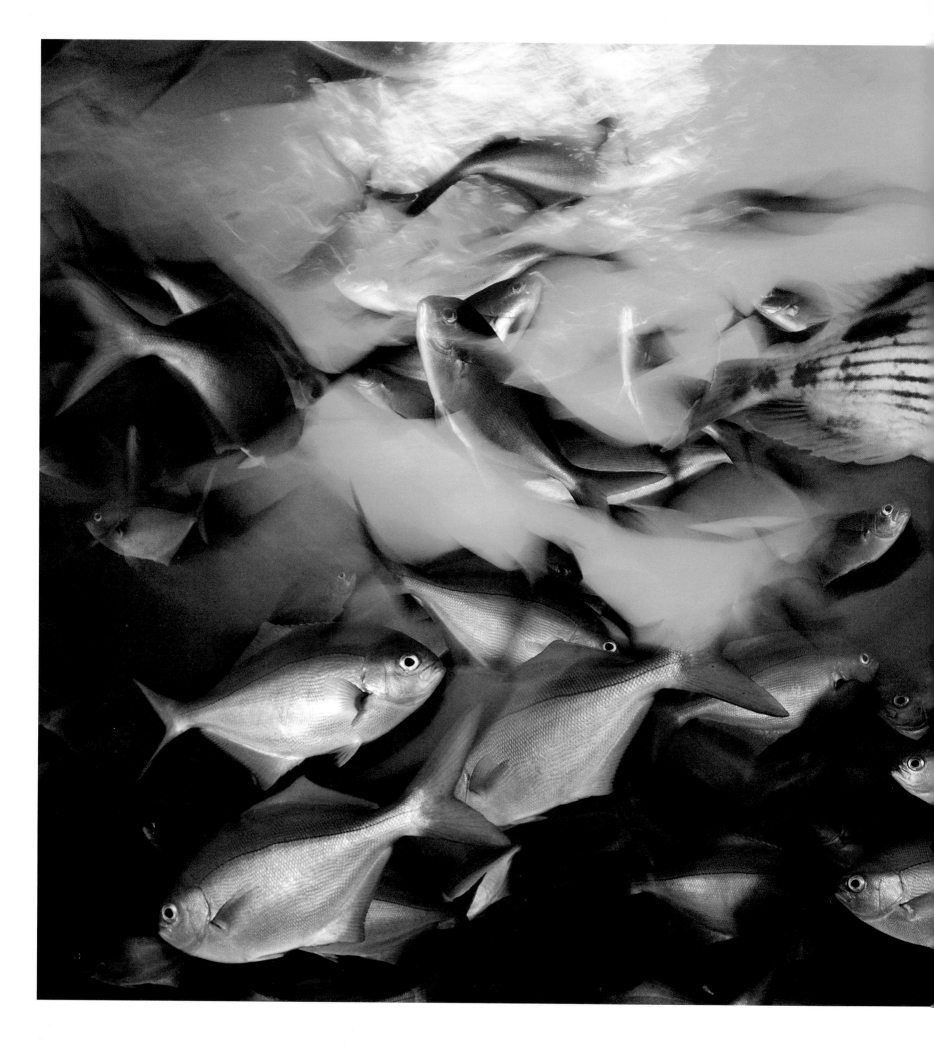

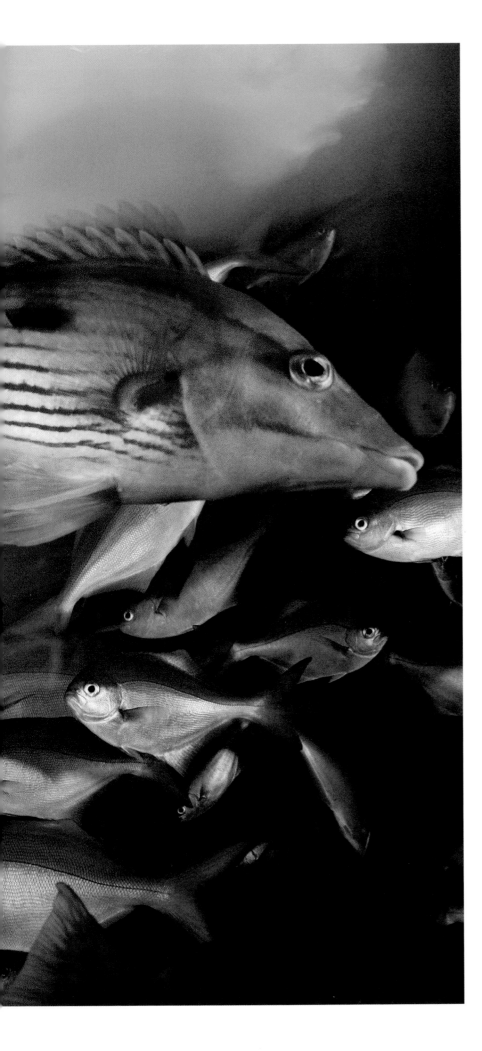

BRIAN SKERRY
New Zealand | 2006

Diving enthusiast and photographer Brian Skerry had just finished a story about overfishing in the world's oceans when he dove into the crystal waters off Poor Knight's Island, New Zealand, one evening. Local divers told him the blue mao-mao liked to hang out near a specific arch. The arch was located within a "no-take zone," an area specified by the government of New Zealand as off-limits to fishing. It had been that way for more than 20 years, and some local divers said the area was even better than it had been during the 1950s. Skerry found evidence of a primal ocean that night, a place that if left untouched could regenerate itself to be as it may have been 200 years ago. It was possible to find diversity in species, abundance of fish, and a healthy environment. He saw brilliant oranges and blues and greens in the dying light of that day. Against the canvas of colors, a red pigfish swam into view. "The overfishing story had been depressing," admits Skerry. "This was a separate story about hope."

VINCENT J. MUSI

English Channel | 2006

With England to my back, France loomed, and the distance between me and the boats grew quickly as they began their race around the world. I wanted to follow them the whole way, go around the world myself, except that the helicopter pilot thought we would run out of fuel.

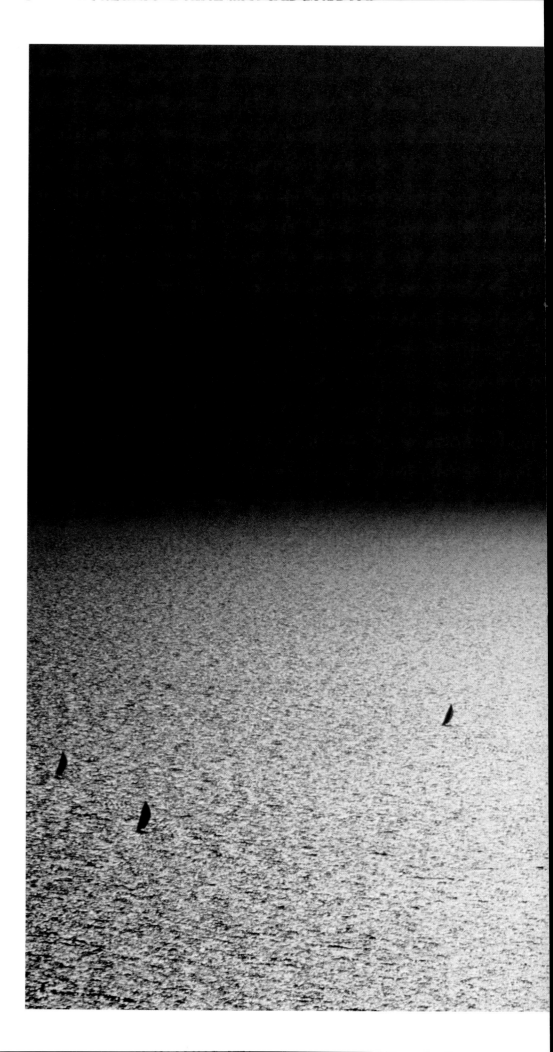

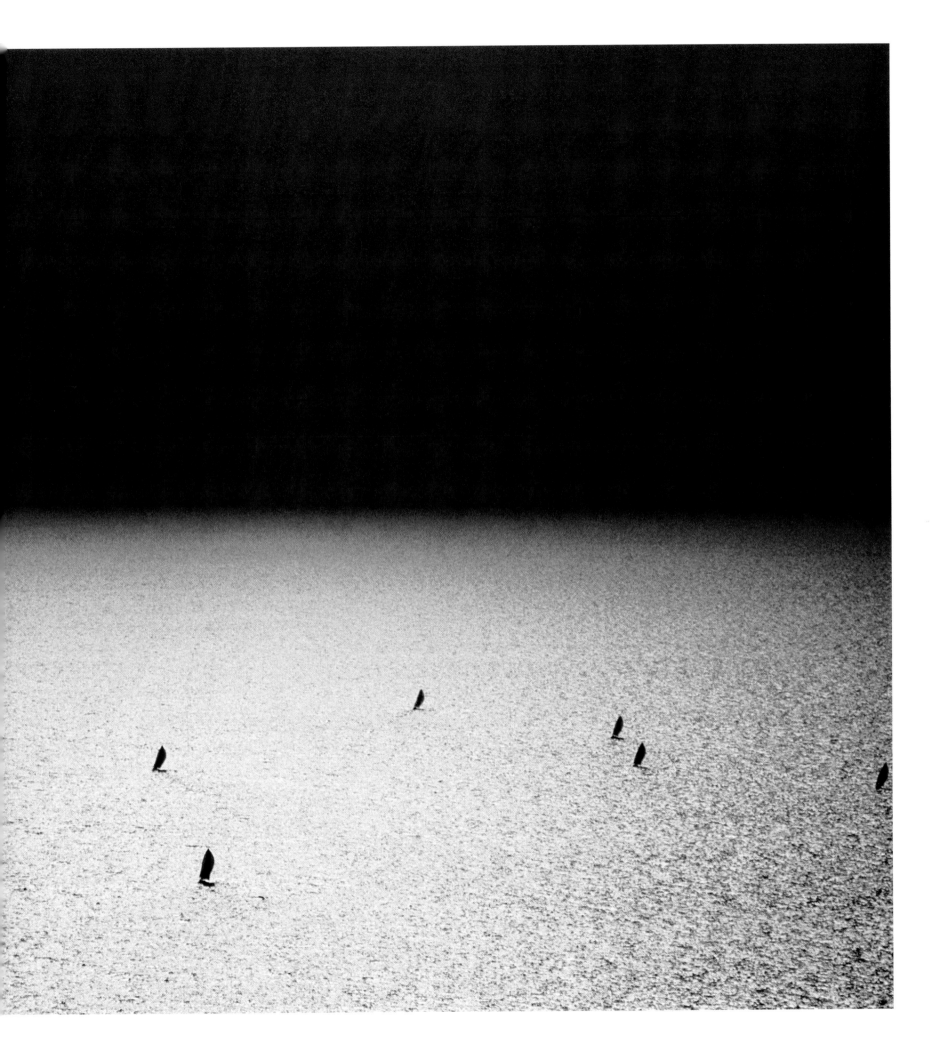

JASON EDWARDS
Japan | 2007

A Koi carp swims just below the surface of a pond in the Rikugien Gardens in Tokyo.

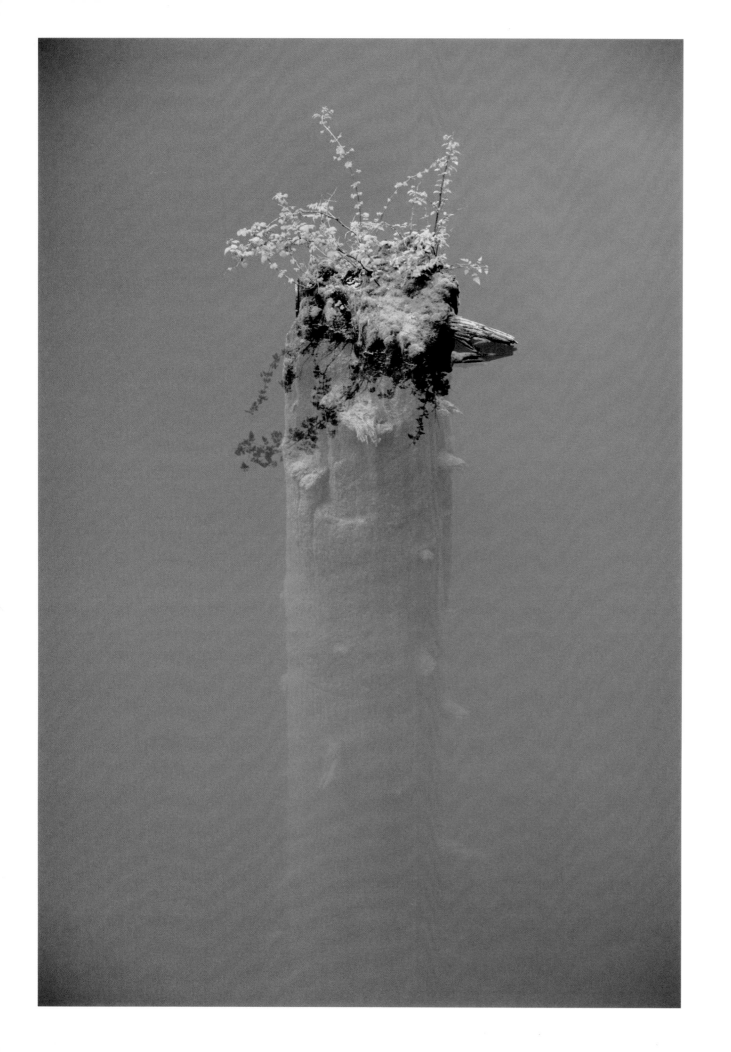

MICHAEL YAMASHITA

Jiuzhaigou, China | 2007

To get to the Jiuzhaigou Valley in the Sichuan Province of the People's Republic of China, you must fly into one of the world's highest airports, located in Chengdu, before you drive for six hours along arduous roads. The trip, however, is worth the effort. "I don't want to sound like a jaded photographer here,"admits Michael Yamashita, who has traveled around the world for the last 20 years, "but I thought I had seen it all until I saw Jiuzhaigou."

Yamashita worked in the valley during three different seasons to capture the incredible color and majesty of a place undiscovered until 1972 and quickly declared a national park in 1982 by the Chinese government to impede the logging industry from stealing its splendor. Twenty thousand people visit the park each day now, but they must walk on pristine wooden walkways and can only travel on government buses run with propane. "I walked every inch of that place, and I never got tired of it," says Yamashita.

"They call it fairyland. That's what Jiuzhaigou means. As I was working, I thought no one will believe this is the color of the water. They will think I pumped it up in Photoshop, but that is what it is." The presence of carbon in the water helps to create these azure blues and greens in the landscape that begin with water cascading out of the forest and just keep going in a succession of ponds and waterfalls, lakes and streams.

next pages: Michael Yamashita

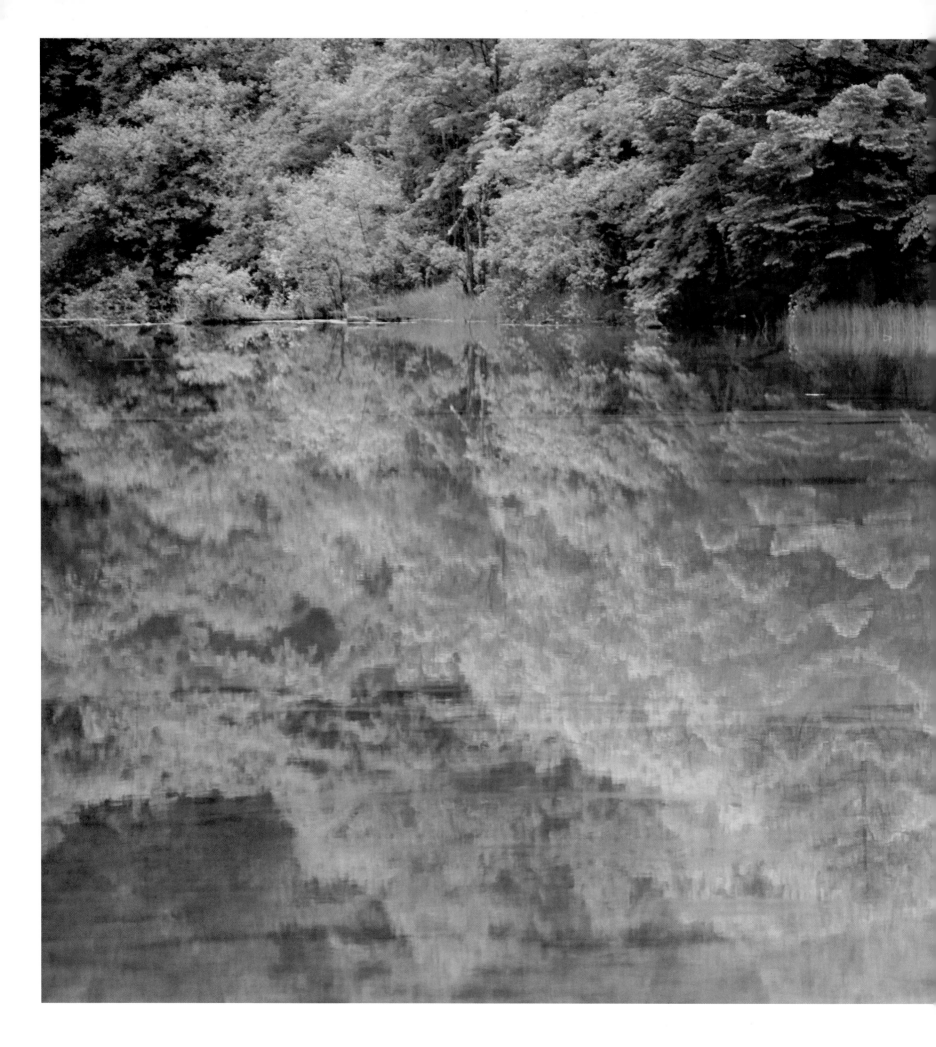

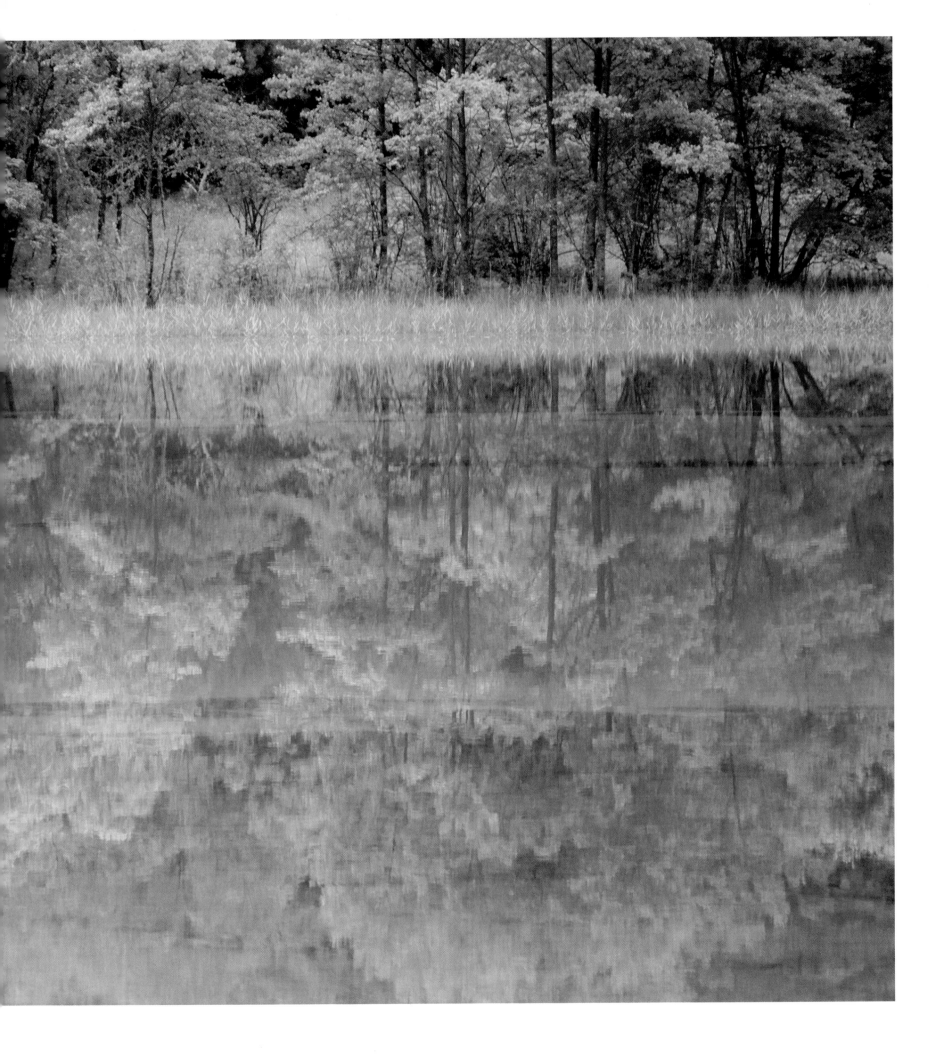

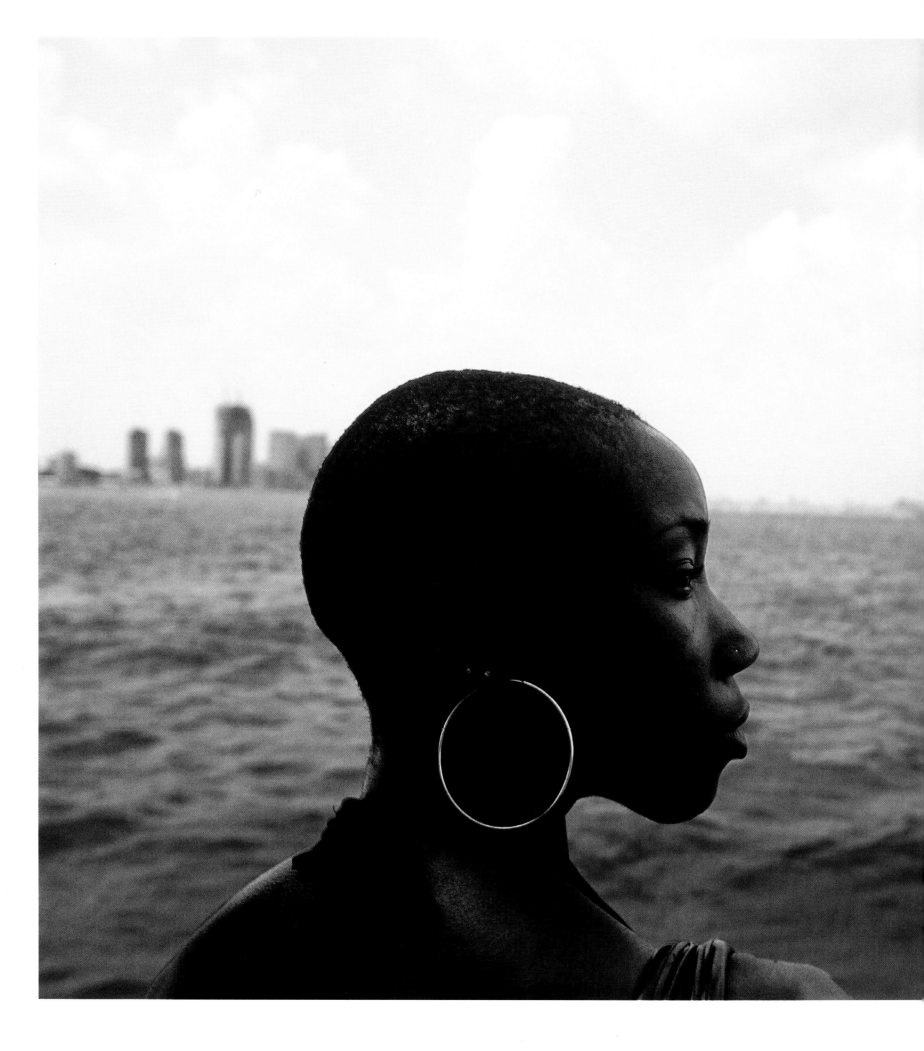

DAVID BUTOW

Lower Manhattan | 2006

A woman gazes toward lower Manhattan, New York, where the World Trade Center once stood, as she rides the Staten Island Ferry.

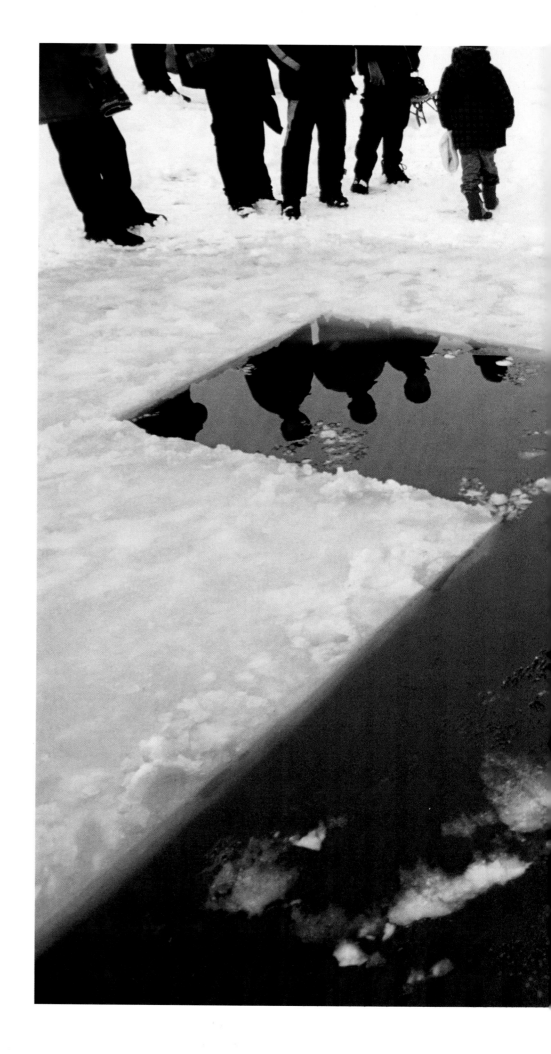

JONAS BENDIKSEN

Moldova | 2004

Members of the Russian Orthodox church in Transdniester await the christening of a new church member near icy waters in January.

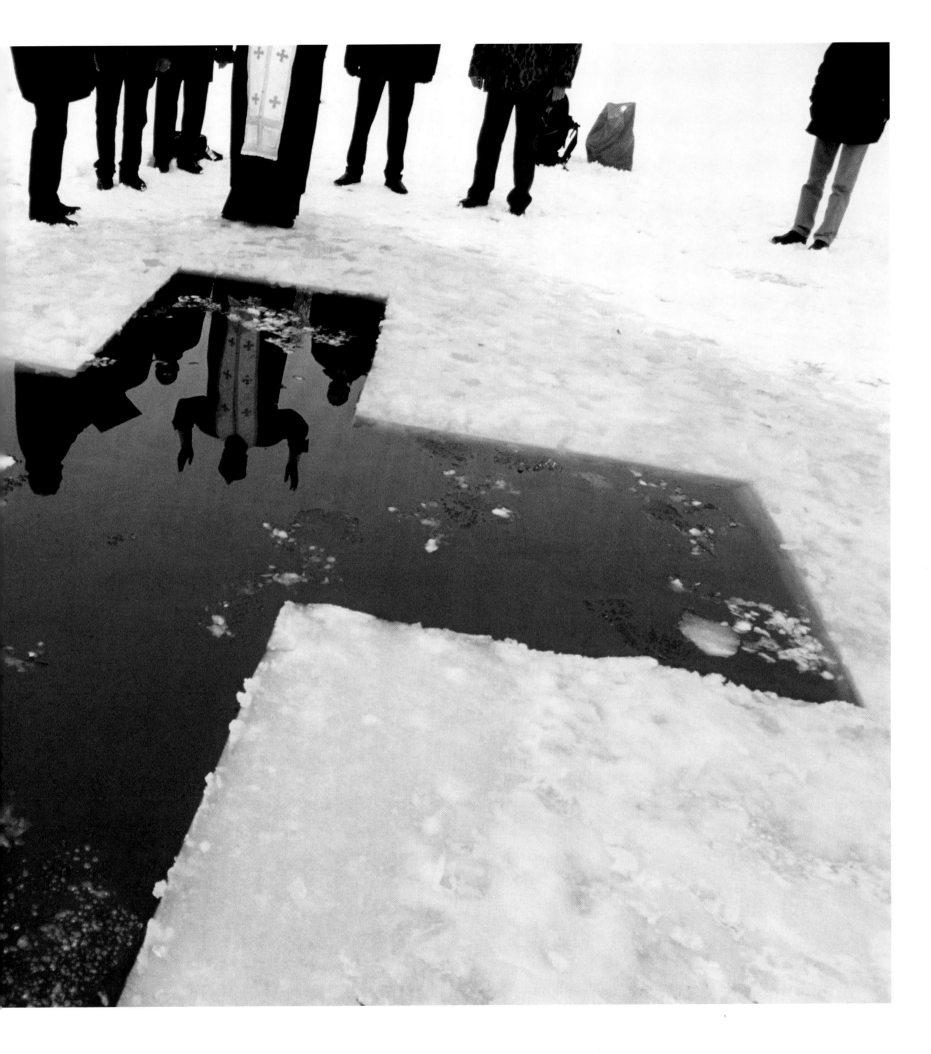

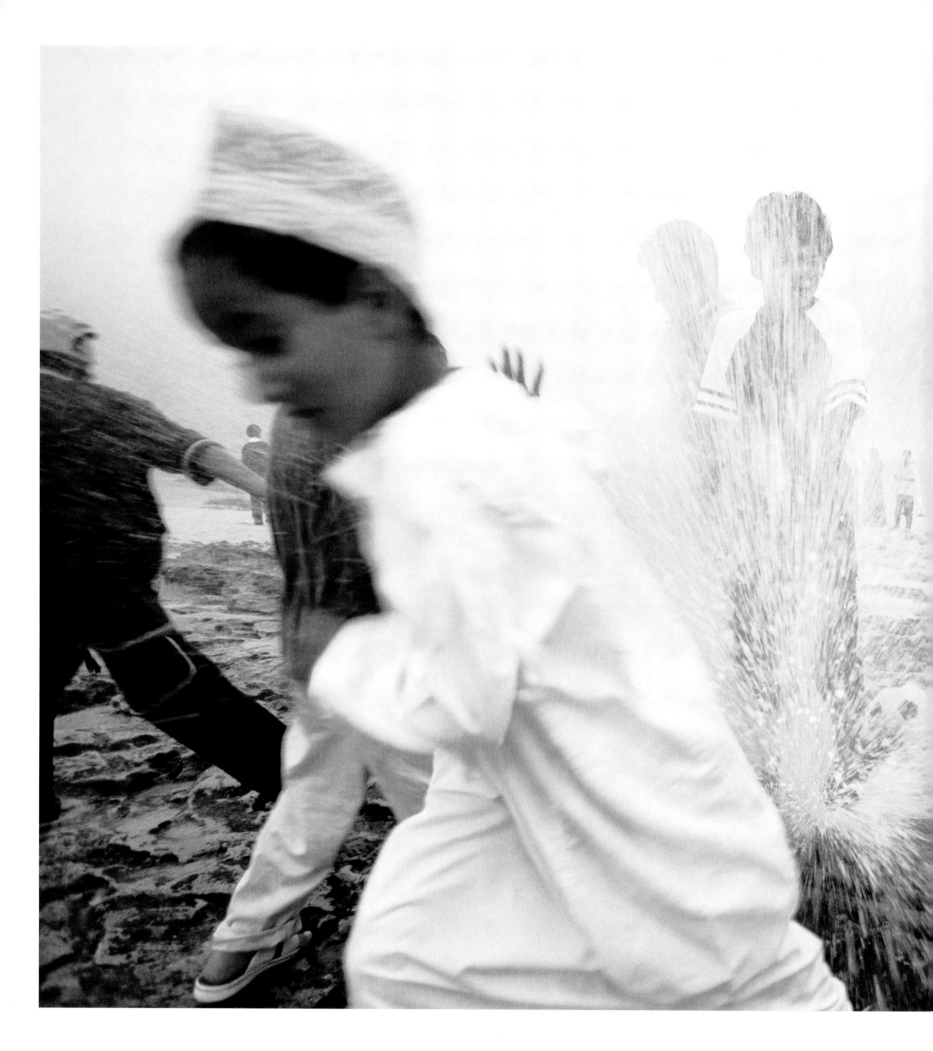

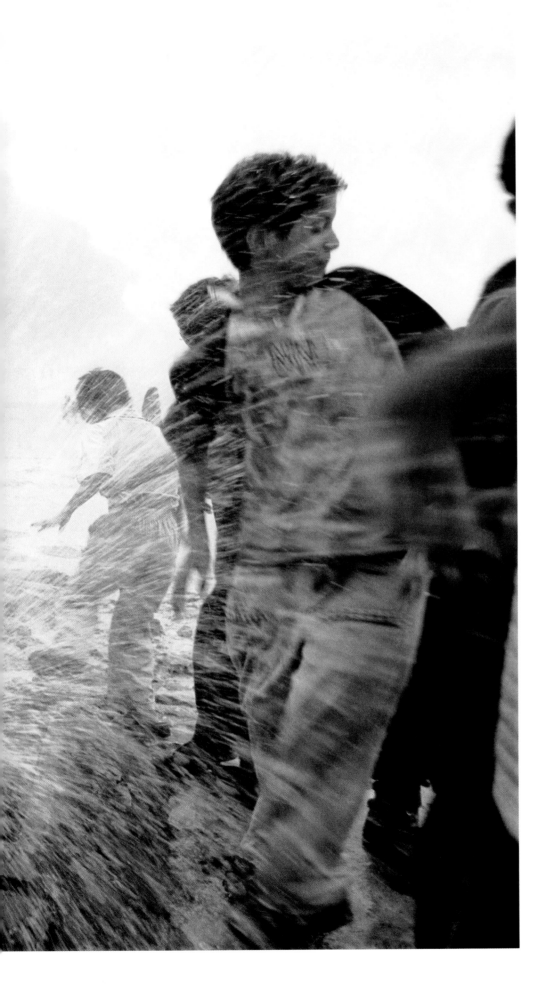

STEPHEN ALVAREZ

Oman | 2002

Children revel in the spray of saltwater from a natural blowhole on the coastline of Oman.

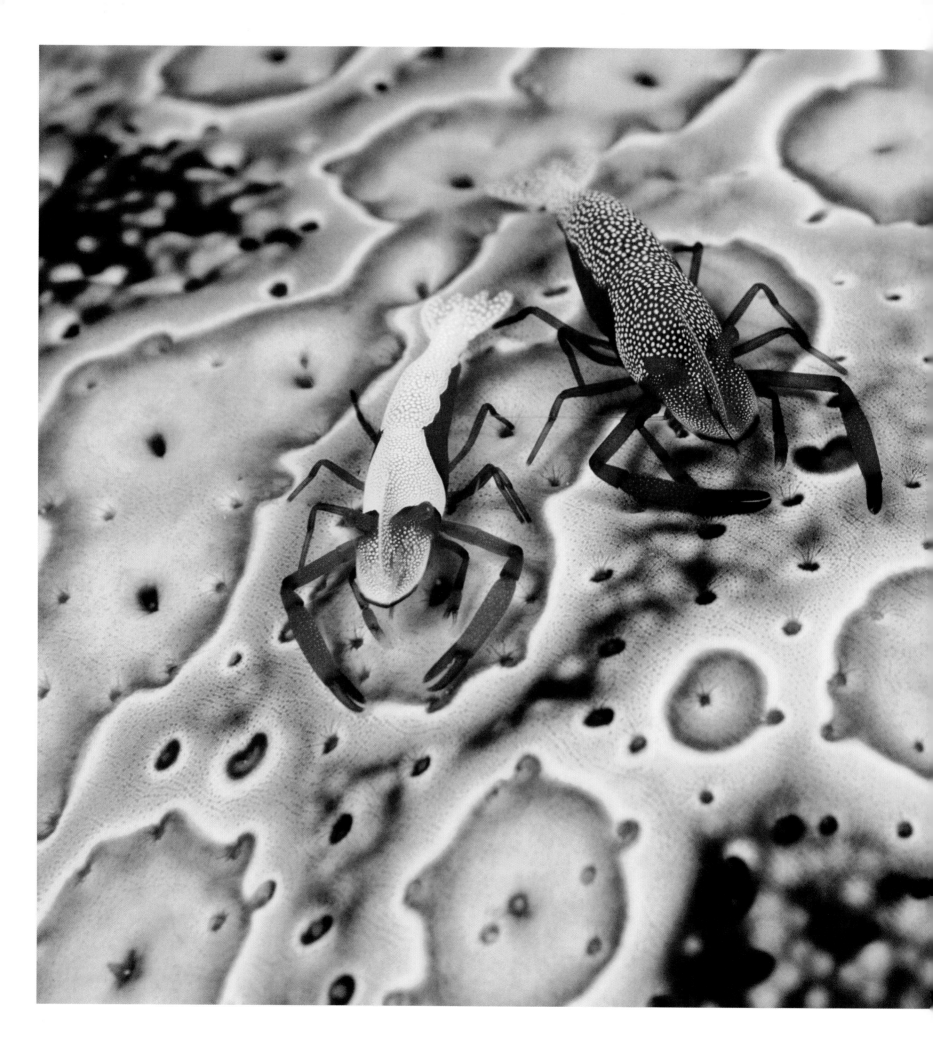

TIM LAMAN
Fiji Islands | 2007

Emperor shrimp crawl on a sea cucumber.

next pages: Tim Laman
A cluster of tunicates on a reef in Malaysia.

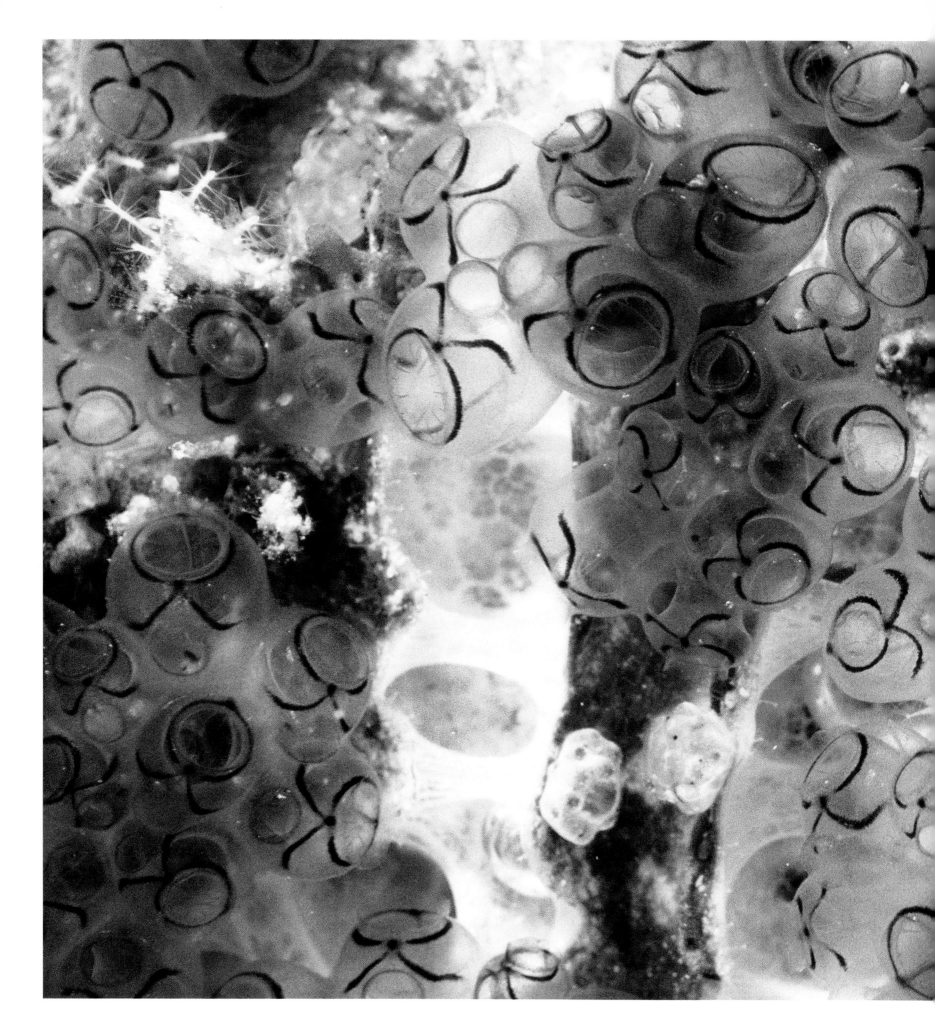

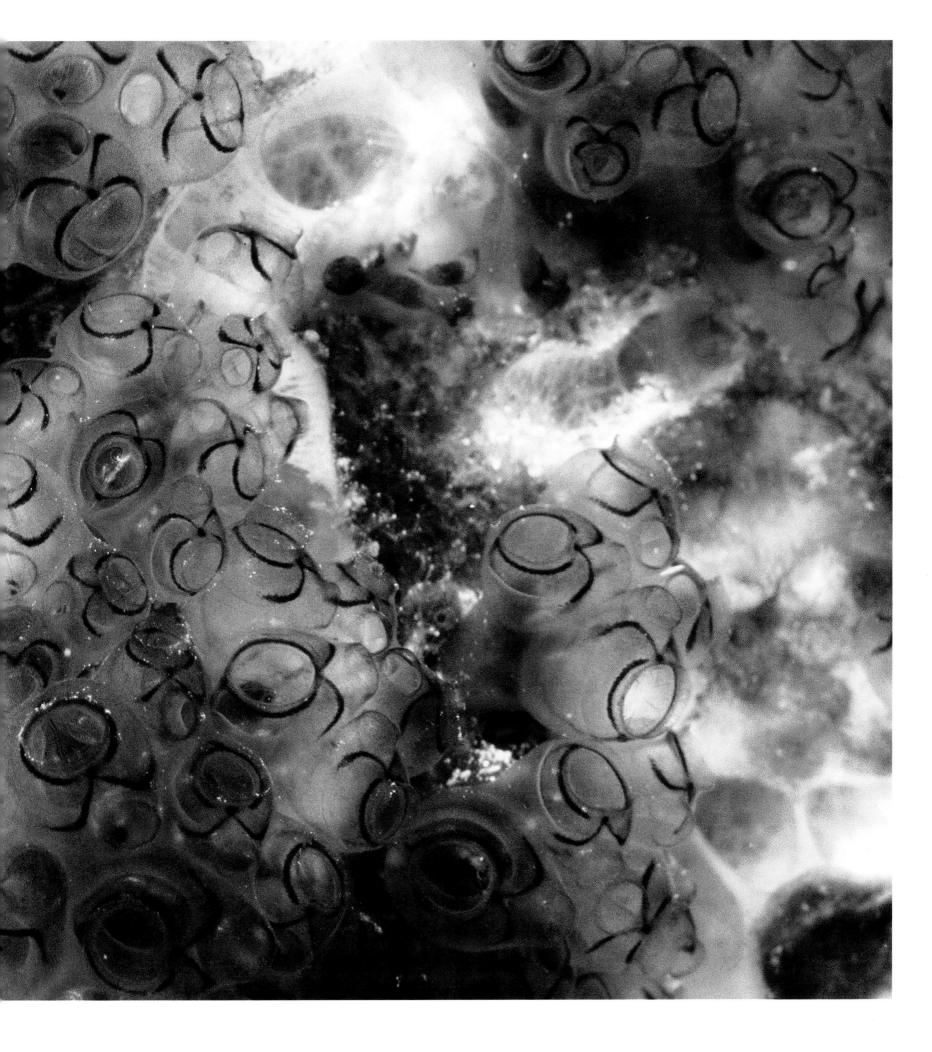

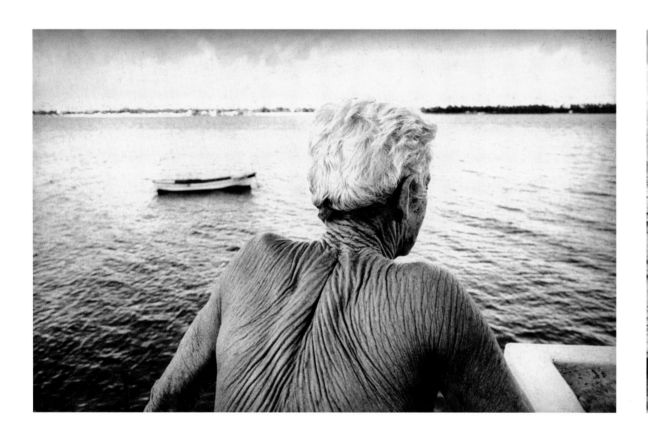

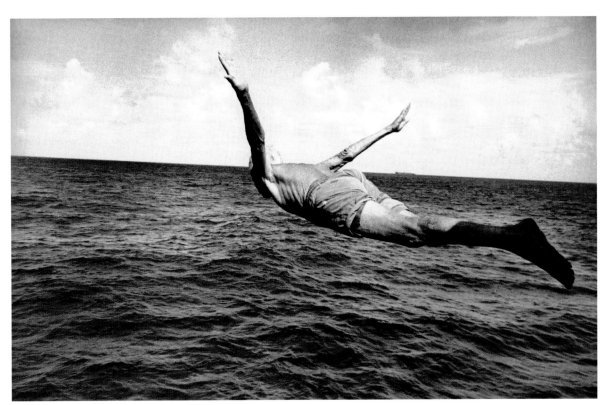

ED KASHI

Brazil | 2002

In the capital city of Aracaju, Sergipe, Ed Kashi found a man people called "ze pesce" or "the fish." It was rumored he never ate but drank only seawater, never bathed, and never wore shoes. Kashi felt like he was living in another century the more time he spent there with him. "The serenity and the simplicity of his life left me feeling tranquil," he remembers.

JUSTIN GUARIGLIA
India | 2003

A man walks across a submerged sandbar in Rameswaram, India.

SAM ABELL

Australia | 1995

A shark and a school of migrating salmon make a
perfect formation in the shallows off Baxter Cliffs
in Western Australia.

next pages:
FRANS LANTING

Utah | 2006

Light patterns reflect off the water onto a vertical
rock wall in Glen Canyon National Recreation Area.

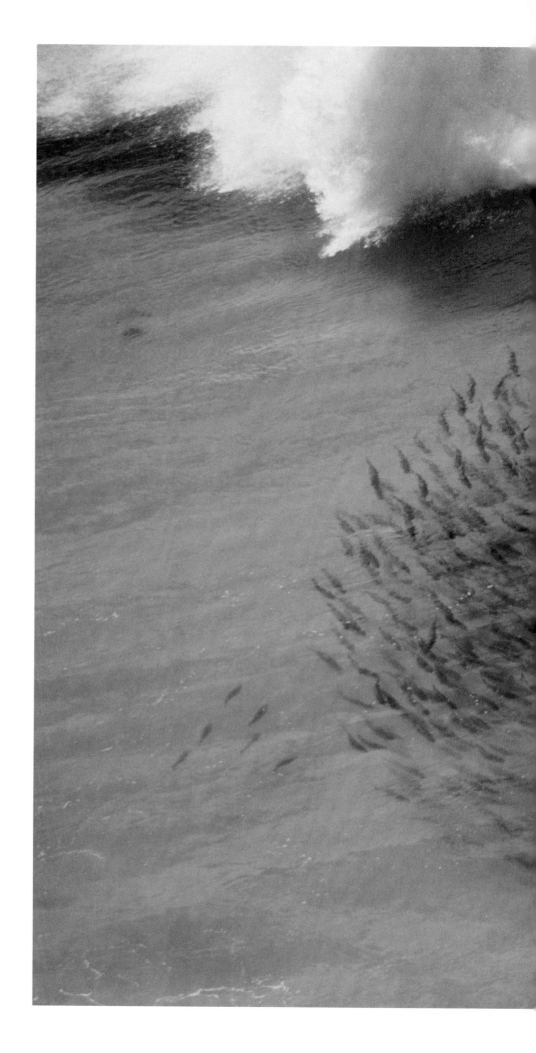

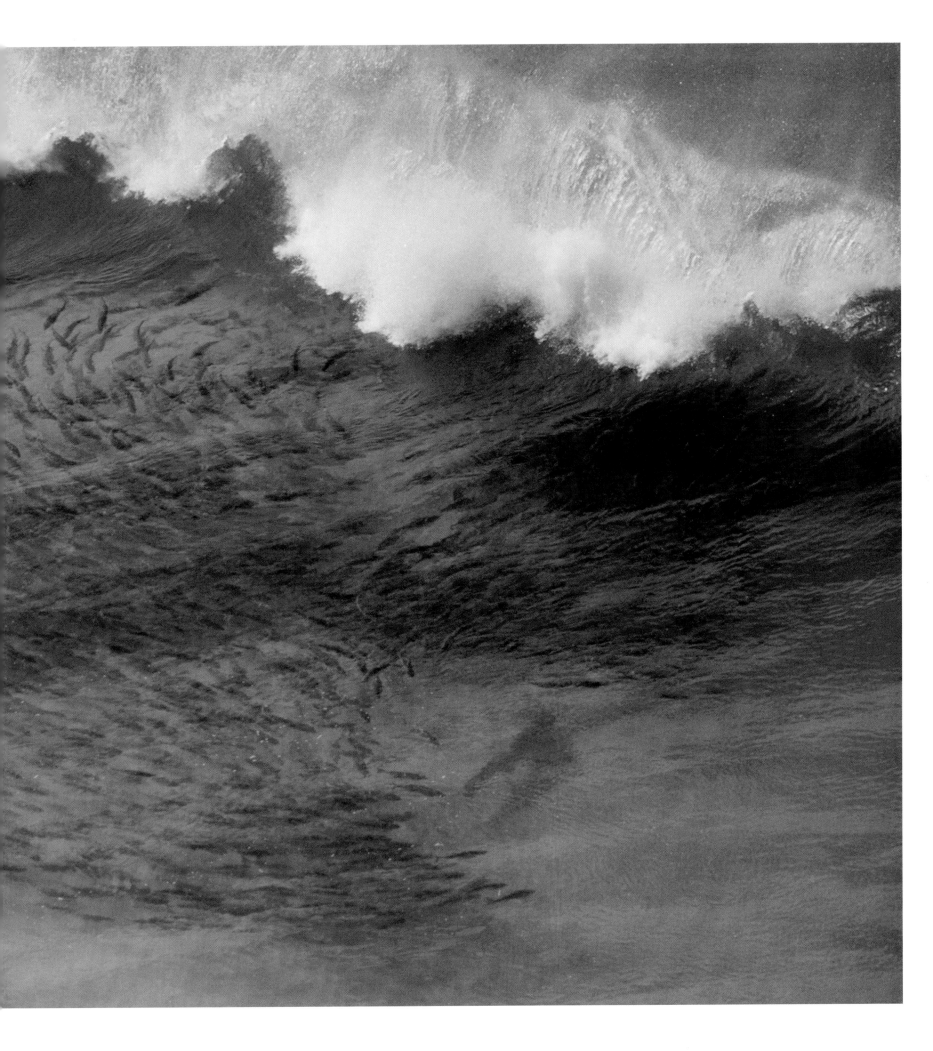

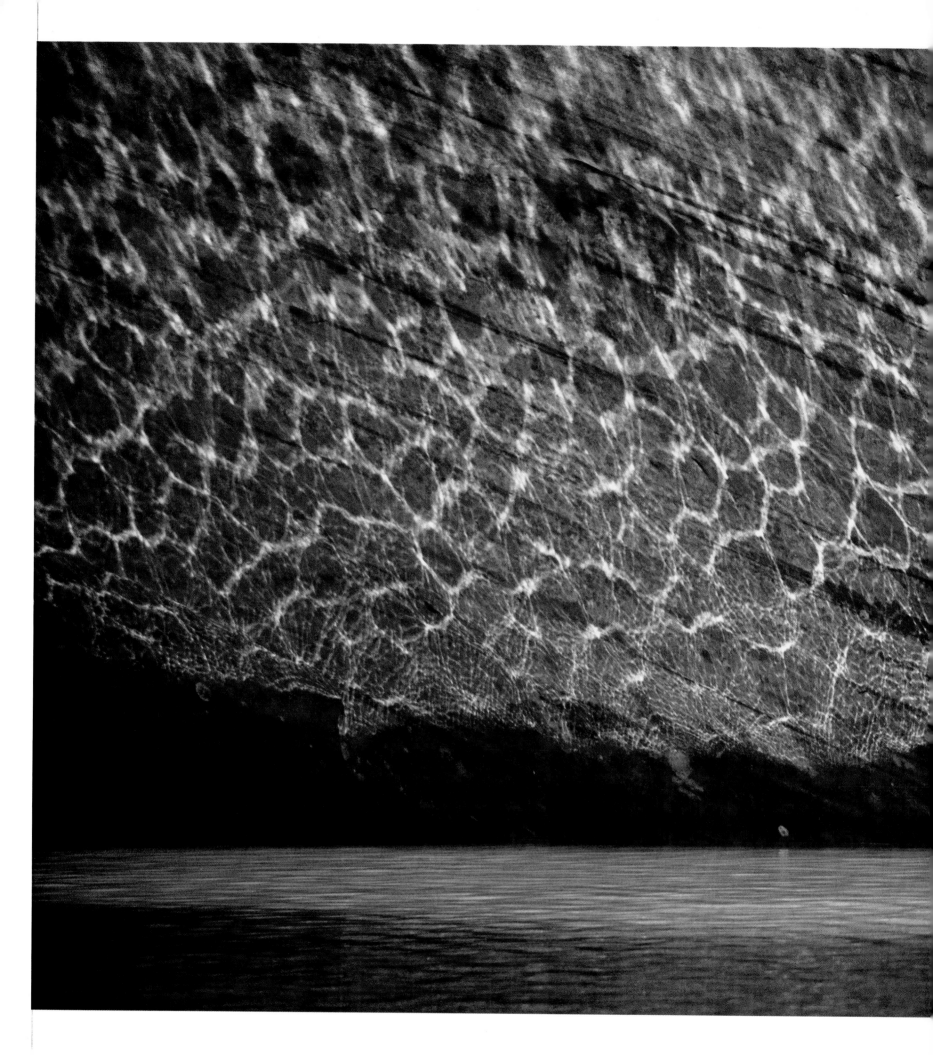

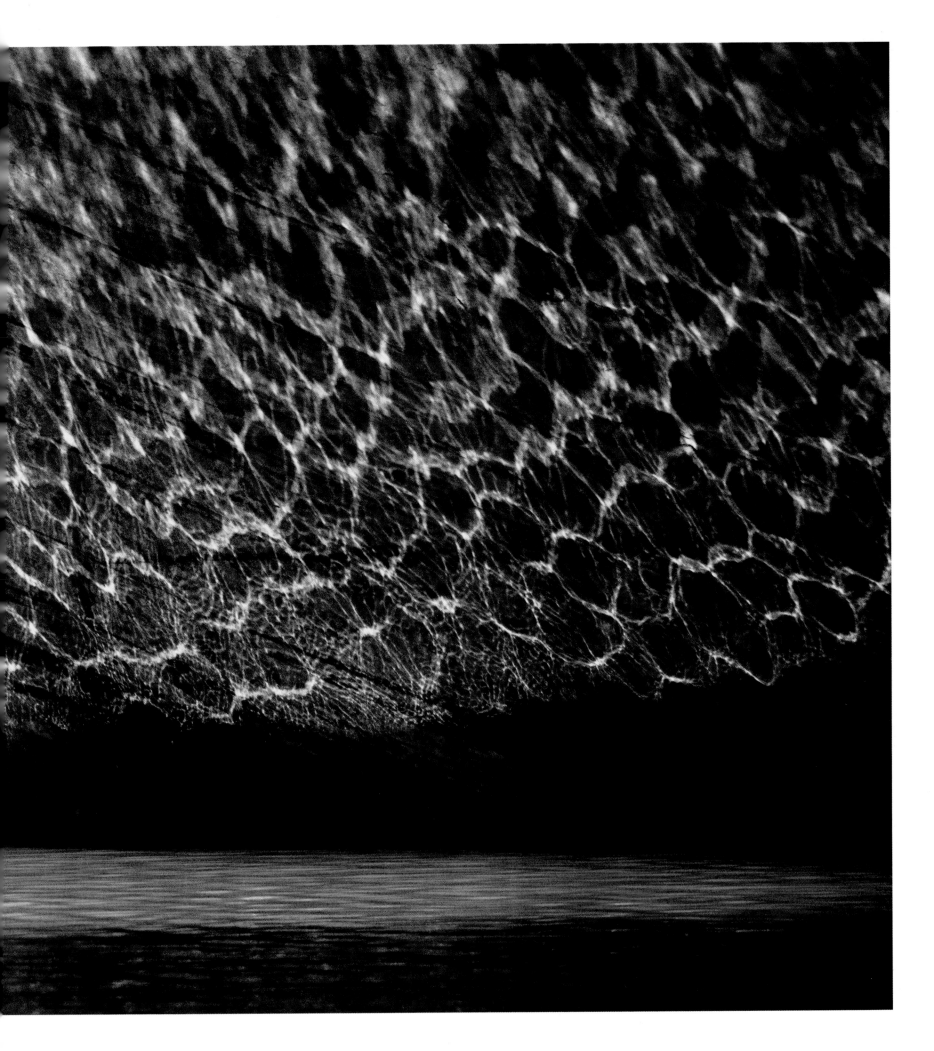

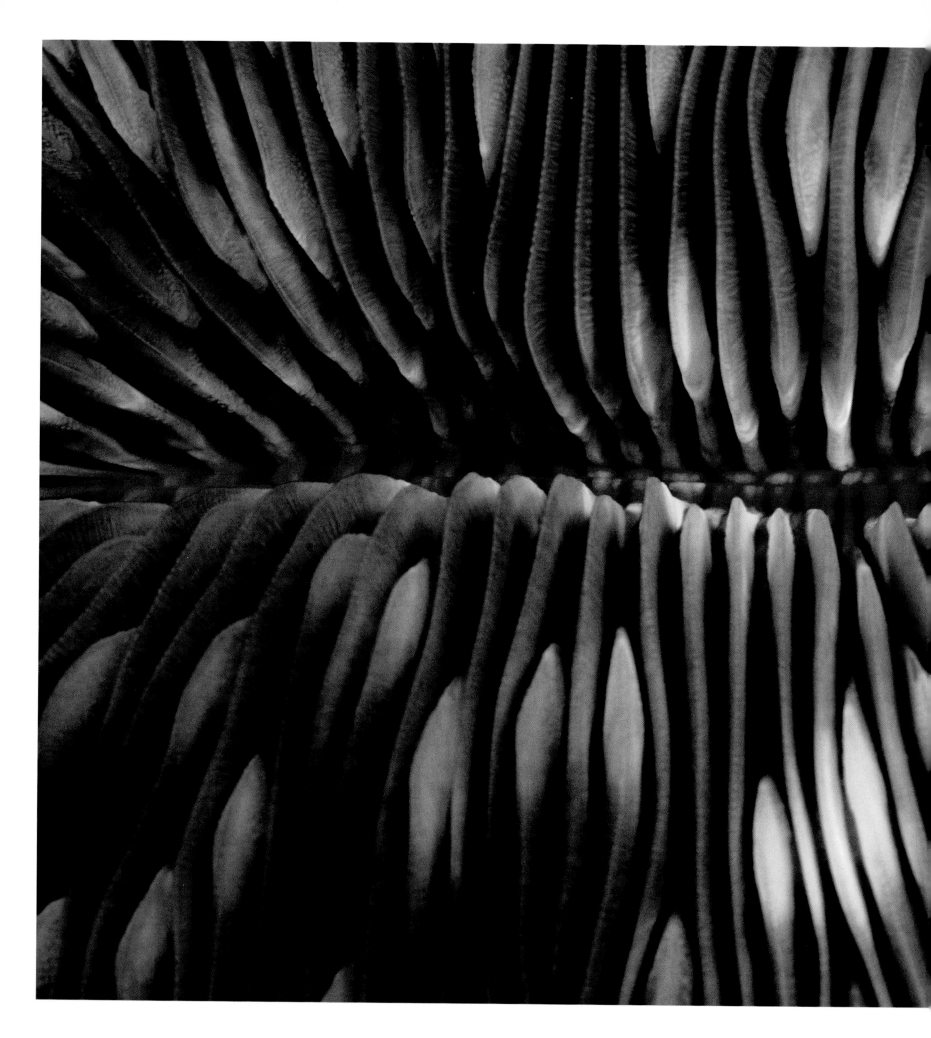

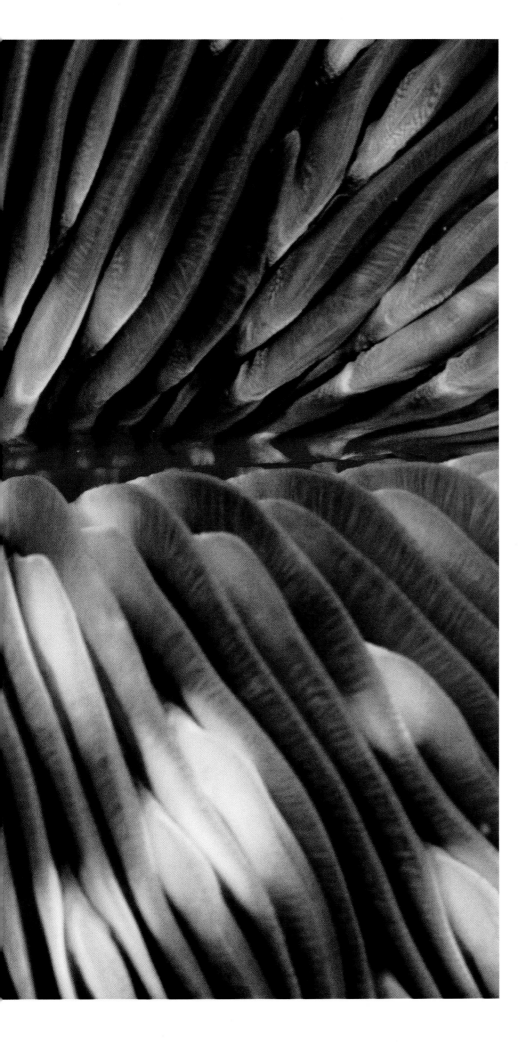

WOLCOTT HENRY
Papua New Guinea | 1998

There are coral reefs in warm waters, and then there are the coral reefs in the western Pacific Ocean. "I have seen very few examples in the world that match those colors that I see underwater," says Wolcott Henry. Since he first started diving in 1995, Henry has been back to the region 12 times, eager to be close to the fish, the shrimp, and the more inanimate animals such as the mushroom coral (left) that enliven the sea.

RAUL TOUZON

Turks & Caicos Islands | 2006

"There is a particular place in the Turks & Caicos Islands where the water drops from 65 feet to 7,000 feet. They call it the G-Spot, and it is full of life and sharks and fish. It is chaos, but at the same time it is also quiet and beautiful."

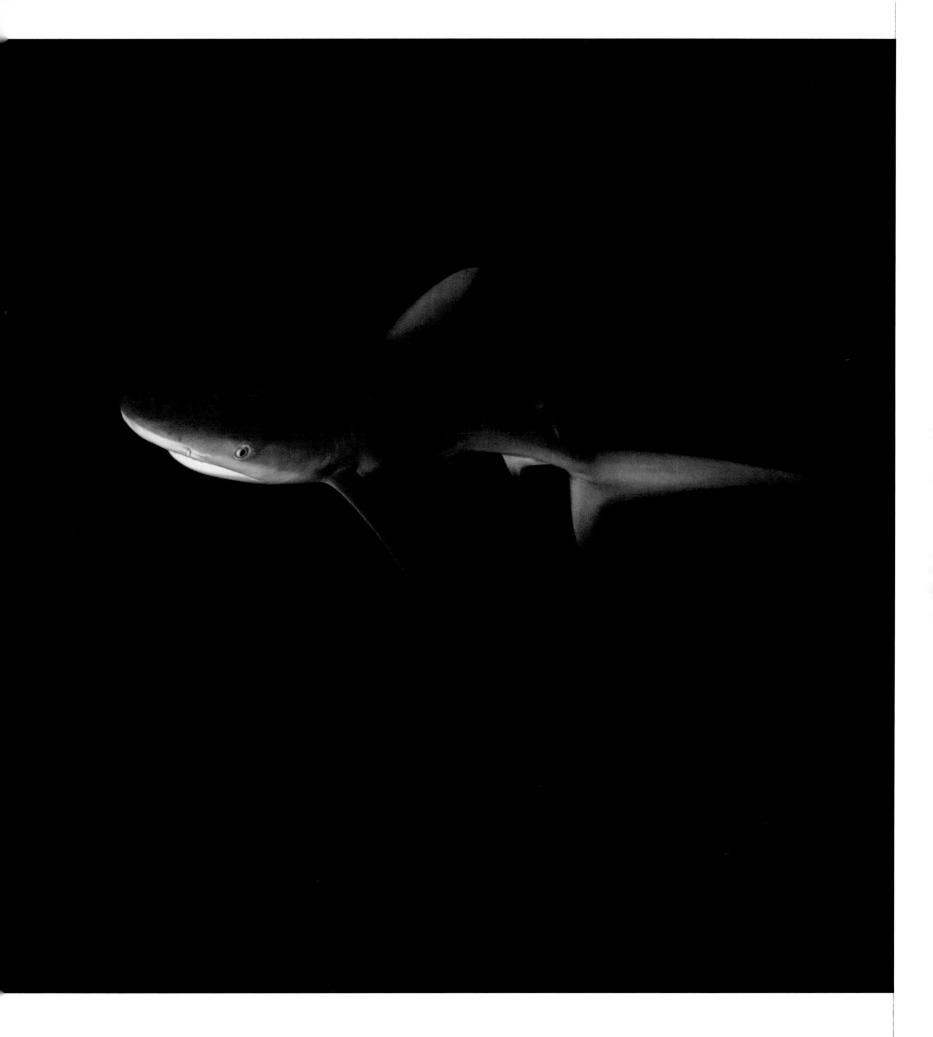

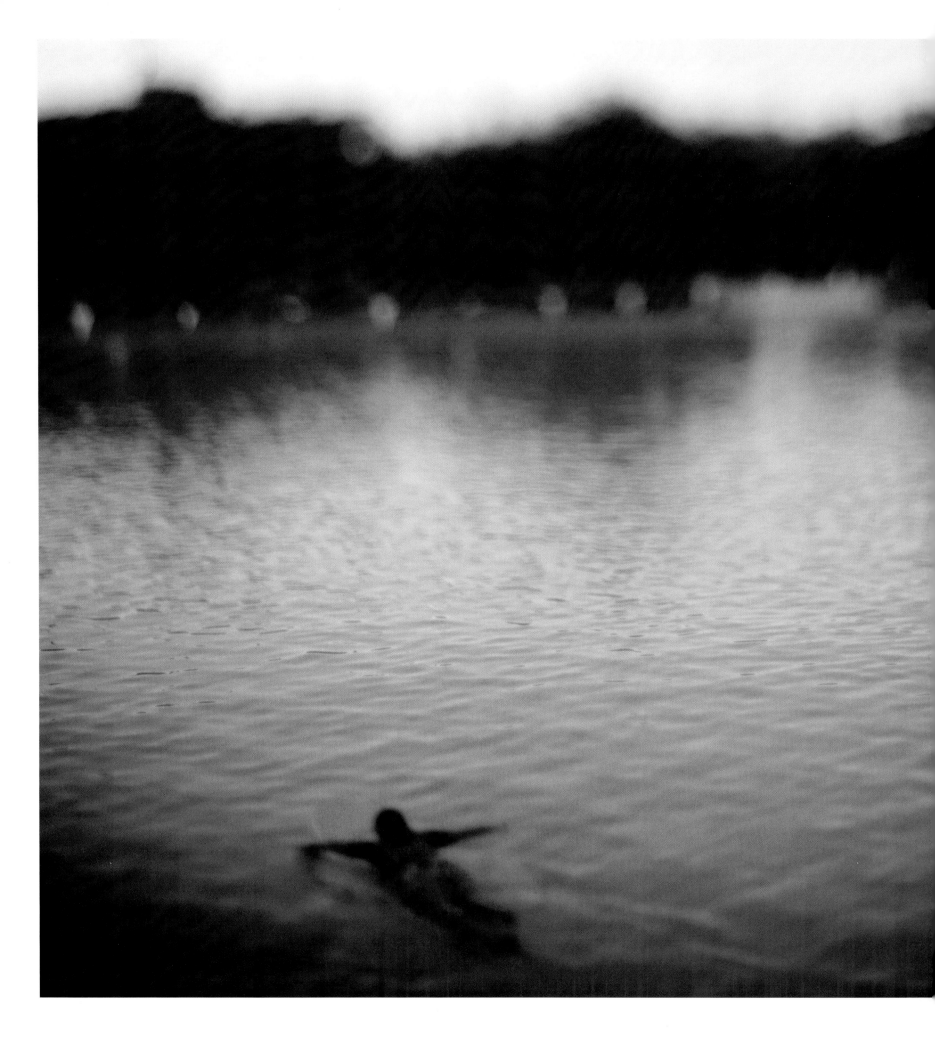

DAVID BURNETT
Florida | 2005

An early morning surfer glides in the Disney World Typhoon Lagoon.

next pages:
CHRIS JOHNS
Mozambique | 2000

A fisherman in the waters off the coast of Vilanculos.

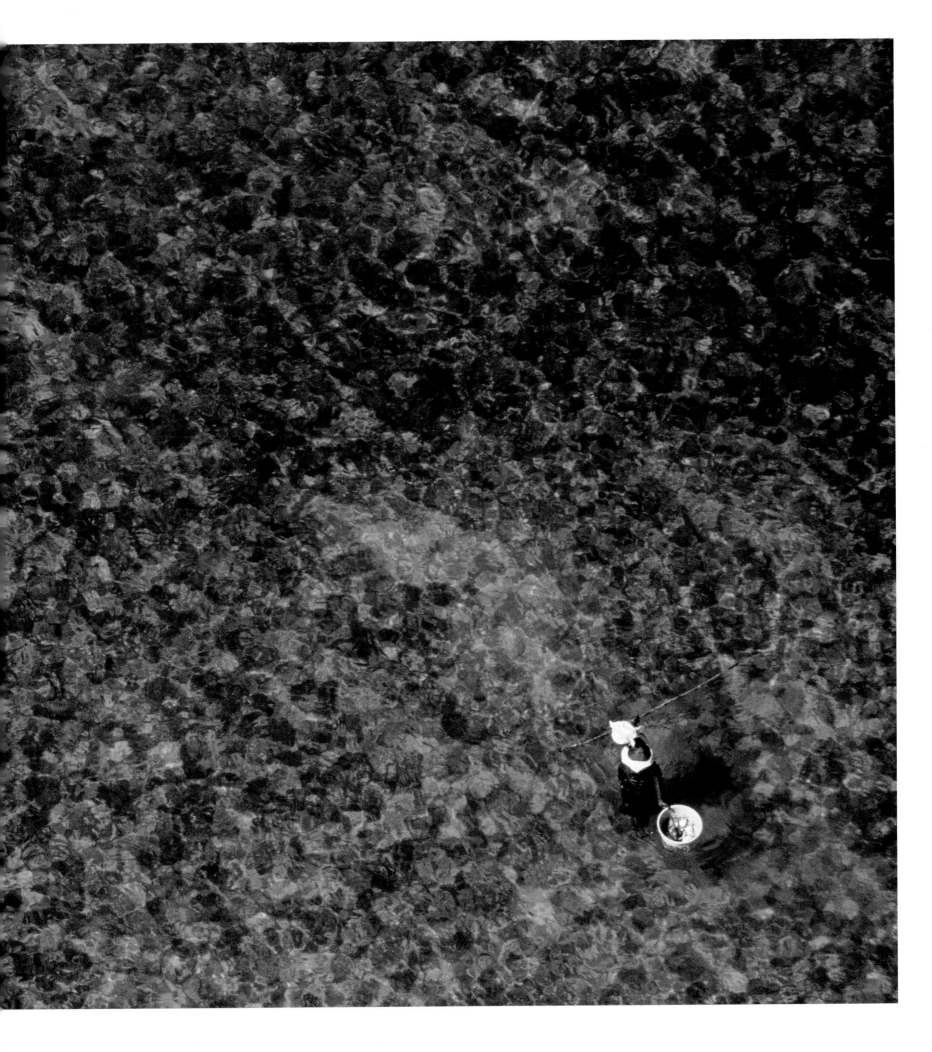

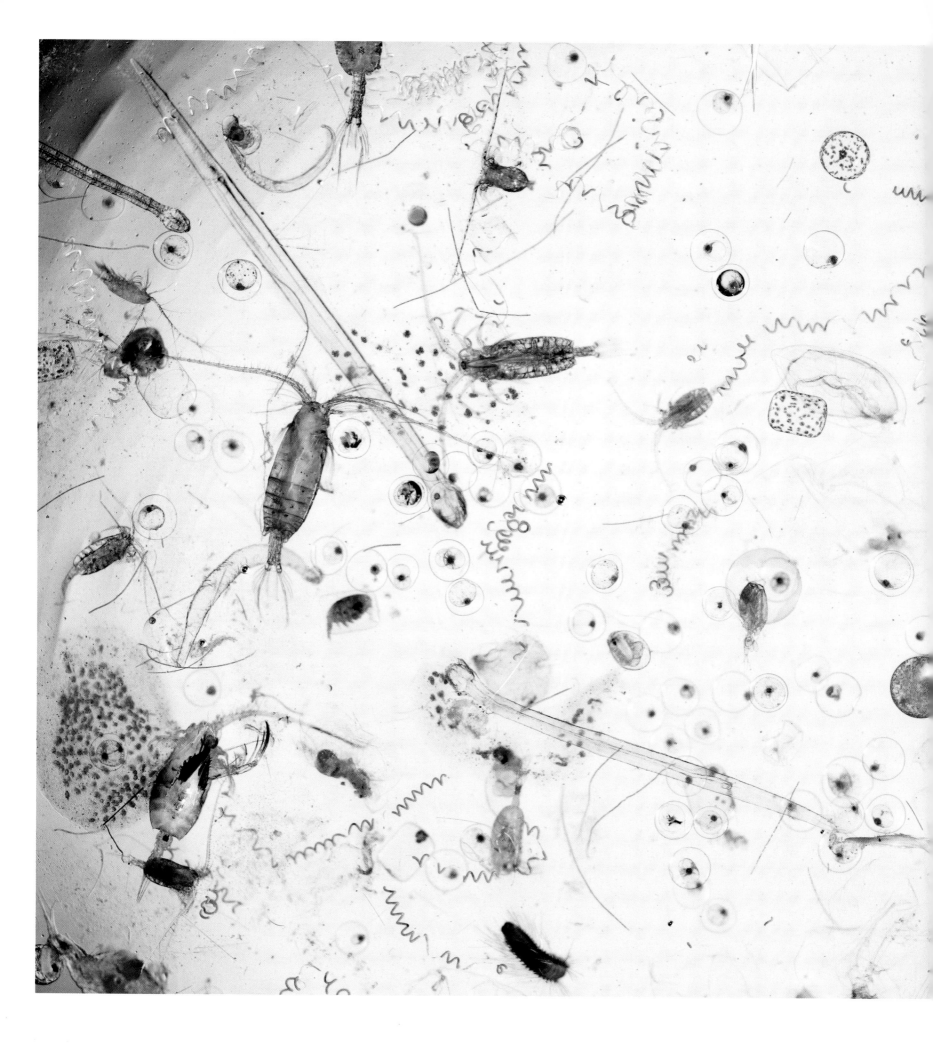

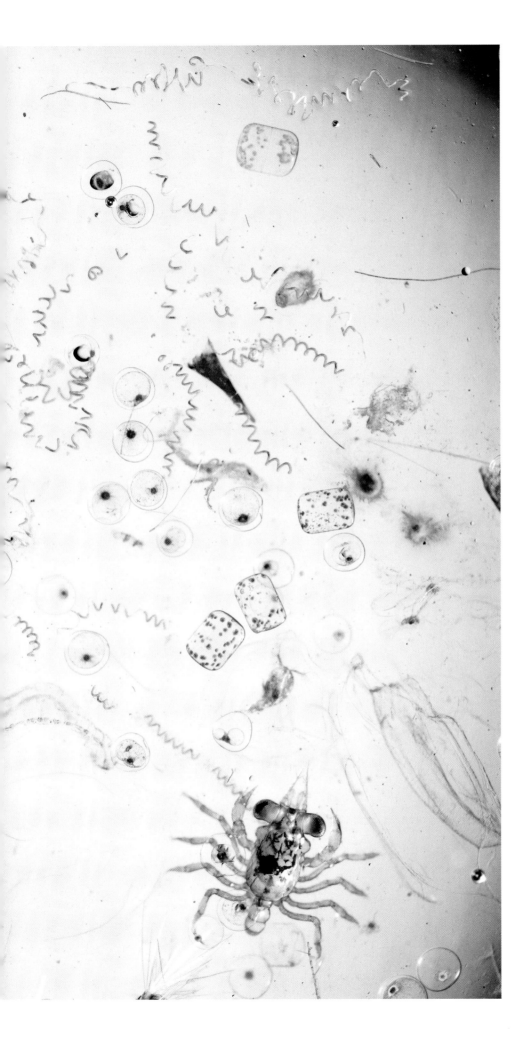

DAVID LIITTSCHWAGER

15 drops of water | 2006

Off the coast of the Hawaiian Islands one night, crewmembers on the ship hung a light off the back of the deck. David Liittschwager saw hundreds of tiny animals surface and swirl in the hazy circle of light below. "I wanted to know what they were," he says.

Liittschwager, who has dedicated his photographic career to capturing images of creatures in danger of being destroyed, set to work. He created this image that is 22x the actual size. In the water he found diatoms (the rectangular cells with dotted green chloroplasts), pteropods (the vase-shaped type of snail on the right), fish eggs (spheres with orange-brown centers), crab larva (self-explanatory), chaetognaths (the nearly transparent elongated worms), and cyanobacteria (the squiggly coiled filaments), among other things. It was a party of marine microfauna. "Here we were near Hawaii, which has often been called paradise, but there's this additional paradise—this riot of life—there, too."

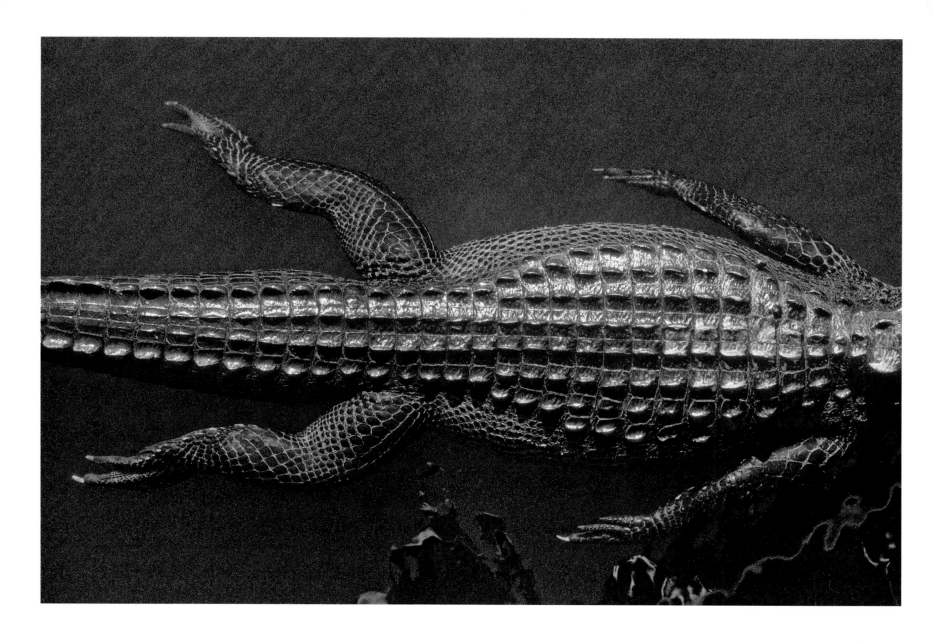

MEDFORD TAYLOR

Florida | 1990

The perfect symmetry of an alligator delights
and amazes viewers in the Everglades.

opposite:
MICHAEL FAY

Namibia | 2004

Clear water flows from high in Angola into the
Okavango River in Namibia.

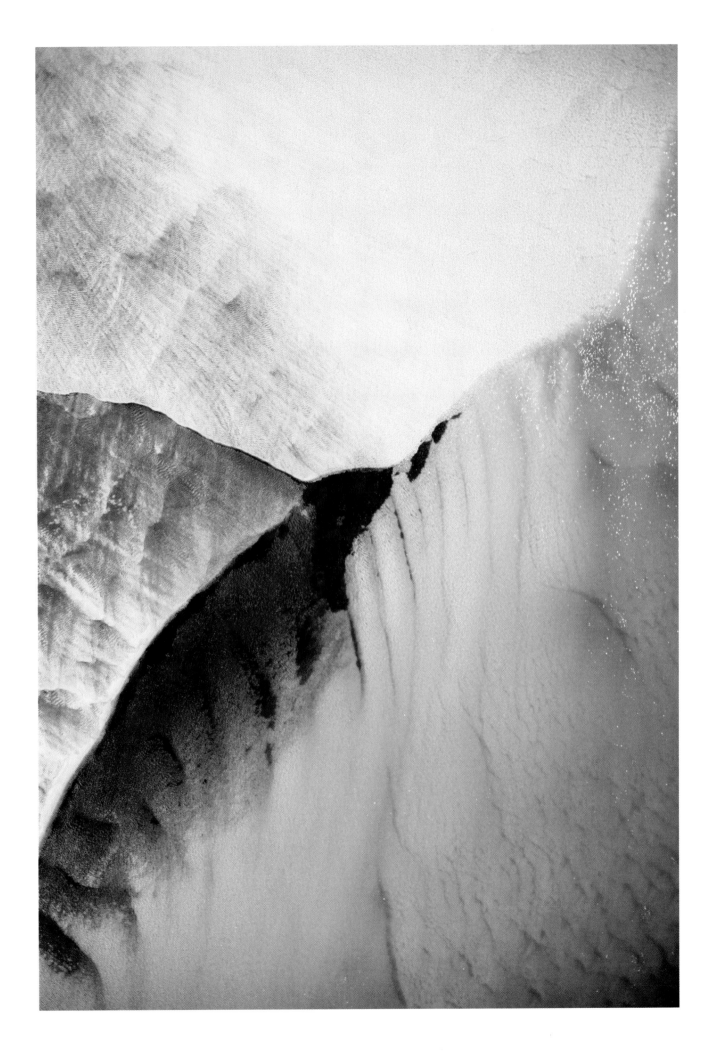

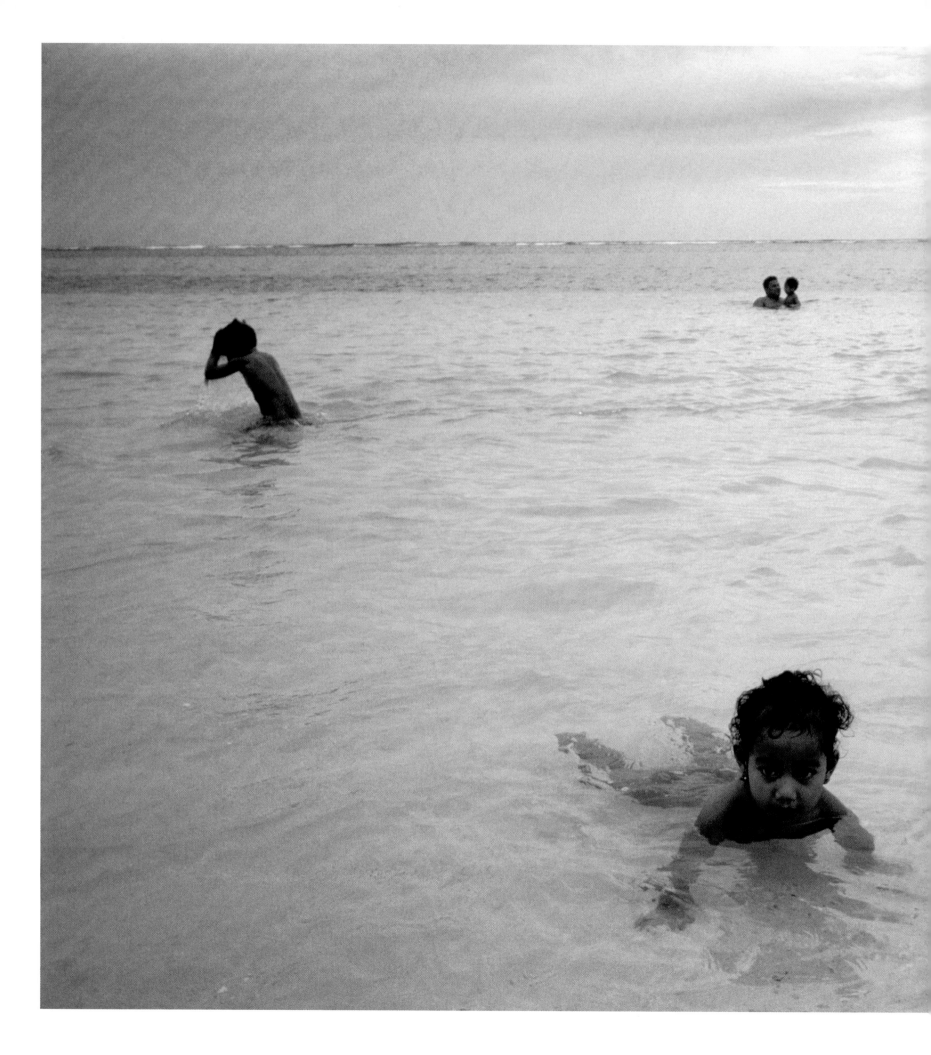

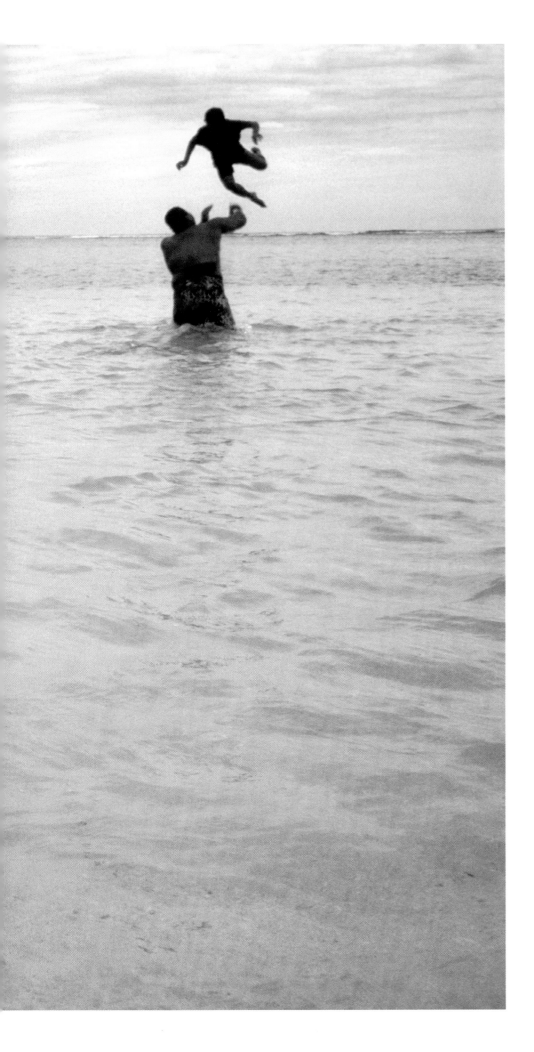

ALEX WEBB
Samoa | 2000

Once a year, shortly after the full moon in October, the palolo worms rise from the reefs of Western Samoa in the South Pacific. Just before dawn, Samoans wade out onto the reefs and rapidly begin scooping up the 16-inch creatures with fine-mesh nets. The worms, which look like greenish-gray linguine and taste somewhat fishy and salty, are considered a delicacy. They are eaten either fresh—raw or boiled—or quickly shipped to the suprisingly large Samoan community in New Zealand.

In 2000 I spent about 10 days on this languorous tropical island, documenting village life as I waited to photograph this annual event. I took this photograph in the small beach community of Manase. A few days later, as predicted, the worms began to surface in the warm waters of the Pacific.

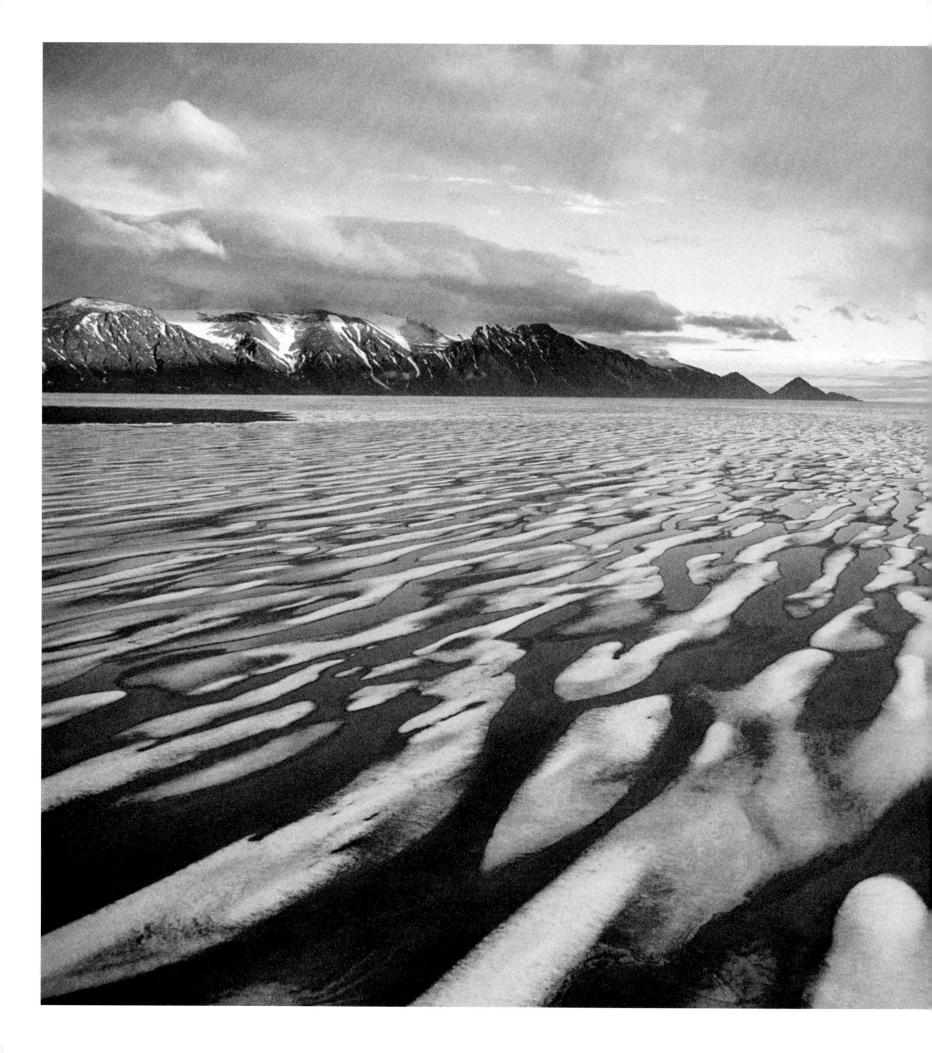

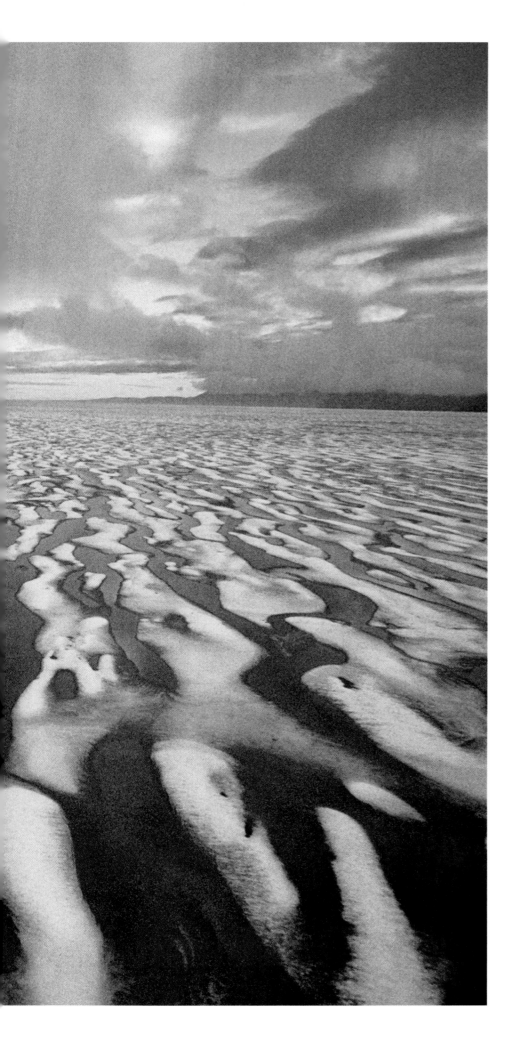

RICHARD OLSENIUS

Northwest Passage | 1998

In love with the waters and coastlines of this planet, Olsenius traveled for months through the Northwest Passage by boat. "Every once in a while there is place that challenges you, not only photographically but on a human level," says Olsenius, who picked this place between Baffin Island and Bylot Island as his paradise. "It was almost a love-hate relation-ship because the conditions here could be so harsh, but there is a raw beauty I have seen in very few places."

BEVERLY JOUBERT

Botswana | 2005

Clear tannin-leached water does little to hide the hippos in the channels in the Okavango Delta.

next page left:
MICHAEL KENNA

France | 2004

At the peak of Mont Saint-Michel, benedictine monks live peacefully in the Abbey, a Romanesque monastery built during the Middle Ages. Kenna, who once studied to be a priest, loves the chance to visit and to be silent for three or four days. But at night, he roams the island with his camera—setting exposures for two or three hours long—to capture the beauty of a place rarely seen.

next page right:
PETER MARLOW

Japan | 1998

Bathers relax in a natural hot spring in Kawayu.

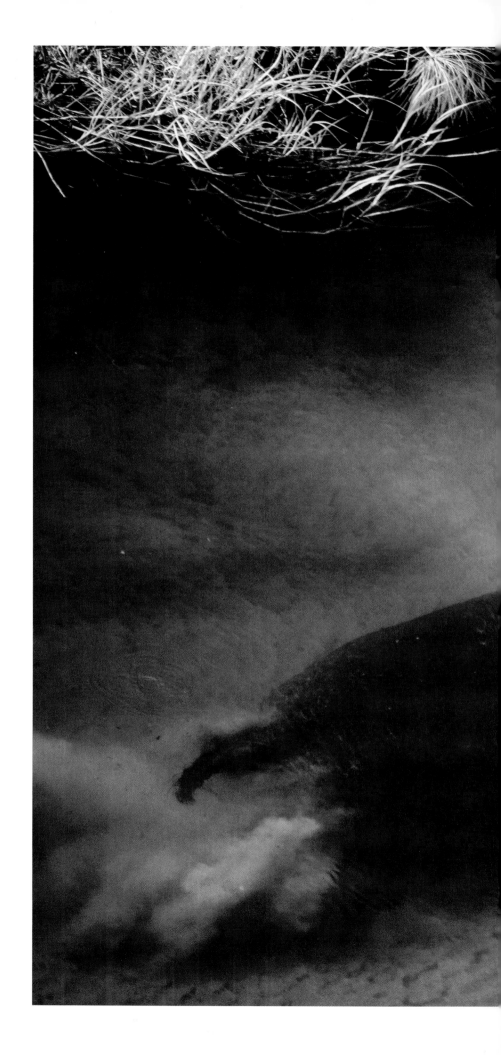

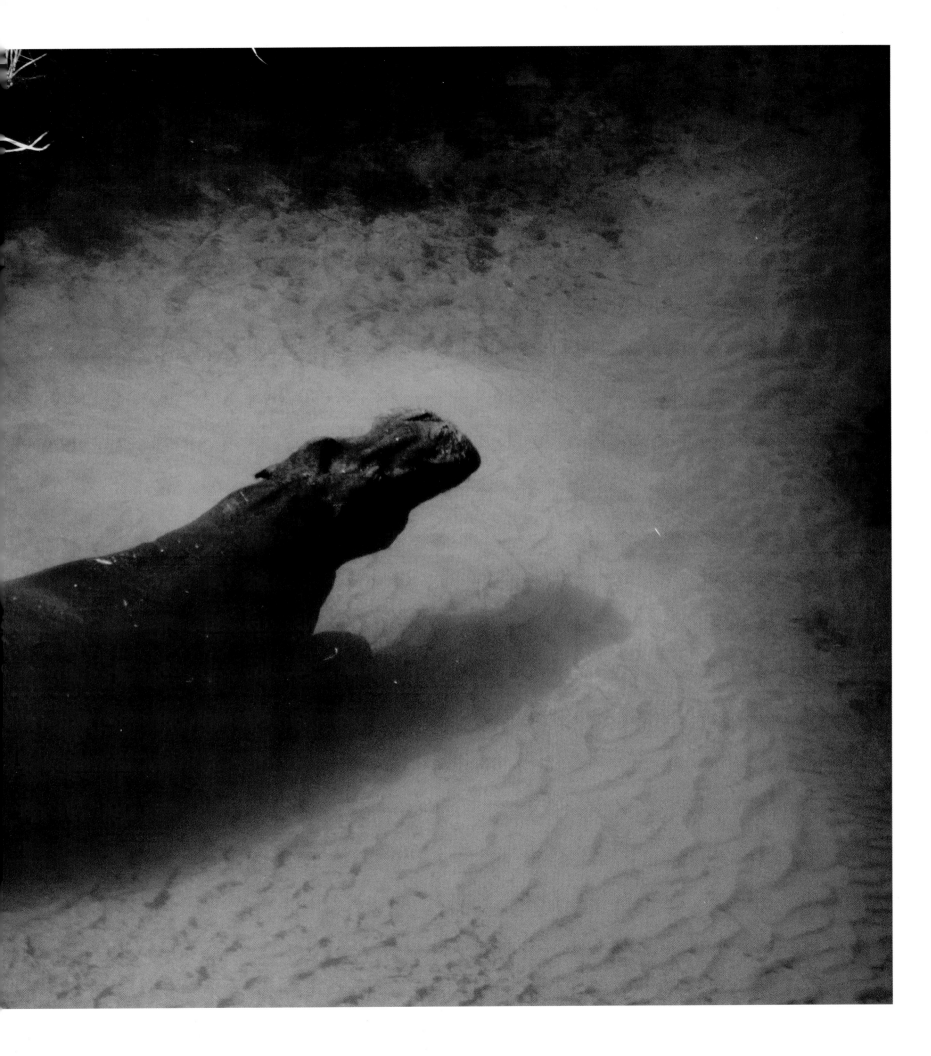

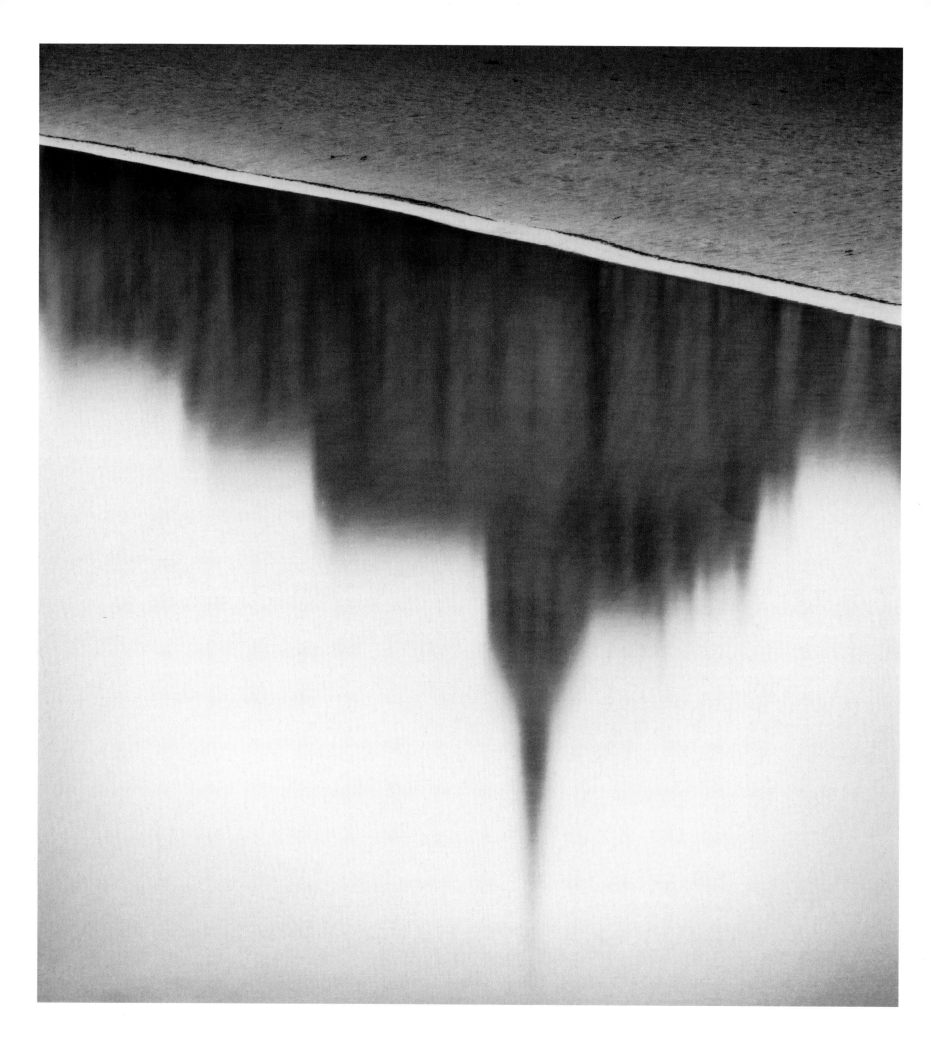

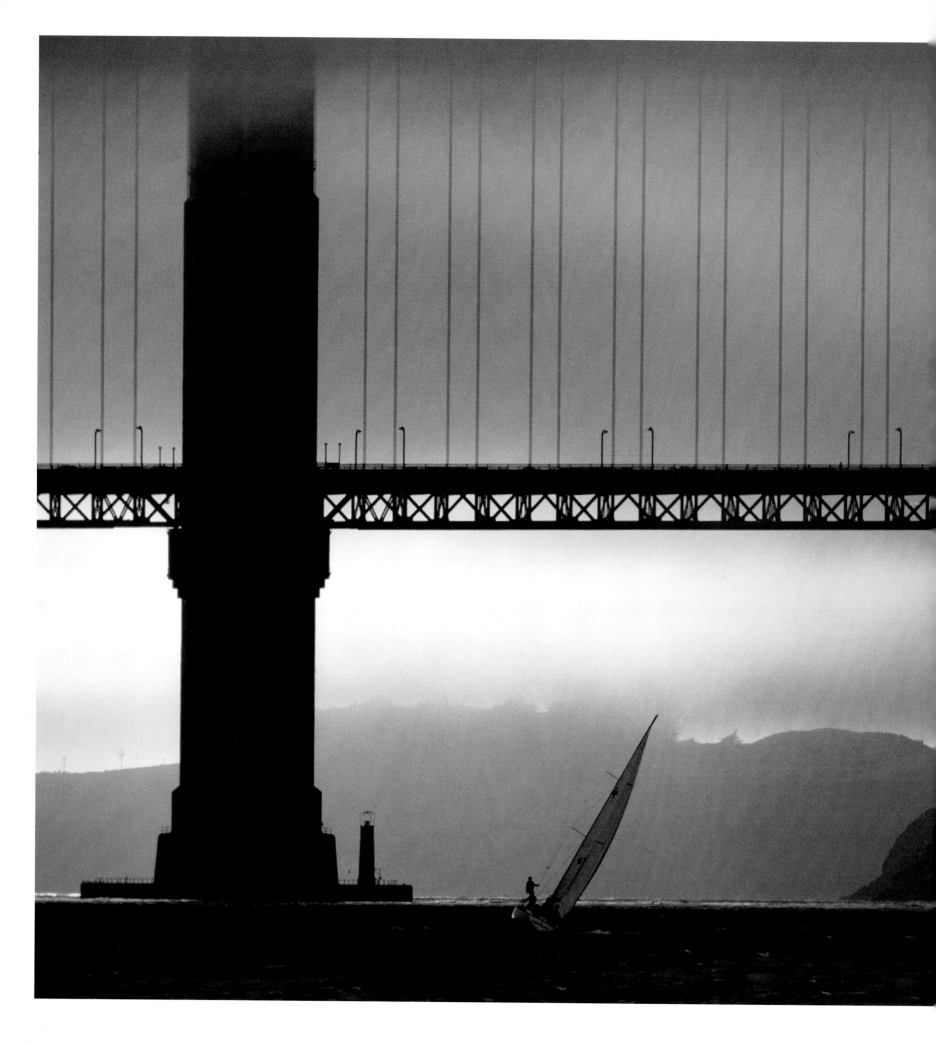

DAVID ALAN HARVEY

California | 1978

A sailboat glides on the waters of the San Francisco Bay underneath the Golden Gate Bridge.

AMI VITALE

Guinea Bissau | 2001

For six months, Ami Vitale lived in a small village called Dembel Jumpora documenting daily life. The boy in the foreground of this photograph, Alio, was diving into a tufe—a sinkhole for collecting rainwater—a sight she often found at the end of the dry season. On her last night she sat under a sea of stars talking with the children. Alio asked a lot of questions, such as "Do you have mango trees like we do?" Later that evening, he innocently asked her if she had a moon in America. For Vitale, it seemed so symbolic and touching that he should feel as if America were a separate world, and reminded her that we are all tied together in an intricate web on this planet, whether we believe it or not.

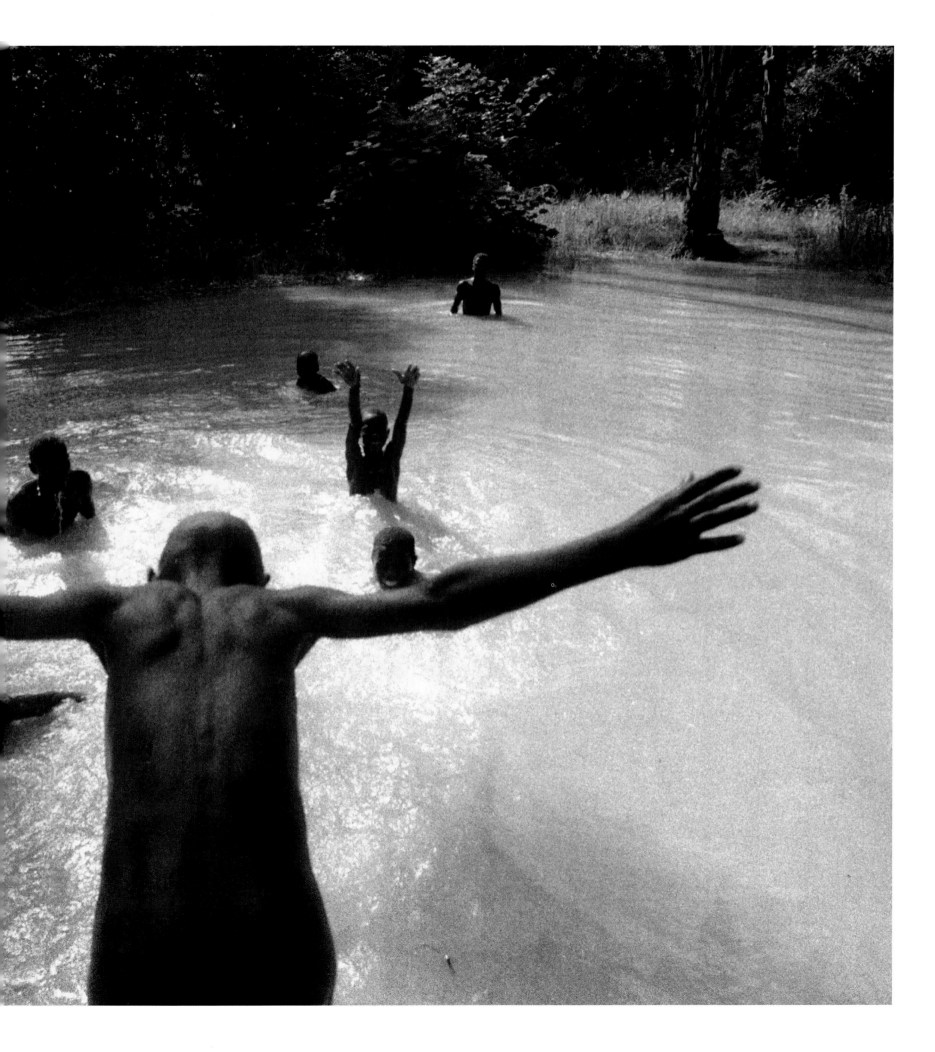

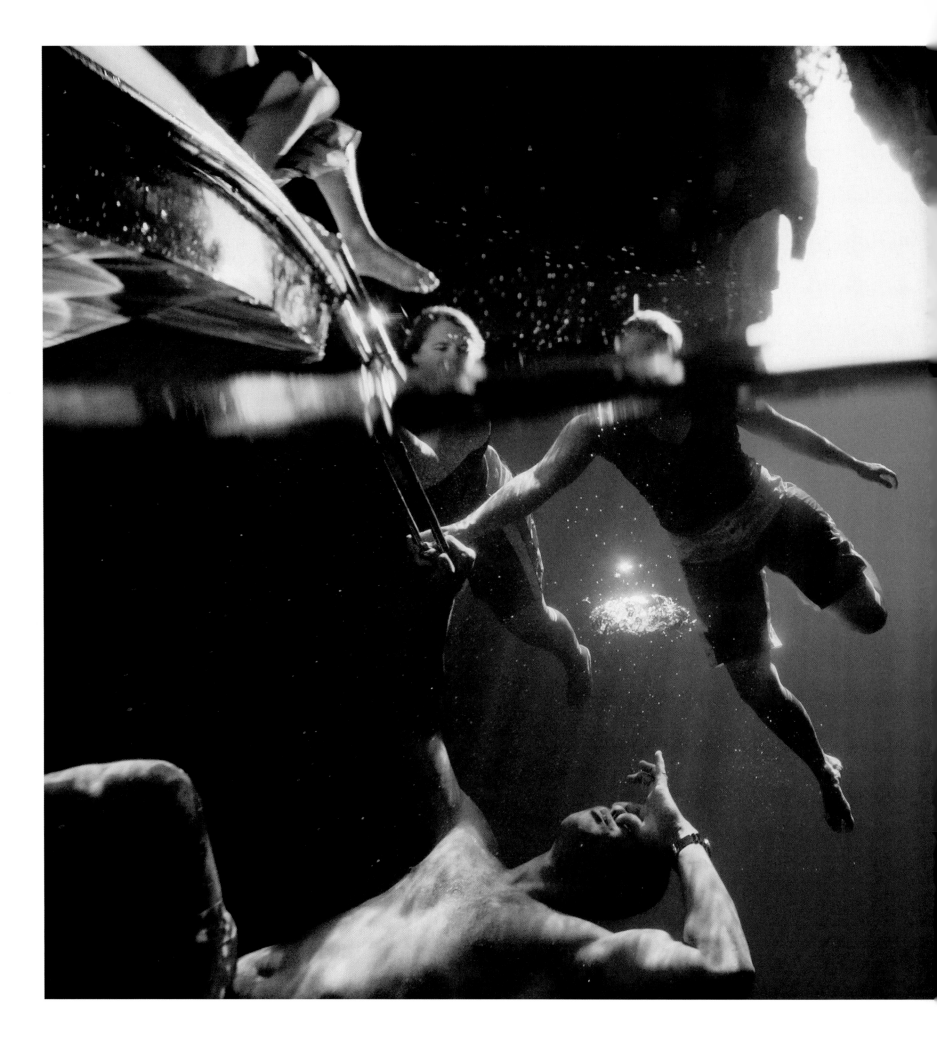

AMY TOENSING

Tonga | 2007

Swimmers enjoy the sparkling waters in Swallows Cave near the Port of Refuge Harbour on Kapa Island.

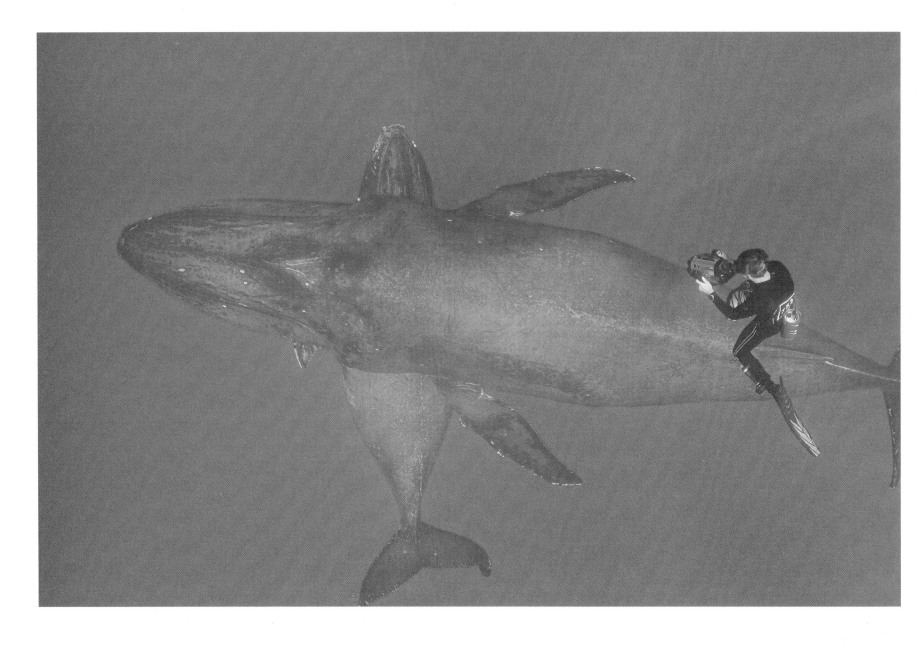

FLIP NICKLIN

Hawai'i | 2006

To reach Flip Nicklin, you will need his cell
phone number, because he'll most likely be
on a boat in the Au Au Channel near the West
Maui Mountains. He has been studying the lives
of whales in this place since 1979, and this is
paradise to him. "They are mythical, magical
creatures," he says, as he watches them swim
out to the open sea one afternoon.

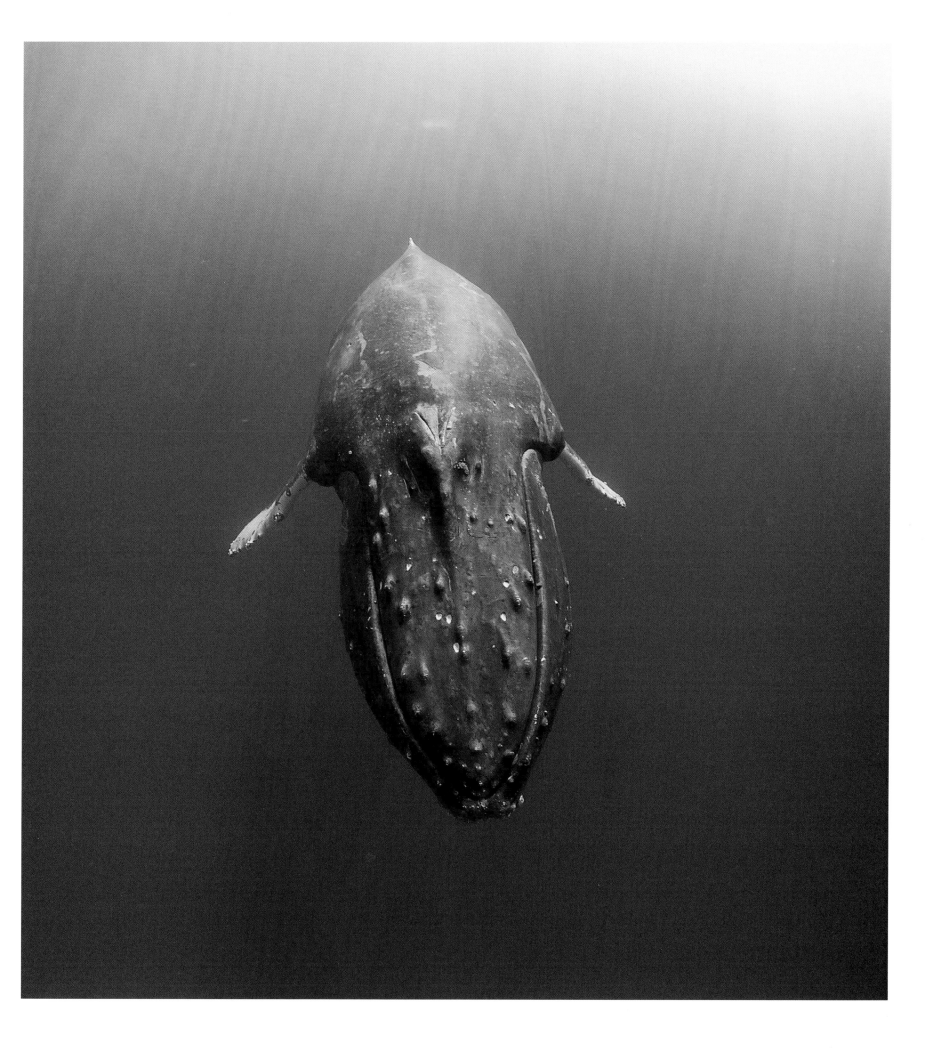

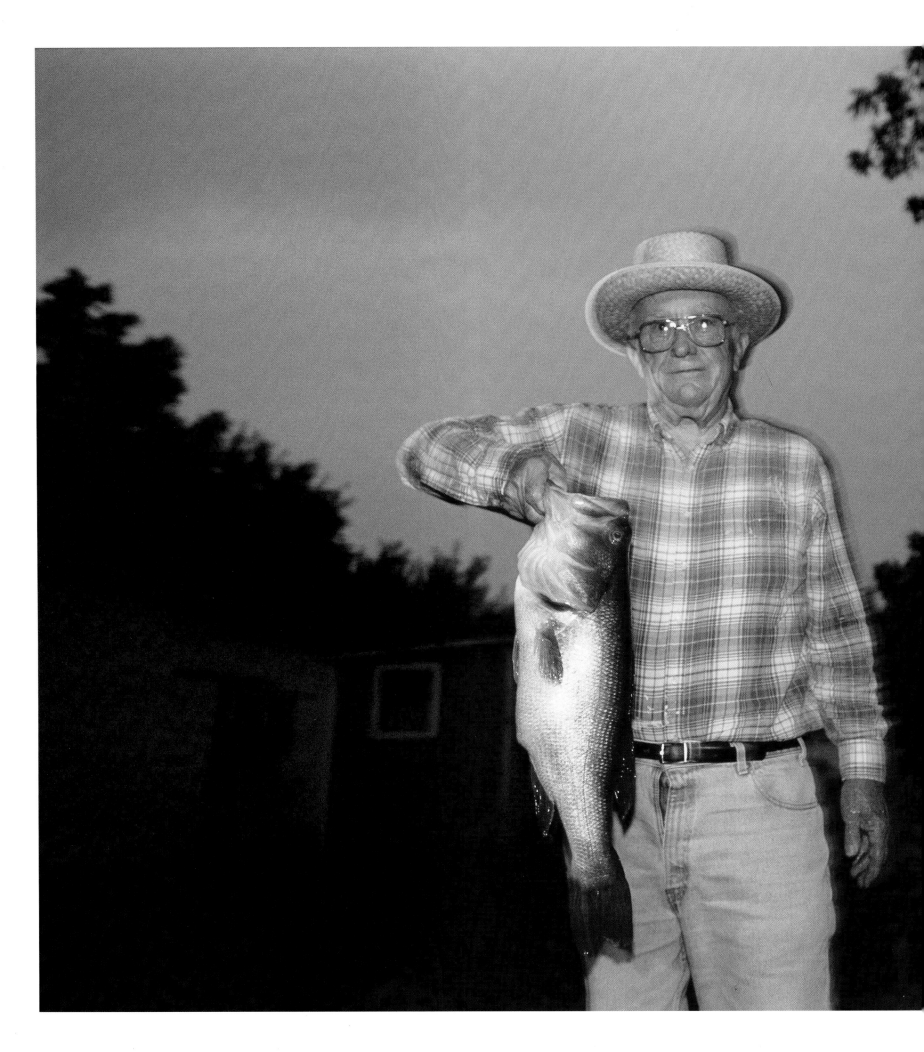

JOEL SARTORE

Kansas | 2000

Personally, paradise is this place and at this moment. That's my dad, John Sartore, standing in the backyard of his mother's house in Arma, Kansas. He normally hates having his picture taken. He made an exception that night though. We had gone fishing at dusk on a nearby strip pit (basically a pond that's left over from coal mining some 50 years ago). He caught a six-pound bass. That's huge.

My father and I had some of the best times of our lives fishing those pits. We never saw anyone else out there. It was just he and I and our little 8-foot Lund rowboat. We took turns at the oars. We hooked each other with top-water plugs. We watched quail and deer and otter along the banks. The air was thick and buggy and smelled like steamed leaves. Afterward, we fried fish and eggs in real butter and slept deeply, healthy and content, and satisfied in every way.

MICHAEL "NICK" NICHOLS

Arizona | 2005

A small creek is visible through some rocks in the Grand Canyon National Park.

next pages:
JAMES BALOG

Bolivia | 2006

As part of his upcoming Extreme Ice Survey, James Balog placed 26 cameras around the world to document the rapid melting of glacial ice. It is a project that he is incredibly passionate about, and this glacier is one of his chosen spots. At approximately 18,900 feet on Huayna Potosi in the Andes mountains, climbers work their way through crevasses and ice cliffs. These glaciers, nourished by snowfall, generated from the collision between air masses from the Pacific Ocean and the Amazon Basin, have lost, on average, about 20 inches of thickness each year over three decades.

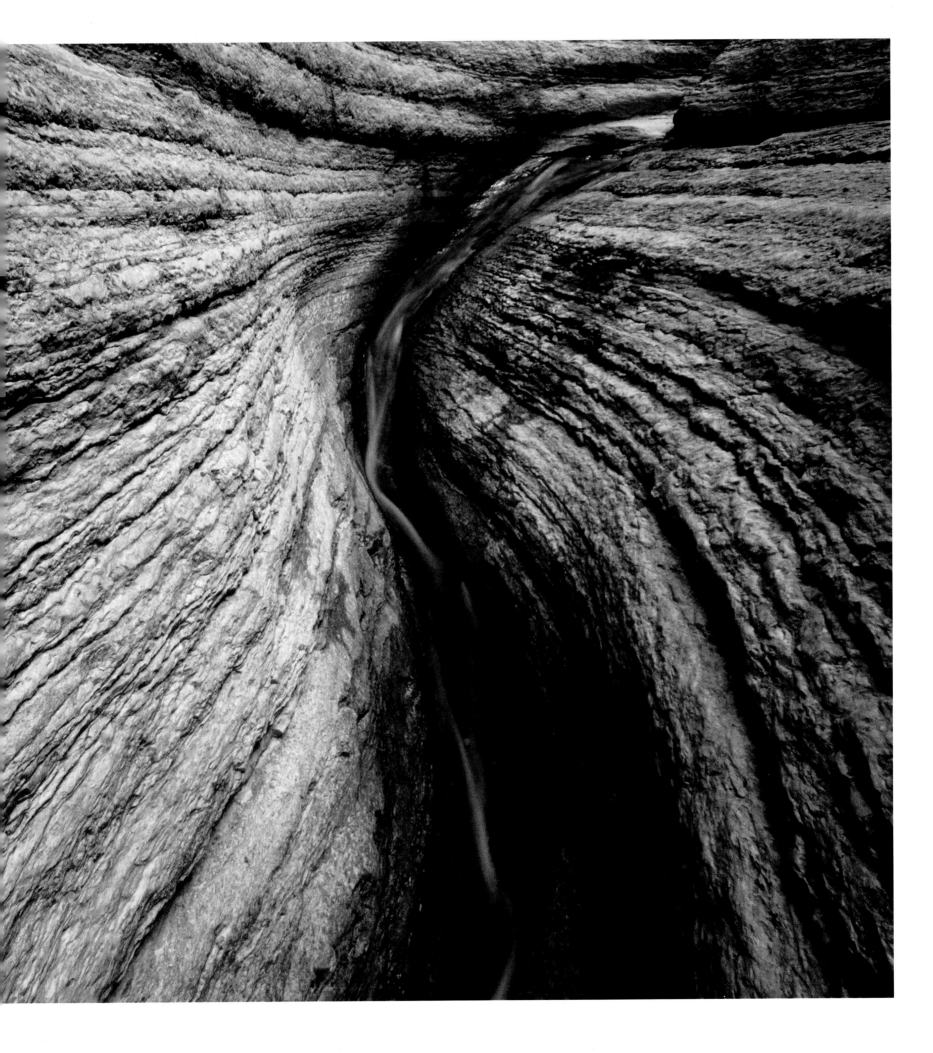

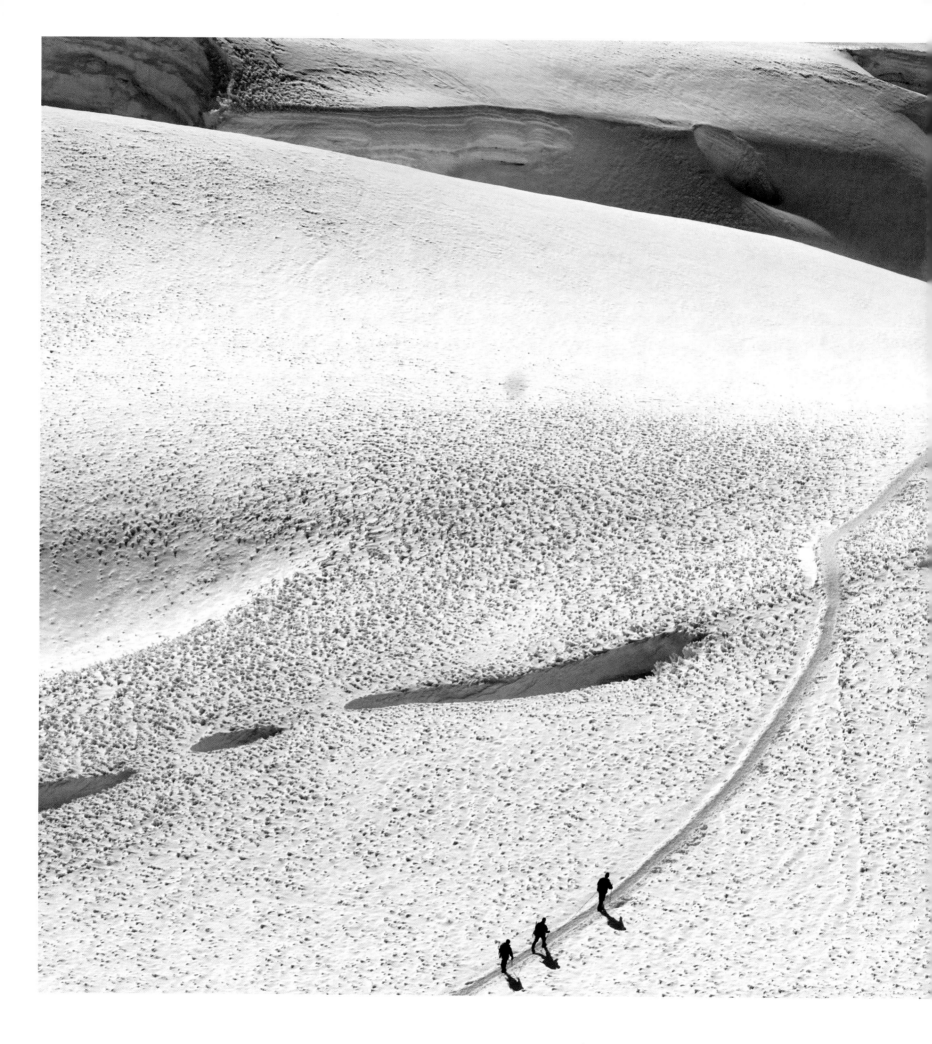

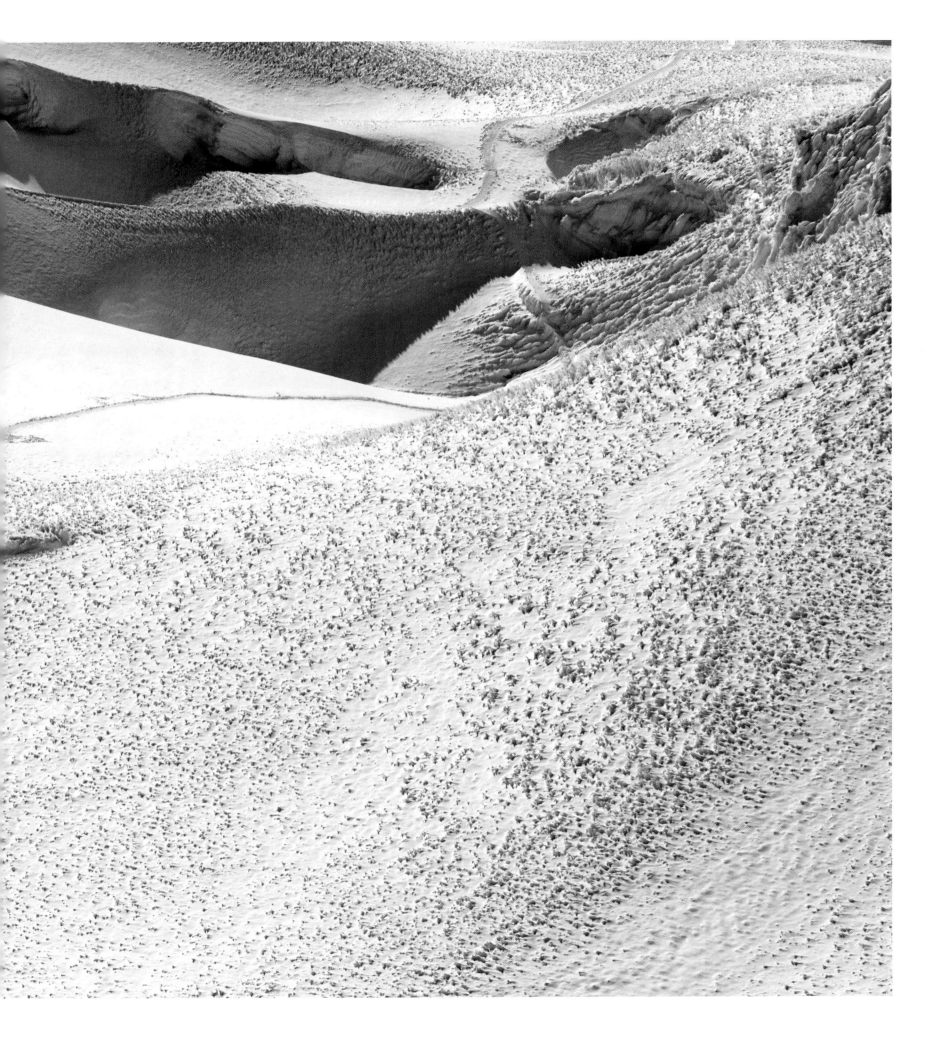

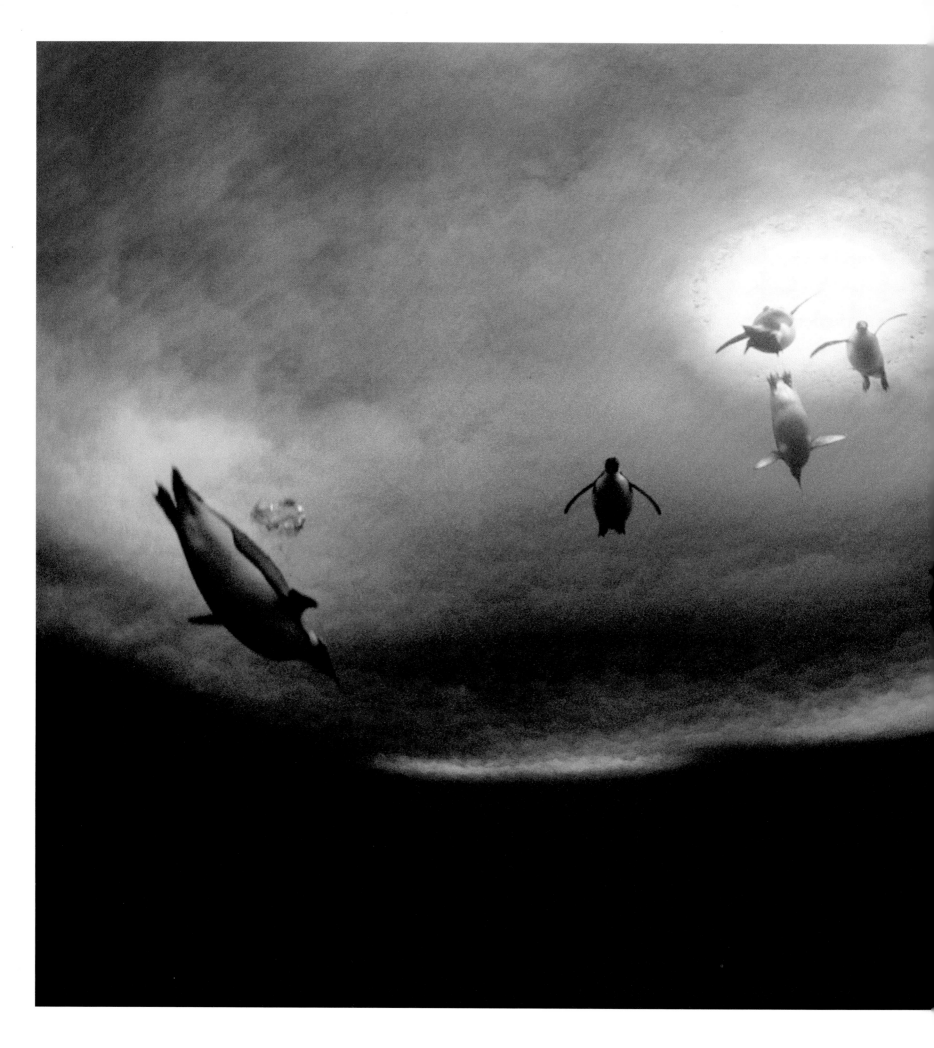

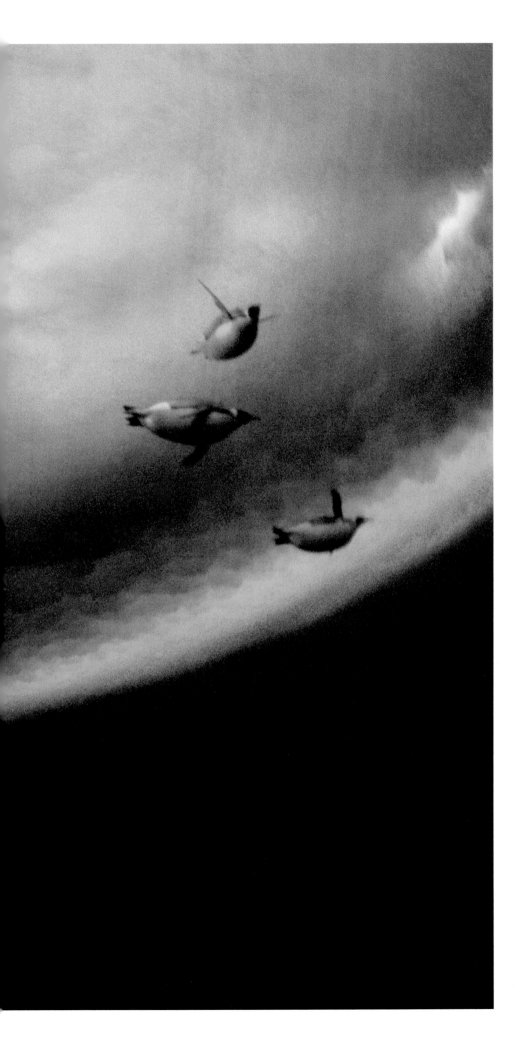

MARIA STENZEL

Antarctica | 2000

"The first time I was exposed to all that ice and no vegetation, it felt like I was on another planet," remembers Maria Stenzel who first traveled to Antarctica in 1995 to photograph a story on sea ice. She took this picture of penguins surfacing near an air hole from a remote camera underwater during her third trip to the region. "But now I think what I am doing down there is relevant. Each time I go there I take away a beauty, a realization that this place is really important to the climate of the Earth."

KAREN KUEHN

Hawai'i | 1999

Kuehn, who has lived in Yosemite, on the lower end of Manhattan, and now in New Mexico, chose the north shore of Hawai'i for her vision of paradise. "I surf," says Kuehn, "and I photographed a wave one afternoon just before sunset. It was the water. I felt transcended by that water."

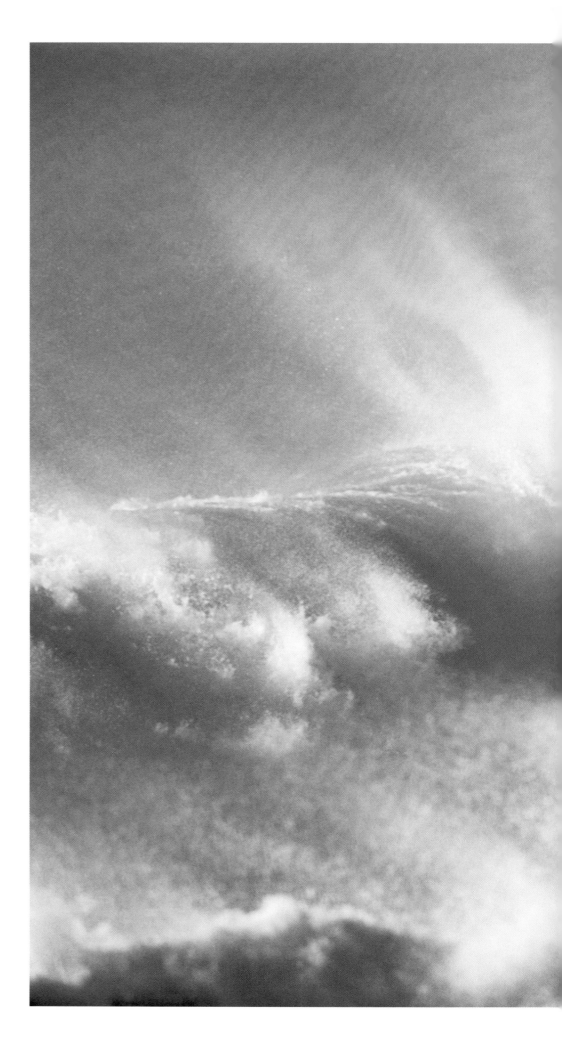

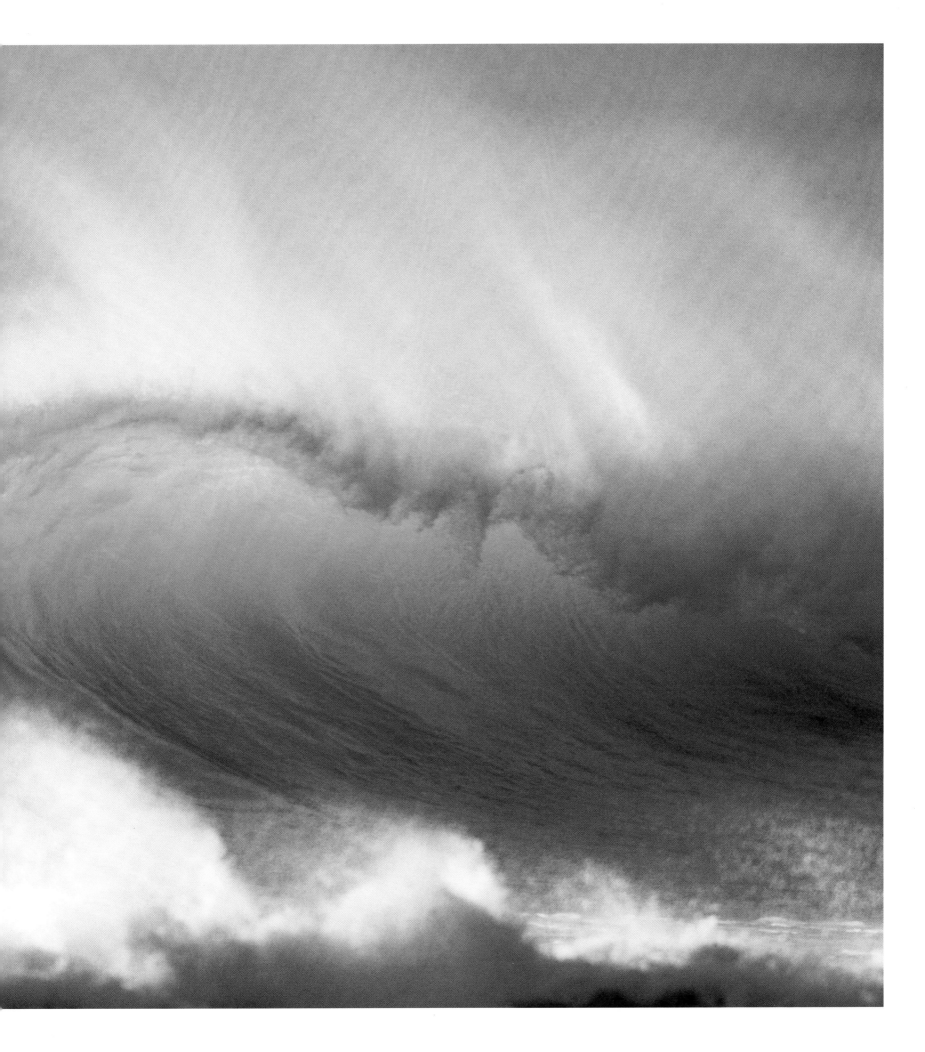

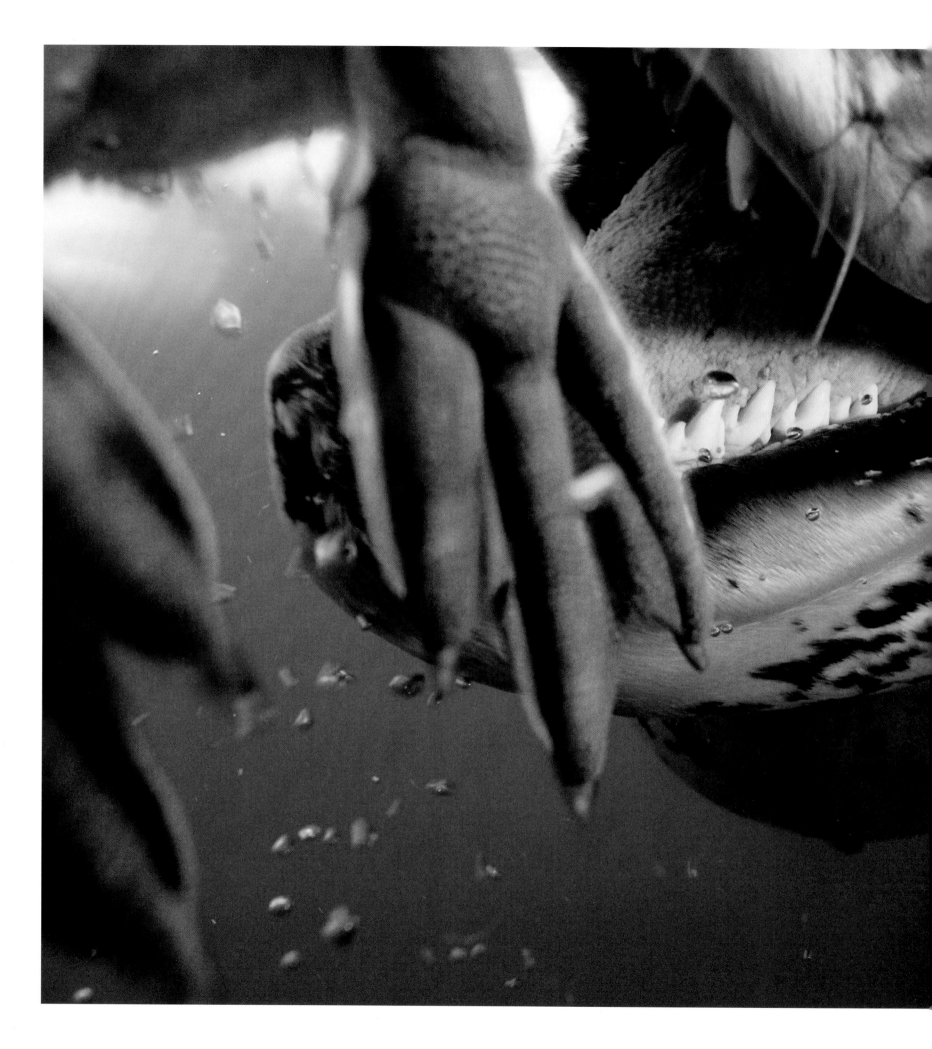

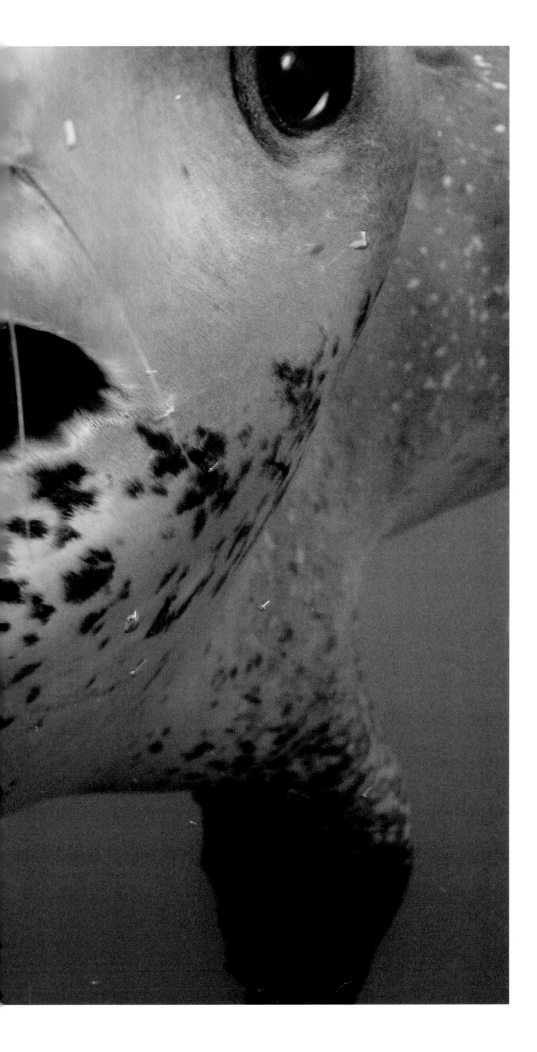

PAUL NICKLEN
Antarctica | 2006

The first time he encountered the leopard seal, Paul Nicklen hesitated to get into the water from the boat in which he sat. Leopard seals were rumored to be deadly and vicious. This seal, however, was just plain curious. The female approached Nicklen often. In this picture she offered him a freshly killed penguin—lunch to her, food for him. The next day she came back looking for him. "I was being cared for," he said.

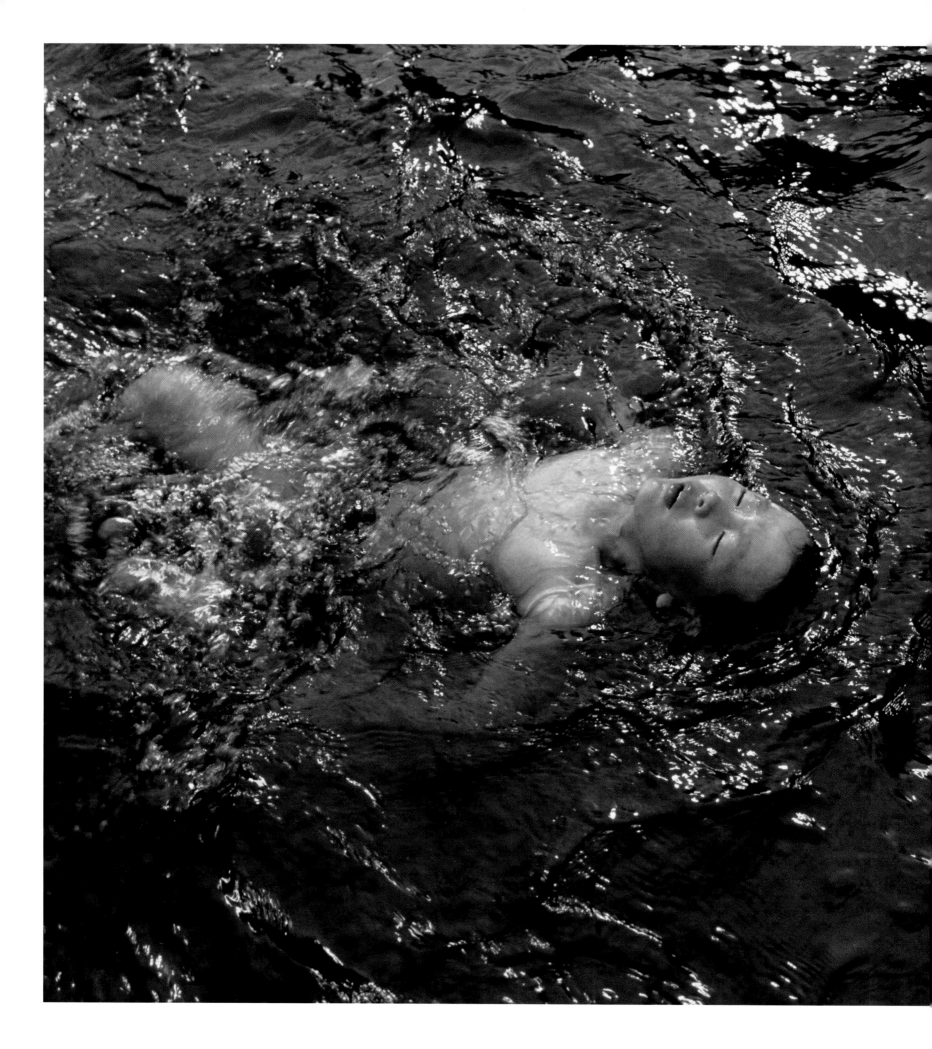

SISSE BRIMBERG
Tuva, Russia | 2000

A month living in Turan, Tuva Republic, was like a month revisiting her childhood in Denmark, Brimberg said. "In the evenings, everyone would gather to greet the cattle as the animals walked across the range from where they had been grazing that day. There was a whole enjoyment of a very simple life. This boy was going into the water, which was so very cold but he loved it."

NICK CALOYIANIS

Arctic Ocean | 1995

It was May, a time of year when the Arctic Ocean begins to warm up just enough that an eight-inch ice sheet can crack and send a thunderous noise through the depths below. Filmmaker and photographer Nick Caloyianis was running out of battery power, and he felt lightheaded after floating for two hours in the 28°F ocean waters. "I felt fragile because of the environment," remembers Caloyianis, who is always aware of the possibility he may not reach the dive hole or be able to pull himself out if he waits too long and his muscles fail him. But he had missed his chance to look for the Greenland shark in the more obvious locale of Arctic Bay, off Nunavut, Canada, so he had weathered a series of bad storms and a trek over the mountain to nearby Victor Bay on a hunch. Both of his fellow divers, Adam Ravitch and Clarita Berger, had already surfaced.

Then he saw a shadow. He swam toward it, slowly recognizing the languorous movements of a large fish in the impossibly black, clear water. He spun around and around to make sure there wasn't a shark behind him or beside him as he kept his eye on the fish swimming toward him. As the 14-foot-long Greenland shark passed by him, he ran his hand along the gelatinous skin. From years of studying sharks, Caloyianis knew the shape and size of the Greenland shark's mouth. He knew it was capable of biting down hard and sucking its prey. He knew that his professor, Dr. Eugenie Clark, once told him these sharks were slow, their primitive looks an indication they may have evolved from an ancient deep-water species. When the shark began to show an interest in him, Caloyianis rapidly backpedaled and surfaced through the diving hole. "I found the shark!" he yelled to his teammates.

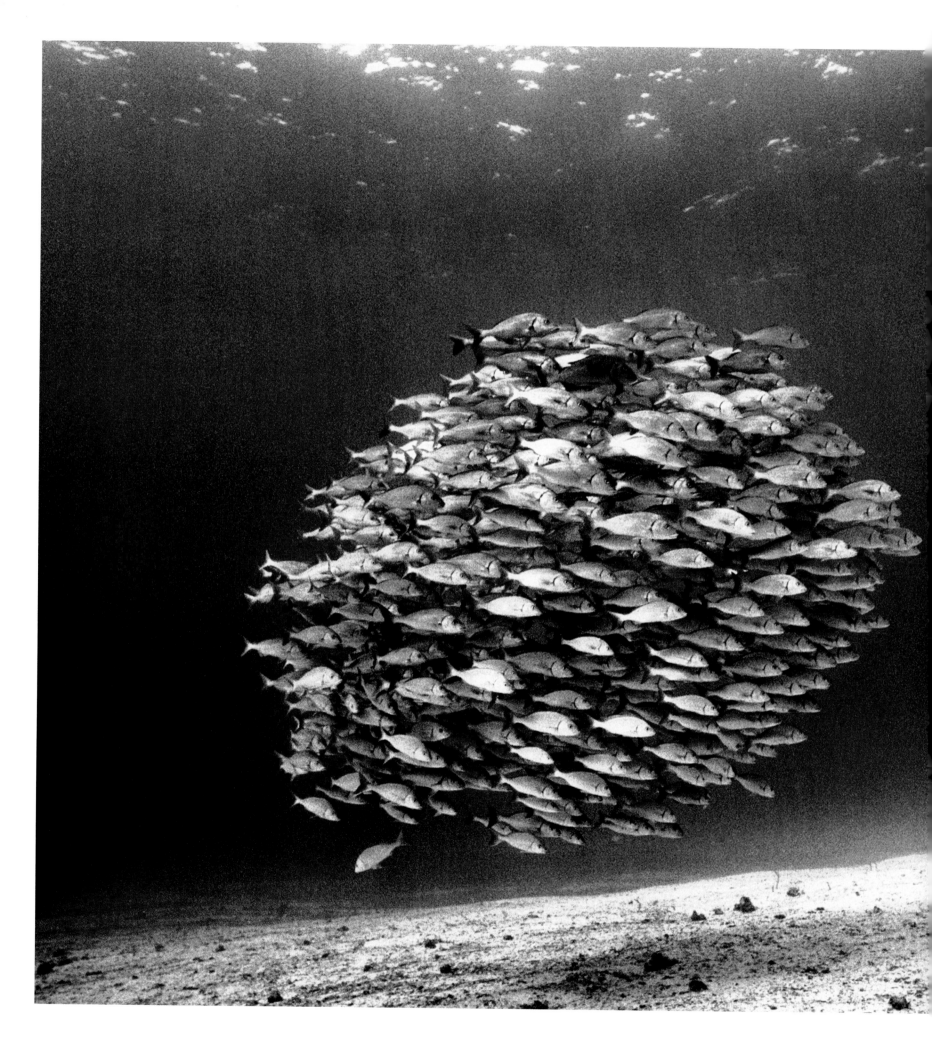

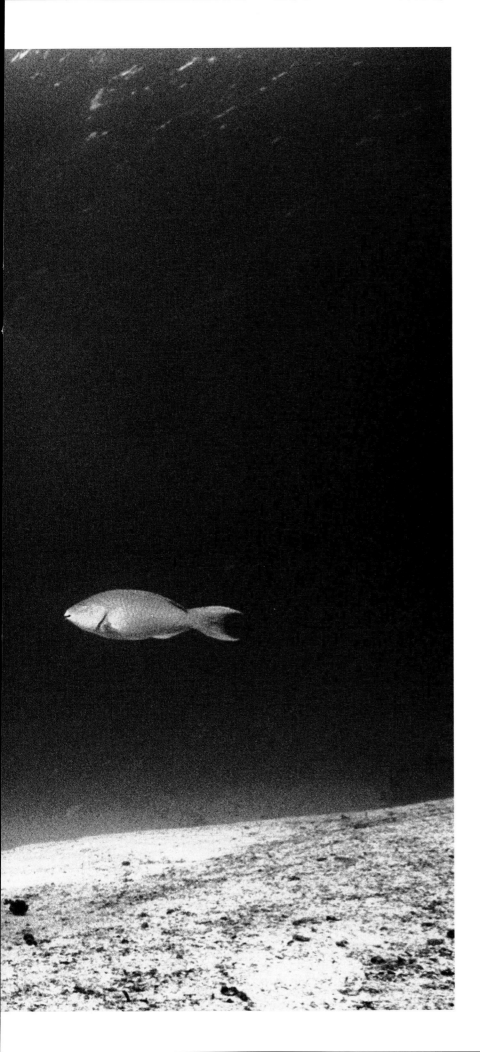

DAVID DOUBILET
Underwater | A lifetime

Oceanographer Jacques Cousteau once said that when he was a boy, he dreamed of flying, but when he started going underwater, he never had those dreams again. For David Doubilet, the lifelong urge to drag cameras and lights below the waves has been about the chance, not only to experience some of the most diverse ecosystems on the planet, but also to capture a world even his parents' generation rarely had the chance to see. "Before, the sea was a skin stretched over the planet; it was an environment like the moon," says Doubilet. "Now you can come face to face with creatures that have been unknown."

His passion has taken him around the world during the last 50 years: to the crystalline coastal waters of Cuba, where he came face to face with a batfish (next page); to the North Sound of the Cayman Islands, where he sat one evening waiting for the stingrays to swim along sand that was freshly raked by the ocean waves; and to the waters right outside the Kona Beach Hotel in Hawaii, where manta rays routinely sweep their gilled mouths through populations of mycid shrimp drawn by the outside hotel lights. When the Grey grunts formed and reformed themselves into a perfect chandelier suspended in the waters off the Galapagos Islands (left), Doubilet found himself watching for things that have a strange mathematical equation to them, an unusual composition. He didn't know the moment would appear after a parrotfish munching a piece of coral ambled by. "It's a street scene, a meaningless moment," says Doubilet. But it's a beautiful picture.

next pages: David Doubilet

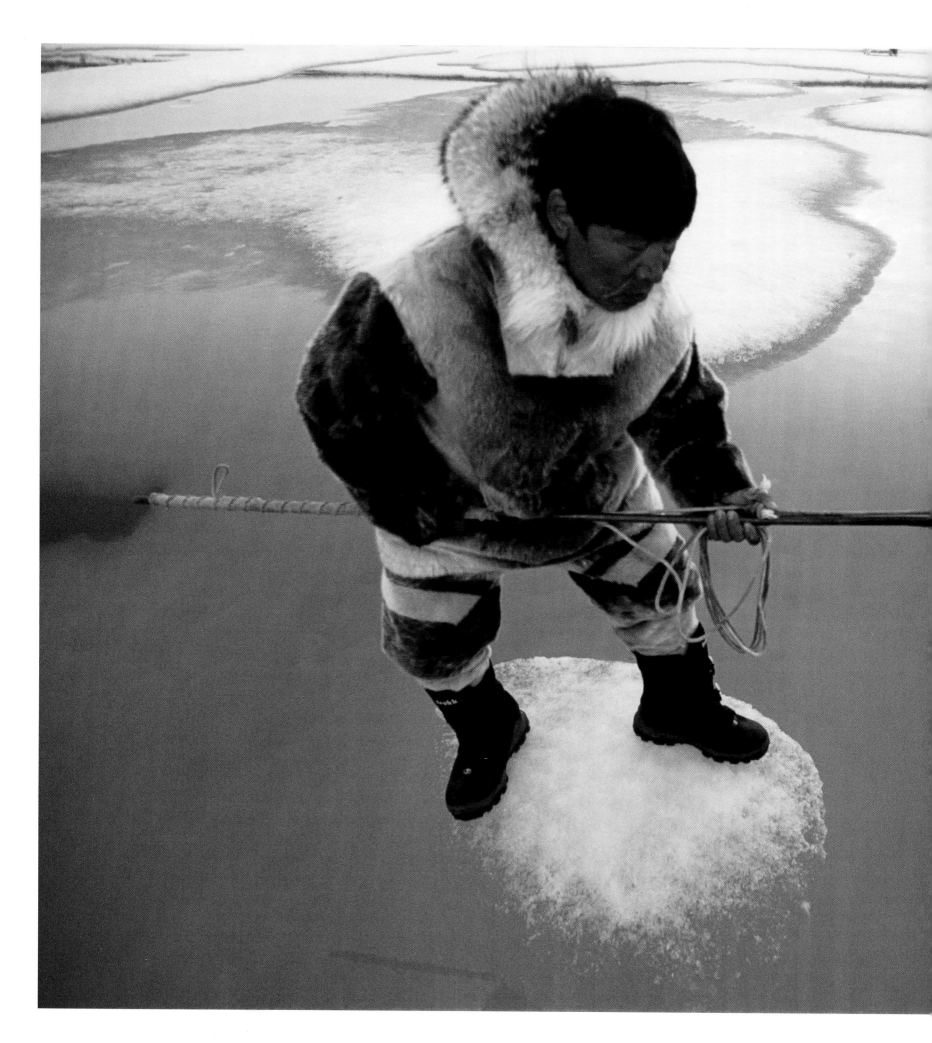

GORDON WILTSIE

Baffin Island | 1998

Jayko Apak, an Inuit man from the village of Clyde River, taught Wiltsie how to hunt ring seals with a spear the same way his ancestors taught him. To Wiltsie, this is paradise because the Inuits are reliving tradition in a beautiful place. "It is the most gorgeous place, the frozen Arctic ice," says Wiltsie, "and you see this incredible panoply of life. Polar bears, narwhals, seals, birds, walruses, and fish. It's just incredible."

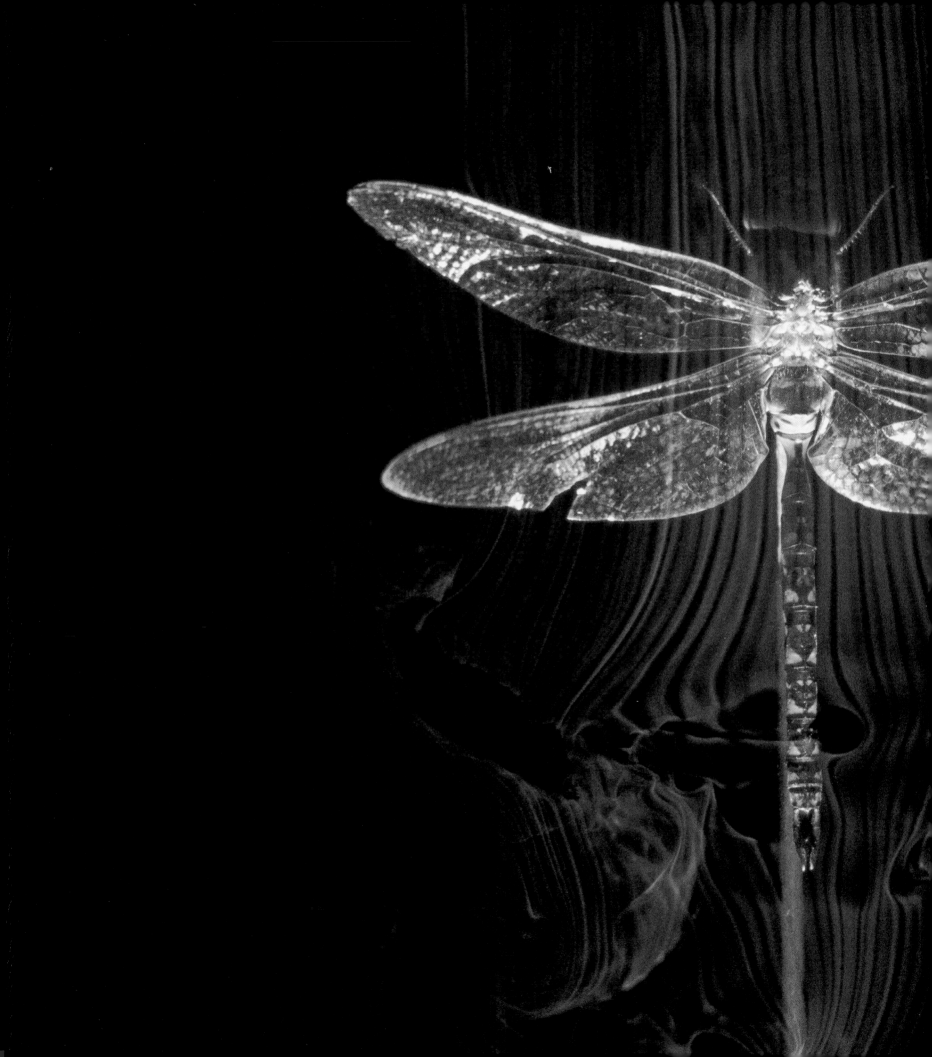

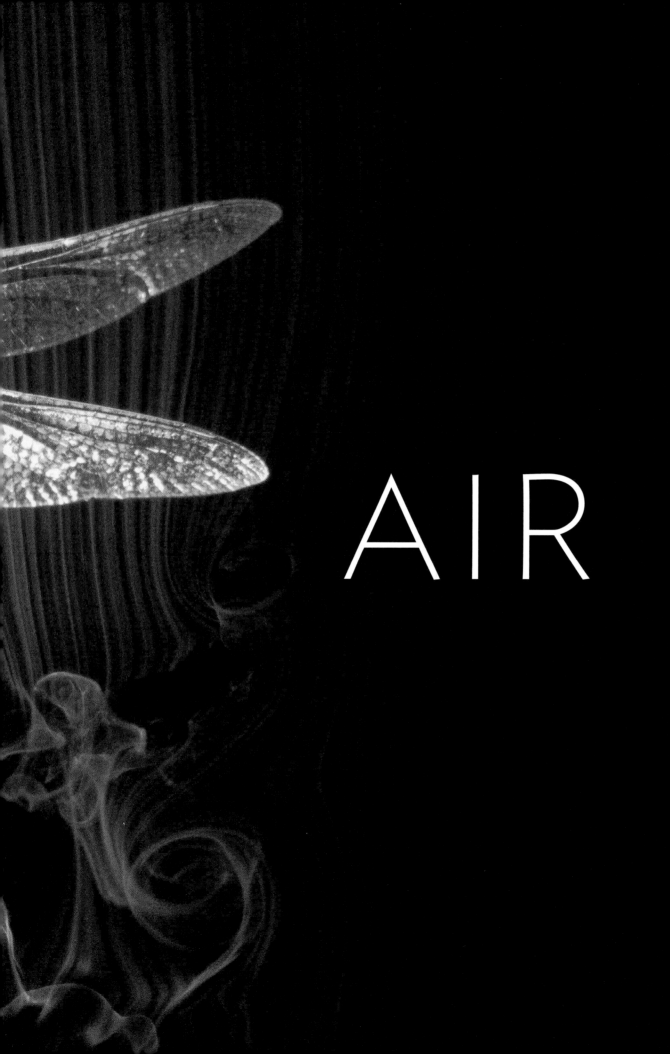

AIR

Brian Doyle

WHAT THE AIR CARRIES

QUESTION: What weighs five quadrillion tons, but you cannot see hide or hair or hint of it?

Answer: Guilt, responsibility, fatherhood, sorrow, love, history ..., but here I mean that most crucial of freighted invisibilities, air, the atmosphere, *our* atmosphere, the incredible blanket from which we breathe, without which our sphere is only another among zillions of lifeless rocks let loose in the endless void. Five quadrillion tons! The parade of zeroes like a circus train behind the engine of the five: 5,000,000,000,000,000.

Air heats and cools, expands and contracts, it is always in motion, and we have spent many thousands of years measuring its motion in words: British sea captain and scientist Sir Francis Beaufort's 1906 scale describes winds in lines of terse poetry, from Beaufort Number 1 *(smoke rises vertically)* to 5 *(small trees in leaf begin to sway, crested wavelets form on inland waters)*, 6 *(umbrellas used with difficulty)*, 9 *(chimney pots and slates removed)*, and 12 *(devastation)*. Or the Smithsonian Institution's 1870 wind scale, citing *a light breeze which sometimes fans the face*, and *a wind that somewhat retards walking*, and *wind that sometimes carries light bodies up into the air.* Or the American physicist Theodore Fujita's 1971 tornado scale, which lists the effects of winds between 113 and 157 miles per hour as *mobile homes demolished, boxcars pushed over, light-object missiles generated*, and for winds between 261 and 318 miles, *trees debarked*, a chilling phrase. Or a 2002 emendation of the Beaufort scale by a wag in Savannah, Georgia, measuring wind power by its effect on lawn furniture: force 11 *(lawn furniture airborne)*, a riveting phrase.

The descriptions make you want to invent your own scale, doesn't it? *Breeze at the beach with sufficient salt to make your eyes water and give you an excuse for the tears that came as you were thinking about your mama's last hours and the way she winked at you right at the end and made you laugh and sob,* or

bracing wind felt upon stepping out the front door of the hospital with new son clamped in your right arm like a moist mewling football, or

wind tart and adamant enough to rattle spectacles in hugely distracting manner while you are down on one knee stammering out a marriage proposal, or

breeze so gentle and insistent and pleasurable that you find yourself grinning and humming for no reason other than you are actually miraculously alive in this bruised and blessed world

The wondrous vocabulary of the air, all these words for wind, from breeze to zephyr. There is the sirocco, which arises in Africa and blows west to the Atlantic Ocean. There is the chinook, which arises in the Rocky Mountains and blows west to the Pacific Ocean. There is the monsoon, the wind rife with rain that blows all over the world. In Alaska there are winds called *knik, matanuska, pruga, stikine, taku*, and *williwaw*. In Asia there are winds called *aajej, datoo, ghibli, haboob, harmattan, imbat, khamsin, nafhat*, and *simoom*. There are tornados and hurricanes, storms and squalls. There are the Santa Ana winds of California that, noted Raymond Chandler, "curl your hair and make your nerves jump and your

skin itch … meek little wives feel the edge of the carving knife and study their husband's neck. Anything can happen."

What the air carries: albatrosses, bullets, currents, dust, electricity, moans, neutrons, regrets, sunlight, titmice, water, x-rays.

Air is a composition, a stew, a motley gaggle of gasses. Wherever you are on this particular rock, the air through which you move is about 80 percent nitrogen and 20 percent oxygen. There's a little argon, and a shred of carbon dioxide, and infinitesimal traces of neon, helium, krypton, hydrogen, xenon, ozone, and radon, but most of what your body slides through and what slides through you is nitrogen, a gas hatched inside stars and mailed to us through the airless void by an unimaginable postal service.

A woman I know breathed life back into her infant daughter. The baby stopped breathing, and the father sprinted to the phone and emergency and expertise, but the mother bent desperately over her baby and locked lips and breathed, the air throbbing through the lungs of these two beings as joined as joined could be, and after a moment the baby's eyes flickered, and her lungs staggered awake again, and she hauled in the holy air with a convulsive sob. Talk about your resurrections.

What the air carries: airs, ballads, curses, darts, effervescence, flying fish, guffaws, hilarity, hissing, irritation, jokes, kingfishers, quarks, rhythms, sibilance, soil, tittering, ululation, vowels, whispers, xylophone parts flung in utter exasperation, yowls, zest.

You can buy air, sell it, rent it, lease it, lend it out, claim it, refuse and deny its use to others. Among nations and urban planners and developers, air is a commodity, a thing measured in footage and mileage and meters. Some air space is greatly coveted: the whirl of wind over what used to be Iraq, the haunted air over what used to be the World Trade Center in New York City. Seven months after the towers were destroyed and the thousands of men and women and children in and among them murdered, two artists and two architects arranged two banks of searchlights nearby and fired two towers of light into the air every night for a month. The lights rose a mile high and could be seen nearly 30 miles away.

QUESTION: Why is it that what we need most—air and water—is what we take most for granted?

There is air in water. There is air in soil. There is air in ice and in rock. Sometimes air is trapped for millions of years in ice and rock or amber. One study of air trapped in the amber of an extinct pine tree found air bubbles 80 million years old. The scientists who examined the air were startled to discover that it had twice as much oxygen as air does today. Does twice as much available oxygen mean beings can grow twice as large? Does more air explain dinosaurs? If we had twice as much oxygen would we be twice as smart?

There is air at the bottom of the sea, inside incalculable creatures six miles deep, viperfish and dragonfish, fangtooth and loosejaw, eelpout and bobtail. There is air in the bar-headed geese who fly

over the Himalayas in their travels. There was a lot of air in the largest flying creature ever, the pterosaur *Quetzalcoatlus,* three times bigger than your car. There is air in the bee hummingbird, smaller than your thumb. There are some two million species of creature on this Earth, and there have been perhaps ten million others, and every one swam in the invisible miracle, and needed it to live, and moved in it with grace and power. Such a generous thing, air.

How was air born? One theory is that sunlight and lightning acted upon water vapor in such a way as to elicit the first gases, on which sunlight and lightning acted to elicit more gases, and the gases acted upon each other in such ways as to allow for living beings made of gas and light and water. The short answer to the question: No one knows. The long answer: There are more things mysterious and miraculous between heaven and Earth than we will ever know in a million years.

Air is an endangered species. We know this, but we ignore it. We nod in agreement when we hear or read something chilling and piercing about increasing poison in the air, but we do nothing. We know beyond the shadow of a doubt that cars and furnaces and factories belch poisons into the air and into our children, choke plants and animals and those we love, but we do nothing. We know poisons in the air are "ferocious volleys of lead fired into us all," as the Uruguayan writer Eduardo Galeano said, but we do nothing. We issue words in vast webs into the air, opinions and commentaries, white papers and debates, seminars and symposia, transcripts and testimonies, and we do nothing. If ever we all at once stopped fighting about the names of God and the color of money, and beamed our

lasered attentions on clean air and clean water, we could make a new world as clean and brilliant as a baby. But we do nothing.

I was once a basketball player, years ago, when I was young and supple, and nothing gave me as much joy as floating into the air, which is maybe why I wasn't a productive basketball player. More than anything I wanted to soar to the rim, inventing a shot along the way, or sail into a play to snare a rebound or block a shot, and you never saw a guy so liable to pump fakes. On the break with the ball, one defender to beat, a quick crossover dribble to mess up the defender's feet and then away up into the air where anything and everything was possible, where bodies were closer to the light.

I was asthmatic as a boy. I spent many nights as thirsty for air as a fish is for water, gasping in the dark, trying to stay calm, trying not to call out for my dad. One of my sons is asthmatic. I have spent many nights listening to his lungs. He hauls in the ragged air with a desperation so intense I think my heart will explode. So many of us so hungry for the wild food of the air.

The air has no end, atmospherically speaking; no one knows quite where the air ends and airlessness begins, which pleases me for murky reasons. Above the Earth is the troposphere, about 11 miles high, and then the stratosphere, about 30 miles high, and then the mesosphere and ionosphere, together more than two hundred miles high, and then what is called the plasmasphere, or hydrogen cloud, which sails off into space for thousands of miles. No one has ever been able to measure officially where it ends and where outer space

as we know it begins. Isn't that cool? We think we know so much, but we really know so little.

The first gasp from an infant in any of the million species on our planet is air. So is the last exhalation of those returning to dust and salt and starlight. Gasps of shock and surprise. Laughing so hard you have to bend over and gulp air. The propulsion of air in annoyance and exasperation. The deep gulp you take before plunging under water. The steady throb of breathing in sleep.

Children leaping into pools, surf, sandboxes, puddles, predicaments, puzzles, passions; swimming through the air, windmilling their arms, their hands cupping air like water; I never tire of watching kids at the beach, on playgrounds, in games, leaping into the air as easily and unconsciously and lightly as leaves. A man or a woman work at getting into the air and need a reason for flight—despair, destination, destruction—whereas a child is at home in the air and will leap off a branch or a bicycle or a bed for no reason whatsoever but sheer mammalian zest. Remember that as a species we are just recently down from the trees, said the writer Peter Matthiessen, and I wonder sometimes if we thirst unconsciously for breezes against our bodies, wind in our hair.

What the air carries: arrows, bees, curlews, ditties, ethereal melodies, flickers, golf balls, hurrahs, ibex, jacaranda petals, quivers and shivers, rubaiyats, sonnets, terzanelles, the shudders of udders, villanelles, wails, xenophobic rants, yips, the rumble and grumble of zebras as they bed down for the night.

Air in words: "I inhale great draughts of space, the east and the west are mine," said that greatest of American poets, Walt Whitman. "Drink the wild air," said Ralph Emerson, our worst essayist and greatest aphorist. "Poetry is the journal of a sea animal living on land, wanting to fly in the air," said Carl Sandburg, a fine poet forgotten. "I just put my feet in the air and move them around," said Fred Astaire, who flew. "This land, this air, this water, this planet, this legacy to our young," said the late Paul Tsongas, candidate for president of the United States. Do you think that we will ever listen?

A musician friend says the reason why so much popular music is in 4/4 time is that it's the harmony of the heartbeat. We have a natural rhythm, an interior melody. He estimates that hominids have been making songs to that beat for maybe half a million years, and that there have been maybe a hundred billion hominids in these last half million years, and that every one of them have hummed and sung songs to that beat, so that if you estimate that every human of every evolutionary stage along the hominid highway has sung a thousand songs, which is a reasonable guess, considering that everyone whether they can sing or not launches a song into the air every week, then we arrive at a sextillion songs, based on the beat of the heart. My calculations could be off; it could be more like a quattuordecillion songs, but you get the point.

Brian Doyle *is the editor of* Portland Magazine *at the University of Portland, Oregon. He is the author of nine books of essays and poems, among them* The Wet Engine, *about the "musics & muddles & mysteries & miracles of the heart."*

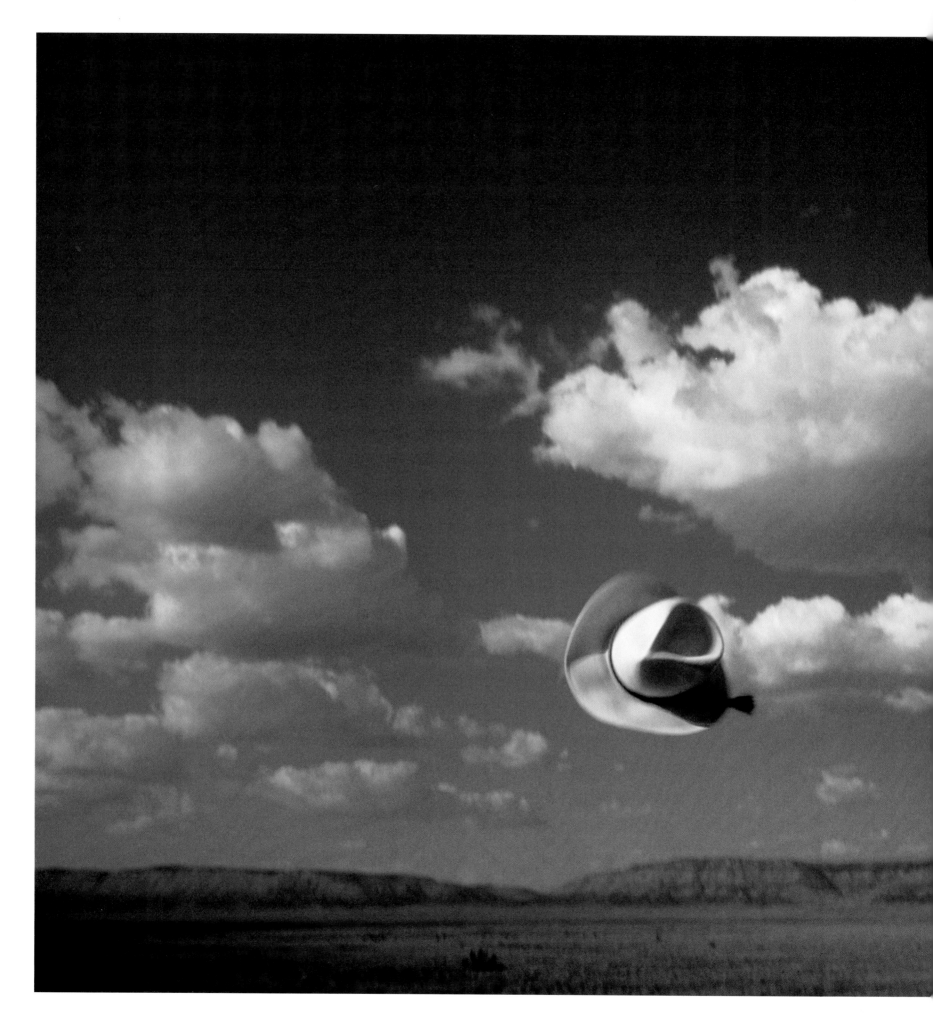

VINCENT J. MUSI
Arizona | 2000

People ask me all the time where my favorite place is, and I inevitably respond that it's the place I haven't been to yet.

next pages:
JOSÉ AZEL
Malaysia | 1989

To get to the top of Mount Kinabalu in the Kinabalu National Park by dawn, you must start the trek at 3 a.m. Even in the darkness the rich biodiversity of trees and plants, for which the area is known, are evident. The bottom of the mountain is a tropical rainforest, but the temperatures at the top can be ice-cold. "When I got there, it was still dark, and the clouds were sitting on top of the mountain," says Azel, who has always found peace on mountaintops. "What you are seeing here is daybreak, as the sun and the wind begin to disperse the clouds."

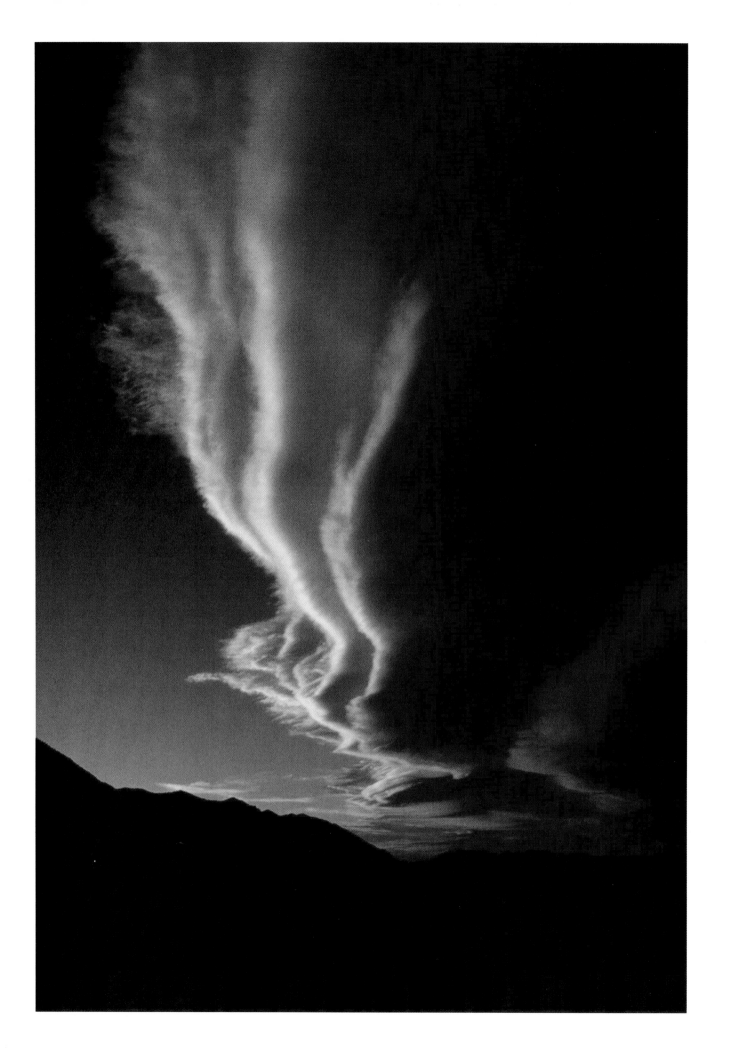

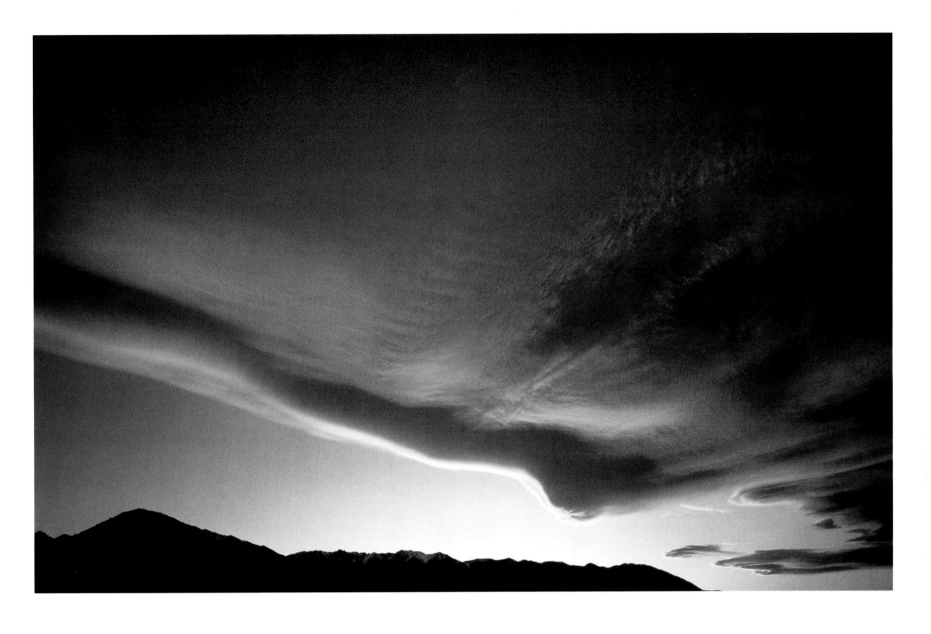

GORDON WILTSIE

California | 1975

Here in Owens Valley is where photographer Gordon Wiltsie was born. "The geographic diversity of this place has always amazed me," says Wiltsie. "It has Death Valley, some of the oldest trees in the United States, the deepest valley in the United States, Mount Whitney, and Yosemite. Sometimes I can't believe I left."

On a recent trip back, he photographed the lenticular clouds again, formations created by brisk air currents running over rough terrain, as he worked. "They look like wings of God to me," says Wiltsie.

CHRISTOPHER ANDERSON
Latvia | 2003

While wandering the beaches in Latvia, Chris Anderson noticed that a lone beach ball kept appearing in his photographs. "It was just there on the beach. I didn't even see to whom it belonged," says Anderson. "Everyone was having fun, and I felt a little ridiculous wandering the beach alone with a camera. Guess I felt like the ball—I needed someone to play with."

CHRIS JOHNS
South Africa | 1995

A lion braves heavy winds in the Nossob river-
bed in the Kalahari Gemsbok National Park.

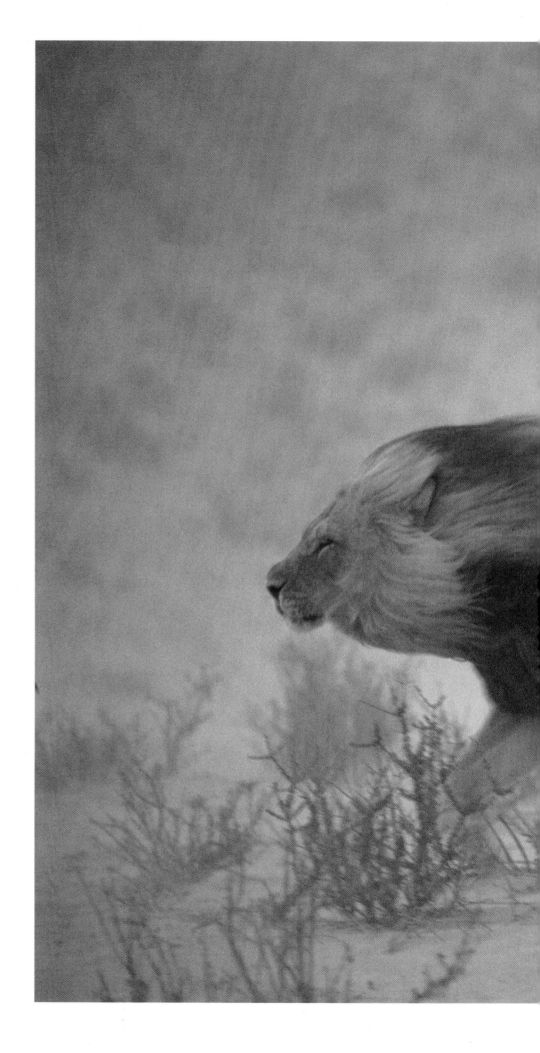

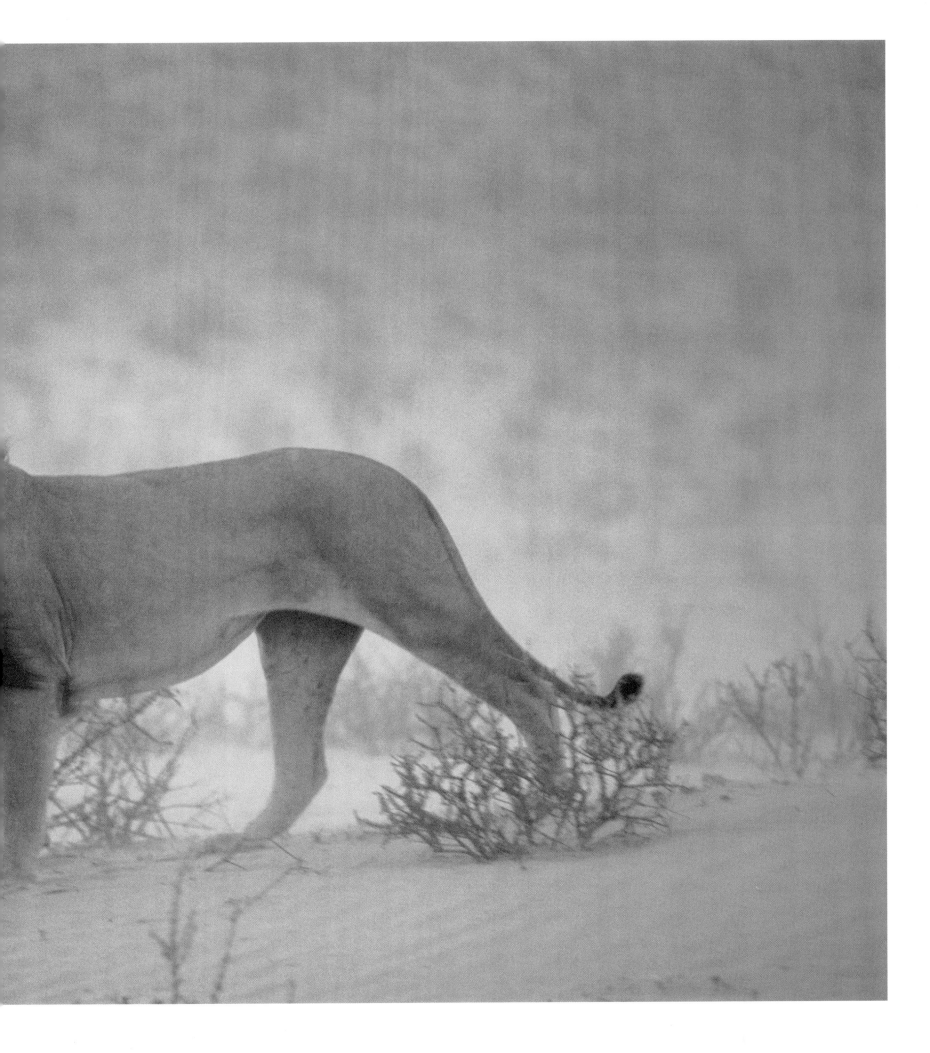

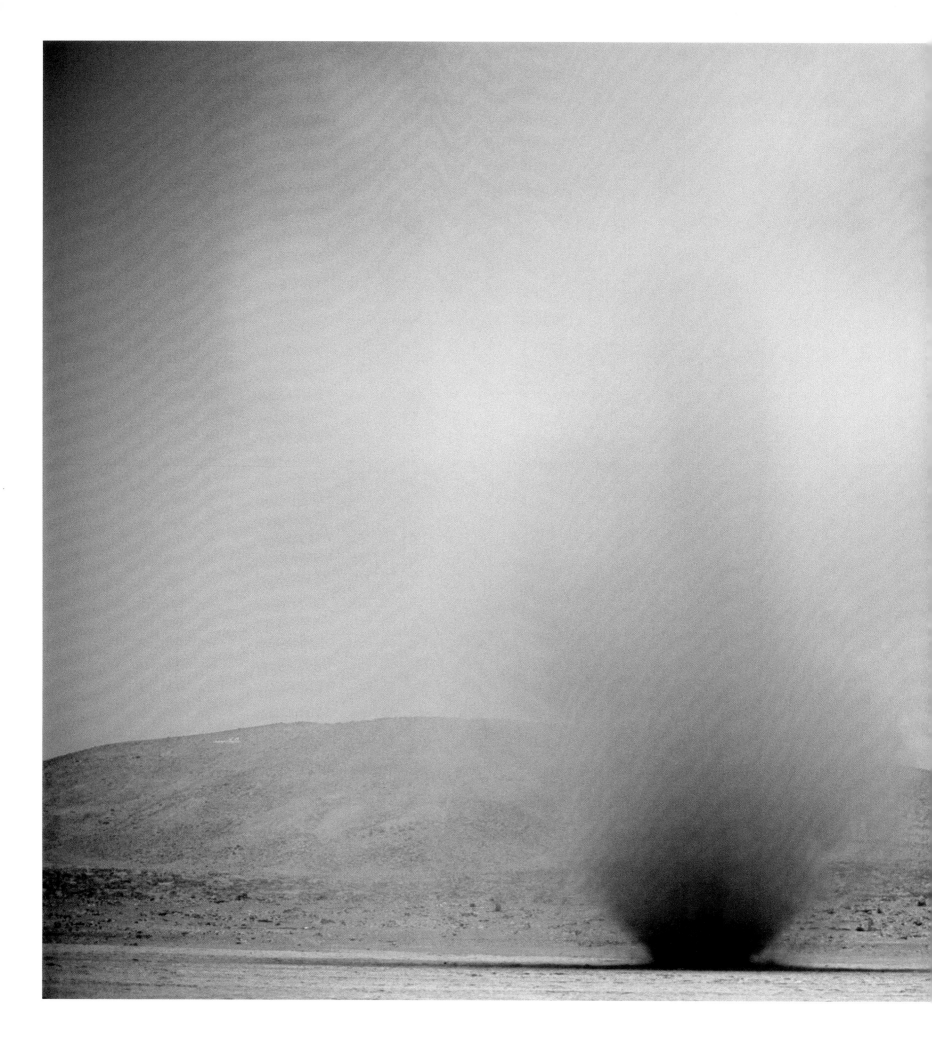

JOEL SARTORE
Chile | 2002

Swirling wind kicks up a dust devil near the Pan American Highway.

<div align="center">next pages:</div>

JOEL SARTORE
Northwest Territories | 1998

An incredible view of the Canadian territory north of Yellowknife on the way to a diamond mine.

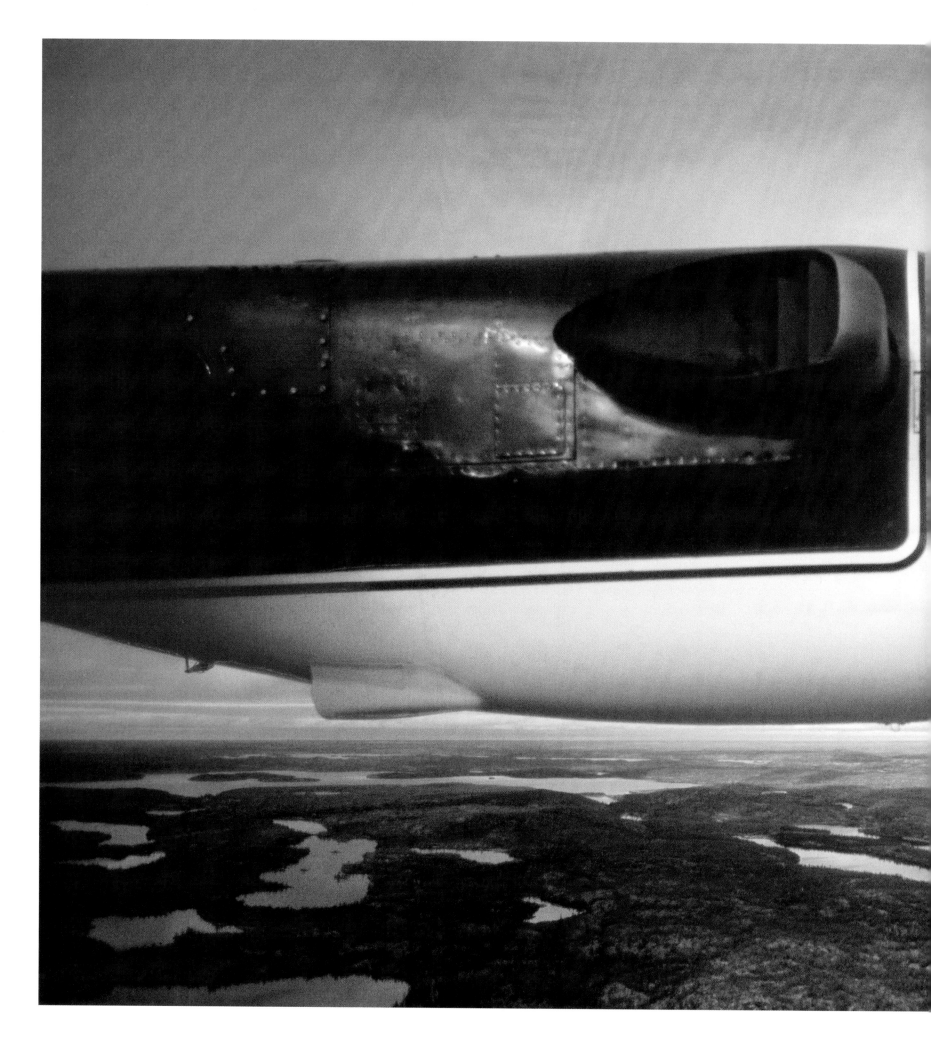

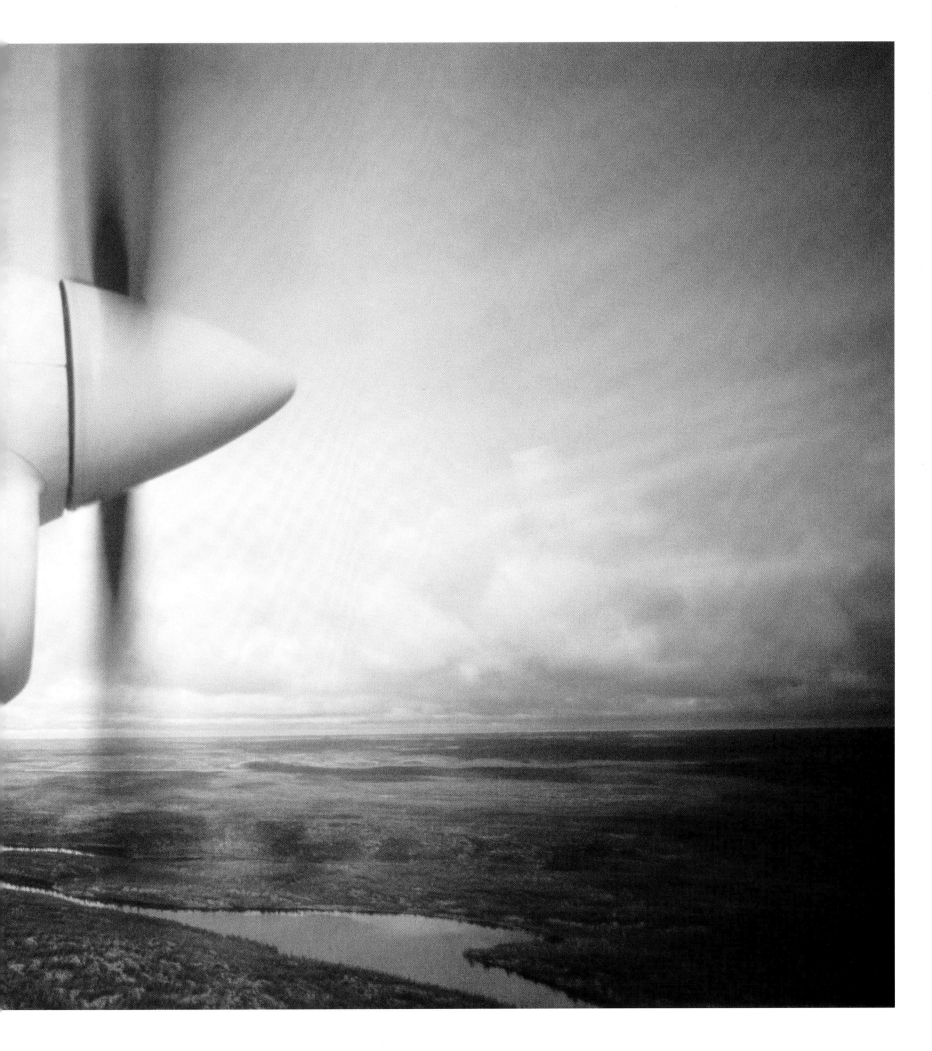

SUSIE POST RUST

Ireland | 1995

A woman breathes in the salty air while lying on the wall of the Dun Aengus, a prehistoric fort, on Inishmore Island, one of the three Aran Islands off the west coast of Ireland.

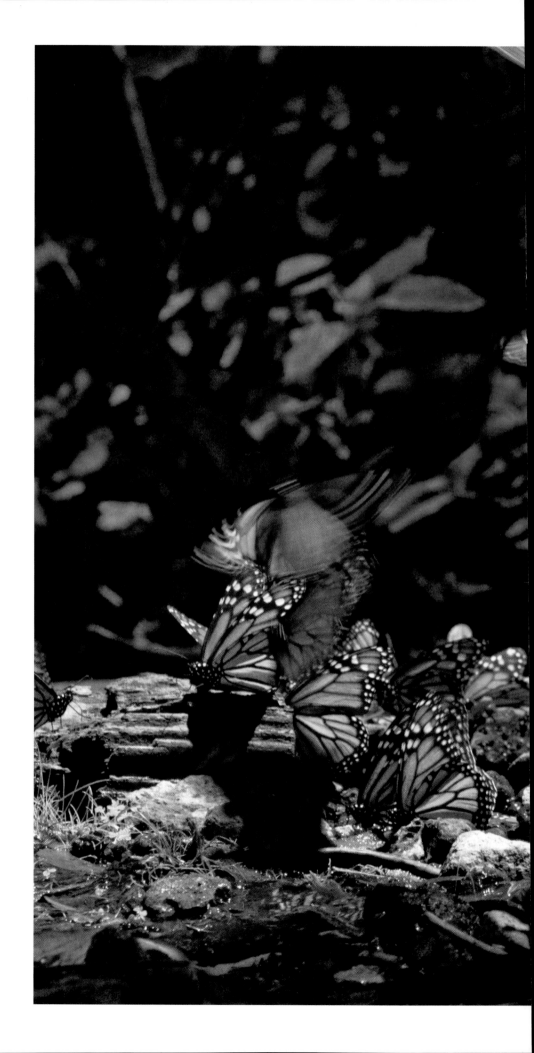

MEDFORD TAYLOR
Mexico | 2007

Each year, photographer Medford Taylor trav-
els to the Sierra Chincua Butterfly Sanctuary
in Mexico to photograph the story of the mon-
arch butterfly. The butterflies arrive by the mil-
lions in the first week of November, resting in
clusters throughout the forest high up on the
mountain. Each morning Taylor hikes for two
hours in the dark up the side of the moun-
tain from the village below to see the butter-
flies before sunrise. "Once the sun begins to
warm their wings," Taylor says, "they fly out
of the forest looking for water. When it's quiet,
you can hear the soft brushing of their wings
against the air."

next pages, Medford Taylor

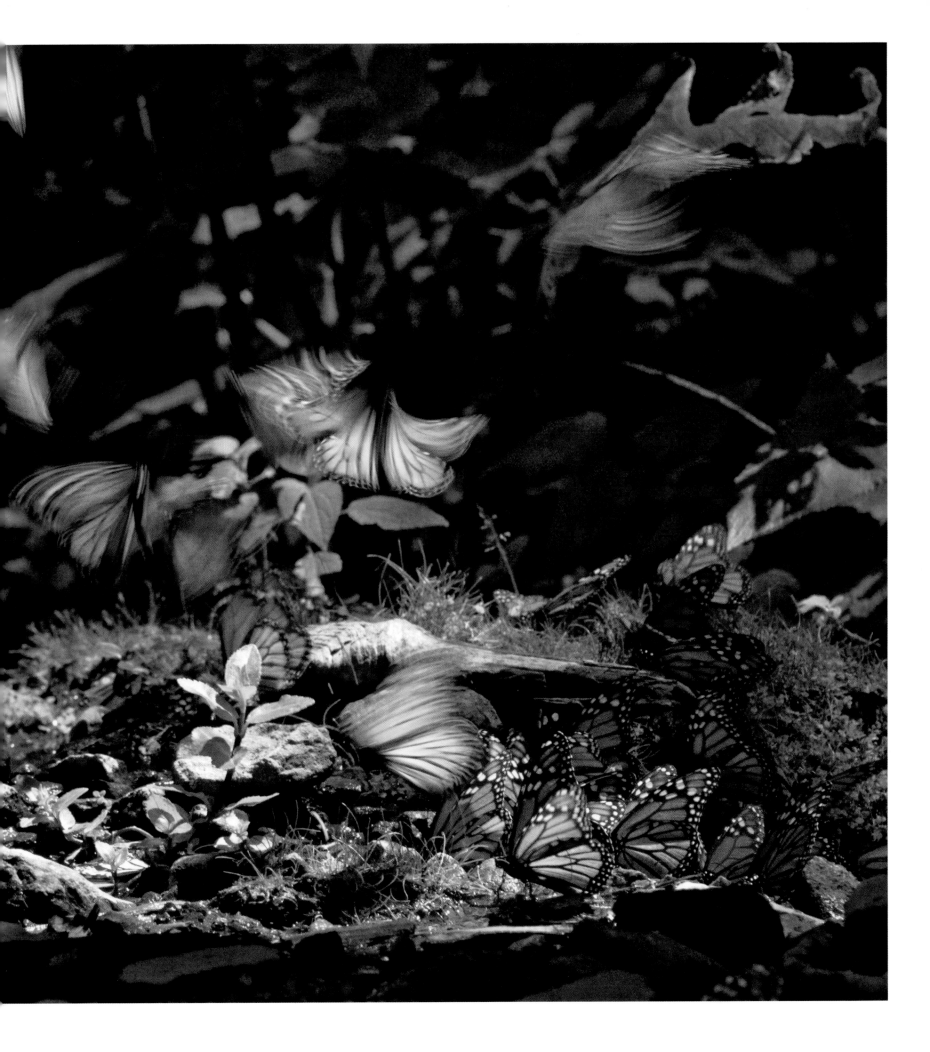

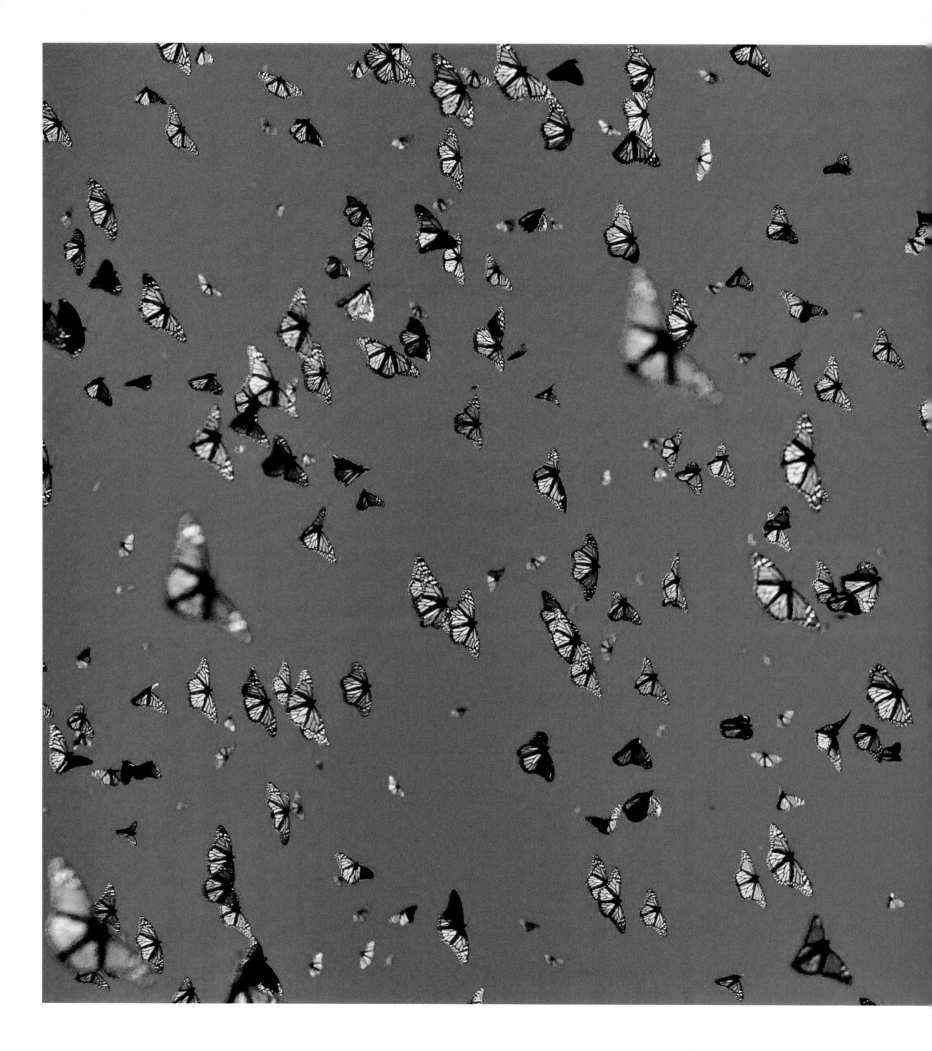

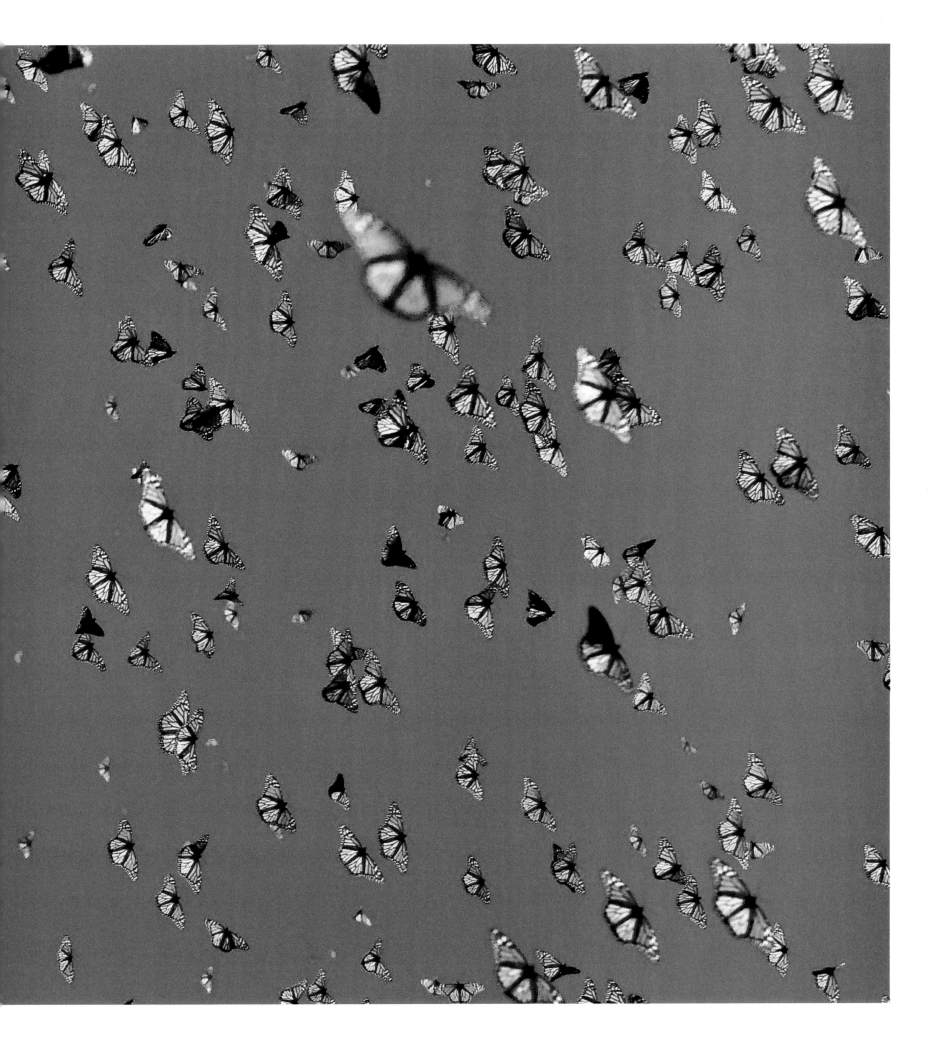

GUARIGLIA + CHEN
China | 2006

Photographer Justin Guariglia lived and worked in Asia for more than ten years. During that time he discovered a passion for Shaolin kung fu, a classic form of martial arts, practiced by Shaolin monks in the hills of the Henan Province in the People's Republic of China. "In Shaolin, paradise is in the mind," explains Guariglia, who is the only foreign photographer to have photographed the real monks practicing their craft. Most pictures you see are of the children practicing kung fu at the Ta Gou Academy. "Martial arts is the fusing of mind, body, and soul. It helps bring these things together within you to make you a better person, to achieve inner peace."

When Guariglia returned to the United States with his new wife, the Taiwanese artist Zoe Chen, he began to look at his photographs in a new light. The result is a video installation and an exhibit that is touring the United States. "This is a collaborative work between myself and my wife. It is multifaceted on many different levels and that is the essence of Shaolin. I had captured the movement with still photography, and we wanted to bring back the movement by creating the pattern. We wanted to bring the energy out. Also, when you stand back from it, the piece looks like Chinese calligraphy. When you get closer you realize that you are looking at little figures frozen in time. It's all about perception, and that's a very Zen Buddhist concept. Things may not be as they appear."

JIM RICHARDSON

Tallgrass Prairie National Preserve | 2006

Richardson grew up on a farm in Kansas and his appreciation of the outdoors is infectious every time he speaks. "Seeing something beautiful is so rare," he muses one afternoon. "You probably see one thousand full moons in your lifetime."

He had the idea to capture the fireflies of summer while he was shooting a story about the Tallgrass Prairie National Preserve in the Western United States. "It was a calm evening, and a storm was coming in from the West," remembers Richardson. "I was out there in the dark—me and one million fireflies—amid the wild alfalfa. For a boy from Kansas, this was me stopping to 'smell the roses.'"

next pages:
CHRISTIAN ZIEGLER

Panama | 2006

A bulldog bat catches a fish in Gatun Lake.

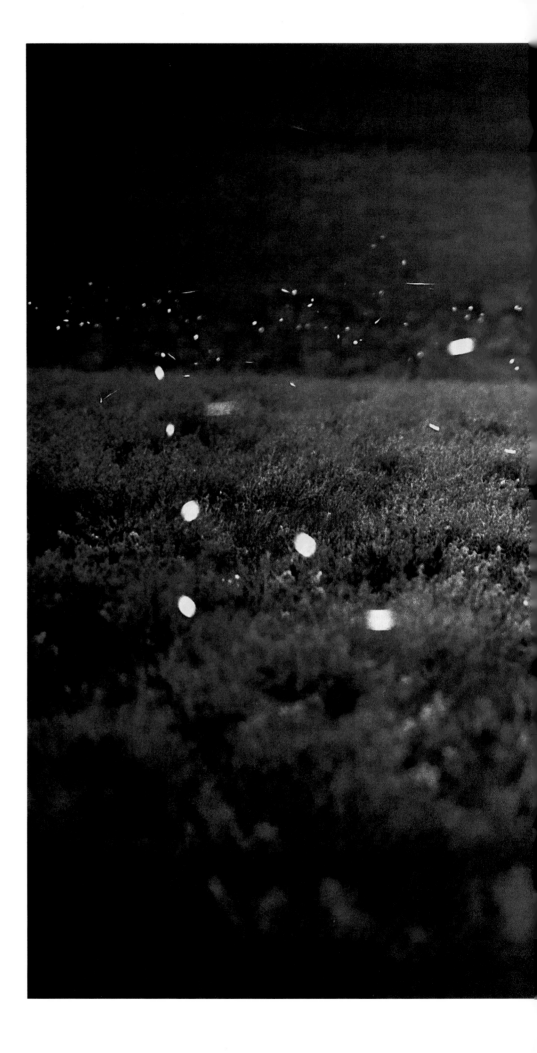

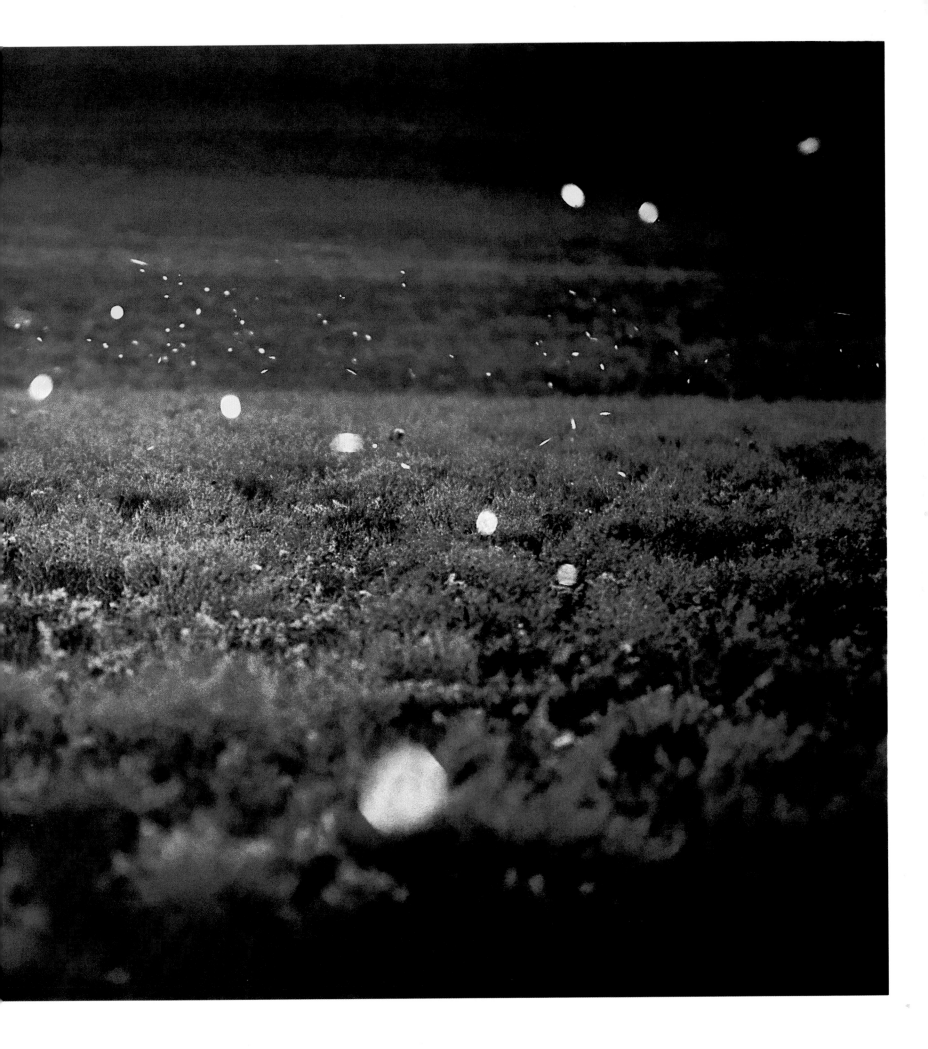

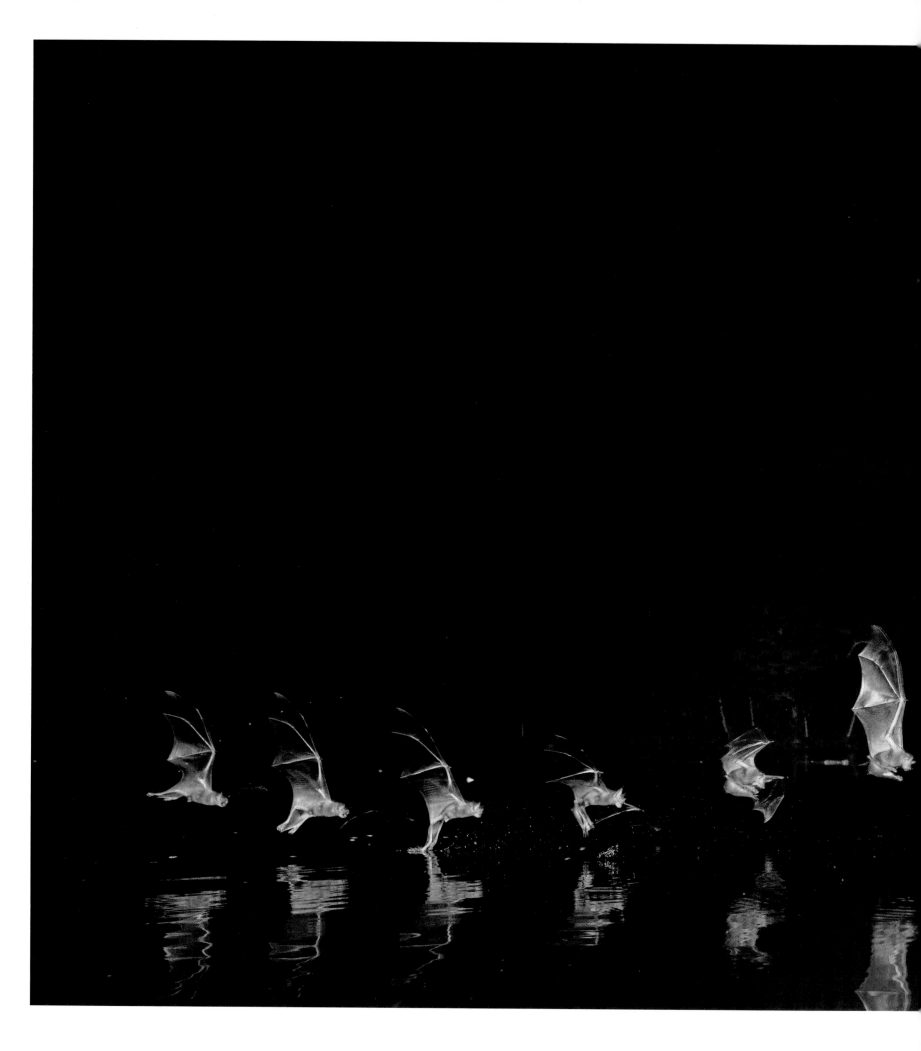

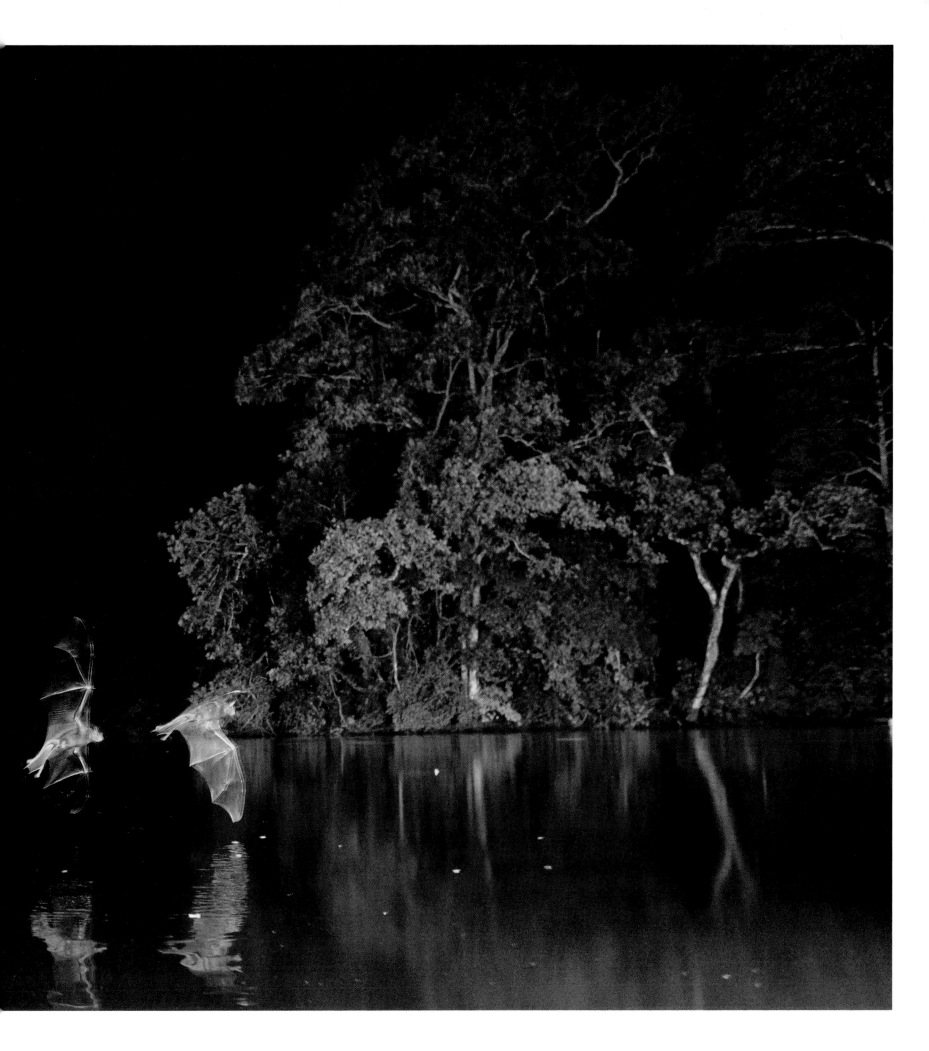

J. CARRIER
Sudan | 2005

No paradise by most measures, Darfur lies at the edge of a desert on the margins of a country.

Fighting between government-backed Janjaweed militias and Darfuri rebel groups, deeply rooted in struggles to control diminishing plots of arable land, has displaced some two million and killed nearly three hundred thousand.

It is a constant struggle to survive for those who have been pushed from their land. Their villages torched and homes destroyed, they have lost more than their earthly possessions, they have lost their paradise: their homeland, their hope.

Gathered in the last slivers of the shrinking morning shade, eager faces turn skyward in anticipation of promised relief; survival and a hope for the return of a paradise lost for millions now rests on the silver wings of a humanitarian airlift.

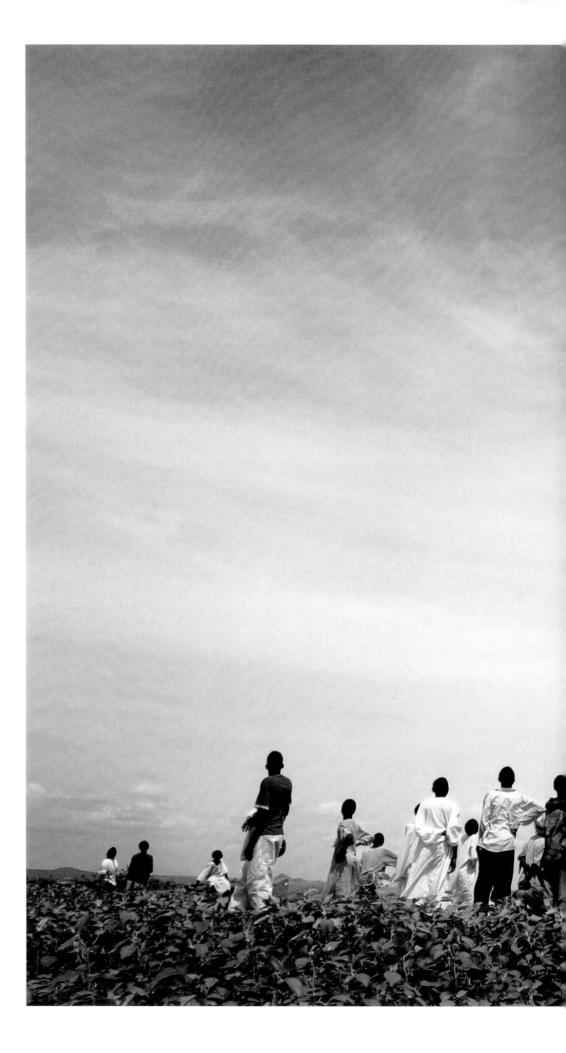

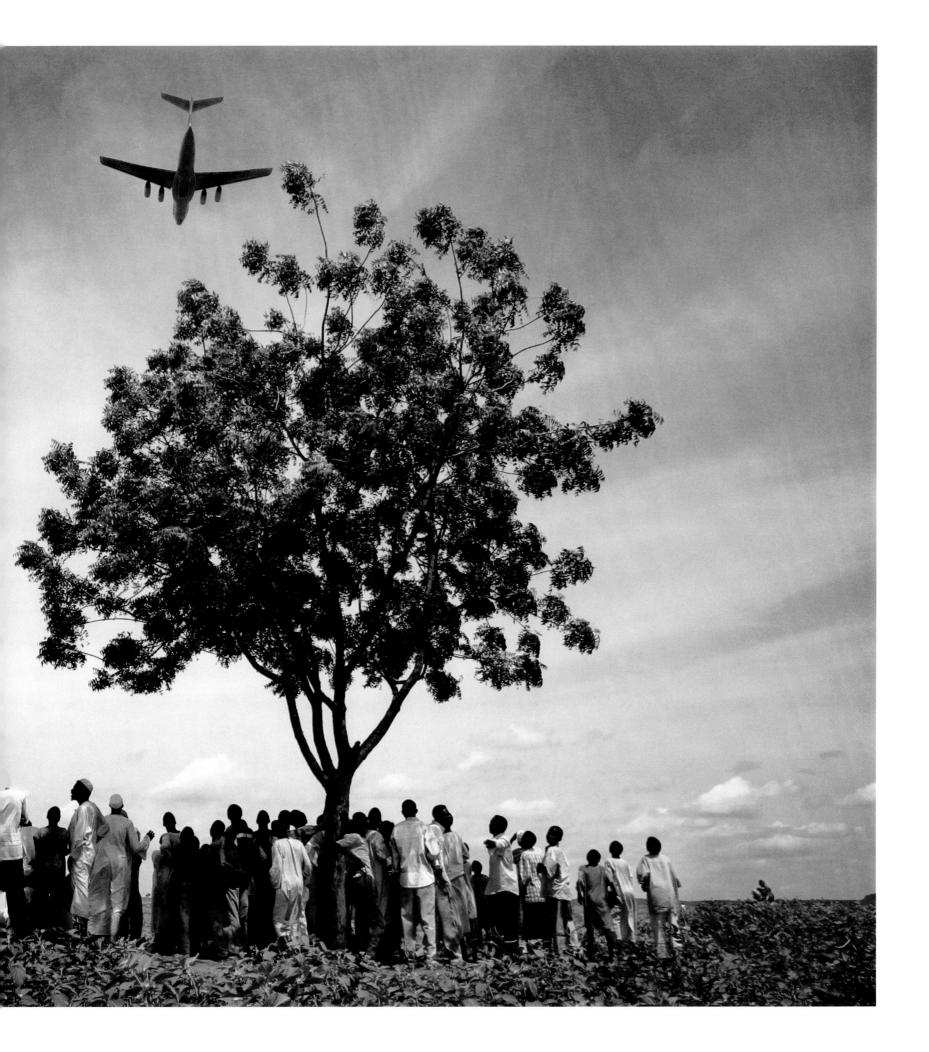

EUGENE RICHARDS
North Dakota | 2007

While photographing a story about ghost towns in the West, Richards found beauty in the fallow landscapes and hidden memories in the relics left behind, such as these kitchen curtains that still catch the breeze inside an abandoned house in the small town of Mott.

BEVERLY JOUBERT
Botswana | 2000

A herd of wildebeest gather at the water's edge at the end of the dry season on the Selinda Reserve.

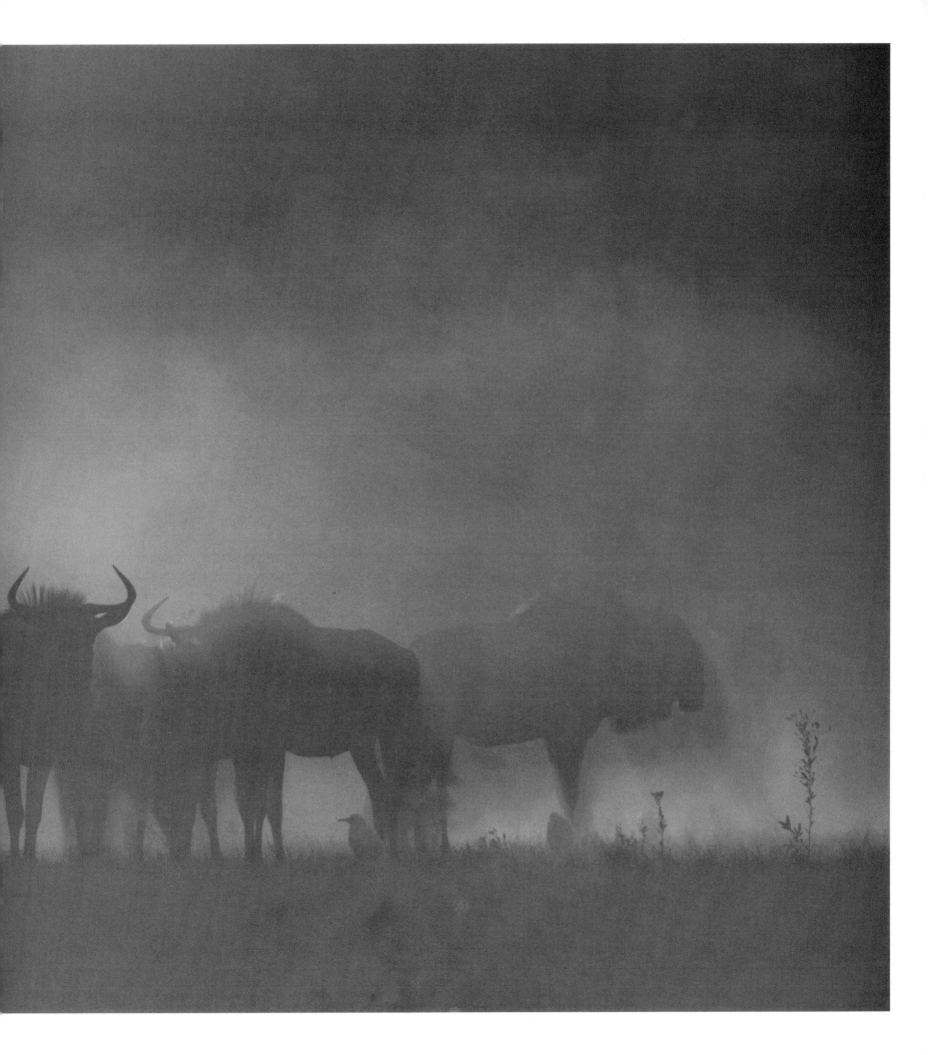

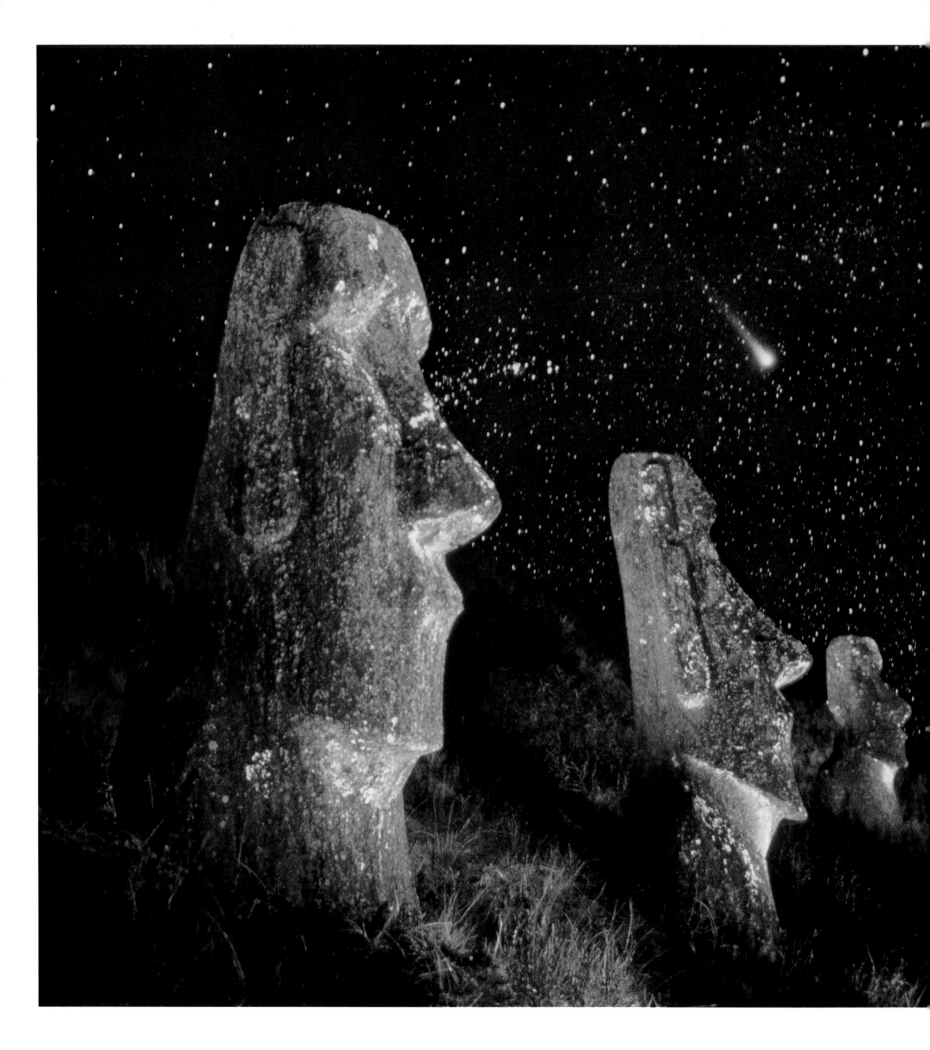

JAMES BALOG

Easter Island | 1986

Chasing Haley's Comet in 1986, James Balog traveled to Easter Island in the South Pacific, one of the world's most remote islands. Nearly 2,300 miles to the east is Chile, its possessor. The next point to the south is Antarctica. There are no rivers, only freshwater lakes near the top of a defunct volcano. "It's a long way from anywhere," says Balog, who stayed for three weeks. "I felt this strange combination of serenity and isolation while I was there, but at the same time I felt incredibly full."

He set up an observation post on top of one of the three volcanoes to watch for the comet, a phenomenon that passes by the Earth's atmosphere once every 76 years. "By professional necessity, I was only shooting at night," explains Balog. "It was obviously a tranquil time, but I have these vivid memories of going up to the observation post. I could hear the ocean waves hissing way below us, and I'd be standing underneath this vault of stars in the southern sky above us. It was pitch-black! I felt as if I were peering into eternity."

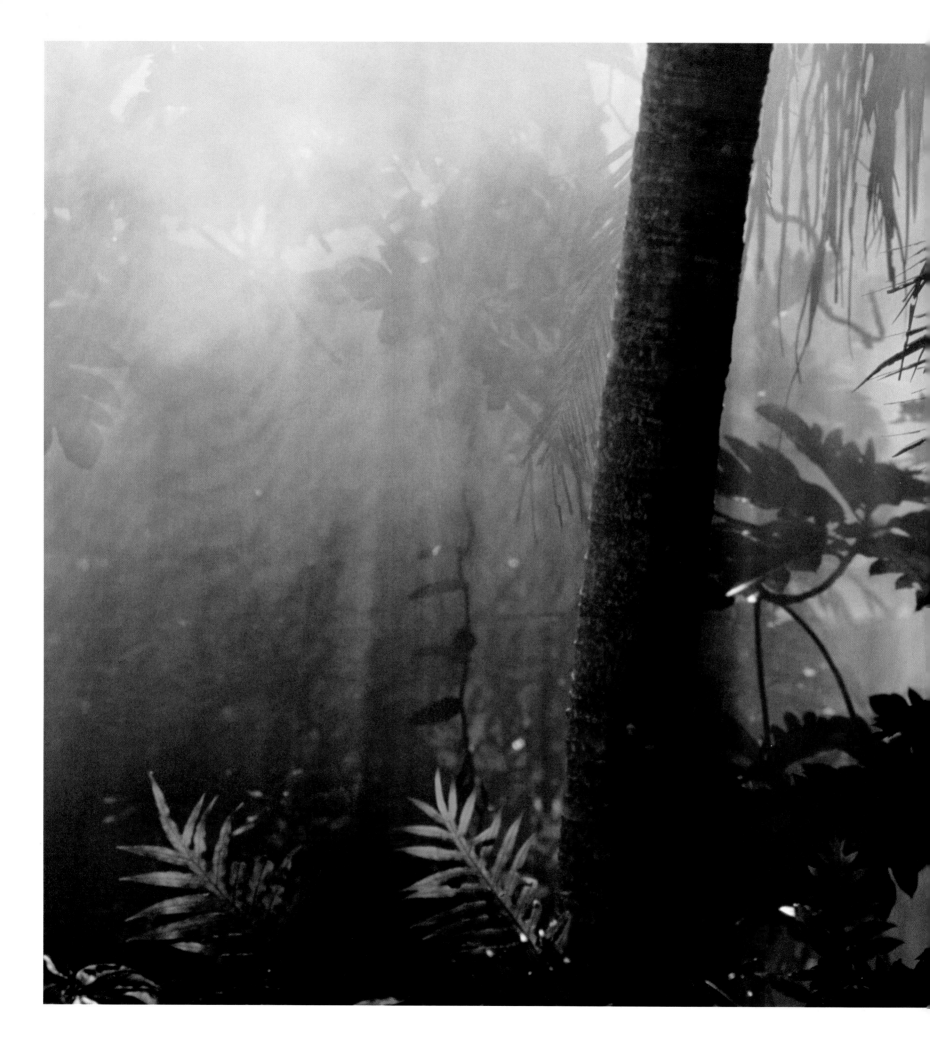

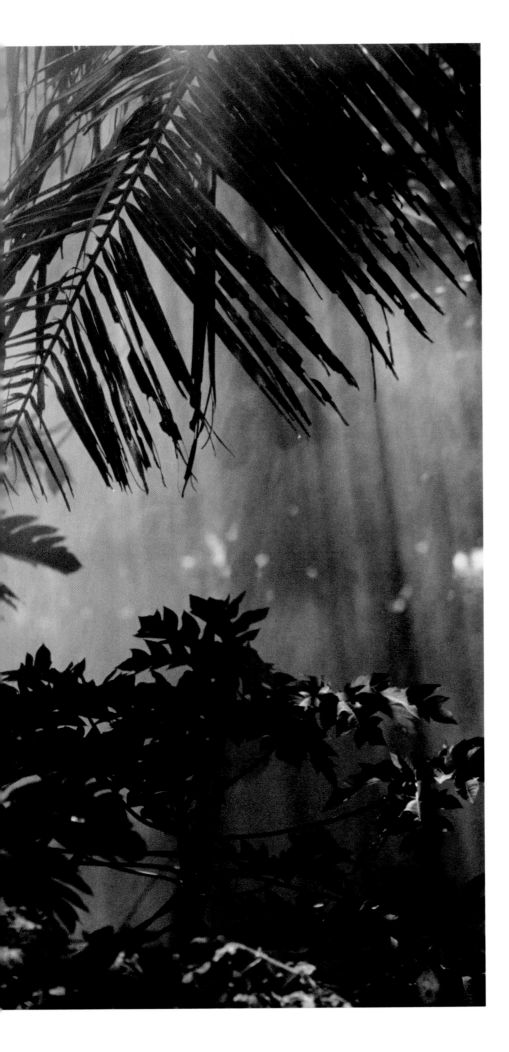

RANDY OLSON
American Samoa | 2006

Smoke from cooking umu, a traditional Sunday meal, fills a forest near Tafuna.

JUSTIN GUARIGLIA

Bangladesh | 1999

People warm themselves in the sun during a wintry afternoon.

next page right:
JAMES BALOG

Texas | 1998

The wind wraps a giant piece of cloth around a Texas Live Oak tree in Rio Frio.

next page left:
NASA

Space | 1969

An archival image of the Apollo 11 space vehicle during the first stage of the takeoff from Earth.

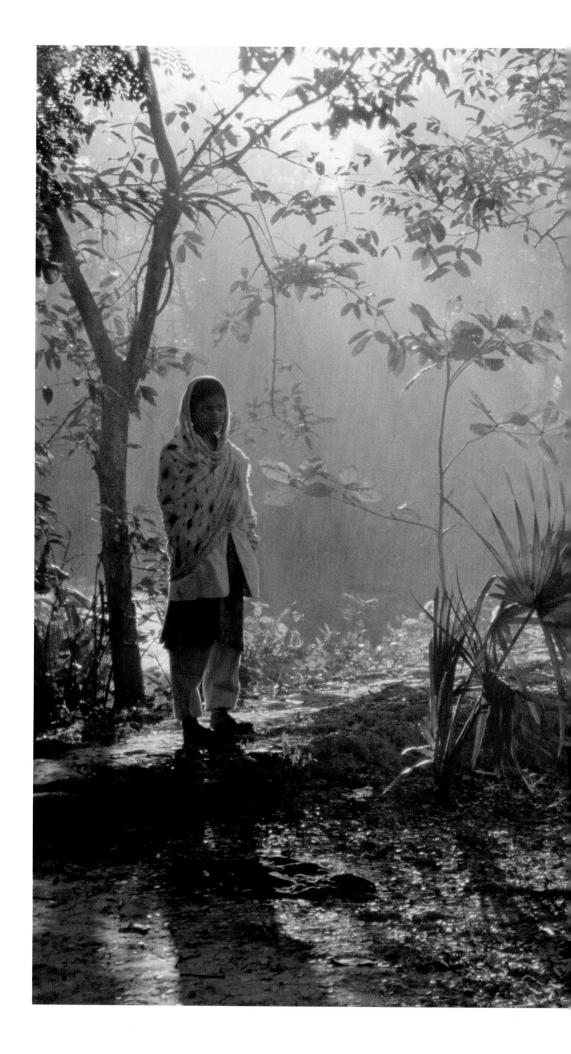

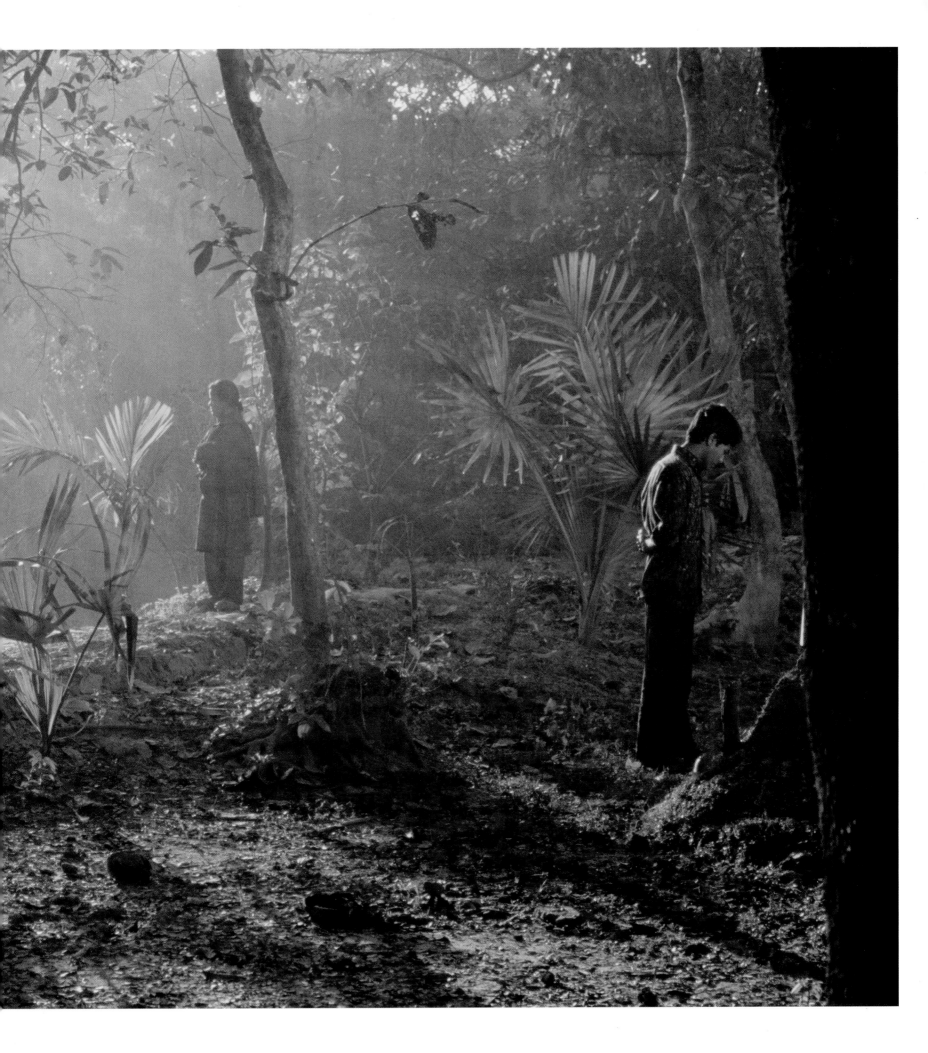

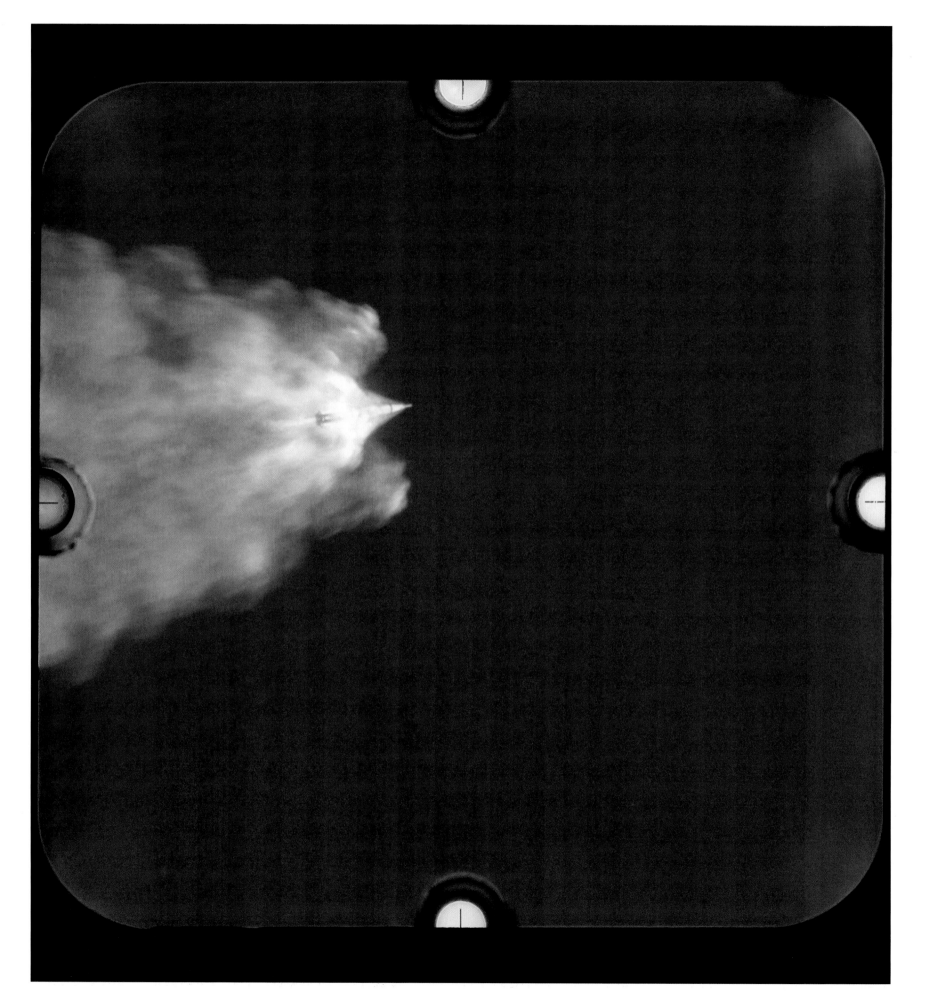

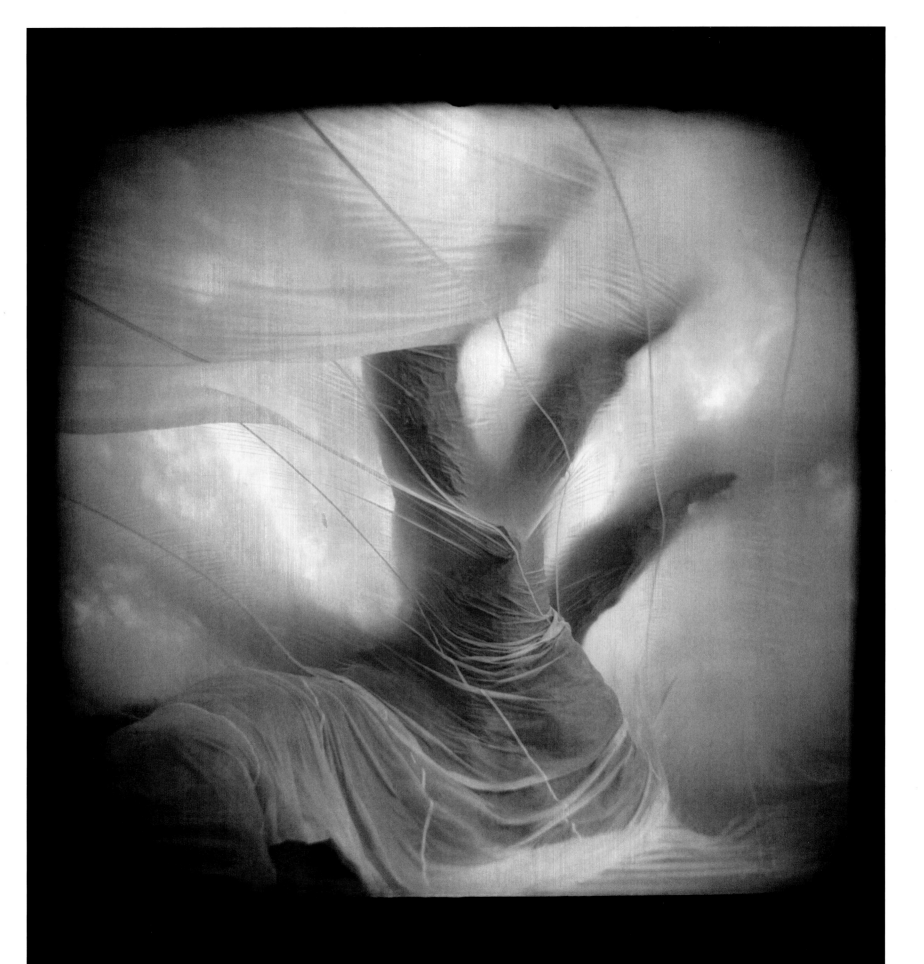

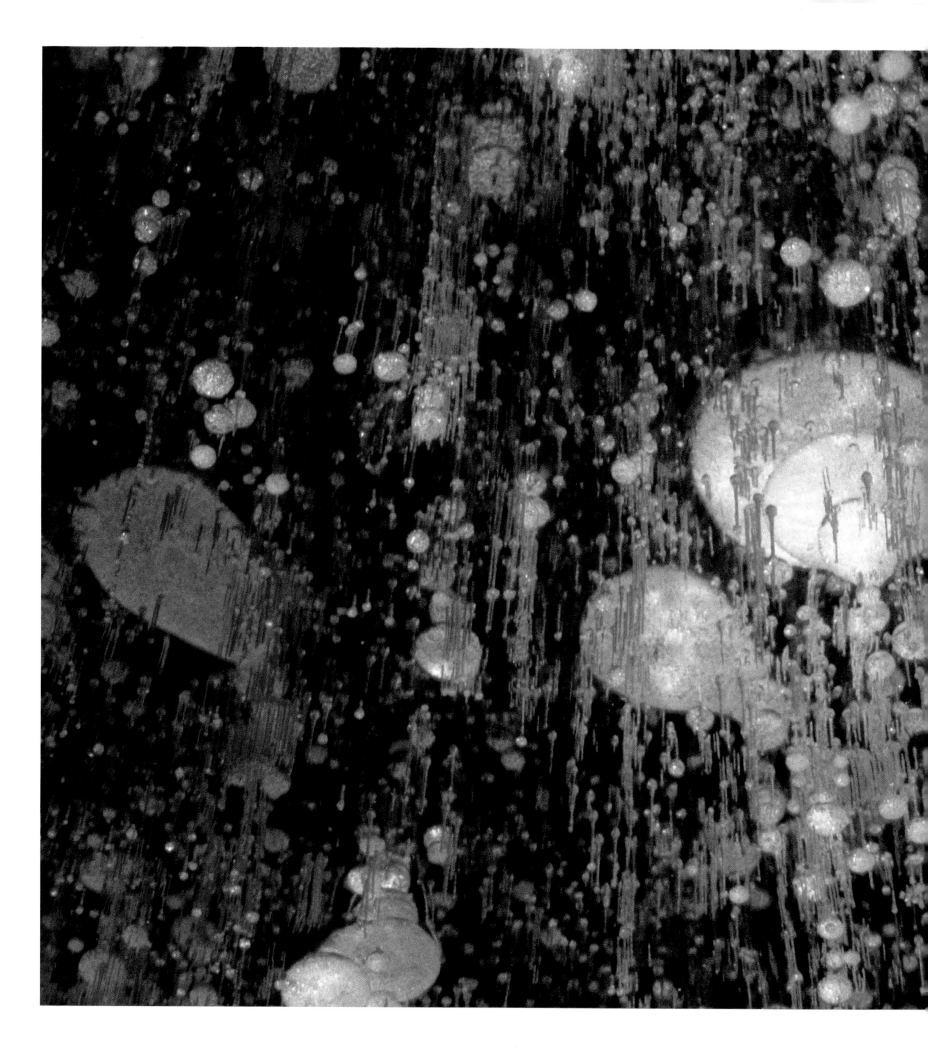

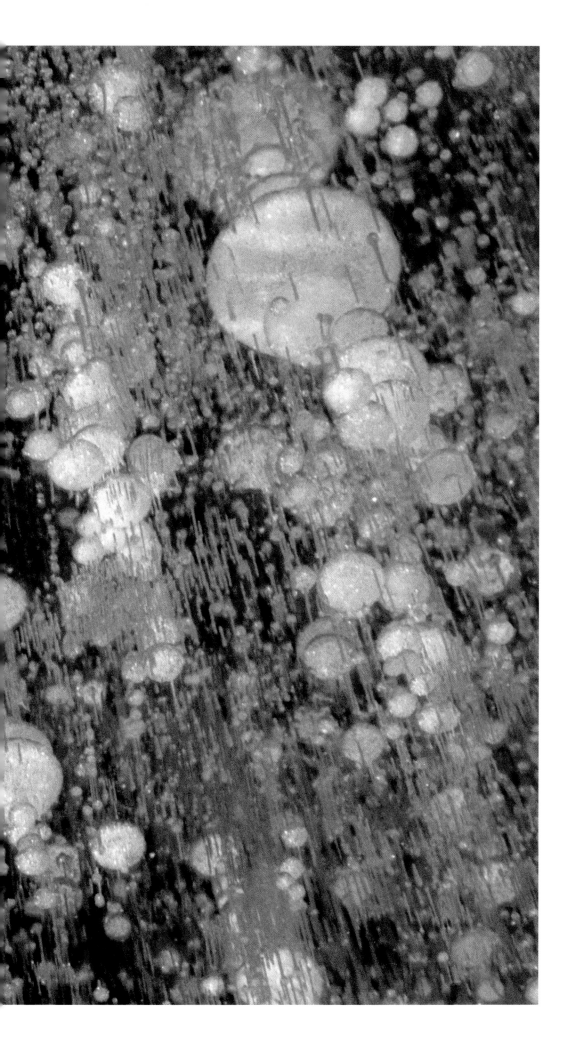

MARIA STENZEL
Antarctica | 1997

Air pockets in the frozen Lake Bonney.

GERD LUDWIG
Tennessee | 2005

A long time ago the Cherokee Indians named the mountain range that bordered North Carolina and Tennessee "Place of Blue Smoke," because of the cerulean mist that enveloped the trees. Scientists would later determine that this is the natural result when oily residues mix with water vapor in a richly diverse forest. In 1930, the U.S. government recognized the region and renamed it the Great Smoky Mountains National Park.

But now the beautiful blue mist is being replaced by a toxic yellow haze. Air currents carry the pollutants there from power plants and automobile emissions from nearby cities.

In his youth, growing up in Germany, Ludwig spent a lot of time in forests. "When I was four or five years old, I often went with my mother and other women from our village into the forest. While they collected berries, I napped on the cool, dry leaves," remembers Ludwig. "Being in nature is a recollection of my childhood, a way of partaking in the divine. To be surrounded by so much destruction now is simply devastating."

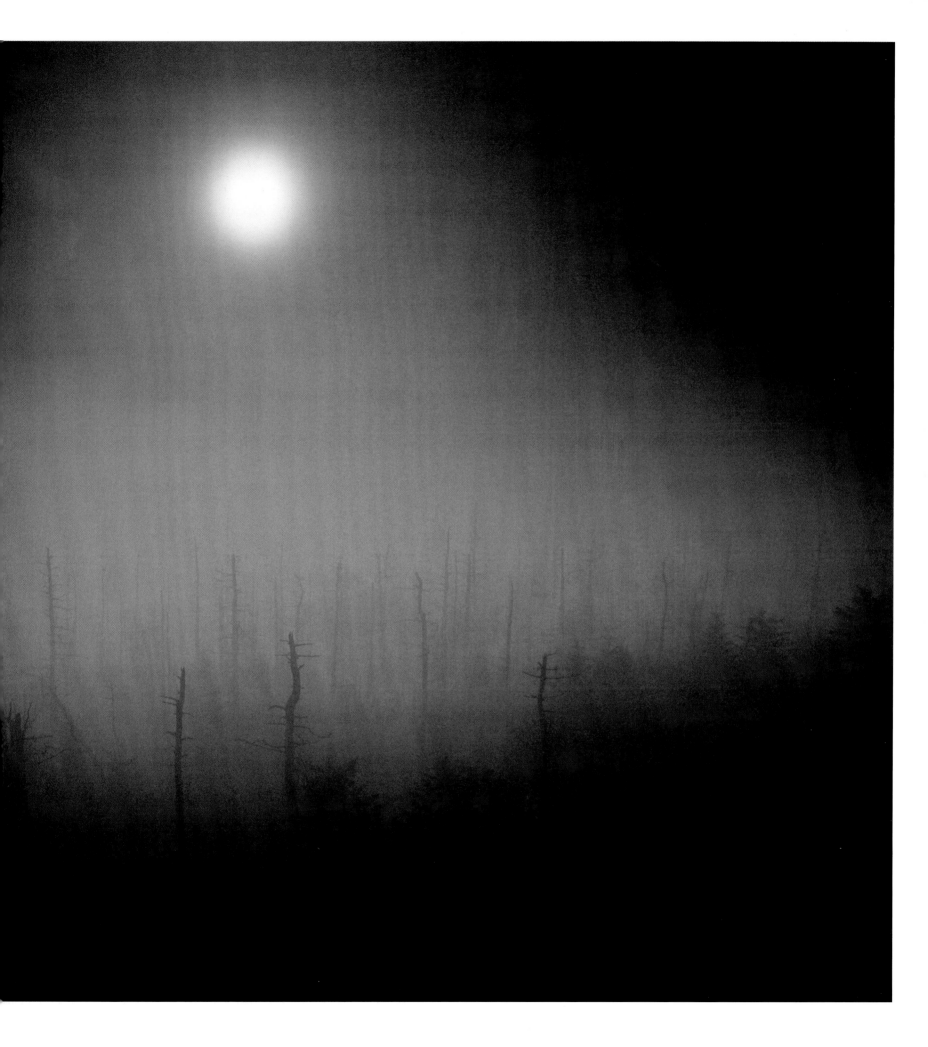

DAVID MCLAIN
Greenland | 2005

Siorapaluk is a tiny settlement and the northernmost inhabited place on Earth. Hunters who still use harpoons live there, and for five weeks David McLain photographed them in minus 40°F temperatures, while they killed walruses and narwhals to feed the town. When they returned to Siorapaluk, the hunters gave him a frozen walrus flipper, two beers, and a spot inside an abandoned house with a propane heater. "That was nirvana," says McLain.

next pages:
PAUL NICKLEN
Polynesia | 2003

Frigate birds soar above Rawaki Island.

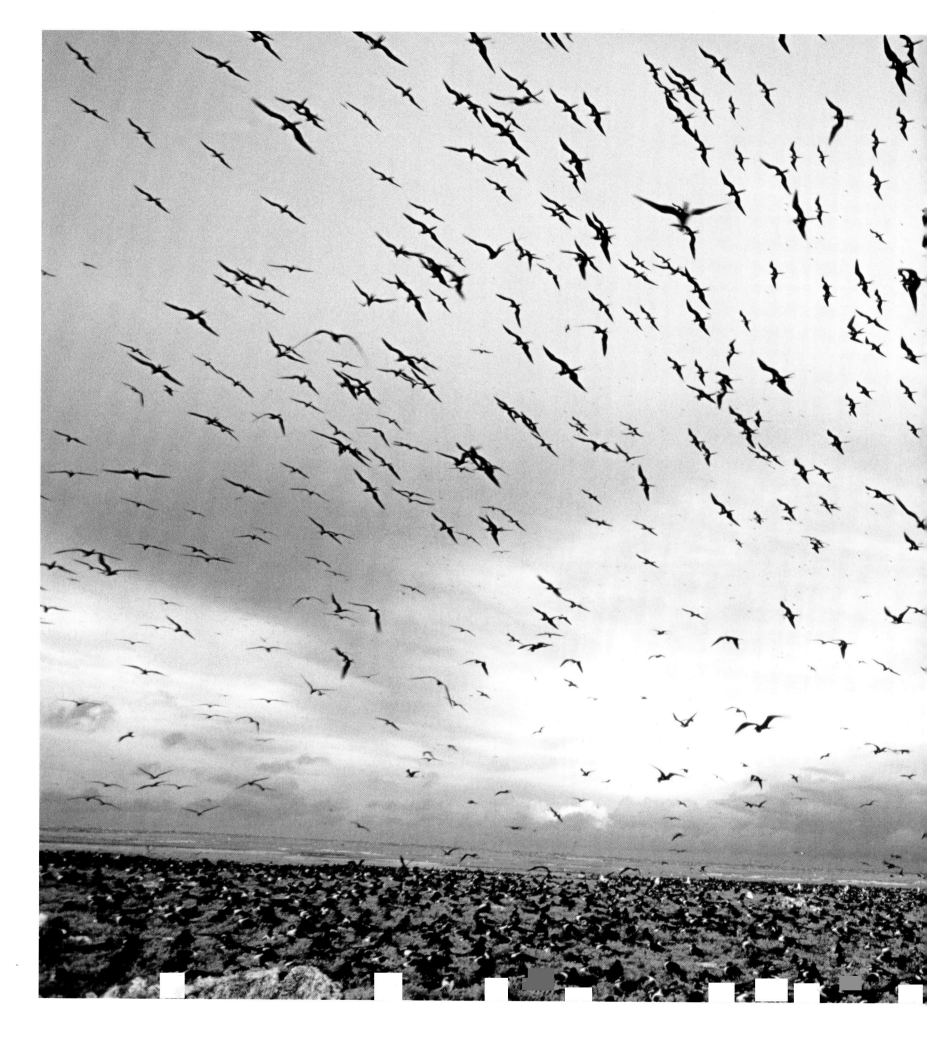

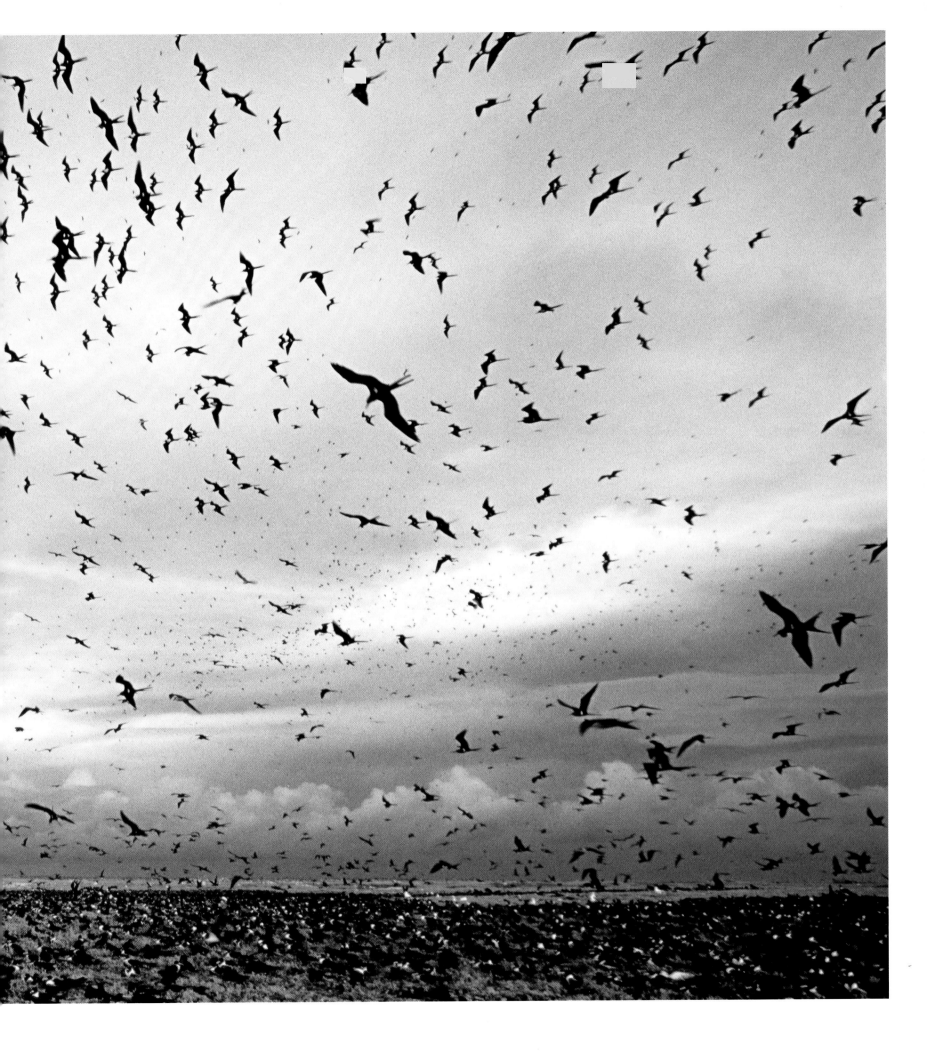

BIOS

Katy Kelly

PHOTOGRAPHERS

Sam Abell has photographed 20 plus stories for *National Geographic* magazine, some documenting wilderness, others different cultures. His many books include *Australia: Journey Through a Timeless Land, Seeing Gardens,* and *The Life of a Photograph.* In 1998, the Ohio-born Abell joined historian Stephen Ambrose in retracing Lewis and Clark's journey through North America's West. The result, *Lewis & Clark: Voyage of Discovery* was so successful that, in 2002, they reunited for *The Mississippi: River of History.*

Lynsey Addario is a self-taught photojournalist who specializes in stories about human rights concerns, women's issues, and humanitarian crises during and after war. She has chronicled life in Lebanon, Iraq, and Afghanistan. Named one of the Thirty Best Emerging Photographers by *Photo District News,* Addario won both an ICP Infinity Award and a Fujifilm Young Photographer's Award. Her work is in three American Photo Annuals as well as *Darfur/Darfur: Life/War* and *Darfur: Twenty Years of War and Genocide in Sudan.*

William Albert Allard's *National Geographic* summer internship came with a caveat: "It's over in the fall." Forty-four years and dozens of stories later, Allard is still on the masthead. A self-described "people photographer," he uses existing light, shoots only color, and doesn't enter competitions. Still, his book *Vanishing Breed: Photographs of the Cowboy and the West* earned a National Book Award nomination and a Leica Award of Excellence. Other books include: *Portraits of America* and *Time at the Lake.*

Stephen Alvarez intended to make large format black and white pictures in the Ansel Adams tradition. Then he saw a Michael "Nick" Nichols photograph that inspired him to go underground. Now a premier cave photographer, the Tennessee native has taken pictures of places few will ever see in life, including Mexico's poisonous Cueva de Villa Luz cave. Also committed to documenting life on the Uganda/Sudan border, Alvarez has won several POYi awards and a Banff Mountain Centre grant.

Christopher Anderson is an accomplished war photographer and photojournalist. Photographing Haitians attempting to sail to the U.S. was pivotal in changing his approach from observer to what he calls "experiential journalism." One of the original founders of the VII photo agency, Anderson joined Magnum Photos in 2005. He has earned a Robert Capa Gold Medal, Kodak's Young Photographer of the Year, and POYi Magazine Photographer of the Year. His monograph, *Nonfiction,* was published in 2003.

José Azel says photography is his way of exploring the world. His pictures carry vicarious explorers to the jungles of Borneo, Antarctic waters, and Kenyan game preserves. His photojournalism has allowed them to ponder environmental issues and to follow coca plants from the field to cocaine makers and to users. The Cuban-born Azel is the co-founder of Aurora & Quanta Productions. He has earned a WPP Olympic Award, the Marion Scubin Sport Award, and several POYi awards.

James Balog's photos, which explore the boundary between man and nature, have been likened to "sacred objects," by photographer James Nachtwey. Balog has won a Leica Medal of Excellence and has twice taken WPP top honors. He has seen his work exhibited in more than 100 museums. His monographs include *Tree: A New Vision of the American Forest* and *Survivors: A New Vision of Endangered Wildlife.* His long-term project, the Extreme Ice Survey, documents glacier change.

Annie Griffiths Belt has photographed many stories for the *National Geographic* magazine and for the Society's book division. A Fellow with the International League of Conservation Photographers who is best known for nature, documentary, and travel photography, Griffiths and author Barbara Kingsolver created *Last Stand: America's Virgin Lands,* which has raised more than $250,000 for conservation grants. She has won awards from the NPPA, the AP, the White House Press Photographer's Association, and National Organization for Women.

PREVIOUS PAGES: GEORGE MOBLEY | *Antarctica* | 1989
An explorer from New Zealand explores a crevasse.

Jonas Bendiksen spent much of his 20s documenting life in the former Soviet Union, resulting in his 2006 book *Satellites*. Since 2005, the Norwegian photojournalist has worked around the globe on *The Places We Live*, a much-lauded work that combines recorded voices and photographs of urban slums. His portrait of the Nairobi's *Kibera* earned a 2007 ASME National Magazine Award for *The Paris Review*. Other honors: two POYi Awards of Excellence and an ICP Infinity Award.

Nina Berman's focus on America's social and political development is reflected in her book, *Purple Hearts: Back From Iraq,* in which she paired portraits of wounded veterans with interviews. A documentary photographer, Berman's work has been shown in museums and galleries in the U.S. and Europe. An International Center of Photography faculty member, Berman is the winner of two WPI awards and several POYi awards and was a New York Foundation for the Arts fellow.

James Blair became a *National Geographic* staff photographer in 1962. Over the next 32 years, he contributed 47 stories to the magazine. Interested in the environment and social change, Blair contributed to *Our Threatened Inheritance*, a high-impact *National Geographic* book about federal land. A man of many honors, including awards from the White House News Photographers Association, POYi and the Overseas Press Club, Blair has had a solo exhibit at Pittsburgh's Carnegie Mellon Museum.

Alexandra Boulat co-founded the photo agency VII "to produce an unflinching record of the injustices created and experienced by people." Focusing on societal ills, news, wars, and the people caught in them, Boulat documented the fall of the Taliban in Afghanistan, the Palestinian-Israeli conflict, fighting in Croatia, Bosnia, Kosovo, and the 2003 invasion of Iraq. Her awards include the ICP Infinity Award, the Paris-Match Award, USA Photo Magazine's Photographer of the Year, and many others. Her books, *Paris* and *Eclats de Guerre*, were published in 2002. On June 21,

2007, while on assignment in Ramallah, Boulat suffered a brain aneurysm and died two months later. She was 45.

Sisse Brimberg has done more than 25 stories for *National Geographic*, many on history and culture. Her work, which has been exhibited at the Newseum in Washington, D.C., won the NPPA Picture Story of the Year and a POYi Award of Excellence. Hoping to "make a cultural difference in the world," Brimberg and her husband, photographer Cotton Coulson, founded Keenpress Publishing in her native Denmark. Among their books are *First Thanksgiving* and *Mayflower 1621.*

David Burnett does it all—news, features, landscapes, and portraits. Co-founder of Manhattan's Contact Press Images, Burnett was named one of the 100 Most Important People in Photography by *American Photo* magazine. Other honors include: Magazine Photographer of the Year from POYi, a Robert Capa Gold Medal, and WPP Photo of the Year. His post-Katrina pictures were exhibited at the George Eastman House in Rochester, N.Y., and New Orleans's Cabildo Museum.

David Butow, a photojournalist interested in public policy and social issues, has made documenting China's Uighur ethnic group a personal and photographic mission. His work has been exhibited in New York and featured in a National Geographic book, *Inside China.* He has been honored with WPP Awards, an NPPA Best of Photojournalism award and inclusion in the American Photography Annual. Pictures taken by Butow in Kurdistan and Iraq in 2000 were exhibited at the Visa Pour L'Image Festival in Perpignan, France.

Colby Caldwell combines the old and the new. After shooting super 8 film in an old camera, Caldwell photographs the projected image with a digital video camera and transfers the images to a computer. The images are printed on watercolor paper, waxed, and mounted. Exhibited internationally, his work was in the Corcoran Museum of Art Biennial

and in *The Landscape of Contemporary Photography,* a group show, simultaneously published as a National Geographic book.

Nick Caloyianis knows sharks, also coral reefs, kelp gardens, and shipwrecks. A leader in underwater filming, his credits list more than 30 National Geographic documentaries including *America's Endangered Species: Don't Say Good-bye* and an underwater scene in the blockbuster movie *Spy Kids.* Caloyianis' photographs illustrate *The Shark Handbook: The Essential Guide for Understanding and Identifying Sharks of the World.* Accolades include six Emmy Awards, four Cine Golden Eagles, an Earthwatch Award, and an Oscar.

J. Carrier's first post-college career was as a drummer in a punk-blues band. It wasn't until 2001, when he was a Peace Corps volunteer in Ecuador, that he realized his calling. As a freelance photographer, Carrier has concentrated on chronicling the lives of the poor in Africa, shooting for major publications, and documenting Save the Children's efforts in Darfur, Sudan, and Ethiopia as well as Indonesia one week after it had been devastated by a tsunami.

Paul Chesley is best known for the work that is his passion: photographs that show the people, culture, and splendor of Asia and the South Pacific. A National Geographic regular, Chesley has published a number of books; they include *The Circle of Life, Thailand: Seven Days in a Kingdom, A Voyage Through the Archipelago,* and *Malaysia: Heart of Southeast Asia.* His work has been exhibited at museums in London, Tokyo, New York, and Washington, D.C.

Robert Clark was a young photographer when he joined Buzz Bissinger in documenting high school football players in Odessa, TX. Good move. *Friday Night Lights* became a bestselling book, movie, and TV series. A frequent contributor to the *National Geographic,* Clark found himself in the right place at a horrendous time—on his roof in Brooklyn, photographing the 9/11 attacks. Clark has been honored with WPP Awards and a National Magazine Award.

David Doubilet was 12 when he put his Brownie Hawkeye camera inside a rubber bag and took his first underwater pictures. Since then, Doubilet, a master diver and a National Geographic Photographer-in-Residence, has worked under waters off New Zealand, Tasmania, Scotland, Japan, and the United States, photographing 60 plus stories for the magazine and accruing the Sara Award, the Lennart Nilsson Award, and other honors. His books include *Great Barrier Reef,* and *Fish Face.*

David Edwards is an adventurer, a Grand Canyon river guide, and a much admired documentary photographer with wide interests ranging from landscape to environmental, portrait to expedition photography. The recipient of a Photography Development Grant from the *National Geographic* magazine, Edwards spent substantial time in Mongolia, where he focused on the Kazakh eagle hunters, the reindeer people, and the horse culture. One of Edwards' pictures is included in the *National Geographic*'s 100 Best Photographs, collectors edition.

Jason Edwards got to hone his photography skills while working as a specialist in primate and carnivore husbandry for the Zoological Board in Victoria, Australia. Since those days the National Geographic photographer has been to more than 25 countries, documenting wildlife, isolated landscapes, and indigenous people. The winner of the Pursuit of Excellence Award by the Australian Geographic Society, Edwards is the author and photographer of two children's books, *African Safari* and *Desert Journal.*

Michael Fay, an ecologist, botanist, and National Geographic Society Explorer-in-Residence, took a 2,000 mile walk through the last of Africa's unadulterated forest, documenting trees and wildlife as he went. He called the adventure Megatransect and followed up with Megaflyover. Eight

months of crisscrossing Africa in a plane produced 116,000 photographs, capturing man's effect on the ecosystems below. Both stories appeared in *National Geographic*. The resulting book is *Last Place on Earth,* with photos by Michael "Nick" Nichols.

Stephen Ferry grew up watching Vietnam War protesters marching. As an adult he has photographed historical developments, some dramatic—the fall of communism in Eastern Europe and the fall of the Twin Towers in New York—and some as prolonged as the destruction of Brazil's rainforest and Columbia's civil war. Ferry has several POYi first place prizes and two WPP awards. He photographed and co-wrote *I Am Rich Potosi: The Mountain That Eats Men.*

Ken Garrett spent his childhood living in Columbia, Missouri, and much of his adulthood living in the past. Specializing in ancient cultures, archaeology, and paleontology, Garrett was present at Egyptian King Tutankhamen's first CAT scan and documented dozens of archaeological discoveries including the skeleton of the father of the Copan dynasty. The Smithsonian Museum and the Museum of Archaeology & Anthropology in Pennsylvania have exhibited Garrett's work. Among his books are *Lost Kingdoms of the Maya.*

Raymond Gehman figured out what he wanted to be in the fourth grade when a National Geographic photographer came to his school. Now on the job for better than 20 years, Gehman has traveled the world with an eye for "weird little details" and a passion for shooting when the light is radiant. His images, which have been called stunning and timeless, illustrate several books including *American Legacy: Our National Forests* and *Exploring Spectacular Canada's National Parks.*

Justin Guariglia has worked in more than 50 countries and lived in six. Designated one of the Top 30 Photographers Under 30 by Photo District News and ICP's Young Photographer of the Year, Guariglia, a regular *National Geographic* contributor, was the first person allowed inside the Shaolin temple to photograph warrior monks practicing Kung Fu. *Shaolin: Temple of Zen* was his first book. The second, *Planet Shanghai,* features people who, although outside on the city's byways, wear pajamas.

Bobby Haas, a master aerial photographer whose work has been exhibited internationally, is the author of six books including two of National Geographic's bestselling volumes, *Through the Eyes of the Gods: An Aerial Vision of Africa* and *Through the Eyes of the Condor: An Aerial Vision of Latin America.* Both are available in 17 languages. Haas is chairman of the board of the investment firm Haas Wheat & Partners. He donates all book royalties to nonprofit organizations.

David Alan Harvey is "a photojournalist's photojournalist," says photographer Dirck Halstead. Harvey documented Mayan culture, the Mexican cowboy pilgrimage to the statue of Cristo Rey, and life in Spain, Belize, Honduras, and Chile. The author of *Cuba, Divided Soul, Fotografi,* and *Tell It Like It Is,* Harvey is an NPPA Magazine Photographer of the Year. His work has been exhibited at the Museum of Modern Art in New York, Nikon Gallery, and the Corcoran Gallery of Art.

Wolcott Henry, a *National Geographic* contract photographer, is also president of the Curtis and Edith Munson Foundation, the Henry Foundation, and chairman of the Coral Reef Foundation. A gifted underwater photographer and determined marine conservationist, Henry launched the nonprofit Marine Photobank based on the idea that in displaying the beauty and the damage, they will be inspiring change. Henry's books, *Hello, Fish!* and *Sea Critters,* made the National Science Teachers Association list of top books.

Kevin Horan is a photojournalist and portraitist with an inclination toward documentary photography and preference for shooting outside

where, he says, "the light is delicious." The Seattle-based Horan has had varied assignments—politicians, post-Katrina Louisiana, and Mormons on a mission—but the picture that pulled him into the business was one he saw at age ten, while visiting a cousin with a darkroom. "When I saw him put my mother's head on a chicken, I was hooked."

Len Jenshel and Diane Cook are among America's leading landscape photographers. Jenshel, a forerunner of the "New Color" movement, is both a fine art photographer and an editorial photographer and has exhibited internationally. His books are *Charmed, Travels in the American West,* and *Charleston and the Low Country.* Cook, his wife and frequent partner, has had solo shows in galleries around the United States. Joint career highlights include two books, *Aquarium* and *Hot Spots: America's Volcanic Landscape.*

Chris Johns, a *National Geographic* magazine contributing photographer for 17 years and now the publication's editor-in-chief, is well known for his photographs of wildlife and Africa. As a photographer, Johns delivered a firsthand look at the Zambezi River, documented Africa's endangered wildlife and gave readers insight into the culture of the Bushmen. His books include *Wild at Heart: Man and Beast in Southern Africa,* and *Hawaii's Hidden Treasures,* which focuses on the islands' ongoing extinction crisis.

Beverly and Dereck Joubert, both National Geographic Explorers-in-Residence, live under canvas in Botswana. They have been smacked by elephants (4 times), stung by scorpions (20 times), contracted malaria (4 times), bitten by a snake (once), and survived a plane crash. The payoff: Sunset tangos on the savanna, documenting previously unknown animal behaviors, producing six books and many documentaries, including *Reflections of Elephants* and *Eternal Enemies: Lions and Hyenas,* and winning five Emmys and a Peabody.

Ed Kashi has documented social and political issues in more than 60 countries. The multi-award winning photojournalist spent much of the 1990s photographing Jewish settlers in the West Bank and eight years producing *Aging in America: The Years Ahead,* which includes a book, a documentary, a website, and an exhibition. The project won POYi and WWP awards; *American Photo* called the book one of the year's best. Other books include *When Borders Bleed: The Struggle of the Kurds.*

Robb Kendrick has photographed sumo wrestlers and Sherpa, the base of Antarctica and the top of Mount Everest, but the pictures he most likes making are tintypes. Cutting-edge when Matthew Brady was documenting the Civil War, Kendrick returned to wet plate photography to make the portraits in *Still: Cowboys at the Start of the Twenty-first Century* and *Revealing Character: Texas Tintypes,* winner of the National Cowboy and Western Heritage Museum's Western Heritage Award for Best Photography Book.

Michael Kenna is known for his landscapes, many taken at dawn or at night using multi-hour exposures to capture a near magical light. His pictures are in the National Gallery of Art in Washington, D.C., London's Victoria & Albert Museum, and more than 100 other permanent collections. Spain's Golden Saffron Award is one of numerous honors. France made him a Chevalier in the Order of Arts. His books include *Michael Kenna: A Twenty Year Retrospective,* and *Japan.*

Karen Kuehn traded New York City and a client list that included *New York Times Magazine* and *Rolling Stone* for a farm outside of Albuquerque, New Mexico. Inspired by the lifestyle of 20th-century artist Georgia O'Keefe, Kuehn is most interested, she says, in making "fine art to complement my editorial and documentary life." Toward that goal, Kuehn, who sees herself as a conceptual photographer, won a Black and White Spider Award, Outstanding Achievement.

Mattias Klum, a professional photographer since age 18, has concentrated on biodiversity—an interest that has required him to weather rough weather, leeches, and an attempted strike by King Cobra. (His weapon? His camera.) Klum, a celebrity in his native Sweden, who reports to the European Commission on environmental issues, is the winner of a Communication Art Award of Excellence. His books include *Borneo Rainforest, Exploring the Rainforest,* and *Horse People.*

Vincent Laforet, a New York-based commercial, editorial, and fine arts photographer, is a winner. With four other photographers, Laforet won the 2002 Pulitzer Prize for Feature Photography. One of American Photo Magazine's 100 Most Influential Photographers and one of Photo District News' 30 Under 30, Laforet holds awards from POYi, Overseas Press Club, National Headliners and the Pro-Football Hall of Fame. His work has been exhibited at Visa Pour l'Image in Perpignan, France.

Tim Laman, a field biologist, wildlife photographer, and researcher at Harvard University's Ornithology Department, concentrates on endangered species and unspoiled lands. A *National Geographic* magazine contributor with an interest in Indonesia, Laman has published more than 12 scientific articles about the rainforest and birds. He won the BBC Wildlife Photographer of the Year four times and Nature's Best International Photographic Award three times. His work is included in *National Geographic's 100 Best Photos* and *100 Best Wildlife Photos.*

Frans Lanting, a leading nature photographer who captured the first pictures of the bonobos of the Congo, spent a year researching the state of global biodiversity and has worked in Amazonia, Antarctica, and Africa. Knighted in the Netherlands for his conservation work, Lanting's accolades include an Ansel Adams Award, a Lennart Nilsson Award, and BBC's Wildlife Photographer of the Year. Lanting's books are *Eye to Eye* and *Forgotten Edens: Exploring the World's Wild Places.*

Sarah Leen was a National Geographic intern when she got her first assignment, a piece called *Return to Uganda.* Her story count is now 14 and climbing. The winner of the Robert F. Kennedy and other awards, Leen has contributed to many *National Geographic* books and was the photographer for *American Back Roads and Byways.* Leen and her husband, Bill Marr, co-founded Open Books, LLC, a design and packaging service that focuses on photographic books.

David Liittschwager was once a fashion photographer, shooting the rare, beautiful, and exotic. He still does. He and photographer Susan Middleton make portraits of endangered species using a monochromatic backdrop to keep the focus on the animal or plant. The often-honored duo was the focus of a National Geographic television special. Their books include *Remains of Rainbow: Rare Plants and Animals of Hawaii, Here Today: Portraits of Our Vanishing Species* and *Endangered Species of North America.*

Gerd Ludwig, a contract photographer for the *National Geographic* magazine, worked extensively in Russia, Eastern Europe, and his homeland of Germany, documenting social changes as they happened and the result in the years that followed. Among his books are *Broken Empire: After the Fall of the U.S.S.R.,* and *Seoul, Korea* both with text by Fen Montaigne. His awards include several POYi Awards of Excellence, three Communication Arts Awards of Excellence, and a WPP Award of Excellence.

Peter Marlow began his career as a photojournalist but soon changed directions. Best known for what he calls "fragmentary landscapes," Marlow often focuses on his native England. Among his books are *Liverpool: Looking Out to The Sea, Concorde: The Last Summer,* and *Europe on the Dark Side of the Stars.* His often exhibited work is in several collections including the Victoria & Albert Museum. He has won a National Headline Award and the Photographer's Gallery Award.

O. Louis Mazzatenta spent 42 years at *National Geographic* magazine and, when he turned out to be a better photographer than retiree, came back for more assignments. Career high points include witnessing the unearthing of the life-size terra-cotta army of Qin Shi Huangdi in Xi'an in China, photo-editing (and touching) Michelangelo's restored frescos in the Sistine chapel, and seeing the excavation of skeletons of those caught under ash and hot mud during the eruption of Vesuvius in A.D. 70.

David McLain's innate curiosity about people shows in his work. Based in Portland, Maine, he has documented cultures during times of unbidden change, underscoring the uncharted evolution of his own business and fanning his interest in fusing the classic with the new, still pictures with HD video. The winner of several NPPA Pictures of the Year awards, McLain holds onto his generalist status calling it "a passport to everything."

George Mobley, a photojournalist who spent 33 years on the National Geographic staff, covered newsmakers—the Kennedy White House and the U.S.–U.S.S.R. nuclear test ban treaty—and ancient times—the discovery of a Mayan tomb—along with a geographical smorgasbord that included Mongolia, Greenland, the Ganges River, and the Japanese Alps. His pictures won awards from the White House News Photographers Association, the National Press Photographers Association, and the Art Directors Club.

Bobby Model took up rock climbing at age 15, a handy skill when you become an adventure photographer making Himalayan expeditions and covering the civil war in Sudan as a photojournalist. Model worked in dozens of countries including Libya, Kenya, Iran, and Pakistan. His emphasis is on making photographs showing conflict and social issues in isolated regions, with the hope that awareness may bring change. Model's photographs have twice taken top awards in the Banff Mountain Photo Competition.

Vincent J. Musi, a frequent contributor to *National Geographic* magazine approaches his craft as an artist and a photojournalist. The perks of work: He has driven Route 66, visited the Arctic National Wildlife Refuge, and photographed life under a volcano. He has also had to flee stampeding buffalo, tend to a retina scratched in a sandstorm, and do cleanup while shooting the story *Animal Minds*. Musi has won a POYi Award of Excellence.

Michael "Nick" Nichols specializes in photographing wildlife in remote places, under conditions so extreme (he once got hepatitis, typhoid, and two kinds of malaria simultaneously) that *Paris-Match* called him "The Indiana Jones of photography." A *National Geographic* staff photographer, Nichols holds four first-place WPP awards, as well as POYi and Wildlife Photographer of the Year awards. His photographs have been featured in six books including *Last Place on Earth,* which followed Mike Fay's 2,000-mile Megatransect expedition.

Paul Nicklen grew up on Baffin Island in Canada where his Inuit playmates taught him to read the weather, survive the Arctic, and cultivate patience; the land trained him to notice light, shadows, and wildlife—all skills that helped make him a first-rate nature photojournalist. Focusing on the Arctic and Antarctica, the frequent *National Geographic* contributor has received four top POYi honors, two WWP awards and twice won BBC Wildlife Photographer of the Year. *Seasons of the Arctic* is his first book.

Flip Nicklin, a renowned leader in whale photography, spent his teen years helping his dad—underwater cinematographer, diver, and *National Geographic* contributor Chuck Nicklin—teach diving. Flip now lives and works—often shooting previously undocumented whale behavior—in Alaska and spends winters working near Maui. He has photographed 20 *National Geographic* magazine feature stories—many about humpbacks, narwhals, sperm, beluga, and bottlenose whales—and ten books including *Face to Face with Whales* with Linda Nicklin.

Richard Olsenius was originally a newspaper photographer who evolved into a filmmaker, musician, *National Geographic* photographer, and web producer. Among his prizes are a WPP award for photography, a Bronze Medal from the New York International Film Festival for *Autumn Passage,* and more for his multimedia project, *Arctic Odyssey.* Among his books is *In Search of Lake Wobegon,* with Garrison Keillor.

Randy Olson goes wherever the *National Geographic* magazine sends him. Over ten years, assignments included the Siberian Arctic, Samoa, Turkey, and Pakistan. In the Sudan he photographed people and brought food to people who had nothing to eat in a forest housing parasites that dine on people. Olson, one of two photographers to win both Newspaper Photographer of the Year and Magazine Photographer of the Year from POYi, also won the Robert F. Kennedy Award.

Carsten Peter's attraction to extreme nature has given him rules to live by: "If you see a bomb (of molten lava) falling toward you, step aside." The German photographer/videographer has risked life and equipment documenting glaciers, deserts, and caves. Nearly blown away by a tornado, he stood his ground, got the closest close-up ever made and won a WPP first prize and a Communication Arts Award. His work on "Into the Volcano" brought him an Emmy Award.

Susie Post-Rust has documented the way people live in Africa, Europe, and the Americas, focusing on both the big and small moments. A contributor to the *National Geographic* magazine, Post-Rust has also taken pictures for a number of nonprofits, including World Vision, Food for the Hungry, MissionsUSA, and Compassion International. She has been honored with a Robert F. Kennedy Journalism Award and five University of Missouri's Picture of the Year Awards.

Reza, single-named and much-admired, spent two decades as a print correspondent in the Middle East before he became a professional photographer with assignments from *National Geographic* magazine. Now published and exhibited internationally, Reza was awarded the 1996 Hope Prize for his work with Rwandan refugees. France made him Chevalier de l'Ordre du Mérite, Spain gave him the Principe de Asturias Medal and the University of Missouri-Columbia, the Medal for Distinguished Service in Journalism.

Eugene Richards is recognized as a master documentary photographer. He is the author of photo essays and more than a dozen books, including *The Fat Baby, Americans We,* and *Cocaine True, Cocaine Blue.* Richards spotlights difficult subjects like pediatric AIDS, breast cancer, poverty, aging, and death. He has won many awards including Nikon's Book of the Year, the Leica Medal of Excellence, ICP's Photojournalist of the Year, and the Kraszna-Krauze Award for Photographic Innovation in Books.

Jim Richardson saw the world while photographing more than 30 stories for *National Geographic* magazine and *National Geographic Traveler,* but it was his penchant for social documentary that led to "the great love of my photographic life." For 30 years and counting, Richardson has taken black and white pictures of the people and town of Cuba, Kansas, population 230. Named Kansan of the Year in 2008, Richardson has published seven books including the critically acclaimed *High School USA.*

Joel Sartore has kept company with wolves and searched in vain for an ivory-billed woodpecker. The longtime *National Geographic* magazine contributor focuses on nature, endangered species, especially the small and unsung, the environment, and life in America, which is epitomized in his book about his home state, *Nebraska: Under a Big Red Sky.* Other books include *Photographing Your Family* and *Face to Face with Grizzlies.* Sartore has an NPPA award, and several POYi awards.

Larry Schwarm returns to the Kansas prairies every spring, not to photograph tallgrass blooming, but rather tallgrass burning. His pictures

of the annual event—done to maintain the ecosystem—capture high flames against blue and black skies. The series, which won the Center for Documentary Studies/Honickman First Book Prize in Photography, is reproduced in Schwarm's book, *On Fire*. Schwarm's work is in the permanent collection of the Smithsonian Institution and the Philadelphia Museum of Art, among others.

Brian Skerry sometimes spends months on the job. He is a photojournalist and one of the great underwater shooters, and has set up temporary housekeeping in the tropics, the Arctic, and in an underwater lab on the ocean floor. A contributing photographer for *National Geographic* magazine for more than 10 years and a diver for more than 30, Skerry, has documented research, shipwrecks, seal hunts, sea turtles, and more. His books include *A Whale On Her Own* and *Complete Wreck Diving*.

Maggie Steber once made herself the center of attention to a herd of wild horses—a dangerous but effective way to get close-ups. The Texan documentary photographer has won Alicia Patterson and Ernst Haas grants, a WPP award, a Leica Medal of Excellence, POYi awards and an Overseas Press Club Picture of the Year. The *Library Journal* called her book, *Dancing on Fire: Photographs from Haiti*, "essential wherever photography, Caribbean studies, and current events titles thrive."

George Steinmetz, an explorer photographer who has averaged a *National Geographic* story a year for 20 years, likes telling the untold, the new and the obscure. Among his subjects: Technological breakthroughs, scientific explorations, China as photographed from above, and Indonesia's tree-house people. A Stanford graduate with a degree in geophysics, Steinmetz, has won many photography honors, including two WPP first place awards in science and technology, along wit POYi, Overseas Press Club, and Alfred Eisenstaedt awards.

Maria Stenzel was raised in Ghana, the Netherlands, and New York. She has taken pictures in Borneo, Tibet, and Kenya, but the place she likes best is the very deep south—Antarctica. On her first trip—traveling by ice breaker—she found herself surrounded by story possibilities from wildlife to science and history. The photographs from her fourth trip, this time to the Sandwich Islands, won a top National Magazine Award and another from WPP.

Jim Sugar spent 22 years as a contract photographer for *National Geographic* magazine. After more than 30 magazine stories, two books and many awards, including the NPPA Magazine Photographer of the Year, he moved to Northern California where he embraced the more relaxed lifestyle and the digital age. He now takes pictures of people, often at play, and machines—planes like the Proteus—and contributes to *National Geographic* as a freelancer.

Medford Taylor, a longtime photojournalist with an emerging interest in fine art photography, has been on assignments in the former Soviet Union, Australia, Africa, Iceland, and in his home state, Virginia. His work has been recognized by the White House News Photographer's Association and the Virginia News Photographer's Association. The internationally exhibited Taylor is the photographer and author of *Saltwater Cowboys: A Photographic Essay of Chincoteague Island*, and his pictures illustrate Fodor's *Compass American Guides: Virginia*.

Amy Toensing, a Detroit-based photojournalist and contributor to *National Geographic* magazine, is drawn to everyday life in small cultures. A former *New York Times* photographer and winner of a POYi award for Excellence, Toensing is known for capturing an insider's view of the people she photographs, from Muslim teenage girls in a Western country to the residents of the remote Monhegan Island off the coast of Maine and the stratified people of the Kingdom of Tonga.

Tomasz Tomaszewski, one of Poland's most celebrated photojournalists, started out shooting pictures for traditional magazines and *Solidarity Weekly.* He quickly expanded his reach. A *National Geographic* contributor for more than 20 years, Tomaszewski goes where the news is—documenting uneasy lives in politically charged South Africa, and El Salvador. Among his books are *Remnants: The Last Jews of Poland* and *In Search of America.* His work has been exhibited in the United States, Germany, Japan, and Israel.

Raul Touzon, a documentary and underwater photographer sees pictures as the "eternity of the moment." In addition to his marine work, one of Touzon's ongoing projects has been documenting Latin America's indigenous people and their cultures. His work has appeared in major publications including the *National Geographic* magazine and *National Geographic Traveler.* For several years Touzon has been a full-time, much revered instructor at the Santa Fe photography workshop and National Geographic Expeditions.

Ami Vitale's goal is to "show how the majority of people live on this planet." Vitale is not comfortable parachuting in and leaving soon after. To get a nuanced story, she settles in as she did in Guinea-Bissau, Africa, and India, where she spent more than five years. She received recognition from World Press Photo, NPPA, POYi, Photo District News, and received the Daniel Pearl Award and Inge Morath grant by Magnum.

Alex Webb approaches his work on foot. As a street photographer he must "walk and watch and wait and talk and then watch and wait some more." With over 35 solo exhibitions in the U.S. and Europe, Webb has won several important grants, the Leopold Godowsky Color Photography Award, the Leica Medal of Excellence, and the David Octavius Hill Award. His books include *Hot Light/Half-Made Worlds: Photographs from the Tropics, Under a Grudging Sun,* and *Crossings.*

Gordon Wiltsie has combined his talents in photography, writing, and mountaineering, and proved the adage about the sum being greater than its parts. A frequent contributor to *National Geographic* magazine, Wiltsie has led more than 100 expeditions outside the United States, including Antarctica and the Himalaya and once discovered a pre-Incan city in Peru's Amazonian cloud forests. Among his books is *To the Ends of the Earth: Adventures of an Expedition Photographer.*

Steve Winter once found himself stuck in quicksand on the world's largest tiger reserve. For Winter, who had wanted to be a *National Geographic* photographer since he was a boy, this was living the dream. A long-time contract photographer for the magazine, Winter has specialized in wildlife and conservation but has also photographed stories about nanotechnology, Cuba, Icelandic volcanoes, and life inside Mother Teresa's Home for Children and a Haitian AIDS hospice for children.

Mike Yamashita has been photographing stories for the *National Geographic* magazine for two decades. Concentrating on Asia, Yamashita has worked on historical stories—the Ming Dynasty, the travels of Marco Polo, and the Great Wall—and modern-day tales of the Japanese fish market. His books include *Mekong: Mother of Waters, In Japanese Gardens,* and the best-selling *Marco Polo: A Photographer's Journey.* Yamashita has received awards from the NPPA, N.Y. Art Director's Club, and Asian-American Journalists Association.

Christian Ziegler's tropical biology research was enhanced by his interest in nature photography, but by the time he finished graduate school, nature photojournalism won out. An employee of the Smithsonian Tropical Research Institute, Ziegler's *National Geographic* projects included red-eye tree bats, Panamanian bats, and ocelots. He has won several international awards, including the BBC Wildlife Photographer of the Year. His book, *A Magic Web,* is about the rainforest.

VISIONS OF PARADISE

Published by the National Geographic Society

John M. Fahey, Jr., *President and Chief Executive Officer*
Gilbert M. Grosvenor, *Chairman of the Board*
Tim T. Kelly, *President, Global Media Group*
John Q. Griffin, *President, Publishing*
Nina D. Hoffman, *Executive Vice President;*
 President, Book Publishing Group

Prepared by the Book Division

Kevin Mulroy, *Senior Vice President and Publisher*
Leah Bendavid-Val, *Director of Photography Publishing*
 and Illustrations
Marianne R. Koszorus, *Director of Design*
Barbara Brownell Grogan, *Executive Editor*
Elizabeth Newhouse, *Director of Travel Publishing*
Carl Mehler, *Director of Maps*

Staff for This Book

Bronwen Latimer, *Project Editor & Illustrations Editor*
Melissa Farris, *Art Director*
Karin Kinney, *Text Editor*
Michele Callaghan, *Clean Reader*
Mike Horenstein, *Production Manager*
Keren Veisblatt, *Picture Coordinator*
Monika Lynde, *MQM Manager*
Andrew Jaecks, *Image Technician*
Jennifer A. Thornton, *Managing Editor*
Gary Colbert, *Production Director*
Meredith C. Wilcox, *Administrative Director, Illustrations*

Manufacturing and Quality Management

Christopher A. Liedel, *Chief Financial Officer*
Phillip L. Schlosser, *Vice President*
Chris Brown, *Technical Director*
Nicole Elliott, *Manager*
Monika D. Lynde, *Manager*
Rachel Faulise, *Manager*

Founded in 1888, the National Geographic Society is one of the largest nonprofit scientific and educational organizations in the world. It reaches more than 285 million people worldwide each month through its official journal, NATIONAL GEOGRAPHIC, and its four other magazines; the National Geographic Channel; television documentaries; radio programs; films; books; videos and DVDs; maps; and interactive media. National Geographic has funded more than 8,000 scientific research projects and supports an education program combating geographic illiteracy.

For more information, please call 1-800-NGS LINE (647-5463) or write to the following address:

National Geographic Society
1145 17th Street N.W.
Washington, D.C. 20036-4688 U.S.A.

Visit us online at www.nationalgeographic.com/books

For information about special discounts for bulk purchases, please contact National Geographic Books Special Sales: ngspecsales@ngs.org

For rights or permissions inquiries, please contact National Geographic Books Subsidiary Rights: ngbookrights@ngs.org

Visions of paradise.
 p. cm.
 ISBN 978-1-4262-0338-1 (alk. paper)
 1. Natural history. 2. Natural history--Pictorial works. 3. Travel photography. 4. Documentary photography. I. National Geographic Society (U.S.)
 QH45.5.V57 2008
 910.22'2--dc22
 2008021392

ISBN: 978-1-4262-0338-1

Printed in United States

Illustrations Credits:
Corbis SABA: pp. 70-71, 72-73.
Hemphill Gallery: pp. 58-59.
Magnum Photos: pp. 1, 39, 104-105, 172-173, 200-201, 207, 251.
NationalGeographicStock.com: pp. 20-21, 32, 34-35, 40-41, 66-67, 68-69, 116-117, 118-119, 164-165, 176-177, 178-179, 188-189, 190-191, 199, 204-205, 218-219, 236-237, 238-239, 248, 274-275, 280-1.
Redux: pp. 128-129, 170-171.
VII: pp. 82-83.